DUQUESNE UNIVERSITY
The Gumberg Library

MILTON'S LEGACY IN THE ARTS

MILTON'S LEGACY IN THE ARTS

Edited by
Albert C. Labriola
and
Edward Sichi, Jr.

THE PENNSYLVANIA STATE UNIVERSITY PRESS
University Park and London

Library of Congress Cataloging-in-Publication Data

Milton's legacy in the arts.

1. Milton, John, 1608–1674—Influence. 2. Milton,
John, 1608–1674. Paradise lost. 3. Arts, Modern.
4. Fall of man in art. 5. Devil in art. 6. Adam
(Biblical figure)—Art. 7. Eve (Biblical figure)—
Art. I. Labriola, Albert C. II. Sichi, Edward.
PR3588.M53 1988 821'.4 86-43037
ISBN 0-271-00497-5

Contents

Introduction

In 1975 Joseph A. Wittreich, Jr., noted in *Milton and the Line of Vision* that a formal study of Milton's influence on English poetry began with John W. Good's premises that "the influence of Milton was powerfully felt upon all the multiplied forms and phases of eighteenth century life" and that "by far the mightiest element of the Miltonic influence came, directly or indirectly . . . from *Paradise Lost*."[1] Since that time Milton's influence upon poets and poetry has been both broadly and specifically studied, often in collections of essays, including, among other examples, Thomas Kranidas's *New Essays on "Paradise Lost*," Wittreich's *Milton and the Line of Vision*, and B. Rajan's *The Presence of Milton*.[2]

The present volume of original essays, by emphasizing Milton's influence on the arts other than poetry, is a significant addition to interdisciplinary scholarship begun long ago by Good. For we choose to interpret Good's words literally—Milton's influence "was powerfully felt upon all the multiplied forms and phases of eighteenth century life"—and to examine the implications of that assertion even into twentieth-century life.

The range and scope of these essays lead to an understanding of one author's influence on the various arts. Accordingly, Milton's epic not only elicited interpretation by artists (as well as by authors) but also influenced their aesthetic expression. Thus, a later artist "uncreates," or "deconstructs," then "re-creates" *Paradise Lost* in another medium. To explain such interaction, one may appropriate but adjust the views of

contemporary critical theorists on intertextuality, though the encounter between an author like Milton and an artist of another medium is more variegated. Harold Bloom, using a Freudian paradigm in *The Anxiety of Influence*, hypothesizes that a later author's interpretation of an earlier author's work is willful revisionism, indeed distortion, affected by psychological factors, including an Oedipal complex aimed at the literary forebear.[3] If, by extrapolation from Bloom's theory, one adduces that revisionism, caricature, disfigurement, and disintegration are Oedipal but artistic responses to an influential predecessor's work, then some insight will be provided into the relationship of later artists to Milton, though, to adjust what Bloom asserts, harmony, rather than hostility, will characterize some of the interactions.

While one may cite the views of theorists like Bloom and adapt them to explain Milton's legacy in the arts, studies of intertextuality often have limited scope because of the models that they employ to measure the difference (either evolutionary or revolutionary) of a later author from an earlier one. Models may be biographical (Vergil's wheel), biblical (the book of Job, the Apocalypse), generic (the epic), and the like. More comprehensive and pertinent theoretical models of interpretation may be derived from *Paradise Lost*, which describes Satan's awe and wonder when he sees and interprets the cosmic dance of "this pendant world" (II, 1052). Having journeyed upward from Hell, through Chaos, and across the convex exterior of the World, Satan is poised momentarily on the ladder from which he looks upward to Heaven before scanning the inside of the World below him. Converging in his psyche are his most recent experiences of Hell and Chaos, the more distant but poignantly remembered experience of Heaven, and his anticipation at entering the World, in which he will interact with God's Creation and creatures, including four angels, humankind, and the several beasts whose forms he will inhabit.

The fourfold convergence of Hell, Chaos, Heaven, and the World in the mind's eye of Satan typifies the perception of artists for whom the depiction of any one plane of activity implies relationships to the other three. For Satan—by directing Sin and Death toward God's Creation and creatures, then by urging the fallen angels to rise from Hell, after which they become false gods on earth—may be construed as a later artist who interprets, deconstructs, and re-creates the canvas and characters of his predecessor. But the Father and the Son—viewing Satan's journey to the World, foreseeing his intention, and anticipating the effects of his intervention—plan to alter, in turn, the archfiend's re-creation of their aesthetic vision; for the Son will enter the human condition so that fallen man may undergo regeneration. The irony of the deific conception is

that the Son's appearance as man will counteract Satan's presence in the serpent. Both dialectical and cyclical, the visions of Satan and God will interact, each influenced by the other, together undergoing interdependent, not independent, metamorphosis through the panorama of time, even as depicted in Adam's dream-vision in the last books of *Paradise Lost*.

The foregoing comments, which imply that *Paradise Lost* may be interpreted as a commentary on, if not enactment of, the genesis, interrelationship, and metamorphosis of aesthetic visions, lead to a consideration of art forms, the emphasis of the present volume. *Paradise Lost*, though an epic, was first conceived as a drama, "Adam unparadiz'd." Vestiges of its dramatic origins include, among other examples, the discourse of the Father and the Son, Satan's soliloquies, and the "tragedy" of Book IX, notably the Fall of mankind. In the epic, moreover, are numerous literary forms—the epithalamion, aubade, dream-vision, pastoral idyl—that have a history of adaptation into other art forms, including book illustration, musical composition, and dance. The essays that follow are extensive and intensive studies of the aesthetic visions and art forms influenced by Milton's poetry, primarily *Paradise Lost*. The essays highlight not only the interaction of later artists with Milton but also the interrelationship among artists influenced by Milton, at times across the span of centuries.

The volume begins with three essays on book illustration, graphically highlighting how successive eras reinterpret, indeed revisualize, Milton's work. Estella Schoenberg, in "Picturing Satan for the 1688 *Paradise Lost*," focuses on Satan's portraits in the first illustrated edition of Milton's epic, a turning point in the use of visual depiction as a means of characterizing and interpreting the devil. Milton and his illustrators were responsible for post-medieval portraiture of Satan, humanoid in face and form. To trace Milton's account of Satan's devolution—from seraph to serpent—illustrators depicted Satan anthropomorphically, even heroically, in the early books of *Paradise Lost*. But in the later books he is visualized animalistically, a loathsome satyr at the Temptation and Fall and more degradingly serpentine as he addresses his followers after his return to Hell. While characterized by regression to medieval conventions of picturing the devil, Satan's devolution is also accompanied by political overtones.

Schoenberg's outlook is complemented by Michael Lieb's "'The Chariot of Paternal Deitie': Some Visual Renderings," which concentrates on the throne-chariot of Ezekiel's vision, a biblical image often depicted in medieval and Renaissance iconography. In Milton's treatment of the throne-chariot in *Paradise Lost* and in the illustrations

thereof, Lieb perceives a change in interpretation and use of the throne-chariot, so that Milton's epic divides earlier from later visual renderings of Ezekiel's vision. Whereas Schoenberg focuses on the 1688 edition, Lieb extends his interpretation of illustrations into the twentieth century, analyzing sequentially how illustrators of various eras accommodated the throne-chariot to their particular sensibilities.

Interlocking with the two preceding essays is "Illustration as Interpretation: *Paradise Lost* from 1688 to 1807" by Ernest W. Sullivan, II. Sullivan, who notes that *Paradise Lost* is the most frequently illustrated work of English literature from the seventeenth to the nineteenth century, analyzes visual treatments of three major scenes in Milton's epic: Satan's appearance on the fiery lake, Satan's encounter with Sin and Death, and Satan's temptation of Eve. By comparative analysis of various illustrations of the same scenes, Sullivan focuses on changing perceptions of Satan (from archfiend to heroic rebel), of Sin (from monster to seductress), and of fallen, though fortunate, humankind.

Beyond the silent and still visualizations of scenes and characters of *Paradise Lost*, the following five essays analyze the sight, sound, and motion—potential or actual—of the performing arts. Like Sullivan and Lieb, who chart visual renderings of *Paradise Lost* across the centuries, Stella Revard, in "From the State of Innocence to the Fall of Man: The Fortunes of *Paradise Lost* as Opera and Oratorio," demonstrates how composers and poets have adapted Milton's epic, in whole or in part, for musical composition, oratorio, and opera—from Dryden's unscored libretto, *The State of Innocence*, to the opera *Paradise Lost* by our contemporary, Krzysztof Penderecki.

Whereas Revard's unfolding historical perspective is encyclopedic in coverage, the next essay, Jean Gagen's "Anomalies in Eden: Adam and Eve in Dryden's *The State of Innocence*," is a sharply focused comparative study of Adam and Eve in Milton's epic and in Dryden's adaptation thereof. Though Dryden's aim was to create an opera, the composition, never having been set to music, was not performed. At present it is read as a drama. Most significant to Gagen's outlook is Dryden's characterization of a self-assertive Eve, more intelligent than her spouse and at times sovereign over him. Gagen contends that Dryden's comedies and heroic drama, which emphasize the superiority of woman over man, may provide the context for the reaction to Milton's antifeminism.

If Milton's beliefs about women, expressed in the characterization of Eve, affected Dryden's adaptation of *Paradise Lost*, then Milton's political views on the monarchy, his advocacy of regicide, and his defense of the Commonwealth influenced culture in imperial France. Leo Miller's "Why Was Spontini's Opera *Milton* Sponsored by Empress Josephine?"

demonstrates how a misperception of the life of Milton—in effect, a romanticized version of his political career—was the basis of an artistic work by a young composer later acclaimed by Beethoven, Berlioz, and Wagner. Miller argues that the characterization of Milton in the opera reflected his reputation in France (from 1650 to 1804) as a poet and a political writer.

A historical perspective on the performing arts likewise characterizes "Milton and the Dance" by William A. Sessions, who surveys seventeenth-century dances and assesses Milton's knowledge of them. Having classified images of dance in Milton's poetry, Sessions then analyzes kinesthetic or choreographed description in *Paradise Lost*, ranging from cosmic dance in the firmament and seasonal interaction, on the one hand, to accounts of licentiousness and wantonness, on the other. Thereafter, he surveys images of dance in stagings of *Comus*—from the eighteenth to the twentieth century, with emphasis on Robert Helpmann's first ballet (1942), choreographed for Sadler's Wells and starring Margot Fonteyn.

The essays on the performing arts are rounded off by Albert C. Labriola's well-focused "'Insuperable Highth of Loftiest Shade': Milton and Samuel Beckett," in which the contemporary playwright's references to Milton—in correspondence and elsewhere—are the points of departure for a comparative study of *Paradise Lost* and *Waiting for Godot*. While arguing, in effect, that Beckett participated in a dialectical encounter with Milton, Labriola analyzes how dramatic elements of *Godot*—dialogue, characterization, tableau, stage properties—may have been influenced by *Paradise Lost*, itself first conceived as a play.

The concluding essay suggests Milton's impact on aesthetics and the philosophy of form. Nancy Moore Goslee's "'Promethean Art': Personification and Sculptural Imagery After Milton" interprets visual imagery of *Paradise Lost* from two perspectives: allegorical personifications of abstract conceptions and sculptural molding. Milton's use of visual images affected, in turn, eighteenth-century aesthetic theory, which often cites *Paradise Lost*. Against the background of Milton's poetry and later aesthetic theory, Goslee interprets personification and sculptural imagery in English odes of the mid-eighteenth century.

If Milton's epic "pursues / Things unattempted yet," then in an analogous way the present volume does what has not been undertaken earlier. No other volume considers the certainty or possibility of Milton's influence on arts as diverse as book illustration, opera and oratorio, dance, drama, and personification and sculpture. Beyond Milton's well-documented effect on poetry and poets, we focus our attention on the other arts and other creative artists whose imaginations, nevertheless,

were profoundly affected by Milton. Our chief aim is to be representative, not fully comprehensive, in demonstrating the manifold influence of Milton—in short, his legacy in the arts. A related aim is to encourage others to continue what we have begun.

NOTES

1. *Milton and the Line of Vision*, ed. Joseph A. Wittreich, Jr. (Madison: University of Wisconsin Press, 1975), p. xiii.
2. *New Essyas on "Paradise Lost,"* ed. Thomas Kranidas (Berkeley: University of California Press, 1969); *The Presence of Milton* (*Milton Studies XI*), ed. B. Rajan (Pittsburgh: University of Pittsburgh Press, 1978).
3. Harold Bloom, *The Anxiety of Influence* (New York: Oxford University Press, 1973), p. 30.

ESTELLA SCHOENBERG

Picturing Satan for the 1688 *Paradise Lost*

Satan, before *Paradise Lost*, was routinely pictured as a classical or medieval composite of animal and fantastic bodily features. Since about the time of *Paradise Lost*, however, he has been portrayed as human in face and form. Zoomorphically scrambled devils, usually incompletely disguised, have not vanished from art and literature, but they have been relegated to comedy and advertising, in both deprived forever of their power to terrify.

When Jacob Tonson planned to publish *Paradise Lost* "adorn'd with sculptures" (the 4th edition, 1688), his commissioned artists had the problem of designing a new-style Satan only vaguely described in the text, and the further problem of depicting his gradual devolution from angel to devil to serpent. [1]

There is no way of knowing how the blind poet envisioned either Lucifer or Satan. His avoidance of verbal delineation has thrown the problem to his illustrators, and artists are generally a stubbornly self-sufficient and pragmatic lot. In Milton's century, limners and engravers working on assignment to the stationers (publishers) took their designs where they found them. The subject of this essay, then, is not so much how accurately illustrations of *Paradise Lost* reflect the poem as how they represent contemporary (late seventeenth century) popular understanding of devil anatomy and costume.

A related consideration is whether Milton's characterization of Lucifer/Satan—basically anthropomorphic but modulating from bright angelic to dark demonic and then suddenly to reptilian—was the first such

and hence entitled to claim inspiration or fresh understanding. In other words, did Milton's Satan bring about a post-medieval devil image, or was the New Model Satan already on the scene? Two earlier seventeenth-century works are to be considered. Both were published at the time of their first performance—both were verse dramas—and both publications were illustrated.

B. Rajan, in 1947, called Milton's Satan "a poetic representation."[2] In short, that is what Satan is in *Paradise Lost*—words. In Milton's poem of the abstract and the invisible and the unknowable, Satan, more than Adam and Eve, and Hell, more than the Garden of Eden, leave the poem's illustrators almost totally helpless or totally free, depending on the robustness of their visual inventiveness or the rigor of their religious indoctrination.

Paradise Lost has been illustrated more than three dozen times since 1688. The succession of Satan portraits chronicles a conceptual evolution or development much too extensive to be attempted here, but its turning point, as far as devil iconography is concerned, coincides or approximately coincides with Milton's portrayal of the Prince of Light becoming the Prince of Darkness, and that is the subject about to be discussed.[3]

Illustrations of Satan's or the devil's visible (visualizable) forms have been assembled by Roland Mushat Frye in his 1978 study *Milton's Imagery and the Visual Arts.*[4] His book is divided into three parts, namely, the three settings of *Paradise Lost*: Heaven, the Garden of Eden, and Hell. All the pictures reproduced antedate *Paradise Lost*, Frye's purpose being to establish the iconographic traditions Milton is presumed to have drawn on in composing his great poem. Dr. Frye himself observes that his efforts to correlate the visual images and Milton's poetic narrative worked very well with angels and cherubs and with Adam and Eve and their garden, but not with the Hell of *Paradise Lost* and its occupants.

Before *Paradise Lost*, pictured devils were not good to look at. Their creators' aim was to put the fear of God—or rather the fear of hellfire—into the beholders. In Milton's Hell, however, Satan and his followers behave pretty much as shipwrecked humans might, and until their sudden transformation to serpents they seem to fit the description of humans or of slightly scruffy angels—no tails, no horns or webbed wings, no cloven hooves or bird claws.

To trace the abrupt change of direction in devil portraiture it is necessary to go back only a little bit before *Paradise Lost* to two seventeenth-century verse dramas, one of them illustrated with medieval devils and the other with "modern," anthropomorphic fallen angels. Both illustra-

tions have a demonstrable connection to *Paradise Lost*, or at least to its first illustrations.

The dramas are *L'Adamo, a Sacre Rapresentatione* (a religious enactment) by Giovanni Andreini (Milan, 1613) and *Lucifer: Treurspel* (an epic tragedy) by Joost van den Vondel (Amsterdam, 1654).[5] As their titles indicate, the Italian work is concerned primarily with the Fall of Man, and the Dutch with the Fall of the Rebel Angels. There is almost no doubt that Milton was familiar with both, as was established by critical controversy in the late nineteenth century, at least in the more important case of Vondel's *Lucifer*.[6]

As for Milton's knowledge of *L'Adamo*, Voltaire believed and wrote without equivocation (but, unfortunately, without substantiation either) that the English poet had attended a performance of *L'Adamo* in Florence.[7] Milton would have been twenty-nine or thirty years old. If Voltaire's statement is correct, the traveler witnessed a troupe of bizarrely costumed Italian actors performing before an elaborately and formally painted scene, descending mechanically assisted from "heaven," and ascending via hinged trapdoors from "hell." First performed in the year of its illustrated publication, *L'Adamo* would have enjoyed an already long run or frequent revivals by the time of Milton's visit to Florence.

Whether or not Milton saw a performance of this dramatic work, its published version would have interested him greatly. It would have been just the thing for inclusion in that shipment of books he sent home to Hammersmith. Here is another reason for scholars to regret the lack of inventories of that shipment and of Milton's library.

L'Adamo contains numerous decorative illustrations, all obviously representing performance on a proscenium stage (except for the title-page picture, which may represent the curtain), from which twentieth-century students of theater history can easily imagine the painted scene, the intricate machinery, and some of the spectacle-producing tricks of the early seventeenth-century production—designs and techniques Inigo Jones had already brought from Italy to London, where they competed with Ben Jonson's poetry for recognition as "the soul of the masque."

The production's costumes and make-up are harder to imagine. Its demonic personae, although they may have worn goatish beards and horns and shaggy kneepants, could hardly have managed the bone-thin bird legs and goat legs with clawed or cloven feet shown in the drawings. There is a pictorial connection, a chain of borrowed or stolen images, traceable from the 1613 *L'Adamo* to Vondel's *Lucifer* to the 1688 *Paradise Lost*. It is the archangel Michael charging in full flight against the falling Satan and his cohorts. In illustrations of the two earlier works,

Michael's costume, shield, and pose are almost identical, the execution of the *Lucifer* illustration being more impressive because larger and more skillfully drawn (Figs. 2 and 4).

The third picture in the sequence is Plate VI of the 1688 series (*Paradise Lost*), the Expulsion of the Rebel Angels from Heaven (Fig. 7, p. 24). Here two armies are similarly clad and armed, but details are obscure. The striking similarity of the 1688 illustration to the one of 1654 is compositional and confined to the top part of the picture. In the earlier picture Michael, in dramatic relief against the sun, brandishes a thunderbolt; and in the *Paradise Lost* illustration, published thirty-four years later, God the Son, enthroned on a chariot of fire, is almost silhouetted against an identically drawn sun in a remarkably similar posture of the arms, head, and shoulders. (For some reason, possibly haste, a rather small-to-begin-with fire drawn by artist John Baptist Medina was omitted by the engraver, Michael Burgesse. Its location was at the very front of the tablet-like bed of the "chariot.")[8]

The devil figures or falling angels in the 1613 pictures (*L'Adamo*) are quite different from either those of 1654 (*Lucifer*) or 1688 (*Paradise Lost*). Furthermore, the 1613 title-page illustration presents the tempter-serpent in a form unrelated to the devil portraits in the rest of the book—and obviously drawn by a different artist. On the title page Adam and Eve stand to left and right of the Tree of Knowledge. The serpent, its tail coiled around the trunk of the tree, has the torso, arms, and head of a woman—a very early concept of the Tempter (Fig. 1).

There are thirty-seven scenes in the five acts of *L'Adamo*, and each scene is headed by a drawing of the scenery before which it was played and of the actors involved in the scene. The characters are conveniently named beneath their depictions. As in *Paradise Lost*, Satan's comrades bear the names of heathen deities.

The headpiece of Act V, scene 8, the Expulsion from Heaven, has been mentioned above (Fig. 2). The rebel angels are depicted in the tumbling fall which so fascinated artists of the late Renaissance, but there are only three of them—opposed or overcome by only three of God's warrior angels. The perspective is from below only about as much as the audience on the orchestra level of a theater would have experienced it. Other paintings of the period and earlier seem by comparison to precipitate falling bodies—devils or the souls of the damned—onto the very heads of the beholders. Although the actors in this scene are so few, if their descents were mechanical and employed more than one machine, as they may well have done, or if the actors simply jumped down onto the stage, six would have been impressive enough.

The cramped composition of this illustration imparts a certain appro-

priate disorder and violence to the scene, but the flames of Hell reach too near Heaven and all of Chaos is filled with the three already metamorphosed rebels. There is no sense of the spaciousness characteristic of *Paradise Lost*.

Satan, in the center of the picture and still touched by Michael's sword point, has already grown long goatlike horns and a patriarchal beard. His wings are no longer feathered, but ribbed and webbed like a bat's. His legs are obscured by a cloud, but there seems to be a naked curled tail. His weapon, grasped as it would be by a farmer pitching hay, is indeed the devil's traditional tool, a pitchfork, or trident. Of his two companions in defeat, the one on the left is less grotesque. He has grown a long ugly tail and his feet and hands are birdlike claws, but his wings are still feathered and his body is still "human." The creature on the right has the tail and hind limbs of a goat, webbed wings, and bird-claw "hands." His face is hidden.

All the scenes of Andreini's drama seem to have been played before the same painted backdrop, a formally trimmed hedge and trees with almost no perspective depth. Some of it is shown in the headpiece of *L'Adamo* I, 4 (Fig. 3), where "Melecano," "Lurcone," and "Lucifero" are met by "Sathan" and "Belzebu," the last two stepping upward from nether regions through a hinged trapdoor and a burst of flame. I have selected this picture as representative of the *L'Adamo* illustrations because the backdrop is included and because of the distinction shown between Lucifer and Satan, two separate characters in Andreini's dramatic allegory.

In *L'Adamo*, a play which must have required a very long evening in the theater, the successful temptation of Eve and Adam is followed by morality-play scenes of postlapsarian trials, the devils abetted by allegorical figures of *Morte*, *Carne*, *Mondo*, and *Vaingloria* and a quartet of elemental spirits—*Ignei*, *Herei*, *Terrei*, and *Acquatiei*. The drama ends on a note of hope, however. Protected by angels, Adam and Eve are saved from Sin and Worldliness; Lucifer and his cohorts are expelled from Heaven, and Adam and Eve receive the angelic promise that their troubles will end in Eternal Love.

The tone of *L'Adamo* is decidedly medieval, especially in contrast to that of Vondel's *Lucifer*, less than half a century later, and Milton's *Paradise Lost*, only about a dozen years after that. The pictured devils of *L'Adamo* are a hodgepodge of zoological forms, but in *Lucifer*'s single illustration both Michael and Lucifer, though winged, are otherwise human in appearance.

Ironically, the single *Lucifer* illustration (Fig. 4) lacks the stylistic consistency maintained in the long series of drawings for *L'Adamo*. The

Ladamo
Sacra Rapresentatione
di Gio. Batista Andreino
Fiorentino.
Alla M.Christ. Di Maria de Medici
Reina di Francia
Dedicata.

Con Priuilegio
Ad' instanza di Geronimo Bordoni libraro.
in Milano. 1613

Fig. 1. Title page, *L'Adamo*, 1613. Reproduced by permission of the Folger Shakespeare Library.

DELL'ADAMO. 163
SCENA OTTAVA.

Archangelo Michaele, Chori d'Angeli,
Chori di Demoni.

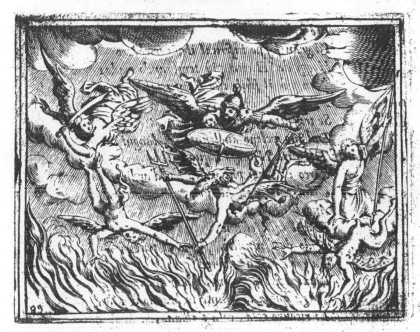

Rema figlio de l'Ira
 Al folgorar di questo aceto dardo,
 Al colpeggiar del Capitan celeste,
 Nè muoui à Dio, à te sol muoui guerra,
E ne l'offese tue te stesso offendi:
Cada tra l'ombre afflitto spirto errante,
Chi d'Angelica luce in tutto è priuo;

Apoc. 7. Et vidi alte
rum Angelū ascē-
dentē ab ortu solis,
& clamauit voce
magna, &c. Nolite
nocere terrę & ma-
ri, neque arboribus
&c.

 Abbagli

FIG. 2. *L'Adamo*, Act V, scene 8. Page 163 of the first edition. Reproduced by
permission of the Folger Shakespeare Library.

DELL'ADAMO. 21

SCENA QVARTA.

Melecano, Lurcone, Lucifero, Sathan, Belzebù.

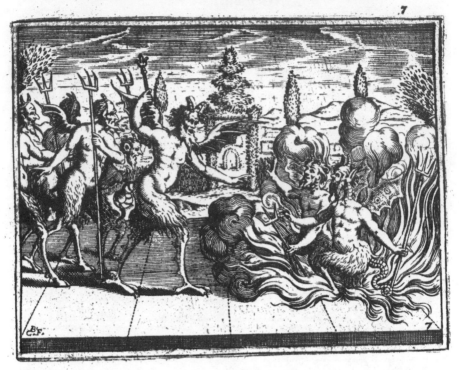

 Mponi alto Signor, che vuoi? fauella;
 Vuoi, ch'al nouello giorno i' spenga il Sole?
 Mira quanta quì meco
 Traggo tenebra, e vampa,
 Per l'ira ohime, che Melecano auampa.
Lurco Ecco Lurcone, ò Imperador d'Auerno,
ne. Che contra il Ciel superno
 L'ire sue volger brama, onde leggiero
 Ben che carco di rabbia

 Com-

FIG. 3. *L'Adamo*, Act I, scene 4. Page 21 of the first edition. Reproduced by permission of the Folger Shakespeare Library.

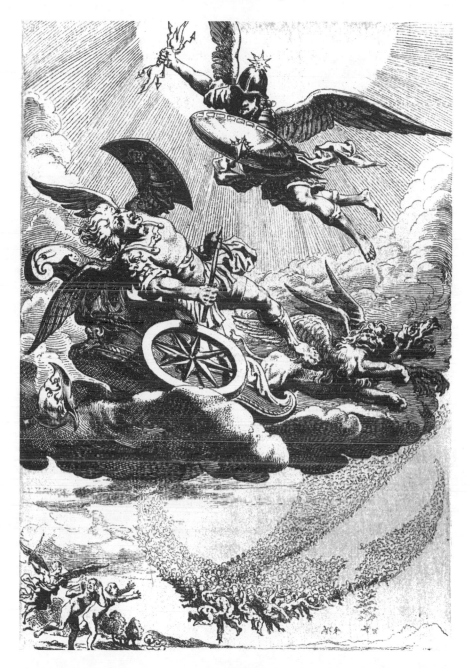

FIG. 4. Frontispiece. Joost van den Vondel, *Lucifer: Treurspel* (Amsterdam: Abraham de Wees, 1654). Special Collections and Archives, University of Kentucky.

Dutch picture's three separate tableaux are assembled in baroque eclecticism on a vast field embracing Heaven, Chaos, and the Eastern Gate of Eden, much as the 1688 *Paradise Lost* illustrations combine disparate pictorial elements and multiple incidents within single frames. Also like the 1688 series, the *Lucifer* plate appears to have involved at least two and possibly three artists and several iconographic sources.

L'Adamo and *Lucifer* are both mentioned, but no illustration of either work is reproduced, in *Milton's Imagery and the Visual Arts*, and both are summarized and partially translated in *The Celestial Cycle*, but Roland Frye, author of the first-named encyclopedic reference work, and Watson Kirkconnell, author of the other, are interested, respectively, in iconographic sources of *Paradise Lost* and in its literary forerunners or analogues, not in the 1688 and subsequent pictorial representations of the poem. Kirkconnell, although his reference is literary rather than pictorial, points out the same discrepancies in devil portrayal between Andreini's work and Milton's that have been implied above in discussion of illustration.

Of much more importance to Milton scholars is consideration of the relationship of Vondel's epic drama and Milton's epic poem. Kirkconnell does not hesitate to name Vondel's *Lucifer* the strongest analogue of *Paradise Lost*. He believes that Milton was aware of the Dutch work, although Dutch was not one of the languages he could read.

During Milton's employment by Cromwell's government, he conducted busy correspondence with Holland and other parts of Europe, both in his official capacity and in his private-public differences with Salmasius and others. The exchange of letters and printed matter between England and the Continent was not difficult or even slow. Although Milton could not have read *Lucifer*—not only because he did not know Dutch but because he was blind by that time—he would not have been without help in translating from the Dutch language.

Roger Williams, the founder of Rhode Island, either instructed Milton in Dutch or (more likely) translated examples of it for him some time between 1651 and 1654, evidently on a fairly regular schedule. Williams, on a long visit to London in the early 1650s, has recorded his exchange of translation or instruction favors with his friend John Milton. Both men would have been interested in Vondel's play, and Williams would have been able to read it in Dutch. Perhaps he read it to Milton translating as he went, or he may have summarized it and described its single impressive illustration and talked about it with Milton.[9] Andrew Marvell too could have been Milton's translator-reader of *Lucifer*.

In February 1654 Vondel's *Lucifer* caused a much-publicized ruckus

in the Netherlands. After only two performances the play was closed by the authorities. "Extreme Calvinist preachers" had complained of "unholy, immodest, false, and very bold things, too cunningly devised for human brains."[10] Among these objectionable and fiendish "things" would have been political insinuations clear to anyone in Holland or England in 1654 and applicable in either place.

The play went quickly through several printings, the first offered for sale as soon as the play closed on the night after its opening. That copies soon found their way to England is certain. The notoriety of the play and its political commentary were the talk of London as well as of the Hague and Amsterdam. The winged lion and the winged dragon harnessed to Lucifer's overturned chariot in the play's single illustration are icons of Pride and Envy, but they are also heraldic beasts of Holland and Zeeland; while the challenger of Divine Rule, Lucifer, is readily matched to challengers of the House of Orange in the Netherlands and the House of Stuart in England.

In the *Lucifer* illustration, the Arch Rebel tumbles in terror from his chariot as the winged beasts that drew it, the lion and the dragon, spring aside. In *Paradise Lost* "Th' Apostate" had stepped down before the battle in Heaven from "his Sun-bright Chariot," which is termed three lines later "his gorgeous Throne."

This image, Satan's combined chariot and throne, is only one of several features common to Vondel's masterpiece and Milton's. At the Second International Milton Symposium, held in August 1983 at Cambridge and Chalfont St. Giles, Albert Gérard presented a paper noting "similarities between Vondel's and Milton's treatment of innocent sexuality in Eden, both poets depicting Adam and Eve in a baroque setting similar in aesthetic effect to scenes of innocent lust in Spenser and Lope de Vega. Though Milton most likely did not know Vondel's work, their similar treatment of good and pleasurable married bliss is remarkable."[11]

Familiar with Vondel's work or not, Milton weighted *Paradise Lost*, as Vondel weighted *Lucifer*, with political implications. This is no longer seriously questioned. The most convinced and convincing exponent of this view is Christopher Hill. His book *The Experience of Defeat: Milton and Some Contemporaries* strengthens the argument of his earlier *Milton and the English Revolution*—that Milton's poetry as well as his prose is pervaded with political conviction.

In his introduction to *The Experience of Defeat* Hill observes of seventeenth-century censorship, "We must never forget its existence, and how exceptional men felt its brief absence (in the 1640's) to be."[12] Intending to reinforce his own earlier interpretation of Milton as a funda-

mentally political writer by providing a context of other, lesser writers who coped, as Milton had to, with an unsympathetic licenser of printing, Hill writes, "Under censorship men restrained themselves from telling the whole truth as they saw it, proceeding by analogy, implication and innuendo," and "those with something original to say found it safer to make use of allegory or pastoral; others cited the Bible or the classics to convey unorthodox views without actual commitment."[13]

It is on the matter of incorporating subversive comment that this discussion moves from Vondel's *Lucifer* and its illustration to Milton's *Paradise Lost* and its first illustration. The first two of its twelve pictures contain, as I have argued elsewhere, political cartooning, the message of which is that the Stuarts belong in Hell. Having said it, I shall leave it there and turn to the Satan depictions among the twelve plates and the problems confronted by John Baptist Medina and the others— at least two others—who designed them.

Ironically, Milton's blindness, I believe, freed him from the responsibility passed by Jacob Tonson to Milton's illustrators; it provided "airy space and scope for [his] delirium."[14] Again ironically, an artist has to "see" things more "literally," especially when working in black-and-white line engraving.

It was Jacob Tonson who saw in *Paradise Lost* a work whose time for illustration had come. Not without supportive confederates, he arranged for a young, newly immigrated Spanish-Flemish artist, Medina, to provide most of the designs. Whether Medina was to provide all of them is unclear. In fact, the history of how, where, and by how many hands this handsome folio edition of *Paradise Lost* was brought to the press would make a good novel.[15] Dr. Henry Aldrich is believed to have been the artist of Plate II and Plate XII, and possibly of Plate I. None of Medina's designs contains political implications, and the book as a whole is spotted with evidence of shifted plans and a last-minute rush to the printer(s). Perhaps Medina left when he realized what he might be held responsible for. (Under the patronage of a Scottish nobleman he moved to Edinburgh to specialize in portraiture and became "the Kneller of the North.")

Two decisions had to be made before the art work could begin: how to represent Lucifer's gradual decline and how to avoid trouble while still pressing a political point. Tonson was not only a sincere admirer of Milton and his work but also an astute businessman. His motivation was not just to stir up a political flurry but also to produce a fine, attractive, and profitable book.

The problem of avoiding trouble while making a political statement

probably was not solved; it was evaded by postponing publication from time to time until James II and his court had fled to France. The problem of delineating Satan's decline was solved by taking established devil iconography as old and older than the Bible, softening it, and in a sense modulating it to suit Milton's devolving characterization of Lucifer/ Satan. At first blush this seems inappropriate or contradictory to the poem, but it is not. Milton provides no precise descriptions to be contradicted, although he makes it plain that the changes Satan is unaware of in himself are *visible* to the angels who knew him as Lucifer in Heaven. Tonson had to be sure the changes would be visible to his subscribers and customers, too, and that these seventeenth-century "consumers" would recognize the devil when they saw him.

Designers of the *Lucifer* plate of 1654 (Vondel's drama) and ten of the twelve *Paradise Lost* plates of 1688 employed the pictorial convention of combining an important foreground episode with two or more background episodes within a single frame. (The *Lucifer* picture is unusual in that the foreground is at the top rather than at the bottom of the design.) This economical and imaginative device, widely used in earlier book illustrations, mural painting, and tapestries, is thoroughly appropriate for *Paradise Lost*, but it was not used in any later illustrations of the poem.

The multiplicity of scenes per plate, and Tonson's employment of three or more artists with no discernible effort to homogenize their various hands, could have ruined the effect of these illustrations, but they did not. Indeed, the pictures successfully embody qualities of Milton's narrative rarely realized in later illustrated editions—the poem's variety and simultaneity of action and scene, its successive narrative points of view, its structural and tonal complexity and richness. The best of Medina's *Paradise Lost* drawings offer a graceful, pastoral delicacy which transcends the necessary change of medium from sketch to engraving.

Satan appears in only five of the 1688 illustrations, not counting either the disguises of his prowl through Eden in Book IV or the Expulsion from Heaven in Book VI, where Satan is still Lucifer and indistinguishable among the other falling rebel angels. The five illustrations in which Satan is identifiable are Plates I–III, IX, and X.

Plate I (Fig. 22, p. 63) is well known to Milton scholars and to historians of printing and book illustration. It is frequently reproduced, not only because it is a striking picture but also for its technical excellence. There are weaknesses in the drawing, caused, I believe, by last-minute changes decreed by Jacob Tonson or possibly by Dr. Henry Aldrich (within a year of publication Dean Aldrich), of Christ Church, Oxford,

and executed by another hand than that of the original artist. No one has complained of this, however, and it need not distort discussion of Satan's metamorphosis as depicted in 1688.[16]

The beginning of Satan's metamorphosis is suggested in Plate I only in the singed state of his feathered wings, in the appearance of little wormlike snakes in place of hair, and by his large pointed ears. Judging by the one heel not hidden, his feet are human feet. Among his fallen comrades, however, one foot is visible, and it has clawlike toes.

In the small court scene in the background, traditional horned devils armed with tridents stand ceremonial guard. These tiny horned figures ensure identification of the setting as Hell and the flames behind the scene as hellfire, although the regal figures (two of them, where Satan presided alone over Pandemonium) and their attendants are seemingly human.[17]

The Satan of Plate II (Fig. 23, p. 65) is easily identified with the Satan of Plate I by the modeling of his face and head and by the style of his armor, but his face and form have undergone several modifications for the worse. He is shrunken in stature, his countenance is coarser and darker, and the snaky hair and pointed ears of Plate I are exaggerated. He has lost his sandals, and his stumpy, thick-ankled legs end in grotesque though still human feet. His singed wings have become ribbed and leathery like a bat's.

After Plates I and II, Satan appears as himself in only three more of the 1688 drawings, and in them his physical form shows no evidence of angelic origin or the heroic remnants of it which invigorate Book I. After Plates I and II, the Satan figures are drawn by Medina, and all but one are traditional faun-satyrs distinguished by a rather wistful humanity of aspect. In Plate III (Fig. 5), looking toward Heaven, where God the Son sits enthroned amid several degrees of angelic supporters, Satan commands the viewer's sympathy for all he has lost—and no antipathy for what he is about to do or to become. His devil features here, aside from the lack of armor or any clothing, are small horns, furry thighs, a tail, and cock's spurs on his heels. His posture is slightly stylized but graceful, almost balletic to modern eyes. Throughout Medina's drawings, Satan's bestiality is softened considerably from the devils collected in Frye's book, even at the nadir of Satan's self-corruption in Book IX.

In Plate IX (Fig. 24, p. 69) Satan has become a loathsome satyr, while behind him in perspective the Temptation and Fall are played out on the landscape of Eden in no less than five episodes. In the foreground, Satan chances upon the sleeping serpent and realizes that it is to be his means of ruining Eve and Adam. This Satan is undoubtedly copied from an earlier artist, probably from a printer's source book of design ele-

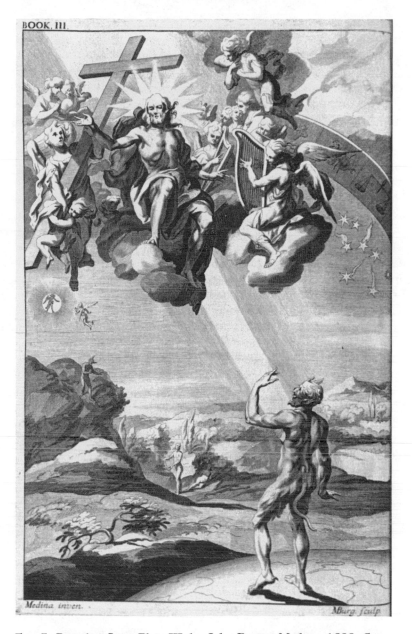

FIG. 5. *Paradise Lost,* Plate III, by John Baptist Medina, 1688. Copied from *PL,* 5th edition, 2nd printing, 1692, in the collection of Estella Schoenberg. The 1688 plates, still in excellent condition, were used in production of the 5th edition.

ments. Besides the figure's general ugliness, it has physical features not found on any other of Medina's Satans—female breasts, for instance, and wings—and the drawing style is not Medina's.

If this foreground figure of Satan is copied, however, the copying must have been done by Medina himself, for the published illustration matches the artist's original drawing, except that it is reversed left to right. The appropriately dark foreground looks as if it had been superimposed upon Medina's landscape by cut-and-paste, possibly replacing another rendering of the serpent and Satan. In the next illustration, Plate X (Fig. 6), Medina continues his own interpretation of Satan's decline as though it had not been interrupted.

The primary subjects of Plate X are Adam and Eve. Behind them at a distance Satan encounters Sin and Death entering the World, attracted there by Man's first disobedience. In a third scene, beyond the bridge spanning Chaos, Satan is seen addressing his legions. Their figures in distant perspectives are tiny, but it is clear that Satan's legs and feet have changed to those of a goat since his meeting with Sin and Death. Changes are evident in his legions, too. One figure has fallen to the ground; tall horns are noticeable on another; and above the demonic gathering in Hell the Tree of Knowledge is overrun by those whose transformation to snakes is complete.

Tonson and his heirs republished the 1688 illustrations over and over again for nearly half a century, having the plates reengraved in ever-shrinking proportions. In the early eighteenth-century they commissioned a new set of designs by Sir James Thornhill and Louis Cheron (1720). In these Satan is horned and hoofed more like Baal than like a satyr. The iconography is in general heavy-handed, and after only one edition Tonson returned to the "Medina" illustrations.

There is no later illustration which employs the medieval or classical devil iconography for Milton's rebel angels, and none in which there is a serious artistic effort to trace Satan's devolution through a gradual metamorphosis.

Whether or not John Milton visualized the degradation of Satan as it is depicted in 1688, and whether or not he would have condoned it—I think he would have, just as he did not seem to mind John Dryden's rendering his blank verse in rhyme—modern readers of *Paradise Lost* tend to visualize the changes differently. Whatever the rationale for illustrating a modern poem with medieval and ancient images, the first illustrators of *Paradise Lost* employed an iconographic code that was sure to be read aright in the late seventeenth century. This was important for whatever political message Tonson and his collaborators incorporated in Plates I and II and in their choice of *Paradise Lost* itself for illustrated folio republication in 1688.

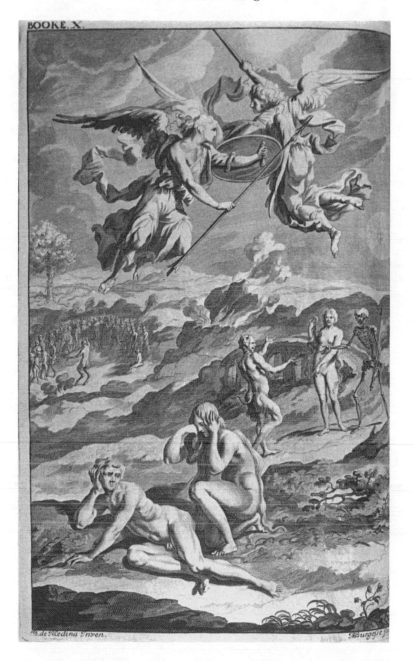

Fig. 6. *Paradise Lost,* Plate X, by John Baptist Medina, 1688. Copied from *PL,* 5th edition, 2nd printing, 1692, in the collection of Estella Schoenberg.

NOTES

1. John Milton, *Paradise Lost*, 4th ed. (London, 1688). Three title pages, one naming Jacob Tonson publisher, one naming Richard Bently, and one naming both Tonson and Bently.

2. Balachandra Rajan in his Introduction to *Paradise Lost and the Seventeenth Century Reader* (London: Chatto and Windus, 1947).

3. There is no comprehensive bibliography of illustrated editions of *Paradise Lost*, but by combining information from C. H. Collins Baker's "Some Illustrators of Milton's *Paradise Lost* (1688–1850)" with Marcia R. Pointon's *Milton & English Art* an almost complete list can be put together: Collins Baker in *The Library* 3, no. 1 (June 1948): 1–21 and (September 1948): 101–19; Thomas Balston, "To the Editor of *The Library*," a letter correcting some details of Collins Baker's two-part article; Pointon, *Milton & English Art* (Manchester: Manchester University Press, and Toronto: University of Toronto Press, 1970).

Collins Baker lists every plate designed by each artist and every printing of every edition from 1688 to 1850. Pointon's interest is in English art, which causes her to omit Gustave Doré, although his *Paradise Lost* work was done in London; also, there is a gap of one decade between the works discussed in her text and an appendix bringing her inventory up into the early twentieth century. There have been at least two important illustrated editions since then, both published in the mid-1930s. The artists of these two books are the only women (I believe) to have illustrated *Paradise Lost*, Carlotta Petrina and Mary Groom.

4. Roland Mushat Frye, *Milton's Imagery and the Visual Arts: Iconographic Tradition in the Epic Poems* (Princeton: Princeton University Press, 1978).

5. For summaries and translated excerpts of *L'Adamo* and *Lucifer* and for evaluation of their relationships to *Paradise Lost*, see Watson Kirkconnell, *The Celestial Cycle: The Theme of "Paradise Lost" in World Literature, with Translations of the Major Analogues* (Toronto: University of Toronto Press, 1952; reprinted New York: Gordian Press, 1968). A complete English translation of *Lucifer* is *Vondel's Lucifer Translated from the Dutch by Leonard Charles van Noppen* (Greensboro, North Carolina: Chas. L. van Noppen, 1917).

6. See George Edmundson, *Milton and Vondel* (London, 1885) and a similar study published in the Netherlands ten years later: J. J. Moolhuizen, *Vondels Lucifer en Miltons Paradijs Verloren* (Gravenhage, 1895). Edmundson provides synopses not only of *Lucifer* but also of Vondel's sequel to it, *Adam in Banishment* (1664), of his *Samson* (1660), and of his essay "Reflections on God and Religion" (1660).

In his conclusion Edmundson quotes both Vondel and Milton on the issue of "borrowing" from other authors and across language barriers. Milton: "To borrow, and better in the borrowing, is no plagiarie." Vondel: "Knowledge of foreign poets helps the coming poet, just as copying of masterpieces of art the student of painting. . . . If you want to pluck flowers upon the Dutch Helicon, so manage it that country-folk (*de boeren*) do not notice it, and that it do not too palpably attract the attention of the learned."

7. Edmundson, p. 1. Reference is to Voltaire's "Essay on Epic Poetry." Masson does not mention this, nor does Parker, although the latter alludes to the essay in a note on another topic. David Masson, *The Life of John Milton: Narrated in Connexion with the Political, Ecclesiastical, and Literary History*

of His Time (New York: Macmillan, 1946); first published 1859–80, the index 1894. William Riley Parker, *Milton: A Biography* (Oxford: Clarendon Press, 1968). Obviously neither biographer considered Voltaire a reliable source of information about John Milton. Edmundson's trust was probably misplaced, but the likelihood of Milton's having owned a copy of *L'Adamo* seems strong, and his having witnessed a performance is not impossible or even unlikely.

8. Medina's eight drawings are in the Dyce Collection of the Victoria and Albert Museum, London. They are published with Suzanne Boorsch's "The 1688 *Paradise Lost* and Dr. Aldrich," *Metropolitan Museum Journal* 6 (1972): 133–50.

9. Kirkconnell, and Parker, note 256, p. 1008. Parker quotes Williams's letter to John Winthrop, 12 July 1654, and by it dates Williams's stay in England between December 1651 and early 1654. The letter seems to Parker to indicate an exchange of language lessons or help with various translating problems or jobs. Williams writes that he had been "called upon for some time and with some persons, to practice the Hebrew, the Greek, Latin, French, and Dutch," and that Milton "for my Dutch I *read* him, *read* me many more languages" (italics added). Parker comments on Williams's failure to mention Milton's blindness. This clouds the nature of the exchange—lessons or translation—as well as the dates of Williams's and Milton's linguistic activities. It all hangs on interpretation of the verb (past tense) *read*.

10. Edmundson, p. 28.

11. I have quoted the *Milton Quarterly*'s report of Gérard's paper because I do not have the text of his paper and cannot tell whether he or *MQ* doubts Milton's knowledge of *Lucifer*.

12. Christopher Hill, *The Experience of Defeat: Milton and Some Contemporaries* (Faber & Faber, 1984), p. 21.

13. Ibid., pp. 21–22.

14. Fictional character Rosa Coldfield in William Faulkner's *Absalom, Absalom!* (New York: Random House, 1936).

15. See Suzanne Boorsch's article, cited in note 8 above. See also: John T. Shawcross, "The First Illustrations for *Paradise Lost*," *Milton Quarterly* (May 1975). 43–46, Estella Schoenberg, "The Face of Satan, 1688," in *Ringing the Bell Backward: The Proceedings of the First International Milton Symposium* (Indiana: Indiana University of Pennsylvania Imprint Series, 1982); Mary D. Ravenhall, "Sources and Meaning in Dr. Aldrich's 1688 Illustrations of *Paradise Lost*," *English Language Notes* 19, no. 3, and Ravenhall, "Francis Atterbury and the First Illustrated Edition of *Paradise Lost*," *Milton Quarterly* 16, no. 2 (May 1982).

16. Sources of pictorial elements in the non-Medina designs have been identified and their use interpreted by at least these: Leonard Kimbrell, *The Illustrations of Paradise Lost in England—1688–1802* (dissertation, Yale University, 1965); Helen Gardner, "Milton's First Illustrator," *Essays & Studies*, new series, 9 (1956): 27–38; Suzanne Boorsch and Estella Schoenberg, articles cited in note 15 above; Mary Dennis Ravenhall, *Illustrations of "Paradise Lost" in England, 1688–1802* (Ph.D. diss., University of Illinois, 1980), and Ravenhall, two articles cited in note 15.

17. In "The Face of Satan, 1688" (see note 15 above) I have argued that the court in Pandemonium (Plate I) represents the Catholic court of James II and that the foreground figure of Satan has been given the face of the dethroned king,

while Satan in Plate II is a caricature of Charles II facing Death in the presence of Sin.

As for Milton's political intent, I believe that is not a matter of either/or. His grand epic concerned Politics with a capital P. Satan is not Cromwell, not Charles II, or any other Stuart. Rather he is all presumptuous rebels before, during, and since the writing of *Paradise Lost*. But this essay is concerned with the illustrations, not with the text of the poem.

MICHAEL LIEB

"The Chariot of Paternal Deitie": Some Visual Renderings

If Satan had been a reader of *Paradise Lost*, he undoubtedly would have observed that the most overwhelming event in Milton's epic is that which depicts the routing of the rebel angels by the Son of God. Having suffered the indignity of that routing first-hand, Satan is one reader whose response it would be difficult to confute. Who more than he "knew / The force of those dire Arms?" (I, 93–94).[1] As Satan, to his great dismay, came to learn, the Son "can put on / . . . [God's] terrors," as much as he can assume God's mildness, "image of . . . [God] in all things" (VI, 734–35). The way in which the Son assumes God's terrors, of course, is through that most awesome of vehicles, "the Chariot of Paternal Deitie." Rushing forth with "whirlwind sound," this mighty instrument of divine vengeance is described as

> Flashing thick flames, Wheel within Wheel undrawn,
> It self instinct with Spirit, but convoyed
> By four Cherubic shapes, four Faces each
> Had wondrous, as with Starrs thir bodies all
> And Wings were set with Eyes, with Eyes the wheels
> Of Beril, and careering Fires between;
> Over thir heads a chrystal Firmament,
> Wheron a Saphir Throne, inlaid with pure
> Amber, and colours of the showrie Arch.
>
> (VI, 749–59)

Onto this remarkable vehicle, the Son ascends like a warrior, armed in the "Celestial Panoplie" of God's warfare. "At his right hand Victorie / Sate Eagle-wing'd, beside him hung his Bow / And Quiver with three-bolted Thunder stor'd, / And from about him fierce Effusion rowld / Of smoak and bickering flame, and sparkles dire" (VI, 760–66). Confronted by the Son in his "fierce Chariot," the rebel angels lose all resistance and courage (VI, 838–39). Bombarded by "a multitude of Thunders" and a myriad of arrows, they are assaulted by the lightning that shoots forth from the countless eyes of the fourfold creatures, which, in turn, propel the chariot over the "Shields and Helmes and helmed heads" of the rebellious crew (VI, 836–45). The experience "withered all thir strength, / And of thir wonted vigour left them draind, / Exhausted, spiritless, afflicted, fall'n" (VI, 850–52). Who would not be overwhelmed by such an event?

This experience of overwhelmingness is, of course, precisely what Milton derived from his biblical source, the prophecy of Ezekiel. In the vision that inaugurates his prophecy, Ezekiel beholds "the likeness of four living creatures," each containing the faces of a man, an ox, an eagle, and a lion. Beside these creatures are wheels, with a wheel in the middle of a wheel. Both the creatures and the wheels are full of eyes (cf. Ezek. 10:12). Above the creatures and upheld by them is the likeness of a firmament, upon which is the appearance of a throne surrounded by the brightness of a rainbow. Upon the throne is the likeness of a seated figure who addresses Ezekiel. In response to this theophany, Ezekiel falls upon his face (Ezek. 1:1–28).

To fashion his own vision, Milton derived from Ezekiel not only specific details but a particular rhetorical technique, one that calls the senses into play not to clarify but to confound. Like Ezekiel, Milton accumulates so many images that what he sees defies visualization. As Michael Murrin observes, Ezekiel's prophetic use of language "reverses its normal use in classical rhetoric, the attempt to assert a form of identity and to explain the unknown by the known." Adopting a peculiar mode of closed discourse, "Ezekiel accumulates the known to create the incomparable."[2]

Milton incorporates this technique into a vision that overwhelms those who are ironically to be cut off from "blessed vision" (V, 613). The kinetic force of the onward-rushing vehicle overwhelms everything in its path. Auditory imagery is invoked to make distinctions of sound—whirlwinds, torrent floods, thunder, the noise of onrushing armies—an impossible task. Visual imagery comes into play to undermine visualization. The flaming chariot, the wheels within wheels, the "fourfold-visag'd Four," the eyes shooting forth lightning and fire, the rainbow

throne, and the seated figure whose countenance is "too severe to be beheld" (VI, 825): all these serve to confound the faculty of seeing. If the rebel angels are overcome by the lightning and fire that shoot forth from all those eyes, the faithful angels are hushed into immobile silence as they stand "*Eye* witnesses of . . . [God's] Almightie Acts" (VI, 849–50, 883; italics mine). For the blind seer who portrayed the vision in his epic, such an experience assumes momentous importance. It is no accident that Milton placed this most overwhelming of events at the very midpoint of *Paradise Lost*.[3] "The Chariot of Paternal Deitie" becomes pivotal in every sense of the word.

Given these circumstances, the task of illustrating the chariot and its rider represented a challenge of the first magnitude for generations of artists and engravers who adopted the theme following the publication of Milton's epic. To assess the significance of their enterprise, we shall trace the development of this theme from its first appearance to its most recent. Doing so will provide insight not only into the visual traditions to which Milton's epic gave rise but into the function of illustration as an aesthetic and exegetical tool.

Before addressing ourselves specifically to Milton's illustrators, however, we should do well to remember that visual renderings of the chariot did not begin in response to the publication of *Paradise Lost*. As Roland M. Frye has so ably demonstrated, the throne-chariot inspired by Ezekiel's vision was the subject of iconography in the Middle Ages and the Renaissance. As early as the Utrecht Psalter of the ninth century, "we find the Son trampling over his enemies as he rushes forward brandishing a spear (presumably a thunderbolt) in a chariot drawn by four horses." Variations on the theme are provided by the fourteenth-century Italian *Treatise on the Seven Vices*, which portrays the Messiah in his chariot expelling the rebel angels as the good angels stand by and watch.[4] The vision of Ezekiel, then, was readily transformed into pictorial representations that fully complement Milton's own account.[5] As contrary to visualization as Ezekiel's vision is, it became the repeated subject of iconography. The same is no less true of Milton's vision of the chariot. Extending from the Medina, Lens, Aldrich designs of 1688, to the Petrina designs of 1936, "the Chariot of Paternal Deitie" assumes a variety of forms.[6] We shall be concerned here with some of the most representative.

The Medina, Lens, Aldrich designs represent a fitting point of departure.[7] Setting the standard for all future renderings,[8] these designs include the chariot among the other subjects they canonize (Fig. 7). Like most of the other illustrations in the volume, the chariot illustration is by John Baptist de Medina, and the engraver is Michael Burgesse (or

Burghers). The illustration itself is panoramic. Emerging from the top of the design is the chariot with its occupant, flanked by the saints carrying banners. The chariot, in turn, is counterbalanced at the bottom by a form that appears to resemble a spouting leviathan. The sense of balance that distinguishes the vertical movements of the illustration is likewise true of the horizontal movements. On either side are massed groups of angels who represent the primary focus of the illustration. It is clear that Medina, however well he knew the poem,[9] did not hesitate to impose his interpretation on this most important of scenes.

The technique of counterbalancing, for example, is very much in keeping with the sense of architectonics that pervades Milton's poem. Although leviathan (if it is, in fact, leviathan that is depicted) is not part of the scene as Milton originally conceived it, the idea of using the image to counterbalance the chariot is very apt. As Milton makes clear in Book I of his epic, leviathan is a type of Satan (I, 200–201), so that Medina's illustration recalls the description of the "Arch-fiend" "stretcht out huge in length" on the "burning Lake" after his fall (I, 209–10). Biblically, the conflation of God's coming forth in judgment and the punishment of leviathan is also to the point. Thus, Isaiah speaks of a day of judgment when "the Lord cometh out of his place to punish the inhabitants of the earth for their iniquity. . . . In that day the Lord with his sore and great and strong sword shall punish leviathan the piercing serpent, even leviathan that crooked serpent; and he shall slay the dragon that is in the sea" (Isa. 26:21–27:1).

In response to the two massed groups of angels, there is apparently some question about whether the angels to the left are good or evil.[10] (Those to the right are obviously evil, for they are in the process of falling.) I am inclined to feel that, just as the chariot is counterbalanced by leviathan in the vertical axis, the good angels (all standing) are counterbalanced by the evil in the horizontal axis. It is significant, no doubt, that those angels to the left are actually on the right-hand side of the Messiah and vice versa. Whereas the left-hand side is the sinister side (PL X, 886), the right-hand side is the dexterous side, represented by the positioning of the Son next to the Father (PL III, 62; cf. V, 741, VI, 762). Moreover, the placement of the charioteer's head, downward toward the falling angels to his left, suggests that those angels to his right are not the objects of his ire. A clear distinction is made, then, between the two massed groups of angels.

As for the chariot and its occupant, it is here that we find the most radical departure from the text. The quality of awesomeness and mystery embodied in the Miltonic rendering is almost totally absent in the Medina design, which is more nearly concerned with the architectonics

of balance and counterbalance than with the tremendous force of that onrushing vehicle. Radically diminished in size, the Medina chariot, in fact, is practically relegated to a subsidiary role in the overall design. Little attempt is made to remain faithful to the Miltonic conception either in spirit or in practice. Nonetheless, we are able to discern even here something of the original conception. As John T. Shawcross points out, the chariot is "shaped, appropriately, like the tablet from which Moses spoke the law," an intriguing suggestion, given the typology implicit in the rendering as a whole. In keeping with that typology, Professor Shawcross directs our attention to the ensigns carried on either side of the chariot by the cherubs: "one shows the sacrificial *agnus Dei*, another shows an open Bible."[11] Type and antitype, then, act as counterbalancing forces in the depiction of the chariot, its occupant, and its entourage.

If Medina's chariot is shaped like the tablet of Moses, it also has something about it of the ancient four-wheeled vehicles used either for transport or for war.[12] In the Medina rendering, the chariot is conceived specifically as a platform upon which is seated a conqueror attired in pagan garb. Inspired in part by Milton's own descriptions, the impulse to classicize extends both to the conqueror and to the angelic legions in the foreground of the illustration. Thus, the conqueror's Roman helmet and armor are replicated in the figures of both sets of angels. True to the Miltonic original, Medina places in the conqueror's right hand something that resembles the "three-bolted Thunder" of Jupiter. Lacking, however, are the bow and quiver and the imperial-winged figure of Victory. In the rendering of the chariot, Medina has also chosen not to delineate the "Wheel within Wheel undrawn" nor the "thick flames" that flash from the original. Although four in number, the angelic creatures that accompany the chariot are certainly not the "fourfold-visag'd Four" of Ezekiel and Milton, and noticeably missing are all those eyes inwrought both in the wheels and in the creatures themselves. (On the other hand, the four angelic creatures do have four wings each, and the hubs of the wheels appear to have faces, possibly with eyes.[13]) Through a careful selection of detail, then, Medina at once classicizes his rendering and biblicizes it in a fashion that suggests Milton's own handling of the chariot in *Paradise Lost*. Unlike Milton, however, Medina effectively denudes his rendering of all those qualities that contribute to the overwhelming nature of the chariot as Milton conceives it. In the hands of Medina, the Miltonic experience is domesticated to the point of losing touch with the visionary quality of the original. Medina's chariot appears to be little more than a kind of stage prop within a larger theatrical setting.[14]

Given the precedent set by Medina, we ought reasonably to wonder what succeeding generations of illustrators did with "the Chariot of Paternal Deitie." The answer might well be viewed from the perspective of the critical outlook that prevailed after the publication of the Medina, Lens, Aldrich designs. If the subject of visual renderings is not to be approached *in vacuo*, any treatment of post-Medina illustrations must take that climate into account. As might be expected, "the Chariot of Paternal Deitie" assumed a special prominence among Milton's commentators from Patrick Hume onward. As early as Hume's learned and voluminous *Annotations* of 1695,[15] the chariot was seen as something profoundly mysterious, awesome, and even terrifying. Invoking the throne-chariot of Ezekiel as primary source, Hume says that Milton has fashioned his own "visionary Chariot of God" upon which the Son rides forth as "a Man of War" in order to triumph over the wicked. Hume is particularly concerned with the experience of terror that Milton's depiction of the chariot produces. The source of that experience, Hume suggests, may be found in the *chashmal*, or fiery *electrum*, that envelops the throne-chariot of Ezekiel (1:27). Anyone who tampers with the throne-chariot runs the risk of being immolated by the *chashmal*.[16] Hume's awareness of such matters reveals the extent to which Milton's earliest critics drew upon Hebraic backgrounds to illuminate the action of *Paradise Lost*.[17]

The mystery and awesomeness that Hume associated with "the Chariot of Paternal Deitie" at the end of the seventeenth century are discernible in eighteenth-century commentary as well. If John Dennis looks upon the chariot as the creation of a poet "rapt with Admiration and moved with Terrour by the Ideas which he had conceiv'd,"[18] Joseph Addison observes that "the Messiah comes forth in the fulness of Majesty and Terrour." Addision likewise comments that "the Pomp of . . . [the Messiah's] Appearance, amidst the Roaring of his Thunders, the Flashes of his Lightnings, and the Noise of his Chariot Wheels, is described with the utmost flights of Human Imagination."[19] In keeping with these remarks, the painter Jonathan Richardson later maintained that the description of the chariot is "the most Amazing Picture that can be conceav'd" and "the utmost that can be found or Hop'd for in a Human Poet."[20] Appropriately, Richardson includes this "Picture" (which he entitles "Messiah . . . Driving on his Foes") as a subject among the long list of pictures that he appends to his *Notes* (pp. 544–45).

In the notes compiled for the Bishop Newton variorum edition, still later in the century, Robert Thyer reflects these sentiments when he says that "the description of the Messiah going out against the rebel

angels" is an instance of "the true sublime."[21] Such a remark indicates the way in which "the Chariot of Paternal Deitie" was assimilated into the cult of the sublime so important to the eighteenth-century critical frame of mind.[22] Milton, of course, was at the very center of this cult,[23] and, as might be expected, his chariot was looked upon as the ideal of sublime transport. Small wonder, then, that Thomas Gray, in his Pindaric ode *The Progress of Poesy*, depicts Milton as one who "rode sublime / Upon the seraph-wings of ecstasy" (96–97).[24] This attitude was to find consummate expression in William Blake, who, in his prefatory poem to *Milton*, viewed himself as a chariot rider after the fashion of the Son in his "Chariot of Paternal Deitie." Thus, Blake proclaims, "Bring me my bow of burning gold: / Bring me my arrows of desire: / Bring me my spear: O clouds unfold! / Bring me my chariot of fire" (9–12).[25] Riding forth in his sublime "chariot of fire," Blake will engage in a warfare ("mental fight") all his own. Enthusiasm for the chariot among both commentators and poets, then, was a long-standing occupation. Such was the critical outlook shared by Milton's illustrators after the publication of the Medina, Lens, Aldrich designs. From the perspective of this outlook, as well as from the precedent established by Medina, we shall now explore the way in which these illustrators responded to the Miltonic text.

Among the most remarkable designs are those by Louis Cheron and Sir James Thornhill for the 1720 edition of Milton's *Poetical Works*, published, like the 1688 edition of *Paradise Lost*, by Jacob Tonson.[26] The illustration of the chariot for Book VI is in the form of a tailpiece (Fig. 8). Cheron is the illustrator and Gerard Van der Gucht the engraver. What makes this illustration so remarkable is that, unlike any other illustration of the Miltonic chariot that I have examined, each of the creatures that propel the chariot is delineated. In his reference to the creatures, Milton makes no specific mention of the form of the "fourfold-visag'd Four."[27] The assumption is that Ezekiel's detailed description is sufficient for those familiar with the biblical precedent. Like such commentators as Patrick Hume, Louis Cheron is implicitly invoking Ezekiel by transforming the creatures into an eagle, an ox, a man, and a lion.

Even Cheron, however, is not faithful to the original rendering in Ezekiel, for whom the creatures, or *chayot*, are such that *each* of the four has the face of an eagle, an ox, a man, and a lion.[28] That is, there are sixteen faces in all, an idea explicit in Milton's "fourfold-visag'd Four." With their multitude of eyes, these creatures are mysterious and terrifying. Not so in Cheron's rendering: his interests obviously lie elsewhere. For him, the creatures look forward typologically to the assimilation of Ezekiel's vision by St. John the Divine in Revelation 4. There, an

FIG. 8. Illustration by Louis Cheron in John Milton, *Poetical Works of John Milton,* 2 vols. (London, 1720), I, 271. Reproduced by permission of the University of Illinois Library at Urbana-Champaign.

enthroned figure is surrounded by "four beasts" (*zoa*) "full of eyes before and behind. And the first beast was like a lion, and the second beast like a calf, and the third beast had a face as a man, and the fourth beast was like a flying eagle" (Rev. 4:6–7). Cheron's creatures are more nearly in keeping with St. John the Divine than they are with Ezekiel. But even here the similarity is provisional, for, among other differences, Cheron's creatures lack all those eyes. Like Medina's depiction, then, Cheron's illustration is univisionary, at least in the sense that pervades Ezekiel's and St. John the Divine's visions, on the one hand, and Milton's, on the other.

Not that Cheron was unaware of the visionary experience. His familiarity with that experience is discernible, for example, in his rendering of Ezekiel's vision for John Baskett's Oxford Bible of 1717[29] (Fig. 9). There, Ezekiel beholds one of the *chayot*, or creatures, and one of the *ofanim*, or wheels. Although the wheel is imbued with eyes, the creature is not, and, although the creature is surrounded by the flames of the

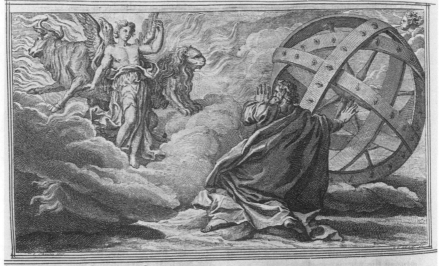

FIG. 9. Illustration of Ezekiel 1 by Louis Cheron in *The Holy Bible, Containing the Old Testament and the New: Newly Translated Out of the Original Tongues* (Oxford, 1717) (John Baskett's Oxford Bible). Reproduced by permission of the Newberry Library, Chicago.

chashmal, or *electrum*, the rendering as a whole gives the appearance of being more nearly iconic than visionary. In addition to the absence of the other creatures and wheels indicated in the biblical text, the enthroned figure is likewise missing. Cheron is obviously more interested in other aspects of the vision.

When he came to render the Miltonic chariot, this iconic sense became all pervasive. What Cheron depicts is nothing less than a *triumphus Christi*. The rebel angels have presumably already fallen, and the Messiah, "Sole Victor from the expulsion of his Foes / . . . his triumphal Chariot turnd," as "he celebrated rode Triumphant through mid Heaven" (VI, 880–89). If the *triumphator* of Cheron grasps the lightning bolts of judgment, he likewise is accompanied by the cherub-borne cross, symbol of what will become the Son's sacrificial and redemptive mission on earth. From this Christological point of view, the *chayot* of Ezekiel are appropriately transformed into the *zoa* of St. John the Di-

vine. As Cheron was undoubtedly aware, the *zoa* of St. John the Divine were fully allegorized by the Church Fathers to represent an entire spectrum of meanings (including the commonplace association of the man with Matthew, the lion with Mark, the ox with Luke, and the eagle with John). But this need not concern us now. What is important is that Cheron fashioned the Miltonic chariot to accord with a Christological perspective that is hardly alien to Milton's own outlook. In this sense, the triumph of the Son in Book VI of *Paradise Lost* looks forward, as Mary Dennis Ravenhall reminds us, to the final triumph of Christ in Book XII.[30] Cheron's illustration of the chariot, as well as his renderings of other aspects of Milton's epic, is perfectly in keeping with this redemptive dimension. To what extent Milton's later illustrators follow suit will be seen upon further investigation.

Moving to midcentury and beyond, we find three illustrators of note that may be considered as a group: Francis Hayman, Richard Westall, and Edward Burney. Although not consistently distinguished, their illustrations of the chariot reveal a certain continuity in keeping with some of the elements implicit in the Cheron-Thornhill designs, on the one hand, and the prevailing critical climate, on the other. Part of the 1749 Bishop Newton edition of *Paradise Lost*, the Hayman designs were engraved by Simon Ravenet and Charles Grignion.[31] According to Ms. Ravenhall, Hayman's illustration of the chariot carries forth Cheron's emphasis upon the parallel between Milton and Ezekiel[32] (Fig. 10). If such is the case, one would be more inclined to look at the Baskett Oxford Bible illustration than at the tailpiece illustration for *Paradise Lost*. From the former, Hayman may have picked up the design for the wheel within the wheel, but he may just as easily have been inspired to include this detail as a result of Milton's own description. This touch suggests at least an attempt to provide something of a correspondence between the visual rendering and the original text. Otherwise, almost all other characteristics of the chariot are missing. For the first time, however, the Messiah assumes a central, active role in the expulsion. Grasping his thunders, he leans from his seat to enact vengeance on the wicked. Both in its depiction of the Messiah and in its rendering of the rebel angels, the illustration is reminiscent of Rubens's painting of *Michael and the Expulsion of the Rebel Angels*. Although not particularly successful, Hayman makes a concerted effort to re-create the sense of overwhelmingness that commentators on *Paradise Lost* emphasized in their analysis of the celestial expulsion scene.

The next illustrator of note, Richard Westall, has two illustrations of the scene in question, one published for John and Joshua Boydell in the 1794 edition of *The Poetical Works of John Milton*, and a later one

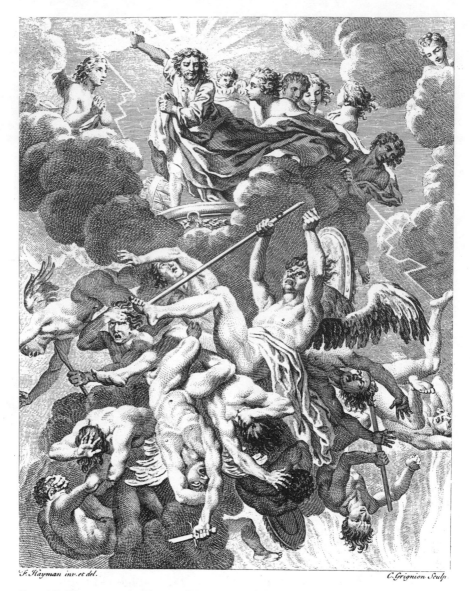

F. Hayman inv. et del.

C. Grignion Sculp.

Fig. 10. Illustration by Francis Hayman in John Milton, *Paradise Lost . . . with Notes of various Authors,* comp. Thomas Newton, 2 vols. (Dublin, 1749), I, between pp. 384 and 385. Reproduced by permission of the University of Illinois Library at Urbana-Champaign.

published for John Sharpe in the 1817 edition of *Paradise Lost*.[33] The two illustrations are vastly different. Engraved by L. Schiavenetti, the earlier illustration is completely devoid of the chariot. Instead, it depicts a large nude, seated figure, who grasps thunderbolts in his right hand (Fig. 11). The figure is reminiscent of Michelangelo's Christ of the *Last Judgment* in the Sistine Chapel. Engraved by Charles Heath, the later illustration contains a frontal view of the chariot with its seated figure (Fig. 12). The caption for the vignette contains the lines: " . . . in his right hand / Grasping ten thousand thunders which he sent / Before him . . . " (VI, 835–37). The lines move us just to the point when the Son assumes the offensive in the final attack upon the rebel angels. Westall's depiction of the scene is interesting because of the two angels that flank the seated figure. In a posture of prayer, these two figures are reminiscent of the covering cherubs that overshadow the Mercy Seat of the Ark of the Covenant, from which Ezekiel's vision is largely drawn. Between these two cherubs, the Dwelling Presence of God was thought to reside.[34] Whether or not Westall had this idea specifically in mind, it does suggest once again the sense of continuity implicit both in the critical perspective and in the visual perspective. From both points of view, the Miltonic text was seen to derive its sublimity from the inspiration provided by its biblical sources. The illustrators seemed to be attuned to these sources as much as were the commentators.

Nowhere is this idea more discernible than in Edward Burney's illustration of the chariot and its occupant. Included in the 1799 edition of *Paradise Lost*, the Burney designs were engraved by various hands at different dates.[35] Reminiscent of Michelangelo's *Last Judgment* and Rubens's *Fall of the Damned into Hell*, Burney's illustration for *Paradise Lost*, Book VI, isolates the precise moment it is depicting (Fig. 13). The caption reads, "headlong themselves they threw / Down from the verge of Heav'n, Eternal wrauth / Burnt after them . . . " (VI, 864–66). This is just at the point when the rebel angels have been fully routed by the Messiah. As we have seen, the moment was a popular one. Extending all the way back to Medina, this event would later be recapitulated in the illustration of Hayman. In his illustration of the scene for the 1802 edition of *Paradise Lost*,[36] Henry Fuseli alluded to the same lines as the Burney illustration, and, in fact, the Burney and Fuseli designs bear a striking resemblance, except that Fuseli uncharacteristically focuses upon a single figure—Satan himself—who is falling into the deeps, while a diminutive Messiah pronounces judgment above. (Interestingly, this illustration was not included in Fuseli's Milton Gallery.) Like Medina, Hayman, and Fuseli, then, Burney focuses primarily on the falling figures.

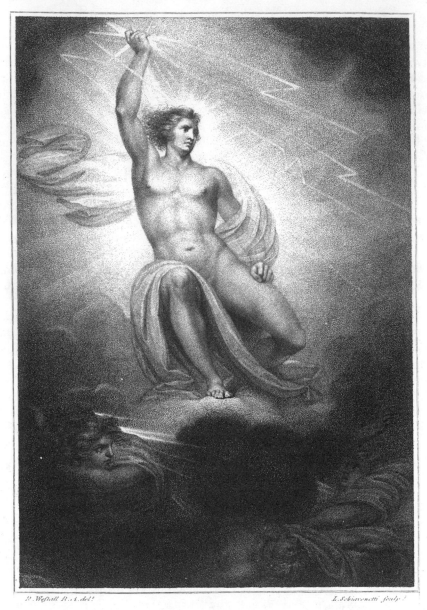

R. Westall R.A. del. *L. Schiavonetti sculp.*

PARADISE LOST.

FIG. 11. Illustration by Richard Westall in John Milton, *The Poetical Works of John Milton,* 3 vols. (London, 1794), I, between pp. 210 and 211. Reproduced by permission of the University of Illinois Library at Urbana-Champaign.

At the same time, however, Burney makes a concerted effort to visualize "the Chariot of Paternal Deitie." In some respects, Burney provides one of the most faithful renderings of the chariot and its occupant considered thus far. If the illustration lacks any sense of the "fourfold-visag'd Four," at least one of the cherubic shapes that accompany the chariot suggests wings that are inwrought with eyes. (The cherubic shape, of course, is not in the least terrifying.) At the right of the Messiah is a figure that might well represent Victory, here bearing the palm. While lacking the "wheels within wheels" imbued with eyes, the chariot is equipped with angelic heads at its base, a feature that suggests something of Milton's idea that the chariot is "instinct with Spirit" (VI, 752). In the regalia of the enthroned Messiah, Burney has gone to the trouble of including not only the ensign but the quiver of thunderbolts. What is most remarkable, however, is that, for the first time in the history of illustrating this scene, Burney has clearly delineated the breastplate of Urim and, implicitly, Thummim in which Milton's Son is attired as he sets out to rout the rebel angels (VI, 761). Signifying "light" (*Urim*) and "perfection" (*Thummim*), these mysterious jewels on Aaron's breastplate (Ex. 28:30) are the insignias of the Son's priestly and oracular function in Milton's epic. That Burney distinguishes this detail here suggests the extent to which he is indebted to the critical and visual perspectives under consideration. Despite his attentiveness to the details of the Miltonic original, however, Burney's depiction of the chariot, like Medina's, is relegated to a minor position in the overall design. The profound sense of mystery and awe that pervades the original is simply not there.

No discussion of Milton's illustrators would be complete without some attention to William Blake. Given Blake's great complexity both as artist and as poet, however, an adequate treatment of his designs would be impossible within the scope of this essay. It will be possible here only to touch on Blake's understanding of the concepts we have been exploring. Having executed his first set of *Paradise Lost* illustrations in 1807, Blake finished his second set the following year. The Huntington Library now has the earlier set, and the Boston Museum of Art the later.[37] Larger and more highly accomplished than the Huntington set, the Boston set will serve as our point of focus.[38]

In the Boston set (as well as in the Huntington set), the Blake design for Book VI of *Paradise Lost* avoids any apparent reference to "the Chariot of Paternal Deitie." Rather, the scene depicted is that of "an almost diagrammatic representation of Christ the archer kneeling within an enormous . . . circle that is surrounded by angels, and tautening the string of his great bow in order to release the arrows of his wrath upon

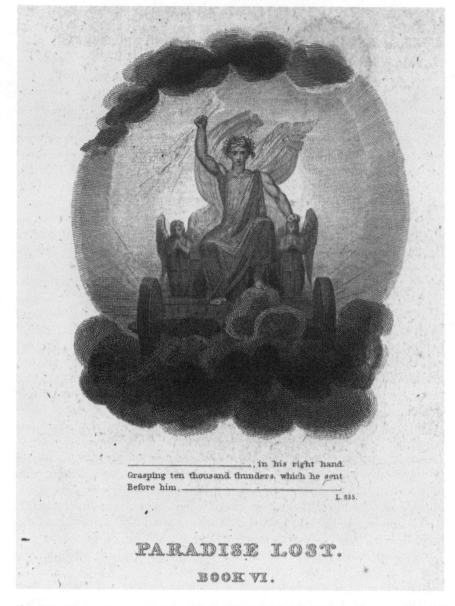

———————————————, in his right hand.
Grasping ten thousand thunders, which he sent
Before him, ————————————
L. 835.

PARADISE LOST.

BOOK VI.

Fig. 12. Illustration by Richard Westall in John Milton, *Paradise Lost*, 2 vols. (London, 1821), I, preceding Book VI of *Paradise Lost*. Reproduced by permission of the University of Illinois Library at Urbana-Champaign.

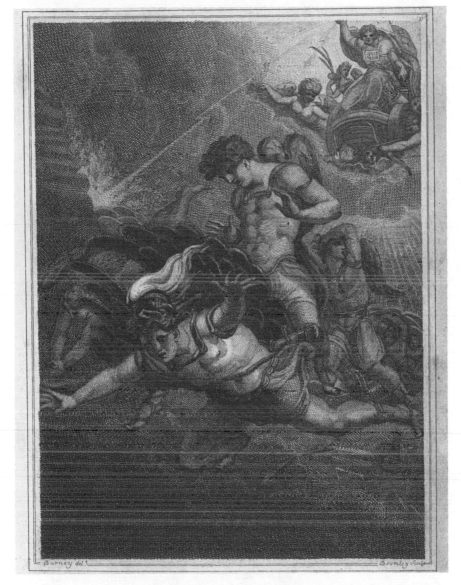

FIG. 13. Illustration by Edward Burney in John Milton, *Paradise Lost* (London, 1799), between pp. 172 and 173. Reproduced by permission of the University of Illinois Library at Urbana-Champaign.

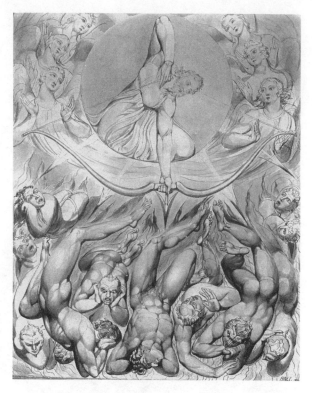

FIG. 14. Illustration by William Blake entitled *The Rout of the Rebel Angels* (1808) for Book VI of *Paradise Lost.* Reproduced by permission of the Museum of Fine Arts, Boston.

the falling devils"[39] (Fig. 14). In depicting this scene, Blake has obviously chosen to focus on one aspect of Milton's description, that concerning the Son's "Bow," from which, as Milton says, "on either side tempestuous fell / His arrows" (VI, 763, 844–45). So too, we recall, Blake, in his prefatory poem to *Milton,* calls for his "Bow of burning gold" and for his "Arrows of desire" in conjunction with his fiery "Chariot."

What then of the chariot? How does Blake conceive of that? The answer lies, in part, in Blake's earlier designs for Gray's *The Progress of Poesy* (c. 1797–98). Among these designs, Blake illustrates the marching forth of Hyperion with his "glitt'ring shafts of war" to rout the creatures of the night (49–53) (Fig. 15). With the flames of the sun encircling him, Hyperion holds his bow taut as the night creatures fall beneath him. As Sir Geoffrey Keynes comments, the sun disk that encircles Hyperion is also "a sort of aerial chariot fringed with shafts of war, which at the same time are rays of sunlight dispelling below the chariot

FIG. 15. Illustration by William Blake for Thomas Gray, *The Progress of Poesy* (c. 1797–98). From the Collection of Mr. and Mrs. Paul Mellon. Reproduced by permission of the Trustees of the Paul Mellon Collection, Upperville, Virginia.

'Night's spectres wan'."[40] If one looks closely at the sun disk as Blake depicts it, he will see, to be sure, the suggestion of a chariot wheel. In her discussion of the Hyperion illustration, Irene Tayler observes that Blake's design for *Paradise Lost*, Book VI, is "a later version of the same picture."[41] If such is the case, then the nimbus that encircles the Son in Blake's *Paradise Lost* illustration performs a function comparable to that of the Hyperion illustration. Embodying the spirit of the sun chariot implicit in the earlier design, the nimbus gives rise to similar associations. Viewed in the context of the Hyperion illustration, the circle from which the Son emerges in the *Paradise Lost* illustration becomes a kind of visual synecdoche for "the Chariot of Paternal Deitie" itself. "Circle and Christ in conjunction," says Pamela Dunbar, "form but one example of the 'figured sun' which recurs throughout Blake's poetry and paintings as an index of spiritual vision."[42]

In keeping with this idea, the four refracted arrows of the Boston design may owe their origin to the "fourfold-visag'd Four" that propel the chariot. The apocalypse at the end of Blake's *Jerusalem* can serve as a fitting gloss on the illustration:

> Albion stretchd his hand into Infinitude.
> And took his Bow . . .
> And he Clothed himself in Bow and Arrows in awful state
> Fourfold . . .
> Then each an Arrow flaming from his Quiver fitted carefully . . .
> . . . bending thro the wide Heavens
> The horned Bow Fourfold, loud sounding flew the flaming Arrow
> fourfold. . . .
> . . . & at the clangor of the Arrows of Intellect
> The innumerable Chariots of the Almighty appeard in Heaven . . .
> A Sun of blood red wrath surrounding heaven on all sides around
> Glorious incompreh[en]sible by Mortal Man.
> (pl. 97, 6–7, 16, and pl. 98, 1–3, 7–11)

The passage encapsulates Milton's own description of the way in which the Son's arrows "on either side tempestuous fell," on the one hand, and the lightning and fire of the "fourfold-visag'd Four" are shot forth, on the other. The chariot of Milton's Son, in turn, becomes in Blake the "Chariots of the Almighty" (cf. Isa. 66:15), an image that is transformed into a "Sun" both glorious and incomprehensible. In the complex relationships suggested by Blake's images (plastic and poetic), one is profoundly moved by the dynamism that energizes his own unique conception of "the Chariot of Paternal Deitie" and its occupant. As a true

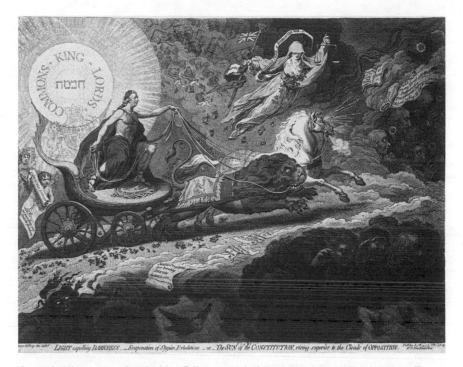

FIG. 16. Illustration by James Gillray entitled *Light expelling Darkness,—Evaporation of Stygian Exhalation,—or—The Sun of the Constitution, rising superior to the Clouds of Opposition* (1795). Reproduced by permission of the Trustees of the British Museum.

visionary, Blake is the first illustrator of the chariot to see not with but through the eye.

In the face of all the chariot illustrations (visionary or otherwise) that we have examined thus far, we might well consider the work of that most remarkable of illustrators, the caricaturist James Gillray. Much influenced by Milton, Gillray provided his own renderings of *Paradise Lost*, among Milton's other works. Although his *Sin, Death, and the Devil* (1792), inspired by *Paradise Lost*, Book II, is perhaps the best known, there are others that bear the Miltonic stamp. One of these is his caricature entitled *Light expelling Darkness,—Evaporation of Stygian Exhalations,—or—The Sun of the Constitution, rising superior to the Clouds of Opposition* (1795) (Fig. 16). In this illustration, Gillray portrays William Pitt as a charioteer guiding the British sun through the

perilous darkness of Whiggish opposition, French alliances, and revolutionary uprising. With his left foot, Pitt tramples a serpent-entwined shield inscribed "Exit Python Republicanus." Behind his right foot stands his magic lyre, the "Magna Charta." Propelling the chariot are the British lion, with the banner of Britannia on his flank, and the white horse of Hanover, with the arms of England inscribed on his cloth. In their path, the forces of dissension—in the form of those who oppose Pitt—are overcome. Overhead, Justice, with her scales and her British banner, scatters roses of approbation. Serpents are dispersed in the upper right-hand corner, while in the lower left glares the fury Alecto, the Hellish embodiment of the Whigs. Two cherubs bring up the rear. Whereas one holds the Bible, the other holds a scroll showing the family tree of George III, bearing George IV and his potential issue.[43]

Iconographically, the illustration is a fusion of both classical and biblical motifs. From the classical perspective, Gillray portrays Phoebus Apollo on his sun chariot expelling the forces of darkness, the same theme that Blake rendered in his Hyperion design for Gray's *The Progress of Poesy*. But Gillray's illustration has biblical roots as well, as the cherub holding the Bible would suggest. At the center of the British sun (which appears to radiate the royal arms) is the (misspelled) Hebrew word for Wisdom (*Ḥokhmah*), surrounded by the signatures of kingdom (king, commons, lords). As a source of light that dispels darkness, Wisdom is associated with Logos in the apocryphal Wisdom of Solomon (7:26–8:1, 9:1–2). As a charioteer, the Logos is seen to guide his celestial vehicle over the universe.[44] Gillray places the idea within an apocalyptic framework. We think not only of Isaiah 66:15 ("For, behold, the Lord will come with fire, and with chariots like a whirlwind, to render his anger with fury, and his rebuke with flames of fire") but of Revelation 12:9 ("And the great dragon was cast out, that old serpent, called the Devil, and Satan, which deceiveth the whole world: he was cast out. . . , and his angels were cast out with him").

The whole, of course, is apposite to what Milton is doing in *Paradise Lost*. Gillray's sun chariot is Milton's Son chariot in classical garb. If Gillray's Phoebus tramples the serpent underfoot, Milton's Son tramples Satan under his. If Gillray portrays the fall of the Whiggish opposition among the elements of darkness that are overwhelmed, his figures are drawn from Milton. Like Milton's rebel angels who drop "thir idle weapons" (VI, 839), Gillray's fallen crew drop their knives. If the creatures that propel the sun chariot of Gillray are fearsome, they owe that quality to their Miltonic counterparts. Indeed, the lightning-glaring eyes of Gillray's Hanoverian horse find their antecedent in Milton's "fourfold-visag'd Four," whose eyes "Glar'd lightning, and shot forth pernicious

fire" (VI, 848–49). Even the flowers that strew the celestial road on which Gillray's charioteer rides are anticipated by Milton's description of the approach of the Son, at whose command "Heav'n his wonted face renewd, / And with fresh Flowrets Hill and Valley smil'd" (VI, 781–84). Among other points of comparison that can be made, [45] there is one final similarity that we might note here. The cherub that holds the scroll entitled "Brunswick Succession"[46] places the central issue of the Miltonic battle in a political context. Just as Milton focuses upon God's lineage through the Son, Gillray celebrates the Hanoverian line extending from George III to "future Kings and Monarchs yet unborn." Although the very thought of such a comparison would have caused Milton to turn over in his grave, Gillray's incorporation of the idea into his illustration is a stroke of genius. Gillray's illustration is certainly one of the most innovative creations to be inspired by "the Chariot of Paternal Deitie."[47] It is refreshing to see that an image so awesome and terrifying could give rise to an illustration at once parodic and apocalyptic.

In this brief history of chariot illustration, we may now move beyond the late eighteenth and early nineteenth century to the nineteenth century proper. Before considering the illustrations themselves, however, we need to glance briefly at the critical climate that prevailed in the early decades of the nineteenth century. Doing so will provide an additional background against which the pictorial tradition may be viewed.

From this perspective, the comments of Wordsworth and Coleridge on the significance of "the Chariot of Paternal Deitie" might be cited as a case in point. According to observations that Wordsworth made between 1808 and 1810, Milton's rendering of "the chariot of the Messiah" and "his advance toward the rebel angels" is characteristic of the sublimest poetry. Wordsworth was particularly fascinated by the way in which the chariot is described as being "instinct with spirit." Inspired by the prophet Ezekiel, Milton's imagination, comments Wordsworth, was able to portray a remarkable vehicle that "had power to move of itself."[48] Such an outlook is reflected in that of Coleridge, who, in his *Table-Talk* (June 23, 1834), maintains that the prime example of the way in which the epic imagination works is discernible in "the magnificent approach of the Messiah to battle." There, the presence of the Messiah in his chariot provides a sense of unity to the variety of images one encounters: this splendid event allows us to see "all things in one."[49] The high esteem in which the chariot was held among the Romantics is evident not only in the sort of critical commentary suggested by Wordsworth's and Coleridge's remarks but in the poetry as well. As Harold Bloom has demonstrated, "the Chariot of Paternal Deitie" is of fundamental impor-

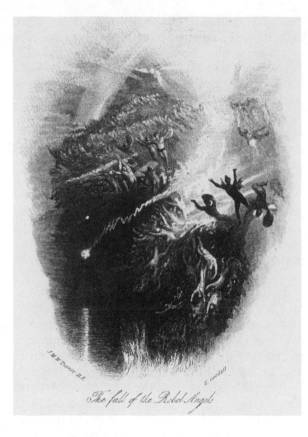

FIG. 17. Illustration by J. M. W. Turner in John Milton, *The Poetical Works of John Milton,* ed. Egerton Brydges (London, [1871]), between pp. 164 and 165. Reproduced by permission of the University of Illinois Library at Urbana-Champaign.

tance to poems such as Shelley's *Prometheus Unbound* and *The Triumph of Life*, among others.[50] With its antecedents in Ezekiel's vision, Milton's chariot becomes the means by which the Romantic visionary outlook assumes consummate form.

Given these circumstances, it is surprising indeed that the critical and poetic enthusiasm for the chariot was not shared by those who later illustrated *Paradise Lost*. As we proceed into the nineteenth century, we become aware of the extent to which illustrators of the first three decades failed to incorporate "the Chariot of Paternal Deitie" into their renderings of the celestial expulsion scene, if, in fact, they even bothered to depict that scene at all. Thus, in his illustrations to the 1826 edition of *Paradise Lost*, John Martin, for example, bypasses Book VI altogether.[51] Although the celestial expulsion scene is important for J. M. W. Turner, the chariot is not. In Turner's portrayal of the fall of the

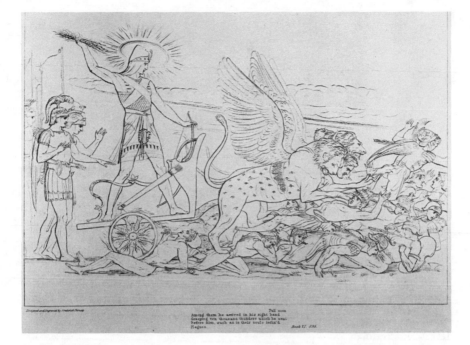

FIG. 18. Illustration of *Paradise Lost* VI, 834ff. by Frederick Thrupp in John Milton, *Paradise Lost . . . Illustrated by Thirty-Eight Designs in outline by Frederick Thrupp* (London, 1879). Reproduced by permission of the University of California at Los Angeles Library.

angels for the 1835 edition of *Milton's Poetical Works*, one finds not the sharply delineated forms characteristic of earlier renderings but the interplay of lights and darks against which a panorama of falling figures is impressionistically suggested[52] (Fig. 17). Rather than depicting a chariot as such, Turner provides an awesome sense of God's overwhelming presence embodied in sudden and dramatic bursts of light. The disregard for the chariot as appropriate subject that one finds earlier in the century persists throughout the later decades, as made evident in the designs of William Harvey and Gustave Doré.[53]

The one dramatic exception to this general rule is discernible in the illustrations of Frederick Thrupp, whose remarkable designs for *Paradise Lost* appeared in 1879.[54] Engraved for the most part by Thrupp himself, these plates are not accompanied by a text of the poem. His illustrations do, however, have lines from *Paradise Lost* appended at the bottom in order to indicate specifically what scene is being illustrated. In

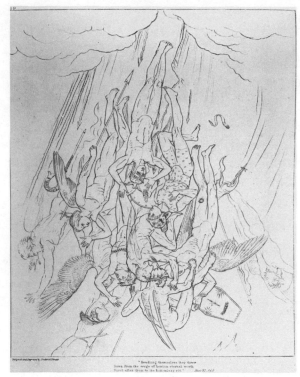

FIG. 19. Illustration of *Paradise Lost* VI, 864ff. by Frederick Thrupp in John Milton, *Paradise Lost . . . Illustrated by Thirty-Eight Designs in outline by Frederick Thrupp* (London, 1879). Reproduced by permission of the University of California at Los Angeles Library.

some cases, the illustrations are labeled at the top as well. Occasionally, individual designs are specifically dated.[55] As indicated in the subtitle to his collection of illustrations, Thrupp's designs are "in outline," which is to say they are line engravings derived from drawings in pencil or pen. In general, line engravings avoid the subtleties of shading and tone, a characteristic that allowed them to be produced economically and abundantly during the nineteenth century. In this respect, Thrupp's designs form part of the British school of line drawing made popular by illustrators like John Flaxman.[56]

The illustrations from Thrupp that are of particular interest here are those that concern the overthrow of the rebel angels by the Messiah in his chariot, the fall of the rebel angels, and the triumphant return of the Messiah in his chariot after the rebel angels have fallen (Figs. 18, 19, and 20). These illustrations constitute a triptych of sorts that indicates the extent of Thrupp's interest in these crucial events. Judging by the

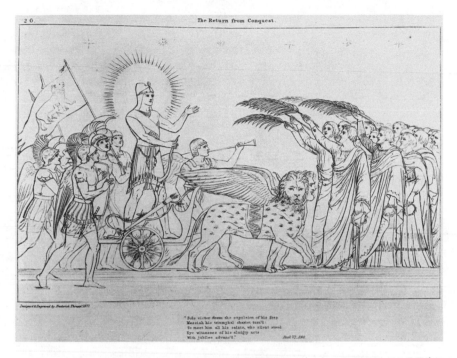

FIG. 20. Illustration of *Paradise Lost* VI, 880ff. by Frederick Thrupp in John
Milton, *Paradise Lost . . . Illustrated by Thirty-Eight Designs in outline by
Frederick Thrupp* (London, 1879). Reproduced by permission of the University
of California at Los Angeles Library.

three scenes he chose to depict at this point, Thrupp obviously wished
to achieve a sense of balance and symmetry. If so, he accomplished his
purpose in a manner unrivaled in the history of Miltonic chariot illustra-
tion. Just as the approach and return of the Messiah frame the fall of the
rebel angels in *Paradise Lost*, so Thrupp's depictions suggest that sense
of closure and fulfillment implicit in the original. What Thrupp lacks, on
the other hand, is the overwhelming sense of dynamism and force that
Milton has so dramatically achieved through his descriptions. Thrupp's
renderings are static and stylized by comparison. In this regard, of
course, they are really no different from the sorts of illustrations one
finds extending back to Medina. Given these limitations, which are prac-
tically endemic, Thrupp's illustrations are eminently worthy of scrutiny,
both as they share and as they depart from those characteristics that
distinguish earlier attempts to render "the Chariot of Paternal Deitie."

In Thrupp's designs, one is struck immediately, for example, by the attention accorded the costuming of the figures that are portrayed. Particularly in keeping with Medina, Thrupp has classicized his figures, but in a much more elaborate form. Both his Messiah and the chariot upon which he rides are derived from the world of Assyrian war chariots.[57] To this Assyrian background, Thrupp adds a Greco-Roman dimension in his depiction of both the faithful and the rebel angels. These figures are attired in the helmets, cuirasses, and greaves common in the classical world. In Figure 20, the figures bearing palms and wreaths are dressed in Roman togas.[58] As in *Paradise Lost* (VI, 880–92), they welcome the *triumphator* home from his conquest (cf. John 12:13; Rev. 7:9; Heb. 2:9).

Thrupp's classicizing of these scenes derives its impetus from a number of possible sources. In *Paradise Lost*, Milton himself, of course, portrays a war that is decidedly classical in its bearing. His sources are to be found as much in the *Iliad* and the *Aeneid* as in biblical accounts of warfare. The accouterments of his angelic soldiers find their antecedents in the armories of the Greek and Roman soldiers that populate the epics of Homer and Vergil.[59] Beyond this, however, Thrupp had a personal and active interest in the customs and attire of other cultures, both ancient and modern. During the winter of 1885–86, he traveled to Algiers in order to study the Arabs and their costumes.[60] His concern with ancient military dress, moreover, is in accord with the spirit of his age. By the time Thrupp executed his illustrations to *Paradise Lost*, Austen Henry Layard's volume *Nineveh and Its Remains* (1849) had already become something of an archaeological bestseller and Paul Émile Botta had long since made his digs at Nineveh and Khorsabad. The regalia that Thrupp depicts in his illustrations had in any case been fully assimilated into the popular culture of nineteenth-century England through theatrical performances, exhibitions, and museums.[61] Accordingly, the cross-cultural accouterments of his figures (Assyrian, on the one hand, Greco-Roman, on the other) should hardly come as a surprise, given Thrupp's own interest in such matters and the intellectual climate that his interest reflects. The stylized quality of his renderings indicates to what extent such conceptions were already a matter of commonplace by the time Thrupp came to invoke them. That he saw fit to invoke them within the literary context of a seventeenth-century biblical epic indebted to classical models is at once visually appropriate and historically apt.

Moving from the issue of attire to other aspects of the illustrations, we note additional matters of importance. For example, Thrupp makes a

point of delineating the features of the "fourfold-visag'd Four." Doing so,
he returns to the spirit of Louis Cheron. Like Cheron, Thrupp eschews
the multidimensionality of the fourfold creatures by reducing the "four-
fold-visag'd Four" to four separate creatures, each with one face, a tech-
nique once again in keeping with Revelation 4. Like Cheron, Thrupp
also reduces the number of wings possessed by each creature from four
to two. Unlike Cheron, however, Thrupp does not make it entirely clear
that his creatures are a lion, a man, an ox, and an eagle. Although the
lion, man, and eagle are clearly delineated (especially in Fig. 18), the ox
is not. The horns of an ox are discernible, but what appears is not the
head of an ox. Rather, Thrupp seems to have delineated instead the head
of another lion. Whether Thrupp made this substitution out of careless-
ness or as the result of deliberation cannot be determined. One is in-
clined to give him the benefit of the doubt. If such is the case, then what
Thrupp appears to be emphasizing in his renderings is the royal, or
kingly, dimension of the Messiah. (Compare Proverbs 19:12: "A king's
wrath is like the growling of a lion.") Certainly, the figure depicted on the
chariot suggests not only military prowess but, judging by the mandorla
surrounding his head, regal splendor as well. Given these circum-
stances, it is interesting to observe the two figures depicted on the
standard in Figure 20: one is a lion and the other a lamb. The typology
suggested by Isaiah 11:6 comes to mind immediately: "The wolf shall
dwell with the lamb, and the leopard shall lie down with the kid, and the
calf and the lion and the fatling together, and a little child shall lead
them." Such an interpretation suggests the way in which the Thrupp
designs move typologically from a destructive to a restorative context.
Doing so, they are faithful to the action of *Paradise Lost*.

One additional feature of the Thrupp designs is worthy of note. To a
greater extent than any illustrator of the Miltonic chariot before him,
Thrupp has seen fit to include the eyes that permeate the creatures [62]
(Curiously, Thrupp does not include the eyes that likewise permeate the
wheels.) It is this aspect of the illustrations that I find particularly disap-
pointing. Rather than glaring lightning and shooting forth fire as in the
Miltonic original (VI, 848–50), the eyes in Thrupp's illustrations are
present merely for the sake of decoration.[63] They are nonfunctional and
certainly "nonvisionary." Although one might see here a missed oppor-
tunity, perhaps one must remind himself that the function of Thrupp's
illustrations is not to be visionary. On the contrary, his illustrations are
present for the sake of adornment, and they serve this purpose splen-
didly. Nonetheless, what Thrupp offers is a far cry from the spirit that
animates Blake's rendering, a spirit once again that compels us to see

not with but through the eye. Splendidly stylized in conception and execution, Thrupp's illustrations, however, provide the perfect opportunity for appreciating what the act of seeing with the eye can accomplish.

As we move from the nineteenth to the twentieth century, the predilections of the modern era emerge fully delineated. Impatient with the sort of decorative habits that characterize the Victorian sensibility of a Thrupp, twentieth-century illustrators eschew *fin de siècle* decadence for an uncompromising integrity that attempts as much as possible to recreate the spirit of the original within a "modern" context. Nowhere is this transformation of sensibility more dramatically felt than in the designs of the American illustrator Carlotta Petrina. Her 1936 illustrations to *Paradise Lost* are a case in point.[64] The product of a penetrating mind and a sure hand, they are at once faithful to the spirit of Milton's epic and venturesome enough to offer an interpretation all their own.

Such is particularly true of Petrina's rendering of "the Chariot of Paternal Deitie" (Fig. 21). Serving as a kind of large-scale headpiece to Book VI of *Paradise Lost*, this design is dark and brooding in tone. At the same time, it is full of energy and force. No longer are the chariot and its occupant relegated to a position of relative insignificance, as in Medina and elsewhere. Rather, they assume an overwhelming centrality that underscores the prominence Milton himself bestows upon them in his epic. Transcending the static or merely decorative, Petrina's design captures the dynamism that propels the original. Her conception of the chariot, for example, combines that mystical and warlike quality suggested in Milton's description. Petrina has captured the "burning Wheels" flashing "thick flames," as well as the "fourfold-visag'd Four." "Instinct with Spirit," the chariot rushes forth "with whirlwind sound" to overwhelm everything in its path. Bombarded with balls of fire from the Messiah's hand, the rebel angels fall prostrate, while the faithful angels look on in silence. Petrina is the first illustrator that I know of to give the fearsome nature of the event its due.

This fearsome quality, in turn, is particularly evident in the figure of the Messiah. Hardly the benign personage that one finds in Cheron, Hayman, Westall, and even Blake, the Messiah of Petrina is truly awesome and terrifying. Full of indignation, his countenance is stern and severe. As such, it exhibits qualities that are at once medieval and modern. With his cruciform aureole and his plated armor, he is the very representation of the *Christus Victor* portrayed in early medieval mosaics.[65] At the same time, he is the product of a sensibility responsive to the devastating forces of modern warfare on a worldwide scale. The energies he embodies are those that were unleashed in the Great War

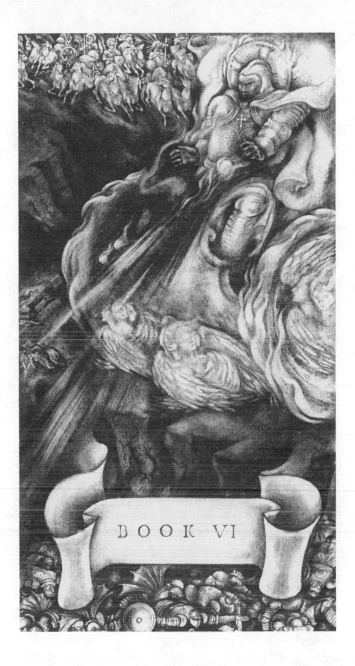

BOOK VI

Fig. 21. Illustration by Carlotta Petrina in John Milton,
Paradise Lost and Paradise Regain'd, with an Introduction by William Rose Benét (San Francisco: Limited Editions Club, 1936), p. 156. Reproduced by permission of the University of Illinois Library at Urbana-Champaign.

and that were shortly to be set loose again in a form even more apocalyptic than the world had ever known.

Placing Milton's epic within this visual context, Petrina provides a "reading" of the War in Heaven and its pivotal event that suggests her indebtedness to earlier traditions and reflects her responsiveness to the currents of her time. In this respect, she reveals a sensitivity not only to the Miltonic original but to the way in which the Miltonic original might assume a renewed urgency in the twentieth century. Although there are certainly details in Milton's description that Petrina has chosen to exclude,[66] her design is in some respects the most faithful we possess. If Medina initiated interest in the subject of the chariot and its occupant, then Petrina offers the most fearsome account of it. Were Milton's Satan given the opportunity of selecting the one illustration truest to the overwhelming experience he was forced to undergo, chances are he would single out the design of Carlotta Petrina.

This overview should suggest the extent to which the central divine act of Milton's epic assumed an importance of the first order for those who adopted it as a subject for illustration. Extending back to Medina in the late seventeenth century, the tradition of Miltonic chariot illustration has a rich and complex history. If Medina set the standard for all future attempts to render "the Chariot of Paternal Deitie," those who came after him did not hesitate to impose upon the subject a visual hermeneutic all their own. Accordingly, such illustrators as Cheron, Hayman, Westall, and Burney left their distinctive marks upon the chariot and the way it was to be conceived during the era in which they worked. They were overshadowed, however, by Blake and Gillray, whose renderings established dramatically new contexts for an understanding of the chariot as, respectively, visionary and political artifact. Although the later decades of the nineteenth century generally disregarded the chariot as an appropriate subject for illustration, the designs of Thrupp restored the chariot to prominence and provided a uniquely stylized way of appreciating its significance to the overall design of Milton's epic. Despite all previous attempts to illustrate "the Chariot of Paternal Deitie," however, it was left to Carlotta Petrina in the twentieth century to give the subject its due. Among the chariot illustrations dating back to Medina, her design is surely the most awesome and terrifying. It has about it the authenticity that comes through a knowledge of warfare as worldwide event. Be that as it may, each of the foregoing illustrators contributes to a fuller understanding of the chariot and its place in *Paradise Lost*. Each provides a visual hermeneutic that illuminates Milton's epic in ways that are often unique and always fascinating. Their statements are certain to endure.

NOTES

1. All parenthetical references by book and line number to *Paradise Lost* are to *The Complete Poetry of John Milton*, ed. John T. Shawcross, 2nd ed. rev. (Garden City: Doubleday, 1971). A portion of the research for this essay was undertaken while I was a Newberry Library Senior NEH Fellow. I am deeply grateful to the Newberry Library for its support and assistance. I would also like to express my appreciation to Mr. Frederick Nash, Curator of Rare Books, University of Illinois, Urbana, for his assistance.

2. *The Allegorical Epic: Essays in Its Rise and Decline* (Chicago: University of Chicago Press, 1980), pp. 166–67.

3. See Shawcross, *Complete Poetry*, p. 383, n. 52. See also Gunnar Qvarnström, *The Enchanted Palace: Some Structural Aspects of "Paradise Lost"* (Stockholm: Almquist and Wiksell, 1967), p. 64; and the discussion in John Carey and Alastair Fowler's edition of *The Poems of John Milton* (London: Longman, 1968), pp. 763–65n.

4. *Milton's Imagery and the Visual Arts: Iconographic Tradition in the Epic Poems* (Princeton: Princeton University Press, 1978), pp. 156–58 and plates 42 and 43. See also Wilhelm Neuss, *Das Buch Ezechiel in Theologie und Kunst* (Münster: Aschendorffsche Verlagsbuchhandlung, 1912), passim.

5. Although the subject is much too complex for discussion here, it is important to recognize that Ezekiel's vision was not always depicted visually as a throne-chariot. In fact, although there is an enthroned figure in Ezekiel's vision, Ezekiel never once uses the word "chariot" (*merkavah*) to describe his vision. That term was used only later by the apocryphal Book of Sirach (49:8). For additional discussions of Ezekiel's vision and its traditions, see, among other works, my book *Poetics of the Holy: A Reading of "Paradise Lost"* (Chapel Hill: University of North Carolina Press, 1981), passim.

6. For discussions of Milton's illustrators, see, among others, Marcia Pointon, *Milton and English Art* (Toronto: University of Toronto Press, 1970); Joseph A. Wittreich, Jr., "Illustrators," in *A Milton Encyclopedia*, gen. ed. William B. Hunter, Jr., 8 vols. (Lewisburg: Bucknell University Press, 1978–80), IV, 55–78; C. H. Collins Baker, "Some Illustrators of Milton's *Paradise Lost* (1688–1850)," *The Library* 3 (1948): 1–21 and 101–19; Mary Dennis Ravenhall, "Illustrations of *Paradise Lost* in England, 1688–1802," Ph.D. Dissertation, University of Illinois at Urbana-Champaign, 1980; Leonard Buell Kimbrell, "The Illustrators of *Paradise Lost* in England, 1688–1802," Ph.D. Dissertation, State University of Iowa, 1965; and Helen Gardner, "Milton's First Illustrator," in *Essays and Studies*, ed. Sir George Rostrevor Hamilton (London: John Murray, 1965), pp. 27–38.

7. In John Milton, *Paradise Lost, The Fourth Edition, Adorn'd with Sculptures* (London, 1688), between pp. 148 and 149.

8. Baker, p. 3. Ravenhall questions this assumption, passim.

9. There is apparently some question of Medina's knowledge of English at the time of the engravings (Kimbrell, p. 12).

10. Whereas Gardner feels that those to the left are good (p. 28), Kimbrell feels that both those to the left and those to the right are evil (p. 59). Ravenhall argues that Medina fails to distinguish sufficiently (pp. 103–7). According to John T. Shawcross, those to the left are good, and those to the right are evil ("The First Illustrations for *Paradise Lost*," *MQ* 9 [1975]: 45).

11. Shawcross, p. 45.

12. Although four-wheeled chariots were well known as early as 3000 B.C., two-wheeled vehicles were better known and ultimately replaced the four-wheeled variety (*A History of Technology*, ed. Charles Singer et al., 7 vols. [Oxford: Clarendon Press, 1954–78], I, 724–25).

13. Of course, only one of the hubs is really shown, but certainly the others would be similar.

14. According to Ravenhall, Medina's conception of the chariot might in fact owe something to the stage sets as they appear in sixteenth- and seventeenth-century engravings. "The use of cloud masses to support heavenly figures was a common device in these sets, as was the appearance of a pagan god mounted high in the sky." Ravenhall cites as an example the design by Parigi for Act V, Scene 6, of *Le Nozzi degli Dei*, engraved by Stegano della Bella (p. 106). There is, I think, much to recommend this view. For additional work on the subject, see John G. Demaray, *Milton's Theatrical Epic: The Invention and Design of "Paradise Lost"* (Cambridge: Harvard University Press, 1980), esp. pp. 85–101 and accompanying plates between pp. 44 and 45.

15. In John Milton, *Paradise Lost. A Poem in Twelve Books. . . . To which is added Explanatory Notes upon each Book*, 6th ed. (London, 1695). This volume contains the Medina, Lens, Aldrich designs, as well as the Hume *Annotations*. For discussions of Hume et al., see John T. Shawcross, ed., *Milton: The Critical Heritage*, 2 vols. (London: Routledge and Kegan Paul, 1970–72), passim; and Ants Oras, *Milton's Editors and Commentators from Patrick Hume to John Henry Todd* (1695–1801), rev. ed. (New York: Haskell House, 1967), passim. Even before the Hume annotations, the impact of "the Chariot of Paternal Deitie" could be felt in the response of Milton's admirers. To determine the validity of this observation, one need only glance at the first of the two commendatory poems that graced the 1674 edition of *Paradise Lost*. Attributed to Samuel Barrow, "*In Paradisum Amissam Summi Poetae Johannis Miltoni*" hails the approach of "the banners of Messiah" and "His living chariot and His armor meet for God." The poet marvels at how the wheels of the chariot "grind horribly, and the fierce lightnings of the wheels burst from those grim eyes, and the flames flash and veritable thunder with intermingled fires reverberates hoarsely in the skies" (in *John Milton's Complete Poetical Works, Reproduced in Photographic Facsimile*, 4 vols. [Urbana: University of Illinois Press, 1943–48], III, 67–68). I am using the translation provided in *The Student's Milton*, ed. Frank A. Patterson (New York: Appleton-Century-Crofts, 1961), pp. 69–70. First suggested by John Toland, the attribution to Samuel Barrow is conjectural.

16. Hume, pp. 207–10. The idea of the *chashmal* has a long tradition in rabbinical thought. It is treated in conjunction with Ezekiel's throne-chariot, or *merkavah*, in Jewish mysticism.

17. Hume also treats other Hebraic dimensions of the throne-chariot, including *tarshish* or beril (Ezek. 1:16) and the concept of light (*or*) (cf. Ex. 28:30). As a counterpart of the biblical, Hume cites such classical antecedents as Vergil's *Aeneid*.

18. *The Grounds of Criticism in Poetry* (London, 1704), pp. 60–61.

19. "The Spectator" (no. 333, March 22, 1712), *Criticism on Milton's "Paradise Lost,"* ed. Edward Arber (1869; reprinted New York: AMS Press, 1966), pp. 94–98.

20. *Explanatory Notes and Remarks on Milton's "Paradise Lost"* (London, 1734), pp. 302–4.

21. Newton's edition of *Paradise Lost* appeared in 1749. I am using *The Poetical Works of John Milton, with Notes of Various Authors Principally from the Editions of Thomas Newton, Charles Dunster, and Thomas Warton*, ed. Edward Hawkins, 4 vols. (Oxford, 1824), I, 416.

22. For the definitive study of the subject, see Samuel H. Monk, *The Sublime: A Study of Critical Theories in Eighteenth-Century England* (Ann Arbor: University of Michigan Press, 1960).

23. See not only the works of Dennis, cited earlier, but Edmund Burke, *A Philosophical Enquiry into the Origin of our Ideas of the Sublime and Beautiful* (1757), ed. J. T. Boulton (London: Routledge and Kegan Paul, 1958), passim; and James Beattie, "Illustrations on Sublimity," in *Dissertations Moral and Critical* (London, 1783), p. 640.

24. In *Eighteenth Century Poetry and Prose*, ed. Louis J. Bredvold et al., 2nd ed. (New York: Ronald Press, 1965). In his poem *The Passion*, Milton similarly conceives of himself as being transported ecstatically in Ezekiel's chariot.

25. In *The Complete Poetry and Prose of William Blake*, ed. David V. Erdman, 2nd ed. rev. (Garden City: Doubleday, 1982). Subsequent references to Blake's poetry and prose are to this edition.

26. In *Poetical Works of John Milton*, 2 vols. (London, 1720), I, 271.

27. Compare, however, Milton's delineation of a lion and a man as two of the creatures of the chariot of Zeal in his *Apology . . . [for] Smectymnuus, The Works of John Milton*, gen. ed. Frank A. Patterson, 18 vols. in 21 (New York: Columbia University Press, 1931–38), III, 313–14.

28. Ezekiel himself departs from this paradigm in chapter 10, in which he substitutes the face of a cherub for that of the ox.

29. In *The Holy Bible, Containing the Old Testament and the New: Newly Translated out of the Original Tongues* (Oxford, 1717). According to Ravenhall, "the Thornhill-Cheron Illustrations for the 1720 edition of Milton's *Poetical Works* followed the format established by their Bible illustrations of 1717, which consisted of headpieces filling approximately one third of the page, somewhat smaller tailpieces, and historiated initials. Each of these illustrations contained only a single narrative or emblematic scene, a feature also employed in the Milton illustrations" (p. 196).

30. See Ravenhall's perceptive discussion of the Cheron plate (pp. 220–21).

31. In *John Milton, Paradise Lost . . . with Notes of various Authors*, by Thomas Newton, 2 vols. (Dublin, 1749), I, between pp. 384 and 385.

32. Ravenhall, p. 328.

33. In John Milton, *The Poetical Works of John Milton*, 3 vols. (London, 1794), I, between pp. 210 and 211; and in John Milton, *Paradise Lost*, 2 vols. (London, 1817), I, preceding Bk. VI, respectively. For the second illustration, I am using the edition of 1821.

34. Compare *Paradise Lost* XII, 224–57; Ex. 25:22. Also, see my *Poetics of the Holy*, esp. pp. 212–45.

35. In John Milton, *Paradise Lost* (London, 1799), between pp. 172 and 173. Wittreich lists Landseer, Neagle, Rothwell, Bromley, Blackberd, and Milton (*Encyclopedia*, IV, 64).

36. In John Milton, *Paradise Lost*, 2 vols. (London, 1802), between pp. 262 and 263.

37. The Huntington Library's set is comprised of twelve illustrations; Boston's set has nine. Blake began a third set in 1822 but completed only three illustrations in it. For conjectures on the Huntington and Boston sets, see

Morse Peckham, "Blake, Milton, and Edward Burney," *The Princeton University Library Chronicle* 11 (1950): 107–26. The Blake plates, with accompanying bibliographical information, are accessible in Martin Butlin, *The Paintings and Drawings of William Blake*, 2 vols. (New Haven: Yale University Press, 1981).

38. Butlin, I, 384: "The figures are more highly finished and solidly modelled." The style is "more monumental." According to Wittreich, Blake was possibly "dissatisfied with his first set of illustrations" and "felt compelled to try again" in the second set ("William Blake: Illustrator-Interpreter of *Paradise Regained*," in *Calm of Mind: Tercentenary Essays on "Paradise Regained" and "Samson Agonistes*," ed. Joseph A. Wittreich, Jr. [Cleveland: Press of Case Western Reserve, 1971], p. 101).

39. Pamela Dunbar, *William Blake's Illustrations to the Poetry of Milton* (Oxford: Clarendon Press, 1980), p. 64. See also Stephen C. Behrendt, *The Moment of Explosion: Blake and the Illustration of Milton* (Lincoln: University of Nebraska Press, 1983), esp. pp. 155–59.

40. In William Blake, *William Blake's Water-Colours Illustrating the Poems of Thomas Gray*, ed. Sir Geoffrey Keynes (Chicago: J. Philip O'Hara, 1972), p. 54.

41. *Blake's Illustrations to the Poems of Gray* (Princeton: Princeton University Press, 1971), p. 87. Compare also Blake's study entitled "The Bowman," in Butlin, II, plate 429.

42. Dunbar, pp. 64–66.

43. For additional discussion of topical significance, see the commentaries of Draper Hill in his edition of *The Satirical Etchings of James Gillray* (New York: Dover Publications, 1976), p. 108; Thomas Wright in his edition of *The Works of James Gillray, the Caricaturist* (London: Chatto and Windus, n.d.), pp. 183–84; and Mary Dorothy George, *Catalogue of Political and Personal Satires Preserved in the Department of Prints and Drawings in the British Museum*, 11 vols. (London: Trustees of the British Museum, 1873–1954), IV, 171–72.

44. The concept of Logos as charioteer is Philonic. See J. H. Adamson, "The War in Heaven: The Merkabah," in *Bright Essence: Studies in Milton's Theology* (Salt Lake City: University of Utah Press, 1971), p. 106.

45. The figure of Justice with her scales might represent another point of comparison. Although not specifically present in Milton's narrative of the war, the spirit of Justice certainly presides over the warfare of the angels and is implicit in the confrontation between Satan and Gabriel in Book IV (1006–15) of Milton's epic.

46. "The Prince of Wales agreed to wed his cousin, Princess Caroline of Brunswick, in return for the payment of his debts. The marriage had been solemnized on 8 April" (Hill, p. 108).

47. See also Gillray's sequel to *Light Expelling Darkness*. Entitled *Phaeton alarm'd!* (1808), this illustration depicts Pitt once again in his chariot (this time, the chariot of Phaëthon) confronting a host of opponents. The illustration contains many of the elements apparent in the earlier *Light Expelling Darkness*.

48. See Annotations to Richard Payne Knight's *An Analytical Inquiry into the Principles of Taste*, 3rd ed. (London, 1806), p. 400; and *The Country Churchyard* (February 1810), in *The Romantics on Milton*, ed. Joseph A. Wittreich, Jr. (Cleveland: Press of Case Western Reserve, 1970), pp. 116–17,

122. Although the Annotations are attributed to Coleridge, evidence points instead to Wordsworth. (See Wittreich, pp. 150–51, n. 19.)

49. In Wittreich, pp. 278–79.

50. See Bloom's two studies: *Shelley's Mythmaking* (New Haven: Yale University Press, 1959), esp. pp. 138–47 and 230–69; and *Poetry and Repression: Revisionism from Blake to Stevens* (New Haven: Yale University Press, 1976), esp. pp. 83–111.

51. *The Paradise Lost of Milton*, 2 vols. (London, 1826).

52. I am using *The Poetical Works of John Milton*, ed. Egerton Brydges (London, [1871]). Engraved by E. Goodall, the illustration of the fall of the angels in this edition is found between pp. 164 and 165.

53. See Harvey's designs engraved by Thompson et al. in *The Poetical Works of John Milton*, 2 vols. (London, 1843), and Doré's designs engraved by Tonnard et al. in *Milton's Paradise Lost* (London, [1866]). Both Harvey and Doré depict the routing of the rebel angels—but without the chariot. Whereas Harvey is content to illustrate a hand holding thunders that strike the falling angels, Doré portrays the falling angels entering the realm of Hell.

54. The full title is *Paradise Lost by John Milton. Illustrated by Thirty-Eight Designs in Outline. Thirty-Four of the Plates Engraved by the Artist and Four by F. Joubert* (London, 1879). Although Thrupp was known primarily as a sculptor, he illustrated not only *Paradise Lost* but "The Ancient Mariner" and "The Prisoner of Chillon." He also designed bronze door panels illustrating Herbert's poems (*DNB* XIX, 815–16). Two other exceptions to the lack of interest in the chariot in the nineteenth century may be found in the illustrations of William M. Craig and J. J. Flatters, both of whom depict the chariot, not from Book VI, however, but from Book VII, in which the Son rides forth to create the universe. In his illustrations to *Paradise Lost* (London, 1804), Craig depicts the Son standing in a diminutive four-wheeled vehicle as angels with harps celebrate his creative acts. In his illustrations to *The Paradise Lost of Milton* (London, 1843), Flatters portrays the Son in a winged vehicle with a handle of some sort, accompanied by angels with a draftsman's and a surveyor's instruments, including a compass, a T-square, a triangle, and a plumb bob. I have found the Flatters illustrations in a number of foreign-language editions of *Paradise Lost*. See also the Sophia Giacomelli designs in *Le Paradise Perdu, par Milton, en Douze Figures* (Paris, 1813).

55. See, for example, illustration 20, which is entitled "The Return from Conquest" and dated 1877 (Fig. 20 in the present essay).

56. For this information, as well as for assistance with the Thrupp designs in general, I thank Mr. Anselm Carini, Associate Curator, Prints and Drawings, The Art Institute of Chicago.

57. See the plates that depict Assyrian military garb, weapons, and chariots of the seventh and sixth centuries B.C. in Leon Heuzey, *Histoire du Costume dans L'Antiquité Classique L'Orient* ([Paris]: Société d'édition Les Belles lettres, 1935), pp. 67–80. Thrupp, however, suggests the uniquely holy nature of his chariot rider by means of the mandorla that surrounds the Messiah's head. In keeping with Milton's description, Thrupp has his chariot rider grasp thunders in his right hand.

58. On this score, see Thomas Hope's *The Costumes of the Ancients*, 2 vols. (London, 1809), a large compendium of source material, the second volume of which is made up of a multitude of line drawings that anticipate those found in

Thrupp's illustrations of the soldiery in *Paradise Lost*. Interestingly, in Figure 20, the armor of one of the faithful angels has the star of David depicted on its shoulder.

59. See, in this regard, Francis C. Blessington, *Paradise Lost and the Classical Epic* (London: Routledge and Kegan Paul, 1979).

60. *DNB* XIX, 815.

61. See Richard Altick, *The Shows of London* (Cambridge: Harvard University Press, 1978), passim.

62. In his illustration of Ezekiel's vision for Baskett's Oxford Bible, Cheron, we recall, depicted eyes in the wheels but not in the creatures. Neither the wheels nor the creatures have eyes in Cheron's *Paradise Lost* illustration. (Compare Medina's chariot and its wheels, which, as indicated, possibly contain faces with eyes depicted in the hubs.)

63. Unless I am mistaken, the eyes that permeate the creatures seem to have found their way into the armor of one of the falling angels in Figure 19. If such is the case, the reason for this transposition is unclear to me.

64. In John Milton, *Paradise Lost and Paradise Regain'd, with an Introduction by William Rose Benét and Illustrations by Carlotta Petrina* (San Francisco: Limited Editions Club, 1936), pp. 156 and 158. Born in Kingston, New York, October 9, 1901, Ms. Petrina has exhibited her works in the Salon d'Automne and Salon des Artistes Français in Paris, the Art Institute of Chicago, and the Pennsylvania Academy of Fine Arts, among other places. A Guggenheim recipient in 1933 and 1935, she has also illustrated *South Wind*, the *Aeneid*, and *Henry VI* (*Who's Who in American Art*, ed. Dorothy B. Gilbert [New York, 1956], p. 367).

65. See, for example, *Christus Victor* (early sixth-century mosaic, Oratory of St. Andrew, Ravenna), in Frye, *Milton's Imagery*, plate 3.

66. She does not attempt to visualize the figure of Victory, for example, or the Messiah's bow and quiver. Nor does she depict all those eyes with which the chariot wheels and the creatures are imbued. The eyes that she does depict on the fourfold creatures, however, are quite fearsome.

ERNEST W. SULLIVAN, II

Illustration as Interpretation:
Paradise Lost from 1688 to 1807

Kester Svendsen, in "John Martin and the Expulsion Scene of *Paradise Lost*," concludes of the parallels between the text of *Paradise Lost* and the efforts of its illustrators that, "As we see more deeply into the poem and into the style, the elements, the method of the illustration, into the bearing of their separate ages and outlooks, we move to a heightened sense of the interrelation of the arts; and thus we are living an experience in cultural history. Illustration finally is illumination."[1] Indeed, an examination of seventeenth-, eighteenth-, and early nineteenth-century illustrations of *Paradise Lost* provides not only "an experience in cultural history" and "illumination," but also important information about how a relatively sensitive group of readers conceived of the characters in the poem and thereby interpreted the poem over a substantial span of time. As Helen Gardner observes of the designs for the first illustrated edition (1688) of *Paradise Lost*: "to look at them gives us perhaps some indication of how *Paradise Lost* was read by men of its own century."[2]

In fact, in the seventeenth century, "illustration" meant "explanation" or "enlightenment"; not until the eighteenth century was the word identified with the engravings: "The original meaning of 'illustration' was 'explanation', or 'spiritual enlightenment'. Bullokar in 1676 defined 'to illustrate' as 'to make famous, or noble, to unfold or explain' . . . By the end of the eighteenth century, however, the term had come to be identified with engravings and the meaning was extended to 'embellishment' [in the decorative sense] as well as 'explanation.'"[3] As Joseph A. Wit-

treich observes, "Milton's illustrators . . . assumed an interdependence of text and design; their objective in illustrating a poem was to illuminate it; their designs, therefore, attempted a crystallization of the Miltonic vision, which the artist then criticized and might even try to correct. Milton illustration, with very few exceptions, is a form of nonverbal criticism."[4] These illustrations (particularly those in editions of *Paradise Lost*), then, provide tangible conceptualizations of the poem acceptable to Milton's audience and are thus an invaluable aid in tracing the evolution of various interpretations of *Paradise Lost*.[5]

During the seventeenth and eighteenth centuries, *Paradise Lost* was the literary subject most frequently illustrated in England (there were twelve different illustrated editions alone); thus, a complete examination of the illustrations and their relation to interpreting the entirety of the poem exceeds the scope of this essay. I will, therefore, largely confine my discussion to seventeenth-century (Sir John Baptist de Medina, Henry Aldrich), eighteenth-century (Francis Hayman, J. H. Fuseli), and nineteenth-century (William Blake) illustrators whose illustrations of four key scenes—Satan's initial appearance, Satan's meeting with Sin and Death at the gates of Hell, Satan's temptation of Eve, and the Expulsion—present discernible stages in the evolution of Satan's characterization from the archfiend of Milton's contemporaries to the heroic rebel of some Romantics (chiefly, according to Joseph A. Wittreich, Blake, Byron, and Shelley)[6] and in the accompanying evolution of the "Fortunate Fall" interpretation of the ending of *Paradise Lost*. As Satan becomes more attractive, so do Sin and man; and as the illustrators elevate Satan, Sin, Adam, and Eve, they portray the Fall and Expulsion less in terms of a ruinous loss of God's grace and a banishment for transgression and more in terms of a fortunate transition from an external Paradise into a "paradise within . . . happier far"[7] with the promise of a future Redemption.

Even though the illustrations or drawings have their own aesthetic identity independent of the text (particularly those of Blake)[8] and are therefore susceptible to the idiosyncrasies and abilities of the artist as artist as well as the artist as critic, to the aesthetics and artistic traditions of the period, and even to the technologies and media available, the essentially constant text retains a sufficiently common role in the genesis of the illustrations to make comparison of the characterizations valid. Furthermore, despite individual differences among the illustrators, the means available to them for creating an interpretation (size, position, pose, gesture, physical features, facial expression, choice of scene and detail, and lighting) also remained relatively constant and therefore readily comparable.

In portraying intangible, supernatural characters like Satan and Sin or "supranatural" characters like the prelapsarian Adam and Eve, the illustrator (with some limitations and guidance imposed by the text) must create a physical representation of his conception of the character, and, when that character embodies moral qualities (as do Satan, Sin, Adam, and Eve), any physical representation is inevitably interpretative. One can draw a bad man who looks exactly like a good man without straining logic, but a drawing of a conception of evil ought not to look like a drawing of a conception of good. Since the text remains essentially a constant, any differences in the moral qualities embodied in the various characterizations of Satan, Sin, Adam, or Eve may safely be ascribed to differing interpretations of the characters by the illustrators.

The illustrator of the first illustrated edition (1688) of *Paradise Lost*,[9] Francis Hayman, and William Blake all depict Satan's attempt in Book I to rally his rebel army in Hell. Just previous to this scene, the text of *Paradise Lost* describes the fallen angels as having lost some of their heavenly brightness but as still-imposing figures:

> O how fall'n! how chang'd
> From him [Beelzebub], who in the happy Realms of Light
> Cloth'd with transcendent brightness didst outshine
> Myriads though bright
>
> .
>
> With Head up-lift above the wave, and Eyes
> That sparkling blaz'd, his [Satan's] other Parts besides
> Prone on the Flood, extended long and large
> Lay floating many a rood, in bulk as huge
> As whom the Fables name of monstrous size.
> (I, 84–87, 193–97)

Nonetheless, any reasonably literal rendering of the text at the moment illustrated would portray a scene of rack and ruin:

> on the Beach
> Of that inflamed Sea, he stood and call'd
> His Legions, Angel Forms, who lay intrans't
> Thick as Autumnal Leaves that strow the Brooks
> In *Vallombrosa* . . .
> when with fierce Winds *Orion* arm'd
> Hath vext the Red-Sea Coast, whose waves o'erthrew
> *Busiris* and his *Memphian* Chivalry,
> While with perfidious hatred they pursu'd

The Sojourners of *Goshen*, who beheld
From the safe shore thir floating Carcasses
And broken Chariot Wheels; so thick bestrown
Abject and lost lay these, covering the Flood,
Under amazement of thir hideous change.

(I, 299–313)

And, indeed, the 1688 illustration of the initial appearance of Satan
(Fig. 22) gives us a satanic Satan amidst a scene of destruction and
dismay. Even in defeat, the seventeenth-century Satan is a formidable
figure, central and upright. Nonetheless, he stands alone, the only erect
fallen angel, and his followers appear totally defeated, demonstrating
little continued interest in his cause. The illustrator ignores the fact that
at the moment illustrated (I, 315–30) Satan's faithful companion,
Beelzebub, would have been standing next to him: "though now they
[the fallen angels] lie / Groveling and prostrate on yon Lake of Fire, / As
we erewhile" (I, 279–81), suggesting the singular nature of Satan's
responsibility for the initial, and any continuing, rebellion. In fact, in
this illustration, Satan's eloquence has evidently been sufficiently di-
minished that he has to rouse the interest of the fallen angels with the
sharp end of his spear. The illustrator has also stripped Satan of his
shield, perhaps to indicate his utter defenselessness against God.
Satan's considerably reduced physical splendor depicts his moral degen-
eration: he retains his feathered angelic wings but has acquired the
traditional demonic horns and pointed ears. He stands partly in shadow,
the darkening of his wings particularly emblematic of his loss of heav-
enly light. The 1688 illustrator, then, presents a decidedly unheroic
Satan deformed in horns and ears—the traditional archenemy debased
beyond the demands of the text.

Between the moment of Satan rallying his troops and his meeting with
Sin and Death at the gates of Hell, the text does not imply any very
substantial change in Satan's appearance (Sin, for example, recognizes
Satan immediately from her memories of him in Heaven [II, 727–34],
and Chaos recognizes him from having witnessed his fall [II, 990–92]),
though he has been metaphorically diminished by comparison of his
troops (Satan himself is compared to a "General" [I, 337] and a "Sultan"
[I, 348]) to locusts (I, 341); burned trees (I, 612–15); bees (I, 768–
76); "Dwarfs," pigmies, and "Faery Elves" (I, 779–81). Satan would
still be an imposing figure:

he above the rest
In shape and gesture proudly eminent
Stood like a Tow'r; his form had yet not lost

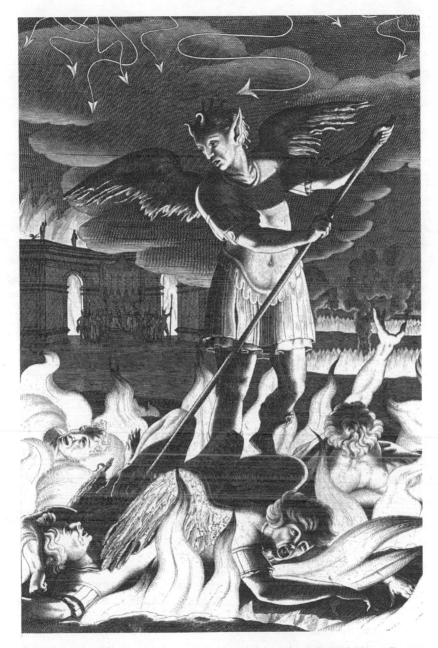

FIG. 22. Anon., "Satan Summons His Legions," from John Milton, *Paradise Lost* (London: Miles Flesher, 1688). Reproduced by permission of the Henry E. Huntington Library.

All her Original brightness, nor appear'd
Less than Arch-Angel ruin'd, and th' excess
Of Glory obscur'd: As when the Sun new ris'n
Looks through the Horizontal misty Air
Shorn of his Beams, or from behind the Moon
In dim Eclipse disastrous twilight sheds
On half the Nations, and with fear of change
Perplexes Monarchs. Dark'n'd so, yet shone
Above them all th' Arch-Angel: but his face
Deep scars of Thunder had intrencht, and care
Sat on his faded cheek.

(I, 589–602)

He retains his substantial powers of flight ("*Satan* with thoughts in-
flam'd of highest design, / Puts on swift wings, and towards the Gates of
Hell / Explores his solitary flight" [II, 630–32]) and his armament
("those bright Arms" [II, 812]). Even so, the text, while not providing
specific physical details, does describe Satan as a "Fiend" (II, 643) just
before his meeting with Sin and Death (II, 648–927).
 The text makes Sin part feminine beauty, part hellish monstrosity:[10]

The one seem'd Woman to the waist, and fair,
But ended foul in many a scaly fold
Voluminous and vast, a Serpent arm'd
With mortal sting: about her middle round
A cry of Hell Hounds never ceasing bark'd
With wide *Cerberean* mouths full loud, and rung
A hideous Peal: yet, when they list, would creep,
If aught disturb'd thir noise, into her womb,
And kennel there, yet there still bark'd and howl'd
Within unseen.

(II, 650–59)

 Again, the 1688 illustration (Fig. 23) offers the least flattering portrait
of Satan (and of Sin), portraits perhaps even more negative than licensed
by the text, and shows Satan as having degenerated considerably since
attempting to rouse his legions in Book I. Satan is front and center
(though not substantially larger than the other two figures), but his
physical deformity has become more pronounced: his wings are smaller
and no longer feathered but reptilian, his horns and ears are larger and
more pointed, his physique is squat and stumpy, his face "Deep scars of
Thunder . . . intrencht," and he stands in shadow. The text does not

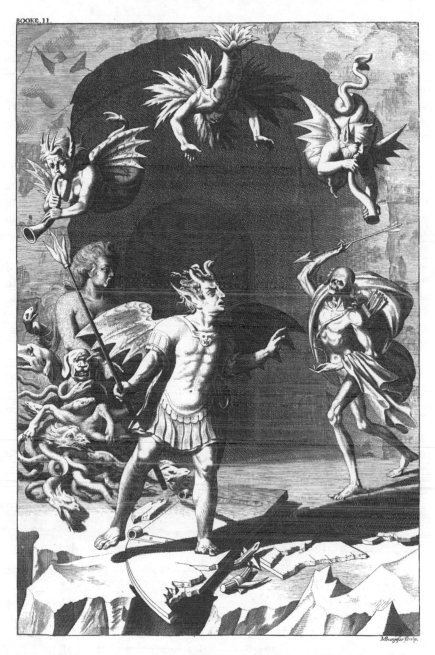

FIG. 23. Anon., "Satan, Sin, and Death at the Gates of Hell," from John Milton, *Paradise Lost* (London: Miles Flesher, 1688). Reproduced by permission of the Henry E. Huntington Library.

suggest this change in Satan's wings (described only as "swift" [II, 631] and as "Sail-broad Vans" [II, 927]); the reptilian wings initiate the 1688 characterization of Satan as serpentine. The illustrator also portrays Sin more negatively than the text demands: "The one seem'd Woman to the waist, and fair" would allow at least an attractive upper half for Sin, but the illustrator, focusing on Sin's monstrous rather than on her attractive qualities, produces a Sin no better than homely and at least two-thirds hellhounds and serpents. The physical deformity of Satan and Sin clearly mirrors their moral deformity.

Furthermore, the illustrator positions the characters and dramatically alters the chronology and details of the narrative to emphasize again the discord and lack of cooperation that characterize evil. The illustrator focuses on the initial instant of the meeting and confrontation of Satan and Death (II, 674–726). Satan, in the foreground, has his back to Sin, who has just opened her mouth to intervene in the conflict between Satan and Death (II, 727); the characters are positioned in a triangle but in different planes, suggesting their lack of equality and unity. Beneath Satan lie shattered pieces of Hell's gates. In the text, the gates are not open until after the reconciliation of the trio (II, 871–84), and they are opened, not broken down, with Sin's key (the illustration omits this symbol of the unholy amity) after Sin reaffirms her love for Satan. Marcia R Pointon and Stephen R. Behrendt's criticisms of this illustration seem inappropriate ("Medina did not read the text of Book II with his customary care" [Pointon, p. 15], and "All three of Aldrich's designs deviate significantly from the details of Milton's text" [Behrendt, p. 92]): the illustrator has not produced a literal reproduction of the text, but an "illustration" in the seventeenth-century sense of "explanation" or "spiritual enlightenment." By transcending the chronological limitations of narrative text to treat the confrontation and the opened gates of Hell simultaneously (while omitting the key and adding the broken gates), the illustrator not only reminds the viewer of three of Milton's main topics—unnatural rebellion (son against father and vice versa), a "broken" commandment (God had commanded Sin not to open the gates of Hell [II, 850–53]), and the discordant and destructive qualities of evil—but also associates these topics in the viewer's mind, an association that Milton would surely applaud.

In the 1688 illustrations for Books I and II, then, the illustrator has pictured an unheroic Satan and an unattractive Sin more negatively than required by the text. This negative portrayal of rebellion and sin foreshadows the 1688 illustrations and interpretations of the Fall and Expulsion as man's rebellion and punishment for sin.

Book IX, containing the Temptation(s) and Fall, asks the illustrator not only to interpret the characters, but also to interpret the Fall in his choice of scene(s) to illustrate: is the essence of Book IX (and the Fall) Satan's temptation of Eve, Eve's temptation of Adam, or both? Prior to Satan's temptation of Eve, the text shows him utterly psychologically and physically degenerate and in the disguise of a serpent:

> the more I see
> Pleasures about me, so much more I feel
> Torment within me, as from the hateful siege
> Of contraries; all good to me becomes
> Bane
>
> .
>
> O foul descent! that I who erst contended
> With Gods to sit the highest, am now constrain'd
> Into a Beast, and mixt with bestial slime
>
> .
>
> so much hath Hell debas'd, and pain
> Infeebl'd me, to what I was in Heav'n.
> (IX,119–23, 163–65, 487–88)

Furthermore, Satan's choice of the serpent guise ironically results in a "disguise" that provides the illustrators with an icon for the degree and nature of his evil. By recalling the "wand'ring mazes" and the "scaly fold" of earlier descriptions of erroneous reasoning by the fallen angels ("Others apart sat on a Hill retir'd, / In thoughts more elevate, and reason'd high / Of Providence, Foreknowledge, Will, and Fate, / Fixt Fate, Free will, Foreknowledge absolute, / And found no end, in wand'ring mazes lost" [II, 557–61]) and of Sin ("The one seem'd Woman to the waist, and fair, / But ended foul in many a scaly fold" [II, 650–51]), the coiled serpent becomes an icon of Satan as the embodiment of error and sin:

> thus wrapt in mist
> Of midnight vapor glide obscure, and pry
> In every Bush and Brake, where hap may find
> The Serpent sleeping, in whose mazy folds
> To hide me, and the dark intent I bring.
> (IX, 158–62)

Not only does Satan enter the serpent at the moment when it is fully coiled ("him fast sleeping soon he found / In Labyrinth of many a round

self-roll'd, / His head the midst" [IX, 182–84]), but also the narrator calls attention to the "folds" and "Maze" in Satan's serpentine disguise as Satan approaches Eve:

> So spake the Enemy of Mankind, enclos'd
> In Serpent, Inmate bad, and toward *Eve*
> Address'd his way, not with indented wave,
> Prone on the ground, as since, but on his rear,
> Circular base of rising folds, that tow'r'd
> Fold above fold a surging Maze.
>
> (IX, 494–99)

Satan's judgment that he could hide any physical clue to his "dark intent" and nature by inhabiting the serpent ("Fit Vessel, fittest Imp of fraud, in whom / To enter, and his dark suggestions hide / From sharpest sight" [IX, 89–91]), then, would seem yet another self-defeating choice on his part. Even so, the text does license depicting Satan as an attractive snake: "pleasing was his shape, / And lovely, never since of Serpent kind / Lovelier" (IX, 503–5), "disturb'd, yet comely" (IX, 668) even in his final speech to Eve.

Sir John Baptist de Medina's 1688 illustration of the temptation scene (Fig. 24) is synoptic (in the tradition of biblical illustration), showing several dramatic moments from Book IX: Satan selecting his serpentine disguise, Adam and Eve discussing their separation, their division of labor, Satan's temptation of Eve, Eve's temptation of Adam, and Adam and Eve clothed in fig leaves. By illustrating the events of Book IX synoptically rather than focusing on a single episode, Medina suggests that the Fall was a composite of several actions and that Satan, Eve, and Adam were collectively and directly responsible. At this late stage in the poem, Medina seizes the opportunity to show Satan's evil intentions by portraying him before he enters the neutral serpent. Here, Medina debases Satan into a combination medieval devil and classical satyr: his wings are smaller than in previous illustrations as well as more starkly reptilian; he has pointed horns and ears, a tail, long claws, satyr's legs, and hooves. Although in the foreground, Satan is not much larger than are the human figures (and, perhaps, no more to blame) and is appropriately drawn in total darkness—the choice of serpent disguise was literally "benighted." The serpent, drawn in an endless coil with its head on its tail, exactly as described in the text, reminds the viewer of the maze of error and the folds of sin, the endless (and circular) error and sin emanating from Satan's head, and God's promise that Satan's "self-roll'd" sins will, in the end, recoil on his own head: "so bent he

BOOKE. IX.

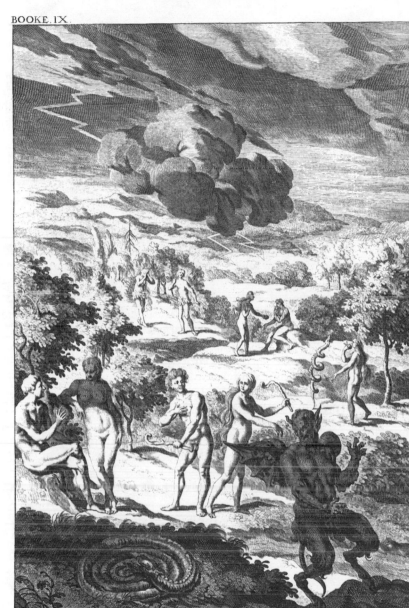

B. de Medina Inven. Burgeſse ſculp.

FIG. 24. J. B. Medina, "The Temptation," from John Milton, *Paradise Lost* (London: Miles Flesher, 1688). Reproduced by permission of the Henry E. Huntington Library.

seems / On desperate revenge, that shall redound / Upon his own re-
bellious head" (III, 84–86). Medina's illustration, then, emphasizes the
fiend within the serpent.

Medina's depictions of Adam and Eve assess blame in an earlier and
more focused way than does the text. In the initial debate over their
separation (IX, 205–384), Medina shows Adam seated below Eve and
Eve's head and heart shaded by a nearby tree (a foreshadowing not even
hinted at by the text), suggesting that even this early Adam "to her . . .
didst resign thy Manhood, and the Place / Wherein God set thee above
her" (X, 147–49) and that Eve's arguments proceeded from a "dark-
ened" mind and heart (though the narrator later describes her as "yet
sinless" [IX, 659]). In the temptation of Eve section of the illustration,
Medina shows Satan upright (and coiled) and Eve clearly separated from
any physical influence on his part (in contrast to William Blake's later
illustration) and obviously asserting her independent choice in full light.
When Eve offers Adam the apple, dark intentions again "shadow" her
head and heart (this time true to the text [IX, 816–33]), and Adam is
again seated, this time with his head and heart shadowed as a reminder
of the intellectual and emotional causes of his erroneous choice: "he
scrupl'd not to eat / Against his better knowledge, not deceiv'd, / But
fondly overcome with Female charm" (IX, 997–99). In Medina's il-
lustration, then, Satan, Eve, and Adam share blame for the Fall, and
their erroneous and sinful actions are not only connected by being
placed in a single illustration, but also by being placed on a single,
spiraling path (presumably leading out of Eden), a path whose mazelike
and coiling qualities remind the viewer of the error and sin depicted
throughout the illustration. Medina provided his seventeenth-century
viewers with a conservative and traditional view of the Fall—no fore-
shadowing of any *felix culpa* here.

Although Aldrich's 1688 illustration of the Expulsion of Adam and
Eve from Eden does not suggest that the Fall was completely unhappy,
his interpretation does not explore the full possibilities of a "Fortunate
Fall" inherent in the text:

> then wilt thou not be loath
> To leave this Paradise, but shalt possess
> A paradise within thee, happier far.
>
> .
>
> In either hand the hast'ning Angel caught
> Our ling'ring Parents, and to th' Eastern Gate
> Led them direct, and down the Cliff as fast
> To the subjected Plain; then disappear'd.

> They looking back, all th' Eastern side beheld
> Of Paradise, so late thir happy seat,
> Wav'd over by that flaming Brand, the Gate
> With dreadful Faces throng'd and fiery Arms:
> Some natural tears they dropp'd, but wip'd them soon;
> The World was all before them, where to choose
> Thir place of rest, and Providence thir guide.
>
> (XII, 585–87, 637–47)

Indeed, in Book XI, God specifically orders Michael to "Dismiss them not disconsolate" (XI, 113), and previous to Adam and Eve's actually leaving Eden, the text establishes their sense of future happiness: "our Sire / Replete with joy and wonder thus repli'd. / O goodness infinite, goodness immense!" (XII, 467–69) and "For God is also in sleep, and Dreams advise, / Which he hath sent propitious, some great good / Presaging" (XII, 611–13).

Aldrich, however, in 1688 sees man as an imitator, if not actually a fellow conspirator, of Satan, and provides only the barest suggestion of a "Fortunate Fall," showing a degenerate and disconsolate Adam and Eve driven from Eden much as the devils had been driven from Heaven (Fig. 25). Aldrich's stone stairs re-create the stone-hearted, man-made steps to the Fall depicted by Medina in Book IX far better than would the natural "Cliff" (XII, 639) down which Adam and Eve descend from Eden in the text, and his stone wall surrounding Eden reminds the viewer less of the text's "verdurous wall of Paradise" (IV, 143) than of the stone tablets that will circumscribe Adam and Eve's future lives. Michael stands atop the last step of the stairs, while Adam and Eve stand on the "subjected Plain," a hint of the altered relationship between man and the angels. The relative positioning may also suggest, contrary to the more optimistic text, that Michael might disappear (XII, 640) before descending to the "subjected Plain," leaving Adam and Eve without the promised "Providence" to be "thir guide" in the world. Michael has his sword drawn (its curved blade suggesting the "flaming Brand" exuding the flames that now "guard all passage to the Tree of Life" [XI, 122]) and a firm grip on Adam, contrary to God's order to "all terror hide" (XI, 111). Also contrary to the text, no one is holding hands: Adam's hands cover his face as if in an effort to hide from God (as he had in Book X, 116–17), and Eve's hands cover her nakedness, previously the symbol of her innocence. As had that of the 1688 Satan, the physical unattractiveness[11] of the 1688 postlapsarian Adam and Eve depicts their moral degeneration.

About the only concessions Aldrich makes to the possibility of a "For-

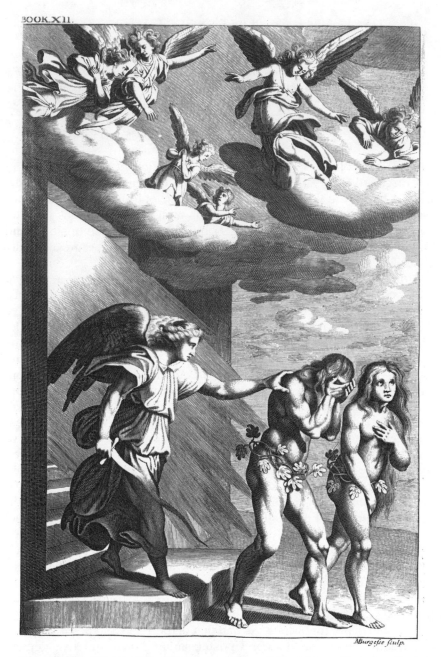

FIG. 25. H. Aldrich, "The Expulsion," from John Milton, *Paradise Lost* (London: Miles Flesher, 1688). Reproduced by permission of the Henry E. Huntington Library.

FIG. 26. F. Hayman, "Satan Summons His Legions," from John Milton, *Paradise Lost* (London: J. and R. Tonson, 1749). Reproduced by permission of the Henry E. Huntington Library.

tunate Fall" are his angels, who overlook the Expulsion with curiosity
rather than with "dreadful Faces . . . and fiery Arms" (XII, 644), and
the differences between the drawings of Michael for Books XI and XII.
Medina's illustration of Michael in Book XI (for a reproduction, see
Pointon, p. 9) follows the text's description of Michael's military arma-
ment exactly:

> over his lucid Arms
> A military Vest of purple flow'd
>
> ·
>
> His starry Helm unbuckl'd show'd him prime
> In Manhood where Youth ended; by his side
> As in a glistering *Zodiac* hung the Sword,
> Satan's dire dread, and in his hand the Spear.
> (XI, 240–48)

Nothing angelic appears in Medina's Book XI portrait of Michael (he
even lacks wings); however, in the illustration of the Expulsion, Al-
drich's Michael more resembles Medina's portrait of the "sociable" (V,
221) Raphael (for a reproduction of Medina's illustration for Book V, see
Pointon, p. 11): angelic wings prominent, Michael wears flowing robes
rather than his "military Vest" and "starry Helm" and is without his
"Spear" (though, of course, he does bear the drawn sword). Pointon
regards the changes in the characterization of Michael between Books
XI and XII as just one of the many "minor inconsistencies" (p. 15) in
the illustration for Book XII and paraphrases Gardner's analysis of the
"failure" of this illustration: "The reason is that the subject of the Expul-
sion from Paradise was too familiar; and Medina, instead of studying his
author, was content with a bad imitation of Raphael's 'Expulsion' in the
Loggia, itself derived from Masaccio's fresco in the Carmine at Florence.
All he did was to take a standard, hackneyed design and add some angels
on clouds at the top" (Gardner, p. 35).[12] The 1688 illustration does
resemble that of Raphael (and those of several others: see Pointon, pp.
29–31); however, whatever the source for the details of Michael and the
angels in the Book XII illustration, Aldrich selected them, and the il-
lustration appears as part of the series. Therefore, the fact that the
illustration produces a softer treatment of Michael and the angels sug-
gests that the illustrator at least mitigates the sense of God's wrath even
though man's fallen status is not much more immediately fortunate for
this softening—man's fall could have been worse.

 The 1688 illustrations of Books I, II, IX, and XII, then, offer a consis-
tent, traditional, seventeenth-century, pessimistic interpretation of *Par-*

adise Lost: an unheroic Satan personifying rebellion and a monstrous Sin prefigure Adam and Eve's sinful and erroneous rebellion and unfortunate fall into woe and punishment by banishment from Paradise. No suggestion of Milton's "paradise within" appears, and the only concession to the covenant for man's Redemption is the absence of wrath in the watchful angels and Michael.

By the mid-eighteenth century, Satan becomes more heroic, Sin more attractive, and the Fall more fortunate than they had been in 1688. Francis Hayman's 1749 illustration for Book I (Fig. 26),[13] while depicting essentially the same scene as had the 1688 illustration, presents a more heroic Satan. Hayman's Satan is not only front and center, but he appears in command of his legions. He does not stand alone against God; Beelzebub stands behind him. His cohorts are "Under amazement of thir hideous change," but two are at least upright in the flames. Satan retains his shield and holds his spear with its curved blade pointed upward (toward God and man), a detail perhaps suggested by lines 347–49: "as a signal giv'n, th' uplifted Spear / Of thir great Sultan waving to direct / Thir course." This detail of the upward-pointing spear, taken from a slightly later location in the poem than were the details in the 1688 illustration, marks an important difference between the artists' attitudes toward Satan: Hayman has chosen to portray Satan, even in the depths of Hell, in a moment of triumph. Through an act of will and his eloquence, Hayman's Satan has rallied the fallen angels; mental and physical armament intact, he has lost the battle but not the war: "What though the field be lost? / All is not lost" (I, 105–6). Nor has his splendor noticeably diminished: free from deformity, he retains his angel wings. As early as the mid-eighteenth century, Satan's rise has begun,[14] and popular taste evidently accepted a more sympathetic treatment of him: "Hayman's illustrations were very popular. They were issued a great many times and therefore, it may be assumed, reached a wide audience" (Pointon, p. 57). Satan is not yet, however, the full-blown Romantic hero: his figure is not heroic, and he stands in darkness.

Unlike the Satan of the 1688 illustration for Book II, Hayman's 1749 Satan suffers no physical degeneration between Books I and II, and Sin is clearly less monstrous in 1749 than she had been in 1688 (Fig. 27). Hayman's Satan is front, center, and above Sin and Death. He retains his feathery angel wings, appears in a moment of flight, and lacks any physical deformities (including the "Deep scars of Thunder" authorized by the text [II, 601]). Hayman's Sin, now in the front plane of the scene, is more humanoid than the 1688 Sin had been—she is about 50 percent human, with far fewer serpents and hellhounds.[15] In contrast to the earlier illustrator, Hayman—again by illustrating a later moment in the

F. Hayman inv. et del: I.S. Müller sc.

FIG. 27. F. Hayman, "Satan, Sin, and Death at the Gates of Hell," from John Milton, *Paradise Lost* (London: J. and R. Tonson, 1749). Reproduced by permission of the Henry E. Huntington Library.

FIG. 28. F. Hayman, "The Expulsion," from John Milton, *Paradise Lost* (London: J. and R. Tonson, 1749). Reproduced by permission of the Henry E. Huntington Library.

meeting of Satan, Sin, and Death—presents Satan in a moment of triumph: he pictures the unholy trio after Sin's intervention in the conflict between Satan and Death has effected their reconciliation and the gates to Hell have been opened (II, 815–29). Satan and Sin leer at each other; Death looks on with considerable enthusiasm; Sin grips the key (emblematic of their accord and of the second rebellion in the poem) to the gates of Hell in her left hand as she vigorously braces open one gate with her right hand; and Satan and Death point their respective spear and dart not at each other but upward toward their new opponent, man. A viewer would still find difficulty describing this illustration as representing the ideal family, but Hayman has clearly chosen to picture Satan's activities in Book II triumphantly. By the middle of the eighteenth century, then, Satan and Sin were being portrayed far more positively than they had been in the late seventeenth century. This more positive portrayal suggests a less militant position against sin and rebellion against God, preparing the viewer for a lesser punishment for and more fortunate circumstances after man's sinful rebellion.

Hayman's illustration for Book IX omits Satan entirely and depicts Eve's offer of the apple to Adam (for a reproduction, see Pointon, p. 55). This omission does not imply any heroic characterization of Satan; however, it does render him less blameworthy. [16] Hayman's portrayal of Satan in his illustrations for Books I and II, more positive than the portrayals in the 1688 illustrations for Books I and II had been, parallels his more positive treatment of the results of the Fall; in fact, Hayman is the first to illustrate the Expulsion scene (Fig. 28) with clearly positive details. Michael, sword sheathed, walks between Adam and Eve—leading, rather than driving, them out of Eden. The "flaming Brand" is hidden behind some clouds, its rays little more ominous than sunbeams. Hayman's Adam and Eve, definitely more attractive than their earlier counterparts had been, have not visibly degenerated from their prelapsarian portrayals. Furthermore, Michael, Adam, and Eve now stand on equal footing on the "subjected Plain," implying a lesser loss of status by Adam and Eve than did the 1688 depiction of Michael on the stair above them and implying that Providence will indeed follow man into his new life. Nonetheless, all is not perfect: Michael still wears his "military Vest" and "starry Helm"; and, although Michael, Adam, and Eve hold hands, Adam uses his free hand to hide his face, and Eve clutches her hair while looking worriedly upward. Even so, Hayman interprets the Expulsion as considerably more fortunate than Aldrich had.

In contrast to the unheroic Satan and monstrous Sin of the 1688 illustrations, Hayman's 1749 illustrations of Books I and II figure a

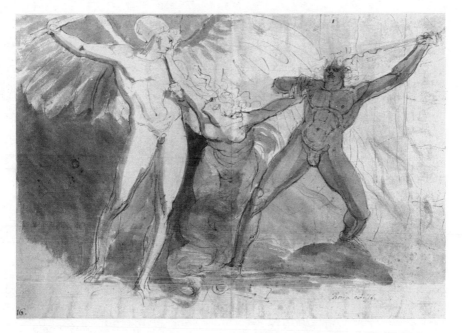

Fig. 29. J. H. Fuseli, "Satan, Sin, and Death at the Gates of Hell" (October 1776). Reproduced by permission of the Ashmolean Museum, Oxford.

triumphant Satan and a more human Sin. This evident greater toleration for sin and rebellion against God set the stage for greater toleration of man's sinful rebellion that constituted the Fall and for a lesser punishment thereof—Hayman's Expulsion is a banishment, but without loss of stature and with clear promise of guidance and eventual Redemption. By the middle of the eighteenth century, Satan could be portrayed triumphantly, if not heroically, Sin as at least half human, Adam and Eve as retaining their perfect prelapsarian features, and the Fall as positive if not entirely fortunate.

The meeting of Satan, Sin, and Death at the gates of Hell in Book II is a favorite of *Paradise Lost* illustrators, and the greater number of illustrations have produced more discernible stages in Satan's rise. J. H. Fuseli's October 1776 ink-and-wash illustration shows the earliest truly heroic Satan[17] and accords Sin new status by moving her to the center of the scene (Fig. 29). Fuseli's Satan is the largest figure in the illustration, retains his angel wings, suffers no physical deformities, and remains a handsome figure of light. Sin is also more attractive than she

had been in 1749—she is at least two-thirds human (more than the text would license), and the hellhounds and serpents which comprise her nether regions in the text are no longer visible, though her legs intertwine in a serpentine manner. While Fuseli does not portray Satan, Sin, and Death in a moment of triumph, as had Hayman, his illustration does suggest their harmony. The depicted moment is Sin's intervention in and prevention of the impending battle between Satan and Death (II, 726–34). Fuseli reduces the seriousness of the conflict by not showing Satan's shield or the pointed end of his spear and by blurring Death's "Dart." Satan is certainly foremost in the drawing, yet the characters are not positioned to suggest an unequal and unharmonious relationship (as they had been in the 1688 illustration) but in the same plane; and, through the outstretched arms of Sin (who, as Satan's self/daughter/wife and Death's mother, literally links the threesome), all are touching, a conceptualization not even hinted at in the text. The key to the gates of Hell (symbol of their ultimate reconciliation and unity) lies prominently in the foreground. By the third quarter of the eighteenth century, Satan had become heroic and Sin humanoid.

Finally, William Blake's 1807 illustrations heroically portray Satan in his rebellion against God, elevate Sin to the near erotic, suggest the sensuality of the Temptation, and depict a postlapsarian Adam and Eve unfallen from their prelapsarian state. In Blake's illustration for Book I (Fig. 30),[18] Satan appears top, front, and center. As had Hayman, Blake selects details from a later point in the poem than those in the 1688 illustration to show Satan in a moment of triumph:

> They heard, and were abasht, and up they sprung
> Upon the wing; as when men wont to watch
> On duty, sleeping found by whom they dread,
> Rouse and bestir themselves ere well awake.
>
> (I, 331–34)

His legions do not lie defeated in a pool of fire, but most gaze upward at him with hope and adoration. He has at least sixteen followers (instead of the four in 1688 and 1749), and two of these retain their spears— Blake's Satan is still a "Leader of those Armies bright" (I, 272). Physically, Blake's Satan has lost none of his splendor.[19] Standing in the light, with a physique like one of Michelangelo's Greek gods, Satan exhorts his followers onward and upward in a pose reminiscent of Christ's crucifixion.[20] Satan seems so confident of his powers that he requires no body armor and has laid his shield and spear (point upward) aside. Here, Satan does not simply lack deformity; he is heroic to the

point of deification, and this heroic embodiment of rebellion prefigures Blake's conceptualization of man's rebellion and subsequent fortunate status.

Blake's smaller (25 x 21 cm.), 1807 pen-and-watercolor illustration in the Henry E. Huntington Library of the meeting among Satan, Sin, and Death at the gates of Hell presents a heroic Satan and the most attractive Sin yet (Fig. 31).[21] Satan is the largest figure, stands bathed in light, carries his spear and shield, and has no physical deformities. His physique is even more muscular than was that of Fuseli's Satan. Satan has suffered no physical degeneration between his appearance in Blake's illustration for Book I and his portrayal here—in fact, were he not facing the viewer three quarters rather than full frontal (as indeed he is in Blake's larger, 1808 version), he would be in very nearly the same cruciform pose. Interestingly, Satan in this illustration closely resembles the figure of "Fire" in Blake's book of emblems, *For Children: The Gates of Paradise* (1793).[22] Anne Mellor's commentary on Blake's illustration of "Fire" applies equally well to his illustration of Satan here:[23] "But the fiery element in man, his Energy, enables him to rebel against such material and mental prisons. . . . This suggestion is subtly reinforced by Blake's use of his famous *Glad Day* or *Albion Rose* figure—the naked youth with open arms, erect torso and wide-spread legs [*Plate 37*]—for his figure of Fire. The *Albion Rose* figure is an icon for Innocence as it expands into Energy, as it throws off all manacles and strikes forth as revolutionary liberation. Here he ["Fire"] carries his spear and shield; he is ready to enter battle, as flames roll past him" (p. 74). Blake's Satan remains heroic until he turns his rebellion against God into an attack on man: in Blake's illustrations for Book III, Satan acquires reptilian wings; in those for Book IV, Satan has reptilian wings and is enwrapped by a serpent or appears as a toad (in the larger illustration); in that for Book V, he retains the reptilian wings and the serpent; in those for Book VI, he is indistinguishable from the other falling angels; thereafter he appears only in the form of a serpent.

Blake's Sin extends the text's "Woman to the waist, and fair" (II, 650) to the near erotic: his Sin is at least three-fourths human, her blond ringlets resemble those of the prelapsarian Eve ("Shee as a veil down to the slender waist / Her unadorned golden tresses wore / Dishevell'd, but in wanton ringlets wav'd" [IV, 304–6]), and the exact nature of her connection to the hellhounds and serpents is obscured. Feminine beauty, of course, lies in the eye of the beholder, but Blake's Sin is clearly more human, feminine, and her features more defined than in any previous characterization.

Blake's selection of scene and arrangement of characters almost ex-

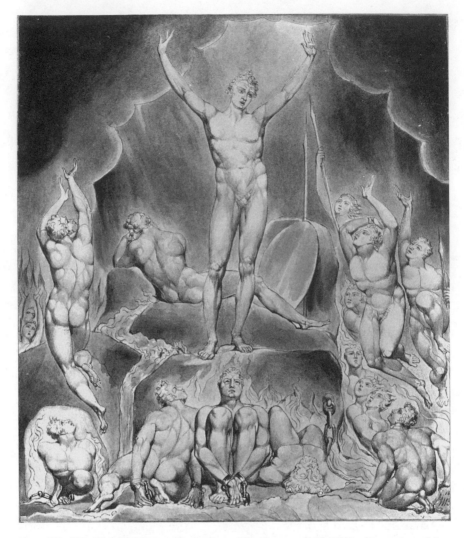

Fig. 30. W. Blake, "Satan Summons His Legions" (1807). Reproduced by permission of the Henry E. Huntington Library.

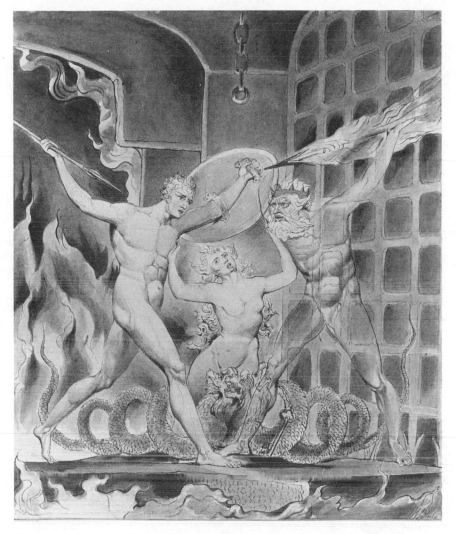

FIG. 31. W. Blake, "Satan, Sin, and Death at the Gates of Hell" (1807). Reproduced by permission of the Henry E. Huntington Library.

actly parallel those of Fuseli—the moment is the intervention, Sin oc-
cupies the center (caressing Satan and touching Death), all three figures
occupy the same plane (equidistant from the viewer), and the key to the
gates of Hell lies prominently in the foreground. As in the Fuseli illustra-
tion, the placement of the figures and the presence of the key fore-
shadow amity among the unholy trinity as well as their successful re-
bellion against God's commandment to keep the gate to Hell shut.

Certainly Satan and Sin are presented as far more attractive to the
nineteenth-century beholder than they had been to the seventeenth-
century beholder. As has been shown with Hayman and will be shown
to an even greater extent with Blake, this progressively more attractive
depiction of Satan and Sin is part of a larger change in the interpretation
of *Paradise Lost*: as rebels and sin become more attractive, fallen man—
the third rebel and sinner—and his rebellion will become more attractive
and his Fall more fortunate.

Blake's 1807, smaller illustration (Fig. 32) clearly shows Eve's eating
of the apple as the basis of the Fall, and Blake focuses on the physically,
one might even say erotically, appealing aspects of Satan's serpentine
disguise[24] rather than on the evil of intention, error of the mind, and sin
of the heart that formed the essence of Medina's 1688 interpretation of
man's rebellion. As serpent, Satan has certainly wound his way into
Eve's affections; Blake has transferred the sensual appeal of the fruit in
the text to Satan in his disguise:

> Fixt on the Fruit she gaz'd, which to behold
> Might tempt alone, and in her ears the sound
> Yet rung of his persuasive words . . .
> An eager appetite, rais'd by the smell
> So savory of that Fruit, which with desire,
> Inclinable now grown to touch or taste,
> Solicited her longing eye.
>
> (IX, 735–43)

In his illustration, Blake, unlike Medina, has not reminded the viewer of
any evil within the serpent; instead, Satan, as the serpent, has become
the object of Eve's love. Eating the apple from the mouth (symbolic of
the oral nature of the temptation) of a decidedly phallic serpent wound
round her body and across her genitalia, Eve falls to sensual appetite
rather than by sinful error. Adam, his back to Eve and the serpent, lacks
any involvement in the Fall. Blake's illustration, by substituting sen-
suality for more traditional representations of evil in the Temptation
scene, prepares the viewer for a "Fortunate Fall"—without evil, punish-
ment of Adam and Eve will be unnecessary.[25]

As the status of Satan and Sin rises in the illustrations between 1688 and 1807, so does that of the third rebel, man, and the now dominant "Fortunate Fall" interpretation—only hinted at in the seventeenth-century illustration and only implicit in the mid-eighteenth-century illustration—becomes obvious in the Romantic illustration. Blake's 1807 pen-and-watercolor illustration of the Expulsion (Fig. 33) depicts a truly "Fortunate Fall."[26] Blake abolishes any walls and gates between Eden and man's fallen world; and although the lightning bolts on either side of Adam and Eve outline stairs leading down from Eden, Blake's frontal, one-dimensional treatment of the scene greatly reduces any sense of distance between Eden and the postlapsarian world. Michael wears his "starry Helm" but is completely unarmed (his "military Vest" has become a translucent tunic). The stern visage of the 1688 Michael has been replaced by one expressing sadness, as though Michael were performing an unpleasant duty. Michael, Adam, and Eve have equal status—all occupy the same plane in the illustration, all are of equal physical stature, and all have stepped hand in hand onto the "subjected Plain," where they walk in step.[27] Blake's Adam and Eve remain as physically (and, by implication, morally) perfect as they had been before the Fall, and Blake has clothed their nakedness (symbol of their prelapsarian innocence) in far smaller fig leaves than those Milton described ("Those Leaves / They gather'd, broad as *Amazonian* Targe" [IX, 1110–11]), leaves more suggestive of an earlier state of innocence than would have been the textually accurate animal skins acquired in Book X ("he [Jesus] clad / Thir nakedness with Skins of Beasts" [X, 216–17]).

As Blake's Adam and Eve look back, waving good-bye to Eden with little evident sorrow (Hughes describes their expressions as "full of sweetness and of something like chastened confidence" ["Illustrators," p. 671]), they see the vortex of flame representing the "flaming Brand" guarding "all passage to the Tree of Life" and four figures on horseback. The identity of these four figures is ambiguous: they are presumably Michael's "choice of flaming Warriors" (XI, 101), which have "four faces each" (XI, 128) and "eyes more numerous than those / Of *Argus*" (XI, 130–31), but they have only one face and two eyes each. Nor would these unarmed figures literally render the angels of Milton's text who with "dreadful Faces . . . and fiery Arms" guard the gate to Eden. Pamela Dunbar sees them as suggestive of Blake's conception of a "Fortunate Fall": "In Blake's system the four mounted guards have their counterpart in the primordial fourfold man who is eventually to be resurrected from the scattered fragments of the Divine Image—the disunited Zoas—at the time of the Apocalypse: 'And every Man stood Fourfold; each Four Faces had: One to the West, / One toward the East, One to the South, One to the North, the Horses Fourfold.' (*Jerusalem*, K 745;

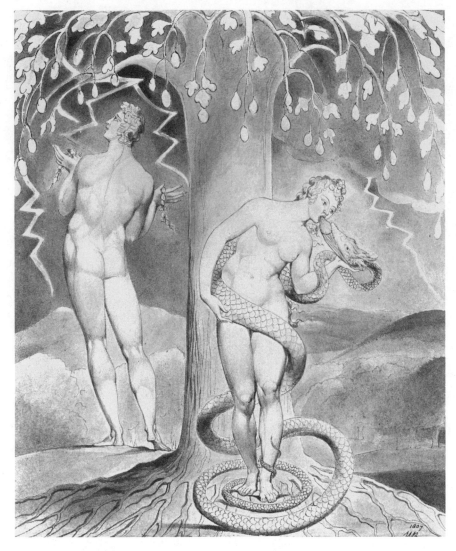

Fig. 32. W. Blake, "The Temptation" (1807). Reproduced by permission of the Henry E. Huntington Library.

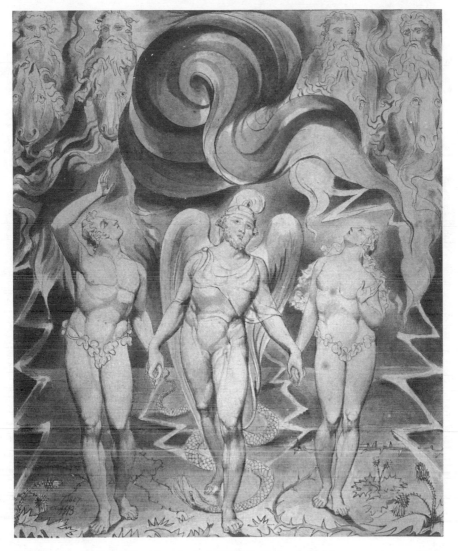

FIG. 33. W. Blake, "The Expulsion" (1807). Reproduced by permission of the Henry E. Huntington Library.

pl. 98, 12–13). Endowed with such a significance, the figures of *Paradise Lost* XII [Dunbar's heading for this illustration] become not only the guardians of the Edenic gate but a pledge of man's eventual renewal, and their stern gaze becomes the gaze of prophecy" (p. 90).

Blake's depiction of the landscape of the fallen world, truer to the text than had been those of Aldrich and Hayman, heightens the viewer's awareness of the fact that the "Fortunate Fall" is into a "paradise within," not into a Paradise of externals. Blake reaches back to Book X, lines 201–4 ("Curs'd is the ground for thy sake, thou in sorrow / Shalt eat thereof all the days of thy Life; / Thorns also and Thistles it shall bring thee forth / Unbid"), for details in his Book XII illustration and includes thorns and thistles on the ground in the path of Adam and Eve, but the viewer can plainly see the "paradise within" in the heroic characterization of Adam and Eve (who, by what must be divine guidance, evade any "thorns of life"!). Furthermore, in Blake's illustration, the serpent (unmentioned in the text) enters the fallen world along with Adam and Eve, but, as Svendsen notes, "Michael, whose function in the poem as in the picture makes him a type of Christ, stands over but does not quite bruise the head of the serpent" (p. 71); thus, Blake's illustration prefigures man's eventual salvation, the spiritual basis for the "Fortunate Fall."

These illustrations, then, show a change in the perception of Satan from archfiend in 1688 to rebel hero in 1807, a change paralleled by Sin's rise from monster to seductress and by man's fall into fortune. The facts that several illustrations are by nonliterary (though very sensitive and sophisticated) artists and that many illustrations were intended for general consumption mean that these changing conceptions of *Paradise Lost* extended beyond the rarefied atmosphere of literary criticism. It is also clear that the interpretations of a heroic Satan and a fortunate fallen man did not spring forth full-blown from the Romantic imaginations of Blake, Byron, and Shelley, but evolved over many years. Finally, the illustrations prove themselves more than historical curiosities: "illustration" as "explanation" or "spiritual enlightenment" speaks as eloquently to our century as to those past.

NOTES

1. *Studies in English Literature* 1 (1961): 73.
2. "Milton's First Illustrator," in *Essays and Studies* (London: John Murray, 1956), p. 38.

3. Ralph Cohen, *The Art of Discrimination* (Berkeley: University of California Press, 1964), p. 249.

4. "Illustrators," in *A Milton Encyclopedia*, ed. William B. Hunter, Jr. (Lewisburg, Pa.: Bucknell University Press, 1978), IV, 56.

5. Svendsen feels that the illustrations contributed to, rather than merely mirrored, the evolution of interpretations of *Paradise Lost*: "These illustrations appeared and re-appeared in dozens of publications as *Paradise Lost* strengthened its hold upon the imagination of eighteenth and nineteenth century readers; unquestionably they contributed to the way it was understood and to its influence" (pp. 68–69), a feeling shared by Helen Gardner ("Medina's illustrations continued to be reproduced . . . until 1784, and cannot have been without some influence, even though unconscious, on the imaginations of readers of the poem" [p. 37]) and Marcia R Pointon ("Blake actually contributes to the symbolic content of the poem through his own very personal interpretation" [*Milton & English Art* (Toronto: University of Toronto Press, 1970), p. 138]). On the other hand, Stephen C. Behrendt deplores the possibility that an illustrator might produce an interpretation indebted to contemporary taste: "illustrators sometimes produced visual hybrids indebted more to the interpretation—or taste—currently in vogue, or to peripheral and irrelevant matters, than to either the letter or the spirit of Milton's epic" (*The Moment of Explosion: Blake and the Illustration of Milton* [Lincoln: University of Nebraska Press, 1983], p. 89).

6. *The Romantics on Milton* (Cleveland: The Press of Case Western Reserve University, 1970), p. 5.

7. *Paradise Lost*, Book XII, line 587. All quotations of the text of *Paradise Lost* are from Merritt Y. Hughes, ed., *John Milton: Complete Poems and Major Prose* (New York: Odyssey Press, 1957).

8. See chapter 1 of W. J. T. Mitchell's *Blake's Composite Art: A Study of the Illuminated Poetry* (Princeton: Princeton University Press, 1978).

9. The identity of the artist for the illustrations for Books I and II in the first illustrated edition of *Paradist Lost* (London: printed by Miles Flesher for Jacob Tonson, 1688) remains uncertain. The frontispiece illustrations for Books III, V, VI, VII, IX, X, and XI list John Baptist de Medina as artist and Michael Burghers (or Burgesse) as engraver, and that for Book IV lists "B[ernard] Lens Senior" as designer and "P[eter] P[aul] Bouche" as engraver; however, those for Books I, II, and XII only list Burghers as engraver, and that for Book VIII is anonymous. Suzanne Boorsch, who located Medina's eight original drawings in the Victoria and Albert Museum, has proven that Medina illustrated Books III and V–XI and that Dr. Henry Aldrich almost certainly illustrated Book XII; she also offers evidence that Aldrich illustrated Book II and speculates that he illustrated Book I ("The 1688 *Paradise Lost* and Dr. Aldrich," *Metropolitan Museum Journal* 6 [1972]: 133–50). For further efforts to identify those who had a role in the production of the 1688 illustrations, see: John T. Shawcross, "The First Illustrations for *Paradise Lost*," *Milton Quarterly* 9 (1975): 43–46; Mary D. Ravenhall, "Francis Atterbury and the First Illustrated Edition of *Paradise Lost*," *Milton Quarterly* 16 (1982): 29–36; and Estella Schoenberg, "The Face of Satan, 1688," in *Ringing the Bell Backward: The Proceedings of the First International Milton Symposium*, ed. Ronald G. Shafer (Indiana, Pa.: Indiana University Press, 1982), pp. 47–59. Since the illustrations produce a consistent interpretation of the poem, the problematical identity of the artist, in this case, is irrelevant to an analysis of the illustrations as an interpretation.

10. For a discussion of the traditions behind Milton's description of Sin, see Hughes, *Poetry*, p. 247n.

11. Hughes particularly notes "the contemptible animal fright that makes the Eve disgusting in the paintings by Raphael and Medina" ("Some Illustrators of Milton: The Expulsion from Paradise," *Journal of English and Germanic Philology* 60 [1961]: 677).

12. As did Gardner, Pamela Dunbar finds the design "merely a slavish imitation of the Vatican fresco by Raphael" (*William Blake's Illustrations to the Poetry of Milton* [Oxford: Clarendon Press, 1980], p. 86). Behrendt feels that the derivative nature of the illustration produces an inappropriate interpretation: "In his version of the Expulsion scene (fig. 20), Aldrich ignores Milton's text and simply copies Raphael's Expulsion scene, providing, not a creative, interpretive illustration, but, rather, an entirely inappropriate and misleading one. Aldrich's design subscribes to the conventional conception of the woeful, despairing state in which Adam and Eve supposedly had been evicted from paradise" (p. 93).

13. Francis Hayman designed the twelve frontispieces in Thomas Newton's edition of *Paradise Lost* (London: J. and R. Tonson, 1749).

14. C. H. Collins Baker, in "Some Illustrators of Milton's *Paradise Lost* (1688–1850)," *The Library*, 5th series, 3 (1948), notes Hayman's priority in attributing heroic qualities to Satan (p. 7).

15. Collins Baker credits Hayman with initiating Sin's rise: "From the 1749 edition onwards Sin became more human, more like Lady Hamilton, and more innocent" (p. 7).

16. It seems unlikely, however, that Hayman meant to exempt Satan from blame—his illustration for Book X shows the serpent, fearing Christ's judgment, exiting stage left as rapidly as possible while Eve points to him.

17. For discussion of Fuseli's treatment of Satan as physically embodying the heroic, see Peter Tomroy, *The Life and Art of Henry Fuseli* (New York: Praeger Publishers, 1972), pp. 162–64.

18. Blake produced two sets of twelve pen-and-watercolor illustrations of *Paradise Lost*: a set of smaller (roughly 25 x 20 cm.) illustrations in 1807 and a set of larger (roughly 50 x 40 cm.) in 1808 (Morse Peckham, "Blake, Milton, and Edward Burney," *Princeton University Chronicle* 11 [1950]: 115–16; and Martin Butlin, "A 'Minute Particular' Particularized: Blake's Second Set of Illustrations to *Paradise Lost*," *Blake Newsletter* 6 [1972]: 44–46). Both sets have two illustrations for Book XII, and neither has an illustration for Book XI; the larger set has two for Book IV and none for Book V. Although neither set was engraved for an edition of *Paradise Lost*, two of Blake's letters (30 January 1803 to James Blake and 6 July 1803 to Thomas Butts) suggest that he considered making illustrations for a planned edition of Milton's works, including *Paradise Lost*: "I write in great haste & with a head full of botheration about various projected works & particularly . . . Cowper's Milton, the same that Fuseli's Milton Gallery was painted for, & if we succeed in our intentions the prints to this work will be very profitable to me . . . The Project pleases Lord Cowper's family, & I am now labouring in my thoughts Designs for this" and "I ought to tell you that Mr H[ayley]. is quite agreeable to our return, & that there is all the appearance in the world of our being fully employ'd in Engraving for his projected Works, Particularly Cowper's Milton . . . These works will be ornamented with Engravings from Designs from Romney, Flaxman & Yr hble Servt,

& to be Engrav'd also by the last mention'd" (Geoffrey Keynes, ed., *The Letters of William Blake*, 3rd ed. [Oxford: Clarendon Press, 1980], pp. 52–53, 57). This proposed edition was partially realized in 1808 (William Hayley, ed., *Latin and Italian Poems of Milton translated into English verse . . . by the late William Cowper*), and the set of smaller illustrations is sufficiently complete (lacking only an illustration for Book XI) and the illustrations of an appropriate size (25 x 20 cm.) to illustrate an edition of *Paradise Lost*.

19. Dunbar, on the other hand, finds Satan's lack of wings suggestive of a fall in his status to that of fallen man: "The omission of the wings in the first and second illustrations, in which Adam is not featured, facilitate the identification of the Satan of those plates with fallen man" (p. 41). Behrendt also treats this depiction of Satan as unheroic: "Blake . . . [replaces] Satan's genitals in this and succeeding designs with an expanse of scales that suggests Satan's alter ego the Serpent, the only offspring he could hope to engender, the perverse projection of his own narcissistic nature. . . . Satan is scarcely in control of the situation, as his hand gestures attest. His raised hands, palms outward, suggest that he is, not rousing his rebels, but *silencing* them" (p. 132).

20. Janet A. Warner does not treat this particular illustration in any detail in "Blake's Use of Gesture" (David V. Erdman and John E. Grant, eds., *Blake's Visionary Forms Dramatic* [Princeton: Princeton University Press, 1970]), but her analysis of the cruciform pose leaves room for a demonic aspect to the gesture: "Blake's using the same form for such dramatically opposed states as Albion [*Albion Rose* in *Jerusalem*] and Satan [in *Job* and here] makes his point emphatically that the divinity in man can be turned to malevolence and death" (p. 178). In *Blake's Human Form Divine* (Berkeley: University of California Press, 1974), Anne Kostelanetz Mellor notes Warner's concern about the ambiguity of the gesture but argues that "Blake gradually evolved a powerful image for Innocence and Energy—the heroic male nude with outstretched arms, captured in moments of passionate desire and vigorous movement" (p. 147) and that Blake used the pose positively even in portraying the devil: "This naked youth, the emblem of Energy, appears again in *The Marriage of Heaven and Hell* designs as the devil from hell on Plate 10" (p. 148). Pointon (p. 144) and Dunbar (pp. 44–45) find the pose (and other parts of the illustration) reminiscent of Michelangelo's "Last Judgment" fresco.

21. The larger, 1808 illustration does not suggest a different conception of the scene (for a reproduction, see Dunbar, plate 24).

22. For a reproduction of Blake's "Fire," see Mellor, p. 73.

23. Mellor notes Blake's own parallel between "Fire" and Satan: "The Notebook legend (Page 91) from *Paradise Lost*, 'Forthwith upright he rears off the Pool / His mighty stature,' identifies him ["Fire"] as Milton's fallen Satan" (pp. 74–75).

24. Hughes traces the tradition behind Eve's attraction to the beauty of the serpent (*Poetry*, p. 390n), and John Broadbent notes the traditionally erotic treatment of the Temptation in paintings (*Paradise Lost: Introduction* [Cambridge: Cambridge University Press, 1972], p. 22).

25. Analyzing Blake's 1807 and 1808 (clearly more pessimistic) illustrations of the Temptation, Dunbar does not find much potential for a fortunate Fall: "The world of *Paradise Lost* IX is a tense and sombre one, depicted in dark and threatening tones and with a preponderance of harsh, jagged lines. Expressionist forms heighten the drama of the scene and are particularly pronounced in the

Boston [1808] version with its spikey tree-stems and roots, and enormous thunderbolts. The landscape contrasts sharply with the delicate beauty of that in the previous illustration and with the restrained grief portrayed in the next, and is itself a foretaste of Experience" (p. 78).

26. Hughes notes Blake's priority in employing some key details suggesting a "Fortunate Fall": "Blake was the first artist to conceive Milton's Expulsion with hope and love in the faces of Adam and Eve, and an unarmed Michael leading them by the hands" ("Illustrators," p. 678).

27. Behrendt does not give Eve equal status in this illustration: "Eve is still very much in the physical world of the senses, though, as her extended left foot indicates" (p. 176).

STELLA P. REVARD

From the State of Innocence to the Fall of Man: The Fortunes of *Paradise Lost* as Opera and Oratorio

In 1677, ten years after the publication of *Paradise Lost*, the libretto for its first operatic redaction was published, Dryden's *The State of Innocence and Fall of Man*, an opera authorized by the poet himself, a five-act rhymed dramatic work, which was never, however, set to music. Three hundred years later, in 1977, Christopher Fry, following in the tracks of Dryden, reduced Milton's epic to a two-act drama, un-rhymed, which was in the year following set to music by Krzysztof Penderecki as a three-and-a-half-hour opera or sacra rappresentazione, *Paradise Lost*. The impulse to turn Milton's heroic poem into musical drama has not flagged in the three centuries since the first attempt. Eighteenth-, nineteenth-, and twentieth-century composers and poets have so frequently turned to *Paradise Lost* either in whole or part for musical compositions, oratorios, and operas that no other long poetic work in English, except, of course, the plays of Shakespeare, has more often been adapted for the musical stage.

In looking at these musical translations, we learn much about the popular image of *Paradise Lost* in the different ages, for in adapting Milton's poem, composers and librettists have not only transferred it to a different artistic medium, they have rewritten and reshaped it to conform to the theatrical and musical tastes of their own eras. Different parts of Milton's poem have appealed to the audiences of the eighteenth, nineteenth, and twentieth centuries, with now the scenes of creation and prelapsarian innocence dominating, now the councils of Satan or of God, now the drama of the fall or the pathos of the expulsion from

paradise. Milton's characters likewise have assumed different traits, as music, as well as words, shaped their personalities. And the ethic or moral of Milton's poem has necessarily been altered as it has been made to "fit" this or that age's notion of biblical theater. Still, no matter whether librettist and composer slavishly follow or freely deviate from *Paradise Lost*, it is Milton's text that first inspires them. In judging the success or failure of such attempts, therefore, we must consider not only how much of the original flavor and spirit of Milton remains in the translated work, but also how the work itself succeeds in its own right as a musical composition. While I cannot include in this study all the songs, choral pieces, oratorios, and operas inspired by *Paradise Lost*, yet by choosing representative works from the eighteenth, nineteenth, and twentieth centuries, I hope to convey something of the musical character of each age as well as its attitude toward Milton and his epic. For the most part, I include only completed compositions, that is, works for which both libretto and music exist. For this reason, I must pass over the first so-called opera inspired by *Paradise Lost*, Dryden's *The State of Innocence*, which is extant in dramatic form only. Not only was no music ever composed for it, but the text for the musical numbers is also missing, although Dryden here and there supplies stage directions to indicate where songs, dances, choruses, and music would have taken over from recitative or spoken dialogue.[1] Hence, Dryden's opera must be considered a literary rather than a musical work.

EIGHTEENTH-CENTURY WORKS

Besides Dryden's unscored opera, we have no seventeenth-century libretti or musical settings for *Paradise Lost*. Early in the eighteenth century, however, composers began to adapt parts of *Paradise Lost* for song and choral presentation, and by the end of the century, several libretti for oratorios were complete, as well as two fully scored oratorios: *Paradise Lost* (1760), with music by John Christopher Smith and a libretto by Benjamin Stillingfleet; and *The Creation* (1799), with music by Franz Josef Haydn and a libretto in German by Gottfried Van Swietan. Most eighteenth-century composers and librettists approached *Paradise Lost* as a Christian epic for which they were providing proper liturgical settings. They regarded Milton as a religious writer of exceptional fervor, who composed an epic unrivaled in religious sublimity, for which music only was lacking. Milton's poetry, they contended, had its origin, as poetry had in the first ages, in religion. Further, as Stillingfleet asserted, "music in all ages has been looked upon as a proper accompany-

ment to religious acts."[2] It was only right then that *Paradise Lost*, the great religious epic, should have its proper musical complement. As a poet, moreover, Milton provides the composer with the greatest variety in religious sentiment that music can express; *Paradise Lost* contains, argued Richard Jago, the author of a libretto drawn from Milton's poem, occasions for "the sublime, the joyous, the cheerful, the serene, the devout, the plaintive, the melancholy."[3] Certain passages in the epic— namely, the Morning and Evening Hymns of Books IV and V, the Marriage Hymn of Book IV, and the angelic choruses of Book VII and VIII— seem, in fact, almost ready-made for vocal translation and adaptation for liturgical composition, for they appear in the poem as songs or hymns or choruses. Other passages, such as the lyric exchanges between Adam and Eve in Books IV and V, could with little adaptation become perfect texts for secular songs and duets. Indeed, these sections proved the first to find their way into song, either because their poetic structure seemed most apt for musical setting or because their praise of God's creative powers or their celebration of ideal human love appealed to eighteenth-century taste. Whatever the reason, first in song and then in oratorio, the prelapsarian world of Eden was re-created by eighteenth-century composers.

Settings of the Morning Hymn or the Marriage Hymn early in the century are important, for these very pieces become choruses or duets in the longer dramatic oratorios in the latter part of the century.[4] Hence, what the first composers did with these hymns affected Smith and Haydn, who could look back in the century to no fewer than five settings, for example, of the Morning Hymn. The Morning Hymn appealed to composers, it seems probable, because it could easily be used for liturgical purposes as a simple chorale or duet for the soloists of the church choir. Such indeed appear to be the two earliest settings by Philip Hart and John Ernest Galliard, both written about 1728, the latter (the more popular piece) revised in 1773 with choruses added by Benjamin Cooke, the organist of Westminster Abbey.[5] Both hymns retain verbatim Milton's text, Hart setting it for unison chorus with harp and violoncello accompaniment, Galliard for soprano and alto with continuo. Hart, responding to the structure of Milton's poetic version (*Paradise Lost* V, 153–208), divides the hymn into four choral stanzas of thirteen, fourteen, fifteen, and ten lines each and concludes it with the four-line prayer. Galliard divides the hymn between two singers, Adam beginning the anthem of praise, and Eve entering, after six bars of music, at the word "unspeakable" (*PL* V, 156). Thereafter, in Galliard's version alto and soprano alternate until the conclusion, when both voices join, as in Hart's version, to give special treatment to the last four lines of prayer. Both

hymns open with strong affirmation: "These are thy glorious works, Parent of good." Hart gives play to the word "wondrous," repeating the descriptive phrase for God, "thyself how wondrous." Both hymns stress by their repetitions the praise of God inherent in the line: "Him first, Him last, Him midst, and without end." Neither composer fails to use coloratura embellishment when appropriate. Both Hart and Galliard provide embellishments for the words "rejoycing" and "resound"; both make their singers' voices rise and fall to the words "rising" and "falling" in Milton's text. Hart makes the winds of stanza 3 "blow" and the pines "wave" to choral embellishment, and Galliard does similarly. The word "vary" prompts special treatment, and the word "praise" sounds and resounds with many repetitions throughout both hymns. With his stanzaic divisions Hart points out the particular aspects of nature that praise God, for he begins the three middle stanzas of the hymns by introducing each: "Fairest of stars," "Air, and ye Elements," and "Fountains." Galliard has a different approach. He uses the alto voice to introduce the "Sun, of this great World, both Eye and Soul," and the soprano to follow up the introduction of the "Moon, that now meets the orient Sun." A 1738 version of the hymn by a different composer proceeds in a like manner, with the alto voice praising the sun, and the soprano extolling the birds. All composers respond to the injunction in Milton's text to "joyn voices," and to the unison final prayer, "Hail! Universal Lord." Hart marks this concluding passage with directions for "firm singing"; Galliard has alto and soprano sing in unison. Hart adds a final page of hallelujahs at the conclusion, whereas Galliard puts emphasis on the dispersal of evil by repeating with embellishments the word "disperse."

Hart's and Galliard's simple hymns for chorus or two soloists become more and more elaborate as the century progresses. A 1738 version creates a framing scene with an angel soloist and choruses in which the duet for Adam and Eve now appears; recitative and chorus open and close the scene, which features the duet for Adam and Eve, a recitative and air for each of the principals. [6] A 1768 version by Niccolo Piccini is a composite from various composers, with Piccini providing the recitatives (some accompanied, some unaccompanied) and airs, but drawing upon Pergolesi and Carissimi for choruses and taking the duet, "Join voices," from Galliard. [7] With Benjamin Cooke's addition of choruses and orchestra accompaniment to Galliard's Morning Hymn in 1773, the piece becomes even more ornate. [8] Hence, we see the Morning Hymn develop from a simple setting for a unison chorus or two soloists with continuo to a full-scale production with soloists, orchestra, and chorus. The scene is set for the next development: for the hymn to assume a place in oratorio or opera as part of a composite epic whole.

Before we look at how Adam's and Eve's praise of the Creator becomes a part of a full-scale eighteenth-century oratorio, we should examine yet another aspect of *Paradise Lost* that moved the musicians of this century: Milton's portrayal of the idyllic domestic life of Eden before the fall. Eighteenth-century composers seem to have been especially attracted to the love scenes between Adam and Eve in Books IV, V, and VIII, and these form the basis for the praise of marriage in two early works: a duet from an opera by Handel and a French masque, entitled "Le Paradis Terrestre," composed in 1736 by L'Abbé Nadal and designated as a "Divertissement Spirituel."9 Set to music by M. Bourgeois and first performed by the Academy of Music of Poitiers, Nadal's masque comprises one act only, and the cast is limited to an angel narrator, Adam, Eve, and a chorus of angels. The action involves the creation of Adam, then Eve, and the celebration of their marriage; so brief, however, is the creation sequence that the piece could easily be retitled "The Nuptials of Adam and Eve." Even allowing for translation into another language, the "Divertissement" has few verbal recollections of *Paradise Lost* and little dependence on Milton's dramatic structure. Yet the concept of prelapsarian love seems, despite everything, derived directly from Milton and Milton's notion that the highest bliss of Eden was the mutual love and shared happiness of earth's first couple. From the most beautiful of beings, announces the angelic narrator in the opening recitative, is formed a spouse, yet more beautiful. In a delicious garden, where a thousand perfumes rise, upon a bed of verdurous grass our lovers open their eyes to one another. Adam is the first to speak, and in a recitative that imitates the Miltonic formality of address, he greets Eve:

> Cher objet, avec qui je me trouve lié
> Des noeuds sacrés d'une ardeur mutuelle,
> Fille du Ciel, ma Compagne fidelle,
> Chère part de moi-même . . .
>
> (p. 32)

Eve responds in kind, asserting on the one hand a dependence on Adam that recalls Milton's Eve, yet on the other assuming the part of a quite un-Miltonic courtly mistress:

> Je brûle de porter la chaîne
> Qui te doit unir avec moi
> Esclav ensemble & souveraine
> Ma gloire est d'obéir quand je regne sur toi . . .
>
> (p. 33)

Adam responds by telling Eve about the fatal tree, which she joyously accepts as an easy pledge of obedience. Scene ii celebrates the happiness of Eden with a trio of Adam, Eve, and the angel, and scene iv prepares for the nuptials, permitting Eve one more opportunity to express her love for Adam: "Amant si sensible & si tendre" (p. 36). The final scene presents the full-scale wedding masque; here Nadal appears particularly indebted to Milton's Marriage Hymn of Book IV and Adam's description in Book VIII of the nuptials in Eden. Drawing his inspiration from Milton's description of Love with his golden shafts, Nadal creates a Celestial Hymen, who appears with a lighted torch to preserve human hearts from the torments of desire and to nourish true love. In other ways he realizes dramatically and musically Milton's description of Eve, "blushing like the Morn," led to the nuptial bower, while Heaven shed its "selectest influence," Earth its gratulation gave, and while fresh gales whispered and birds sang joyously (VIII, 510–20). In Nadal's masque, the chorus of angels sings, directing Dawn to favor the lovers and the birds to apply their choir: "Chantons sous ces rians l'ambris, / Chantons les délices secretes / De deux coeurs ardemment épris" (p. 38). Nadal's Adam and Eve then blend voices, declaring their love:

Charmant Epoux,
Charmante Epouse, } être toujours le même.

(p. 39)

The choir of angels, like that at the conclusion of *PL* VII, urges the lovers to know their happiness and to persevere upright: "Puissez-vous durer à jamais!" (p. 40).

The French masque presents, of course, a highly selective view of *Paradise Lost*; reverberations of future fall are all but banished from the "Gallic" Eden, with only Milton's enchanted scenes of prelapsarian love and bliss surviving. In a similar way, for his oratorio *Alexander Balus* (1748), Handel draws from Milton's Marriage Hymn of Book IV only the exalted portrayal of ideal love and nothing whatsoever of the dramatic setting or characterization. The duet occurs at the end of Act II, and the original words of Milton's narrator are set by Handel for alto and soprano, who celebrate, not the joys of Adam and Eve, but those of the ideal hero and heroine of *Alexander Balus*. The marriage hymn for the earth's parents has become only a marriage hymn.

Hail, hail, hail wedded Love,
 hail Wedded Love, mysterious Law,
Hearts Delighting, Souls uniting . . .

> A thousand thousand Sweets
> from thee we draw . . .
> Peace and Pleasure without measure,
> A thousand thousand sweets from thee we draw.[10]

From the twenty-five-line set piece of Book IV, only the first line retains its Miltonic integrity, "Hail wedded Love, mysterious Law" (IV, 750); the other verses, while perhaps inspired by Miltonic originals, are non-Miltonic. Yet, such is Handel's genius that in this lovely duet, as in many of the pieces from the oratorio *Samson*, he manages with only the fewest of Milton's lines to preserve the essence of Milton's hymn: the mystery and wonder of wedded love that through the union of hearts and souls diffuses delight, sweetness, pleasure, and peace. Further, as we noted in the settings of the Morning Hymn, the music enhances with florid embellishment, with select repetition, with the blending of vocal line the very notions that Milton's original text suggests. Rather than taking away from the marriage Hymn, Handel's musical setting transports its mystery and delight to another medium.

The eighteenth- and nineteenth-century oratorios, which follow in the wake of the musical setting of Milton's Hymns to Marriage and Creation, seem to have been inspired by many of the same sentiments as these shorter pieces, for it is idealized love and the wonders of creation that they celebrate above all. Richard Jago and Benjamin Stillingfleet created libretti for *Paradise Lost* at approximately the same period in the latter part of the eighteenth century. They were anticipated in their work by almost two decades, however, for in the early 1740s Mary Delany had worked out a proposed oratorio from Book IX, hoping to interest Handel in it. All these pieces center the story in Eden, making Adam and Eve the main characters and supplying angelic guardians for narrators and chorus. Since the Delany libretto is lost, we can only guess how certain aspects of plot would have been developed, but we do know that the oratorio began "with Satan's threatenings to seduce the woman, her being seduced follows, and it ends with the man's yielding to the temptation"; we know further that Mrs. Delany adhered closely to Milton's text: "I would not have a word or thought of Milton's altered."[11] Whether Mrs. Delany actually made Satan a character in the proposed oratorio or whether, as in Jago's and Stillingfleet's versions, the temptation occurs offstage is a matter of considerable interest, for in all the pieces from the eighteenth-century that we have looked at so far or will consider, the main mover of the action is banished from the stage, never to act in the drama he creates. The effect of such absence is startling, for it permits the librettist to heighten idyllic sweetness before the fall and pathos

afterwards. The issues of temptation and sin central to Milton's epic are muted when the tempter is never seen and the temptation becomes an offstage calamity.

What remains, however, from Milton's epic is not totally un-Miltonic, and it is totally consonant with the eighteenth-century notion of *Paradise Lost* we have seen in the other pieces. *Paradise Lost* furnished eighteenth-century librettists and composers with endless opportunities to expatiate on the charm of perfect creation and human love, and the libretti that Jago and Stillingfleet created emphasize these wonders before the fall. Drawing their recitatives directly from Milton without altering the blank-verse line, Jago and Stillingfleet use angelic narrators to describe the blissful paradise that Adam and Eve enjoy. Jago includes in *Adam or, The Fatal Disobedience* as much as possible of unaltered "Milton" in these long stretches of recitative. Even in the airs and choruses, when constrained to alter the iambic line, Jago attempts to retain Miltonic phrases, though, as this introductory chorus from Act II illustrates, sometimes with parodic effect: "He, who sits enthron'd on high, / Above the circle of the sky, / Sees his rage, and mocks his toil, / Which on himself shall soon recoil" (239–40). We have no record that Jago's oratorio was actually set to music (it appears posthumously among his *Poems* in 1784); yet it is clear from Jago's introductory remarks that he has, while varying "as little as was possible from the order of time, and the language of Milton," attempted to appeal to a prospective composer.[12] He divides the oratorio into three acts, the first celebrating perfect life in Eden, the second leading to the fall, and the third, beginning with an announcement of the fall as a fait accompli, leading to the aftermath. Whether consciously imitating the librettists of the shorter pieces or purely suiting the temper of the time, Jago chooses to make choral celebration and hymeneal rapture the major focus of his first two acts. The opening air for Adam is a song of praise to God ("Then let us ever praise Him, and extol / His bounty" [39]), and the concluding chorus of the second scene a praise of matrimony ("Hail, Hymen's first, accomplished Pair! / Goodliest he of all his Sons! / Of her daughters she most fair!" [233]). The entire final section of Act I is devoted to the setting of the Evening Hymn, and almost all of the second scene of Act II is taken up by the Morning Hymn, which Jago chooses to place, oddly enough, after his dramatization of the morning quarrel of Milton's Book IX.

The setting of both hymns makes us recall that Jago was a clergyman as well as a poet. Yet, however prominent the placement of these two hymns in Acts I and II, the design of Jago's oratorio is more domestic than devotional. His emphasis throughout is on the celebration, the

rupture, and the healing of the marriage of Adam and Eve. In Act I, scene ii, he gives us an Adam who sings how sweet it is to tend the garden with Eve, an Eve who recounts (affectuoso) the day she first met her husband, and an angelic narrator (no Satan turns aside here "with leer malign") who describes in recitative the "am'rous sport" of this "fair couple" (232–33). In scene iii, Jago gives us still more domestic dalliance, with Eve centrally featured in her air "Sweet is the breath of morn" (235–36). In Act II, Adam's "Awake! / My fairest" is set to balance Eve's serenade. Jago, however, dispenses with Eve's demonic dream to dramatize in Act II the morning quarrel, immediately after Adam's aubade. And he concludes Act II with a recitative and air by the angelic narrator, who describes the beauty, grace, and vulnerability of Eve working alone among her roses. With a fair amount of artistry, Jago shapes the four scenes of Act III to dramatize the pathos of Adam and Eve after the fall. In scene i, the Guardian Angels in recitative and chorus announce the fall, "The Tempter hath prevail'd, and Man is fall'n" (252); vindicate God's ways, "Righteous are thou, O Lord! and just are thy judgments" (253); and prepare for the disconsolate appearance of Adam and Eve, who once more assume central importance in the final three scenes of the oratorio. Adam dominates in scenes ii and iii with several recitatives and airs, particularly his opening lament, "O Eve! in evil hour," and the recitative and air "Out of my sight!" (254–58). To Eve, however, in scene iii Jago gives the recitative "Forsake me not," and in scene iv the affecting air "O unexpected stroke . . . Must I then leave thee, Paradise" (263). A chorus marked allegro, "The world was all before them" (263), was designated to end the oratorio.

In reshaping *Paradise Lost* as a domestic drama, Jago chose the most vivid of Adam's and Eve's speeches for musical setting and attempted to re-create the dramatic confrontations between these two characters before and after the fall. Adam is in turn an attentive, a reproachful, and a reconciled husband; Eve, an affectionate, a rebellious, and a penitent wife. Beyond the static sequences of the Evening and the Morning hymns and their worshipful praise of God, there is little development of the human and divine relationship. Still less part in the drama has Satan, never an onstage character. Jago's *Adam* is a thoroughly human affair.

Stillingfleet, in his oratorio *Paradise Lost*, does slightly better in acknowledging the devil's part, even though Satan does not appear and the fall is accomplished offstage. In the very first scene, Satan's arrival is announced and the guardian angels put on their guard: "Glory, beauty fades away, / When we from our duty stray"(6).[13] Act I closes, moreover, with the angelic chorus exhorting Satan's return to Hell: "Back,

oh! back again to hell, / Learn obedient there to dwell" (12). Eve's
demonic dream opens Act II, and the angelic chorus, alerted by Ithuriel
to Satan's presence in the bower, recalls his defeat in Heaven. As in
Jago, the morning quarrel is prominent, with Adam's warnings to his
adventurous wife: "Trust not over much, fair Eve, / To thy strength"
(17). Though Eve's encounter with Satan occurs offstage, Stillingfleet
attempts to give climactic value to the fall. Framing the incident are airs
for Gabriel, followed by angelic choruses, the first song, "Man so fa-
vour'd" (19), a warning, the last a lament, almost to our ears comic in
tone:

> Too, too sure the deed is done,
> Man is ruin'd, sin's begun,
> Subtle rebel! yes, thou hast
> With thy wiles prevail'd at last.
> (21)

Yet surely the two showpieces are the songs for Adam and Eve, sung by
alto and soprano, respectively. Eve's is a florid aria, marked vivace, in
which she, entering after eating the fruit, celebrates her new-won wis-
dom. Her voice soars as she sings, "Celestial visions strike my eyes,"
and she repeats the phrase "I seem to mount, I seem to mount, and
tread the skies" (20). Adam responds in an equally demanding aria,
marked allegro, which one critic has thought reminiscent of Mozart.[14]

> Thrilling horror chills my veins,
> Death, alas! will be thy meed;
> Love incites me, fear restrains,
> To repeat the desperate deed.
> (20)

By focusing in this central act of the oratorio on Eve's appearance to her
astonished husband and by omitting her encounter with Satan, Still-
ingfleet has made the fall a dramatization of each character's inner emo-
tions: exultation or horror. The music too of John Christopher Smith's
score, however simple throughout most of the oratorio, rises to dramatic
heights with Stillingfleet's libretto at this point in the action.

In 1760 Smith printed twenty-five songs from the complete score, the
choruses from Act I, the recitatives, and several other pieces having
been omitted. Of these twenty-five, nineteen are for Adam and Eve (two
duets and seventeen solo airs) and six for Gabriel, Michael, or Uriel.
Adam's part was written for an alto and was sung in the first perfor-

mance of 1760 by a woman; in the revival of 1774, however, Thomas
Norris, a tenor, took on the role, becoming (as Kay Stevenson has
pointed out to me) the first man to sing the part of Adam. The musical
score, then, as Smith published it, puts its emphasis on Adam and Eve
and the human drama, depicting their emotions at all points in the
action. That these emotions should be religious awe and marital joy
before the fall and anguish and agitation afterwards is not at all surpris-
ing. From our knowledge of the other settings of Milton in this century,
we might almost anticipate the contents of many of these songs. Adam
celebrates the responsibility of dominion, Eve the joy of obedience. In a
florid coloratura air, she proclaims, "Duty and delight combine, / Truest
bliss is to obey" (8). A similar set of songs voices Adam's and Eve's
delight in each other: the first by Adam, "Sweet partaker of my toil" (9),
to which Eve replies with a song, "Yes, Adam, yes; the sun I see / Is set"
(9); a recitative, "Sweet is the breath of morn" (9); and a second song,
"Glittering stars," with a brilliant de capo section, "Why, oh! Adam, tell
me why, / All this glory in the sky?" (10). Although Adam's and Eve's
arias remain balanced throughout most of the oratorio, here in Act I, and
once more in Act III, Eve is given two arias to Adam's one. At both these
points in the action, she dominates as a character, expressing in Act I
her love for her husband, her appreciation of the beauties of nature, and
her wonder at the universe with its glittering stars above (9–10); in Act
III, she supplicates Adam in one aria, expresses her dread of death in
another, and says farewell to her nuptial bower in a final one. We cannot
fail to notice the predilection of eighteenth- and nineteenth-century li-
brettists and composers for re-creating these two speeches of Eve in
recitative, aria, or duet. Eve's "Sweet is the breath of morn" appears as
an aria or recitative in Jago's and Stillingfleet's oratorios, recurs as a
duet for Adam and Eve in Haydn's *The Creation*, and reappears as a
duet in the latter part of the nineteenth century in J. L. Ellerton's *Para-
dise Lost* (1862). No other aria for Eve has such popularity, except the
third-act lament, "Must I leave you, paradise," prominent in both Jago
and Stillingfleet, retained by Ellerton in his oratorio, and the "hit" of the
1817 season in London, when Matthew King included it as a central
piece in his oratorio *The Intercession*.[15] Clearly, the sweetness of Eve's
attachment to Eden and the pathos of leaving her flowers deeply affected
the sensibility of early and late Romantic England.

Similarly, the devotions of Adam and Eve in evening and morning
prayer, drawn from Books IV and V of *Paradise Lost*, which appeared in
the Jago libretto, also appear in Stillingfleet, and reappear in Haydn. In
Smith's score, these prayers are the only settings for two voices; not in
love duet do Adam and Eve join voices, but in praise of the Almighty,

and we can scarcely doubt that the settings of the Morning Hymn earlier in the century affected Smith's versions of both the evening and morning prayers.[16] These duets mark the climax of Act I and the conclusion of the first part of Act II and, though simpler and briefer than the full-scale treatment of Galliard, serve to prepare for Haydn's inclusion of the Morning Hymn in *The Creation*.

For the most part, Stillingfleet limits the Guardian Angels to narrative and commentary. In the first two acts they have larger parts in recitative than in aria, though there is an affecting song for Gabriel at the end of Act I, where he celebrates the happiness of Adam and Eve in lines drawn from Milton's narrator, "Roses shed your rich perfume / Cover o'er the lovely pair" (12). By Act III, however, when Michael appears to announce God's judgment, the angels expand beyond narrators and commentators to take part in the action. Michael comes on stage immediately after the reconciliation of Adam and Eve. The act had begun with Adam's lament, his denunciation of Eve, and had reached a climax with Eve's two pleading songs to Adam: "My only strength! my only stay" and "It comes! it must be death!" With the appearance of Michael, sung by a bass, the tonal palate is complete, for a bass joins the alto Adam and soprano Eve. It is perhaps significant that from this final act only two of Adam's arias, three of Eve's, and three of the angels' (for Gabriel and Michael) were printed by Smith in 1760. The drama that has been dominated up to this point by Adam and Eve concludes with the two angels as actors and commentators.

Franz Josef Haydn's *The Creation* (1799) presents a similar range of character and focuses upon many of the same themes that we have found in the eighteenth-century oratorios and hymns, especially the Stillingfleet-Smith *Paradise Lost*, from which Haydn's librettist and, to a degree, Haydn himself must have benefitted. Because Haydn's oratorio retains little of Milton's drama and still less of his language in the German original or in the official English translation created for London audiences (which I will use throughout), *The Creation*, while thriving as an independent musical composition, has received little acknowledgment as an authentic redaction of *Paradise Lost*.[17] Yet, despite the problems of Baron Von Swietan's text and the disputes about its origin from an English libretto by Lidley or Liddell, *The Creation* is squarely in the tradition of oratorio set forth by the eighteenth century.[18] Like the Jago and Stillingfleet versions, it limits its cast of characters to the guardian angels and to Adam and Eve. In the first two parts of *The Creation*, Haydn uses his soprano, tenor, and bass soloists for the parts of angels (Gabriel, Uriel, and Raphael, respectively); in the final section,

the soprano and bass assume the roles of Eve and Adam (Haydn insists that the father of mankind be sung by a man!), while the tenor (Uriel) retains the part of angelic narrator. Although *The Creation* does not dramatize the story of the fall (its narration takes us no further than the happy establishment of Adam and Eve in the garden), it does celebrate the wonders of the created universe and joyous love of Adam and Eve, not unimportant considerations in either Milton's epic or the musical works based on Milton in the eighteenth century.

Haydn divides *The Creation* into three parts, which reflect different sections or aspects of *Paradise Lost*. The first part moves from the creation of the earth and the bringing forth of vegetation to the ordering of the heavens above with stars and the sun. Though based literally upon Genesis, as is Milton's account of the creation in Book VII, Haydn's ordering and emphasis betray debts to *Paradise Lost*. *The Creation* begins with a symphonic re-creation of chaos, a musical portrayal equivalent to Milton's description of the "vast immeasurable Abyss / Outrageous as a Sea, dark, wasteful, wild" (VII, 211–12). Milton makes clear connections between the raging of the enemy elements in chaos and the warfare in heaven that has just been quelled by the Son. As he purged heaven, the Son "downward purg'd / The black tartareous cold Infernal dregs / Adverse to life" (VII, 237–39). Similarly, Haydn glances at the fall of the rebel angels: "Despairing cursing rage attends their rapid fall."[19] The creation of light, described so simply in the single line in Genesis (1:3), "And God said, Let there be light: and there was light," is given special emphasis in Milton and Haydn. Milton does it with elaboration: "and forthwith Light / Ethereal, first of things, quintessence pure / Sprung from the Deep" (VII, 243–45); not only is the word "light" made emphatic by its position at the end of the first line, but two lines later the stress falls on the word "sprung." Haydn does all this musically with a single effect, as chorus and orchestra rise fortissimo on the single word "light." With the creation of light the storms in nature begin to be quelled. In his recitative the bass Raphael describes the scene, while the orchestra in the background mimics the wind, fire, and the lighter effects of hail and snow.

Now furious storms tempestuous rage,
Like chaff by the winds impelled are the clouds,
By sudden fire the sky is inflamed,
And awful thunders are rolling on high:
Now from the floods in streams ascend reviving show'rs of rain,
. .
The dreary wasteful hail, the light and flaky snow.

Taken alone, the poetry is hardly in a class with Milton's; taken with Haydn's vocal line and the support of his orchestral sound painting, the total effect is not far from Miltonic. Haydn does with key words and phrases what Milton requires a line or two of poetry to build. Consider how the chorus, with one line and particularly with the repeated "springs up," creates the effect of the spontaneity of God's creation: "a new-created world springs up, springs up at God's command." Or notice how the chorus echoes the air of Gabriel, so that the "praise of God" does truly resound in choral tones "to the ethereal vaults." The effect of angelic singing that Milton is so eager to suggest Haydn vividly re-creates. Milton tells us that the angels "touch'd thir Golden Harps, and hymning prais'd / God and his works, Creator him they sung, / Both when first Ev'ning was, and when first Morn" (VII, 258–60). Haydn makes the chorus take the part of Milton's angels and "awake the harp" and let the "joyful song resound": "Rejoice in the Lord, the mighty God, / For he both heaven and earth, / Hath clothed in stately dress." Three times in section one and at its end, Haydn's chorus bursts forth in praise of the creator and his works, "The heavens are telling the glory of God"; at the end of sections two and three, the angelic chorus once more sings, "Achieved is the glorious Work," and "Sing the Lord, ye voices all." Though the words of the choruses recall the Bible as well as Milton, the device of choral response is Miltonic. After passages of description in Book VII are passages of choral praise; Haydn allows his chorus to serve as the responses of praise after the passages of descriptions presented in the recitatives and airs of his soloists.

The second element that recalls *Paradise Lost* is the adaptation of the narrative solo to special effects in descriptions. Haydn has a full range of solo voices from soprano to bass, as well as the support of a mixed chorus, so he can range from high to low in onomatopoetical shadings, with the instruments of the full orchestra aiding the singers. What Milton does with language only, Haydn does with language and vocal and instrumental technique. Milton's streams of water must roll or ebb or wind through the sheer force of his poetic line:

> So the wat'ry throng
> Wave rolling after Wave, where way they found,
> If steep, with torrent rapture, if through Plain,
> Soft-ebbing; nor withstood them Rock or Hill,
> But they, or under ground, or circuit wide
> With Serpent error wand'ring found thir way,
> And on the washy Ooze deep Channels wore . . .
> (VII, 297–303)

Haydn can suggest this effect with select choice of Miltonic phrase and the tone painting of voice and orchestra supporting: "In serpent error rivers flow. / Softly purling, glides on / Through silent vales the limpid brook." Haydn wonderfully adapts the different voice types for special descriptive effects. To describe a lovely pastoral landscape, he chooses the bright, clear sound of the lyric soprano, who begins the air with a Miltonic phrase, "With verdure clad the fields appear, / Delightful to the ravish'd sense." For the soprano he reserves the merry lark, the cooing of the tender dove, and the nightingale's soft, enchanting lays. To the tenor Haydn gives the account of the splendid rising of the sun as well as the first appearance of man upon earth. To the bass Haydn gives a variety of vocal stances: his deep voice sings of the roll of the "foaming billows," the roar of the "boisterous sea." If the soprano describes the creation of the birds of the air, the bass tells of the great whales that appear and the beasts that come forth when earth opens her fertile womb. To phrases and descriptive tags that are basically Miltonic, Haydn adds instrumental and vocal effects that make Milton's images yet more vivid. The tawny lion leaps in the music, the flexible tiger still more flexible sounds, and the steed "with flying mane / And fiery look, impatient neighs." The orchestra supplies the heavy sound of the beasts as they tread the ground. Lighter, and even comic, effects are not missing. The bass slowly descends to a low "a" to suggest the slow, sinuous movement of the serpent: "in long dimension / Creeps, with sinuous trace, the worm." In many instances the key words in these lines are directly borrowed from Book VII; in some cases, as with the worm, one line in Haydn is a composite of several in Milton: "Whatever creeps the ground, / Insect or worm," and "thir long dimension drew, / Streaking the ground with sinuous trace" (VII, 475–76; 480–81). Though the musical humor in this instance is Haydn's, Milton renders some sly wit in the account of the creation as well as in other parts of *Paradise Lost*, as when the unwieldy elephant, to make mirth for Adam and Eve, wreathes "His Lithe Proboscis" (IV, 347). Penderecki more than a century and a half later, follows Haydn in finding opportunity for musical humor in the creation sequence.

Having celebrated the creation of the physical world and of the animals in Parts I and II, Haydn comes at last at the end of the second section to that of man and woman. Drawing upon Milton's description of the creation of the human couple in Book VII and their appearance hand in hand in the garden in Book IV, Haydn presents in concept and in detail a picture that is essentially Miltonic. The bass Raphael prepares in his air for the full-scale description that the tenor Uriel gives us in recitative and air. Raphael emphasizes that the glory of creation was

made for man alone: "Now heaven in fullest glory shone; / Earth smil'd in all her rich attire"; without man all this work would be incomplete: "there wanted yet that wondrous being, / That grateful, should God's power admire, / With heart and voice his goodness praise." The notion that man is the final end of God's creation, the culmination of the six-day work, is, of course, biblical, but the idea that man's most pleasing quality to his creator is his ability to know his creator and to render him thanks and praise is the very keystone of *Paradise Lost*. Though the description of Adam and Eve in Uriel's air is brief, it too is drawn conceptually from *Paradise Lost* (288–94):

> In native worth and honour clad,
> With beauty, courage, strength, adorn'd,
> Erect, with front serene, he stands
> A man, the lord and king of nature all.

Like Milton in Book IV, Haydn emphasizes the godliness, honor, and majesty of the human couple and their complementary relationship: the wisdom and majesty of the man, who is the image of God; the beauty and grace of the woman, who "with fondness leans upon his breast"; the "love and joy and bliss" that unite the two. Repeating the key words and concepts from the Miltonic text, Haydn and his librettist take no more liberty with Milton than Berlioz did with Vergil in *Les Troyens* or Verdi with Shakespeare in *Otello*. For what they have attempted to do is to convey through music and song the love and joy and bliss that Milton through his poetry made the essence of Eden.

Part III is devoted totally to that celebration, giving us in the first section an Adam and Eve reverently worshiping their creator (their words drawn, of course, from the Morning Hymn), and in the last an Adam and Eve joining voices to pledge their love (with words now drawn from Eve's own "Sweet is the breath of morn"). These two popular favorites could hardly have been an accidental choice on the part of Haydn's librettist, and the great master seems to have profited by those who had gone before him in setting Milton's texts to music. In neither the hymn nor in the love duet do we have a close adherence to Miltonic text and order, and for that Haydn and his librettist have been criticized. Yet the choice of Miltonic words and the alternation of joined voices, chorus, and single voices create an impressive passage. Haydn sets the scene with a tenor recitative: "In rosy mantle appears, by music sweet awak'd, / The morning"; he describes Adam and Eve appearing hand in hand. Then soprano and baritone unite voices in song: "By thee with bliss, O bounteous Lord, / Both heaven and earth are stor'd." The

chorus echoes in response, "For ever blessed be his power, / His Name be ever magnified." To those accustomed to the Miltonic phrases of "Parent of good," the words are disappointing; the musical effect, however, is not. Adam begins the main part of the hymn with the praise "of stars the fairest" and "thou, bright sun . . . / Thou eye and soul of all"; the chorus responds to his words, and then Eve praises the moon and "all ye starry hosts." So the solo voices alternate in their praises, as in Galliard's hymn, until they join on the words: "Ye creatures all, extol the Lord"; the chorus once more responds: "extol the Lord; / Him celebrate; him magnify." The final joining of Adam's and Eve's voices is a general hymn of praise. The librettist makes no attempt to follow Milton's closing, which fits the particular situation in *Paradise Lost*; instead this Adam and Eve urge nature to repeat the praises of their song. There is even an aptness in the choice of the Miltonic phrase "made vocal by our song," for in providing the vocal melody to these Miltonic words, Haydn has done precisely that:

> Ye valleys, hills and shady woods,
> Made vocal by our song,
> From morn till eve you shall repeat
> Our grateful hymns of praise.

The repetition of the grateful hymns, moreover, is carried forth by the chorus, which repeats, "We praise thee now and evermore." As a writer for the voice, Haydn had to set phrases that were simple and singable. Only the larger concepts of the Miltonic text, only those Miltonic phrases that could be grasped immediately, could be retained.

Van Swieten and Haydn follow these principles in the final duet for Adam and Eve, where librettist and composer attempt to portray simply how Adam's and Eve's delight in one another transcends even their delight in Eden. Hence, after Adam in recitative promises to be Eve's guide, and Eve, with proper Miltonic submissiveness, responds that Adam's will is law to her and obedience her whole happiness, they begin the final duet with courtly address: "Graceful consort / Spouse adored" ("Holde Gattin / Teurer Gatte" in the original German). The words of their duet echo Eve's "Sweet is the breath of morn" only in a few choice phrases: "without thee," "the morning dew," "the breath of even." For the rest, it is the perfect blending of voices, the pledge of love ("With thee delight is ever new"), and the repeated affirmation of "thine, thine" that make the duet effective. Like Handel's setting of the marriage hymn earlier in the century, Haydn's setting of this love duet properly catches the Miltonic spirit with the fewest of words. As such, it provides a fitting

close to the century of musical adaptations, where so often the idealized Adam and Eve, happy in their love for one another and in their devotions to their God, expressed the highest creations of Milton's art.

NINETEENTH-CENTURY WORKS

For the first half of the nineteenth century, English composers, following in the line of Smith and Stillingfleet and encouraged perhaps by the success of Haydn's *The Creation* in London, continued to regard *Paradise Lost* as the source for devotional cantatas and Christian oratorios. While some composers turned to new sections of Milton's epic for dramatic material, most drew upon, as their eighteenth-century predecessors had, the sequences in Eden and the description of Creation for their choral and solo pieces. Not until the latter part of the nineteenth century did English composers expand the scope of their oratorios and Continental composers join their ranks, creating oratorios that were more operatic in style and different in intellectual approach. In the early part of the century three composers dominated the English scene: Matthew King (1773–1823), whose oratorio *The Intercession*, performed at Covent Garden on 1 June 1816, is perhaps his best-known work; Pio Cianchettini (1799–1851), an English pianist and composer born of foreign parents; and Sir Henry Rowley Bishop (1786–1855), a composer of light opera as well as oratorio, whose most famous vocal composition is undoubtedly "Home, Sweet Home" from *Clari, The Maid of Milan*.[20]

Pio Cianchettini's cantata based on *Paradise Lost* (1820) is a derivative work, in that it uses most of the sections of *Paradise Lost* and most of the vocal and choral techniques exploited by composers in the eighteenth century.[21] Set for two voices with the support of choruses and full band, it begins with an opening full chorus, "Great are thy works Jehovah," and continues with a cavatina for Adam, "Awake my fairest, my espoused," a recitative and air for Eve, "My author and disposer," "With thee conversing I forget," and the allegretto, "Sweet is the breath of morn," both of which offer the soprano opportunity to display her high B-flat. The chorus reenters with the praise of mankind, "Thrice happy man and sons of men," and the cantata concludes with Adam and Eve's morning hymn, followed by a choral set of hallelujahs. The focus, as in Haydn's work, is on the grandeur of God and the happiness of man and woman in paradise.

The middle section of Matthew King's *The Intercession* (1817) also focuses on man, but it emphasizes the postlapsarian woe of Adam and

Eve. Only slightly longer than Cianchettini's cantata, it is scored for orchestra, pianoforte or organ, at least three soloists, and chorus.[22] With the air for Adam, "Why comes not death," and Eve's lamentation, "Must I leave thee, paradise," the oratorio recalls some of the pathetic effects of the third act of the Smith-Stillingfleet *Paradise Lost*. It is probable that these scenes of human lament are the ones that most moved the audience, for the most popular air and the only lasting concert piece from the score is the soprano's simple and affecting lamentation (Fig. 34). Not a florid vocal showpiece, this air relies, like the Countess's arias from *The Marriage of Figaro* and Pamina's lament from *The Magic Flute*, on a clean legato line and demands a vocal expressiveness from the soprano (it is marked affettuoso) for its effect. The remainder of King's oratorio focuses either on heavenly choruses or on a character prominent in *Paradise Lost* but not yet a part of any previous oratorio or vocal work drawn from the epic: the Son of God. In its opening and conclusion, King's oratorio presents the Son of God, who in the first scene (taken from *Paradise Lost* III, 227ff.) offers to save mankind, "Father, thy word is past," and in the concluding scene (taken from XI, 22ff.) raises an intercessory prayer on behalf of fallen man, "Father, see, Father, what first fruits on Earth are sprung." The Son's recitatives and airs are supported by angelic choruses that offer hallelujahs or make the air "ring with jubilee and loud Hosannas." King's oratorio is interesting then in presenting the Son as a dramatic character and assigning his offer to save mankind prominence in an oratorical work; in only a few other musical adaptations of *Paradise Lost* of the nineteenth and twentieth centuries do the Son and his intercession achieve comparable importance.

Two of Sir Henry R. Bishop's cantatas based on *Paradise Lost* follow closely in the track of the works of Cianchettini and King: *The Seventh Day* and *The Departure from Paradise*, both written for the Philharmonic Society and performed in 1834 and 1836, respectively.[23] Like Haydn's *The Creation*, Bishop's *The Seventh Day* has soprano, tenor, and bass soloists with chorus; shorter than Haydn's oratorio, however, it draws only from the conclusion of *Paradise Lost* VII and includes mostly the celebratory aspects of the epic. A solo bass begins, "The great Creator from his work desisting," and thereafter, as in Haydn, choral and solo pieces alternate. A full chorus sings, "Open ye everlasting gates"; a trio celebrates, "Great are thy works, Jehovah," with the full chorus entering on the phrase "Greater now in thy return." After a chorale on the Miltonic phrase "Thrice happy men and sons of men," the cantata concludes with a final chorus, "Sing ye celestial choirs," where the words "Lord of all" are repeated as if in Handelian echo. For it

2

FIGS. 34A–D. "Eve's Lamentation," from *The Intercession* by Matthew King (London, 1817). Reproduced by permission of the Bodleian Library, Oxford. Mus. 1. c. 294 (3).

Eve's Lamentation,
Sung by
Miss Stephens.

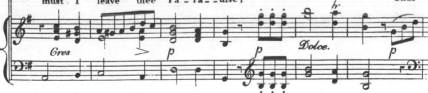

is the kind of splendor that Handel achieves in the climactic moments of *The Messiah* that Bishop seems to be reaching for throughout his cantata. Only one mood from Milton's Book VII is imitated, and that is triumphal celebration.

Bishop's earlier oratorio, *The Battle of the Angels* (London, 1820), aims for splendor of a different sort, being the earliest attempt to render the war in Heaven in epic musical style. [24] Actually a long concert recitative and aria with orchestral accompaniment, rather than a full-scale oratorio, it is written for single tenor voice, the same singer, Mr. Braham, who created the part of Adam in Cianchettini's cantata, here taking the part of Raphael. After an excited orchestral introduction, the tenor begins, sotto voce, with the narrative opening of *Paradise Lost*, Book VI, "All night long the dreadless angel unpursu'd." Omitting the dramatic dialogue of Milton's war, the recitative and aria concentrate only on presenting the military action, the gathering of "thick embattl'd squadrons," the marching forth of the host "in mighty quadrate," and the joining of the two armies in battle. Throughout the long recitative, the orchestra supports the tenor by varying the tempi to suggest martial rhythms and by adding trumpet flourishes to introduce the battle scene; the war in Heaven in this descriptive scene might be any war. The tempi range from larghetto to tempo di marcia to an allegro moderato for the aria proper; with a sounding of trumpets immediately before, the tempo quickens to a march: "the loud / Ethereal trumpet from on high 'gan blow." With repeated high A's and sustained notes in recitative as well as aria, the tenor suggests the excitement of battle; the aria begins, "But the shout of battle," a key phrase repeated throughout, and the tenor's voice rises as he describes the striving for "victory" and the "storming fury" of the host. Only at the end do we have an andantino expressivo, as the tenor intones: "And Clamour such as heard in Heav'n / Such as heard in Heav'n / Now was never." We might pass off Bishop's dramatic scene as merely a showpiece for the tenor, were it not for the fact that it announces a shift in attitude toward *Paradise Lost* as a source of musical compositions. For the first time, the focus is on an aspect far removed from creation, devotional worship, or Edenic bliss or woe: it is on *Paradise Lost* as an epic. Bishop's interest in the description of heroic warfare prepares us for the interest in Satan as a heroic character and the first treatment of the epic councils in Hell that are to mark the oratorios of the latter part of the century. *Paradise Lost* as something other than religious oratorio or domestic drama now becomes a possibility on the musical stage.

While the most ambitious attempts to realize the epic potential of Milton's poem in the latter part of the nineteenth century came from

Continental rather than English composers, one composer of English oratorio, John Ellerton, in his *Paradise Lost* (1862), expanded the action of previous English works and included scenes in Hell and fallen angels—Satan, Beelzebub, and a supporting chorus—as characters.[25] After an opening first part in Eden (which includes a symphonic description of Dawn, an aubade from Adam, followed by a recitative in which Eve recounts her demonic dream, and which concludes with the Morning Hymn), Ellerton turns the scene to Pandemonium. A chorus of Fallen Spirits laments the fall to Hell, their words chosen from Satan's own soliloquies from *Paradise Lost*, Book I: "Hail horrors, hail / Infernal World" and "Is this the seat / That we must change for Heaven?" (p. 9). (Throughout Ellerton appropriates the words of Miltonic characters for use of the chorus of either Fallen or Unfallen Spirits.) Beelzebub, sung by a tenor, is given the opening recitative and air, "O Prince, O chief of many throned powers" (9–10); and Satan, a bass in this version, opens with the words from his first address to the fallen angels in Book I, "Prince, Potentates, / Warriors, the flower of Heaven" (10). After a march in which the fallen angels reassemble before him, Satan once more addresses them and in an air and following recitative proposes to tempt man in paradise. The chorus lauds his bravery, "O Prince, O Chief of many throned powers!"; and Ellerton once more chooses Satan's own words for the chorus: "All is not lost; th' unconquerable will, / And study of revenge, immortal hate, / And courage never to submit or yield!" (13). The rest of the oratorio follows in lines now familiar. In Part Third Adam and Eve sing a duet based on Eve's "Sweet is the breath of morn," the Chorus celebrates wedded love, the fall occurs offstage (Ellerton provides a symphonic account), and the Chorus laments Eve's act. Part Fourth gives us the expulsion, with Eve's lamentation as the final piece for the fallen couple before a concluding chorus. In these scenes Satan makes only one brief appearance onstage to render an air to the sun as he enters paradise, the words drawn from his opening soliloquy from *Paradise Lost* IV. Despite Satan's relative unimportance in the rest of the oratorio, his appearance in Hell and the heroic treatment of him, as well as of the Fallen Angels who support him, broaden the dimensions of the work. It seems no longer possible in the second half of the nineteenth century to relegate Satan to an offstage character or to make the fall of man merely a domestic drama. The presence of the heroic Satan in this English oratorio is a signal of the change in the times and the taste.

For Continental composers *Paradise Lost* was not merely a religious drama but an epic of cosmic significance. In the oratorios of Anton Rubinstein, Theodore Du Bois, and Enrico Bossi, Satan figures as a

prominent character, and the fall becomes a cosmic struggle of good and evil. These three composers from different backgrounds and countries all moved *Paradise Lost* from oratorio into semi-opera, for they had experience in opera as well as in religious music. The Russian-born Anton Rubinstein (1829–1894), pianist as well as composer, set a number of sacred operas to German texts, modeling them on the style of Mendelssohn's oratorios. *Das Verlorene Paradies* was first composed to a German text by A. Schlonbach in 1856; in 1875 it was adapted to an English text. (A German oratorio by the same name, adapted from Milton's text by a different librettist, was set by Peter Ritter [1763–1846] in Mannheim in 1819.) The French composer, teacher, and organist Theodore Du Bois (1837–1924), remembered now for his religious works, wrote pieces for the stage in nearly every genre. After failing to achieve success with musical theater in Paris, he attempted religious oratorio: *Les Sept Paroles du Christ* in 1867 and *Le Paradis Perdu* in 1878. The Italian Marco Enrico Bossi (1861–1925) was also an organist and master of cappella, with numerous compositions for the organ, for which he acquired an international reputation. He also wrote operas, however, and choral works, producing *Il Paradiso Perduto* (which was also translated into German) in 1903.[26]

Although there is no evidence that these composers or their librettists were influenced by one another (their opera-oratorios seem to be independent compositions), they approach the problem of setting *Paradise Lost* to music in much the same manner. First of all, their compositions are free adaptations with little attempt made to adhere closely to Milton in plot or language. Even allowing for the fact that these are foreign-language adaptations, few verbal echoes of Milton occur. Second, the composers and librettists aim for large effects—all of these works attempt to be epic in scope. The scene changes from Hell to Earth to Heaven. The cast of characters now includes not merely Adam and Eve and their guardian angels, but Satan with a number of his followers and God and the Son. The time scheme is extended also; the drama moves from the rebellion of the angels to the creation to the temptation and fall. All three opera-oratorios aim to create the grandest and most sublime of effects, and if the music does not achieve the full measure of sublimity, it is not from want of effort on the part of the composers. The age of opera that produced the spectacular in musical scenic effects with Meyerbeer and Verdi, the epic in design with Berlioz and Wagner, envisioned *Paradise Lost* as musical epic.

Anton Rubinstein set out to create a grand opera-oratorio in his *Das Verlorene Paradies*, beginning with a full chorus of celestials praising God.[27] A heavenly voice (tenor), which represents now God, now the narrator, now the Son, proclaims the creation of man and, rising to a

high A on the final word, directs the angels: "to him your homage be due." The Chorus echoes submission. At this point Satan steps forth and in a brilliant basso recitative and aria proclaims his resentment ("Anger so long hid deep in my core") and rouses the rebels to arms ("Raise, ye dark spirits, ye who for freedom craving"). The celestial voice summons the opposing loyal angels, and in a trio Raphael, Michael, and Gabriel (sung by soprano, mezzo-soprano, and contralto, respectively) bid the heavenly trumpet sound, while a chorus of loyal angels sings: "We hasten, we rally, to battle we sally." Martial music sounds; the opposing Luciferian chorus hails Lucifer's name, and he in turn urges his angels into battle. Almost immediately, the heavenly chorus, with a cry of "Osanno," proclaims victory. Satan and his angels cry woe, while the trio of angels sings: "Hurl the rebels, hurl the rebels / Into hell's everlasting fire." After the celestial voice announces that Heaven's vengeance is satisfied, the chorus of rebels, now in Hell, laments their loss. The basso Satan steps forth once more to deliver a rousing aria; once more we hear a brilliant call to arms: "War, yes, war relentless never ending / Still 'gainst Heav'n's might contending." In the final scene of Part I, the heavenly and diabolical councils, as in *Paradise Lost*, are opposed one to another. The rebels in Hell second Satan's plan for revenge, while the angels above respond to the proposal by the heavenly voice to create the world with a cry: "Lord, thy will be done."

The treatment of Satan in Du Bois's and Bossi's works is comparable. Like Rubinstein, Du Bois devotes the first part of his "drame oratorio," *Le Paradis Perdu*, to the revolt of the angels.[28] After an orchestral introduction, the choir of angels, led by the first and second sopranos with a solo mezzo-soprano as the archangel, begins the hymn of praise to God: "Aux profondeur éthérées / Pleines de frissons / Louons le Seigneur." A solo voice proclaims that the Lord is no longer alone on his holy hill but is attended by the Son. "un être à la face divine / Et ce lui là dieu le nomme son fils." While the choir once more echoes praise, Satan steps forward. In a long recitative, he announces that he will not be servile like the choir that docilely praises the Son, for as the first archangel, he has been eclipsed in honor by the Son. He proceeds to rally the other angels to their new master. Before our anger, God will soon tremble, sings the basso Satan, who, like the Satan of Rubinstein, delivers a fiery aria ending in an E-sharp. In response the chorus of rebels pledges their support of Satan and liberty. Unlike Rubinstein, Du Bois urges envy of the Son, rather than envy of man, as the motivation of Satan's revolt, thus more closely adhering to Milton. Both composers, however, create a Satan who in his war-mongering professes, like Milton's Satan, to support the cause of liberty.

The battle in Heaven in Du Bois's oratorio, as in Rubinstein's, is

waged musically, with rebels and faithful angels (the tenors and basses from the full chorus) challenging one another, the rebels singing, "Suivons Satan," while the faithful proclaim, "Dieu nous conduit," and both singing of their fierce determination to smite the foe: "Sans pitié, sans trêves / Frappons de nos glaives." As the battle heightens, only the word "frappons" is sung by both choruses above an increasingly excited orchestral accompaniment. As in Rubinstein, the Choeur de Fideles proclaims the victory ("Victoire, Hosanna") and a solo archangel pronounces judgment ("Tombez, coeurs pleins de haine / au gouffre plein de flamme").

The second part of Du Bois's oratorio takes place in Hell and begins with a lamentation of fallen spirits, the words based distantly on Milton's description of Hell from Book I: "Dans L'horrible fournaise, ah comme nous souffrons." Imitating Milton's trio of angels from Book II, Du Bois assigns Uriel (soprano), Beliel (bass), and Moloch (bass) the task of accusing Satan of having led them to perdition: "Auteur de nos crimes, sois maudit." Satan steps forward to counter these accusations and proposes in a long recitative his plan to tempt man in paradise, concluding with another rally to arms: "Frappons le maître en son ouvrage / Et le père dans son amour." Moloch now asks who will undertake the task for them, and Satan accepts the offer: "Soit, j'accepte la tâche et combattrai pour vous." The second part ends with a renewed chorus of war and pledge of support for Satan.

Bossi, who calls his *Il Paradiso Perduto* a Poema Sinfonico Vocale, eliminates a separate account of the war in Heaven but maintains Satan as warlord and leader of the rebel armies.[29] Beginning the oratorio with a choral and instrumental depiction of the creation, drawn conceptually from Milton's Book VII, Bossi musically portrays the vast uncreated nothing of chaos moved by the mind of God, then the created work appearing from the rays of dawn and dusk, as the sacred celestial voices sing. Finally, in the pupils of man, life smiles, and the chorus proclaims, "Gloria, O Signor." Hardly has the word "gloria" faded when the voice of Satan stirs in the deep, with a surge of dramatic music. Satan, here a baritone, recollects, as in *Paradise Lost* I, his opposition to God and determines to wage eternal war ("A noi, compagni maledetti, pugnammo") and to soar out of the abyss, regaining paradise for himself and his angels. Like Du Bois, Bossi attempts a rendering of the council in Hell, limiting the angelic speakers to Moloch (a bass) and Belial (a contralto) but essentially preserving the Miltonic character of both angels, if not their precise words. Moloch urges war ("Tu guerra invochi? e guerra sia!"); Belial, like his Miltonic counterpart, advises caution ("Guerra? ben guerra vorrei, ma troppe lacrime piangemmo è forza ar-

rendera al destin che ci atterra"). The chorus complains of its bitter lot, assigned to Hell's flames, and cries for renewed war. Satan suggests in reply that new war is vain and proposes in a long recitative to direct attention against man. Depicting the beauty and happiness of man ("Un uom d'angelo il volto, / sereno l'occhio e l'anima innocente / vivrà nel sol"), Satan suggests that it will be fit vengeance to destroy this work of God, whereupon Satan's angels once more proclaim him king and sound his praises: "Gloria a Satana Re."

The Satan of these three oratorios who urges battle, who hurls contemptuous scorn at the Almighty, who plots to tempt and destroy mankind, is close kin to the satanic villain-hero or devil that began to appear on the operatic stage in the 1820s and 1830s. Prompted perhaps by the Romantic preoccupation with Satan as a heroic figure who, although flawed by evil, was magnificent in his defiance of God and his pursuit of revenge, operatic composers developed the villain-hero as a leading character. Almost always sung by a bass or low baritone, this malevolent figure attempts to destroy the hero, usually a tenor, and to thwart his happiness. Sometimes a rival for the soprano, sometimes merely a malcontent who envies the soprano's love for the tenor, the operatic bass or baritone is a layer of evil plots. The type culminates in Ponchielli's evil Barnaba (*La Gioconda*, 1876) and Verdi's satanic Iago (*Otello*, 1887), both creations of the librettist Boito. When the operatic villain-hero is the devil himself, the effect is still more sinister. Samiel, the devil-ranger of Weber's *Der Freischutz* (1821) (in this case a non-singing part), using Caspar to tempt Max, almost succeeds in destroying him. The Wolf's Glen scene, where Samiel works his demonic magic, became justly famous. Meyerbeer's *Robert Le Diable* (1831) includes another tempting devil, the insinuating Bertram, who hopes to win the soul of the gullible Robert. In Act III Bertram for a moment throws off his disguise and, meeting his demons at the entrance to Hell, gloats over his plans. But the Faust operas, inspired by Goethe's poem, include the most famous examples of the operatic devil. The Mephistopheles of Berlioz's *The Damnation of Faust* (1846) triumphantly rides off to Hell with the hapless Faust, while a chorus of devils exults. The sardonic and urbane devil of Gounod's *Faust* (1859) plays the part of tempter throughout most of the opera but becomes master of Hell in the Walpurgis Night scene. The villain-hero of Boito's *Mefistofele* (1868), however, is the most princely of the nineteenth-century devils, for he appears in the opening prologue in his own domain, proclaiming the supremacy of his evil and singing a mocking hymn to God as sovereign lord. Without the reinforcement of this operatic tradition, Rubinstein, Du Bois, and Bossi, who incidentally was a student of Ponchielli, could

hardly have achieved epic musical and dramatic scope in their portrayals of Milton's Satan.

The increased prominence of Satan and the Rebel Angels in nine-teenth-century oratorio results, however, in some curious displace-ments in the story of man's fall. In Rubinstein's version, Adam and Eve become proportionately less important as the cosmic struggle is waged between diabolical and heavenly forces. Although Satan does not appear as a singing character after the First Part, the Rebel Angels maintain their presence until the end, celebrating at the beginning of the Third Part Satan's offstage victory over Adam and Eve ("Shout we, shout we, pow'rs infernal") and once more exulting in the Finale, as Adam and Eve are expelled from paradise ("Satan glorious, thou'rt victorious, / Man hath sinn'd, hath fall'n thy prey, / Hail, mighty Satan! hail"). Adam and Eve are subordinate throughout as singing characters, even though the dramatic action revolves perforce about their creation and their fall. Rubinstein devotes the Second Part of the oratorio to the creation and, like Haydn, alternates the choral and solo parts as each new thing comes into being, but he pays far less attention to detail and makes little attempt to follow the scheme or the language of Milton's Book VII. With the actual creation of mankind, Adam and Eve for a moment become central characters, as first Adam, then Eve, wakens to life. But, for all that, they have only two important musical pieces in the entire oratorio, both duets: their prayer to God at the end of the Second Part and their lament at the beginning of the Finale. The Celestial Voice continues to be important in the Third Part, proclaiming that man, in consequence of his sin, must suffer and in the following scene passing judgment on Satan, Eve, and Adam. Apart from the virtuoso role of Satan in the First Part and the use throughout of the Celestial Voice for narration and commentary, Rubinstein's *Das Verlorene Paradies* is a choral work, and some of its most memorable effects come about when double cho-ruses of Celestials and Rebels combine or sound against one another. In the Finale, moreover, Rubinstein not only contrasts the double cho-ruses but interweaves the mournful duet of Adam and Eve ("Curs'd, oppressed, lorn, distressed, / hopeless, banished ah from Eden's home") and the hopeful trio of angels, whose final plea for redemption closes the oratorio ("Now unto the mortals close, / Heav'nly portals, / till of Redemption comes the day!"). With his handling of chorus, Rubinstein comes the closest to realizing at least a part of Milton's large epic scene. But, for all that, we can hardly call *Das Verlorene Paradies* a close imitation of *Paradise Lost*. The later opera-oratorios of Du Bois and Bossi strive much more seriously to adhere to the text, characteriza-tion, and plot of the epic that inspires them.

Both Du Bois and Bossi depict the temptation as a major part of the action in their oratorios, Du Bois presenting Satan's seduction of Eve, followed by Eve's of Adam, but Bossi rendering only the latter. Devoting approximately half of *Le Paradis Perdu* to the fall and its aftermath, Du Bois introduces Satan into Eden as an actual singing character, treating the scenes between Adam and Eve in this Third Part in a unique manner. What he attempts to realize is Milton's own scheme in Book IV, for his Adam and Eve in their Morning Prayer and Love Duet are witnessed by the devil. While the human couple sings their praises to God and pledges their love to one another, Satan, with his ominous low baritone undercutting the soprano and tenor duet, menaces them in secret: "Priez, priez encore, hôtes du Paradis. Mais des jours vont éclore où vous serez maudit . . . aimez encore." In the next scene Eve, left alone, expresses her love for her husband, but as Satan in the form of the serpent appears, she feels the sudden oppression of a secret emotion. He calls her name, and Eve feels herself drawn where she has never gone before. While basically adhering to Milton's version of the temptation, Du Bois, using the medium of music to create his effects, simplifies Satan's words of seduction. Du Bois's Satan directly urges Eve at the outset to extend her hands and pluck the fruit, telling her only that it has sovereign power to make her queen of the universe. Eve almost immediately responds, declaring that the branch is not high and Heaven is far off. But as she hesitates, remembering the divine punishment of death, Satan urges her on, promising the joys of divinity and blaming the jealousy of God: "Il vous trompait, il vous trompait, le Dieu jaloux." At last, Eve cries that she resists no longer, and as she approaches the tree, declaring her intention to succumb, Satan's voice joins with her, soaring to an E-flat as she plucks the fruit. The scene that follows between Eve and Adam is just as extraordinary in its way, for after Eve and Adam alternate their voices in duet, she urging him to join her in sin, he expressing horror at her act, their voices join as he yields to her, and Satan at that very moment joins the pair and the duet becomes a trio, with Satan proclaiming his victory. The human couple exits, and Satan, in a brilliant aria, marked allegro marcato energico, exults. However effective this scene of seduction and fall, it is inspired probably as much by Gounod's *Faust* as by *Paradise Lost*. In the garden scene of *Faust*, the devil observes the lovers, goads Faust into seducing Marguerite, and as the lovers succumb to their passion, remains onstage, gloating with derisive laughter. Further, in the final act the voice of Mephistopheles joins those of Faust and Marguerite in the final trio. Contemporary French opera offered Du Bois both dramatic and musical suggestions for his setting of Milton's temptation scene.

Bossi, in *Il Paradiso Perduto*, presents another version of the fall, not a formal dramatic scene of temptation and final succumbing, as we have observed in Du Bois, but an impressionistic scene that subtly suggests the lapse into sin from paradisal happiness and innocence. Parts Two and Three of the oratorio depict Eden before the fall; in the second part, the dawn of day is described by a chorus of angels, then by Adam and Eve in yet another version of the Morning Hymn. The angels sing of the beauty of light, the mother of the vivid colors of nature; Adam and Eve bless the creator, who woke the grass from sleep and breathed life into all creation. Eden throughout this part is at its zenith, and Bossi attempts to portray this perfection in the choruses and duet. In Part Three, however, when Bossi makes the angelic chorus sing of the fall of light and the inevitable coming on of evening, he is preparing us for the event to come: the fall of man. Drawing his inspiration from the closing scenes of Book IV of *Paradise Lost*, where Adam and Eve prepare for the night, Bossi creates what first appears to be a love duet. Adam begins, remarking to his companion Eve on the gentle descent of night on her lovely face and praising God for bringing blessed peace to earth by extinguishing the light in the sky. Eve, however, resists, saying that she feels no desire for sleep—the flowers of earth are yet breathing their essence—and she urges Adam to stay. There is a singing in the dark wood, she tells him, and a sweet suggestion in his eyes; does he not feel a wave of desire? Adam replies that desire is a name unknown, untaught by the angels. Eve demands to know why these feelings have been roused. Don't ask, don't ask, Adam rejoins, but Eve continues: Why is each branch filled with fruit and flower? She calls his name, and the wood murmurs in reply, but Adam, she protests, does not answer. Adam, Adam, listen to me, she sings: "In cento lai odo nei fremiti della foresta laggui ripetersi l'arcana inchiesta" ("In one hundred lays I hear in the forest tremors far off a secret search repeated"). Finally Adam begins to yield: Why is there an unknown ardor in your eyes, he asks, now sounding Eve's name as she cries, "Io t'amo," to which he replies "T'amo" as the angelic chorus echoes their words. After a brief orchestral interlude, the voice of God proclaims their sin, "Errasti." Clearly, what we have witnessed in the preceding scene was not Adam and Eve's expression of love for one another, but a portrayal of Eve leading Adam into sin.

Another interesting feature of Bossi's and Du Bois's oratorios is their use of the Son and his mediation as a part of the dramatic action. Du Bois introduces the Son only in the last part of *Le Paradis Perdu*, using him to resolve the plot, so to speak. The archangel has descended to earth to announce God's judgment and to expel Adam and Eve from

paradise. In an ensemble Adam and Eve, together with the archangel and the first and second sopranos of the chorus, lament the just vengeance of God. The voice of the Son (here a baritone) interrupts, offering comfort, "Homme, courage, O femme espère," and promising to be their savior; the full chorus lauds his sacrifice, and the oratorio ends with the renewed praise to God. The Son figures more fully in Bossi's *Il Paradiso Perduto*, where his part is taken by the tenors in the chorus rather than by a solo voice (the full chorus sings the part of the Voice of God). As in Milton's dialogue from Book III of *Paradise Lost*, the Voice of the Son (Voce del Verbo) and the Voice of God engage in debate. Part Two begins with Uriel's announcement of Satan's approach to paradise, whereupon the Voice of God predicts the fall of man. After an orchestral passage marked lentamente con dolore dolcissimo, the Son begins his plea in man's behalf: If the immutable will of God must exact death for man's sin, yet hope must abide. The Voice of God assents, "E sia!", and the orchestra rises to a crescendo. God explains that infinite sorrow must descend on man unless someone is willing to change places with him and descend into life and die. The Son accepts the challenge, concluding, let thy will be done. God then proclaims the Son to be man's hope, and a second chorus, taking up God's words, praises the Son. Bossi employs the Son once more at the end of the oratorio. After God has condemned man's sin, the Son responds, offering new hope: "Pure nel lungo e desolato inverno ultimo dono avrai la santa face della Preghiera" ("But in the long and desolate winter, you shall have as the ultimate gift the sacred torch of Prayer"). The oratorio closes as Adam and Eve bid Eden a sad farewell, while the tenors of the chorus, representing the Son, promise a new paradise. Musically, Bossi's oratorio looks back to the operatic tradition of the nineteenth century, but in its use of impressionistic effect and symbol it looks ahead.

TWENTIETH-CENTURY WORKS

Twentieth-century composers, particularly in the post—World War II period, have shown a renewed interest in *Paradist Lost* as a subject for song, oratorio, and opera. In the past fifty years, no fewer than four full-length operas or oratorios have been based on *Paradise Lost*; sections of the epic have been employed also for songs and individual choral pieces. [30] These twentieth-century adaptations demonstrate interest in and respect for Milton's poetic text and employ it, whenever possible, as the basis for libretti and vocal lyrics. In his oratorio *Genesis* (1958) Franz Reizenstein uses, for example, Milton's description of the coming

of evening (*Paradise Lost* IV) as the text for the choral piece with so-
prano and baritone soloists: "Now came still evening on."[31] Further,
some composers, reexamining Milton's epic design, aspire to reproduce
the pattern of the work in their musical development. Others aim merely
to distill the epic's essence.

Igor Markevitch's cantata *Le paradis perdu* (c. 1936) is a distillation
of various Miltonic motifs.[32] Freely adapting *Paradise Lost*, Markevitch
makes little use of the Miltonic text after a luminous opening solo for the
soprano based upon Milton's "Hail Holy Light!" ("Salut lumière sacre").
More a morality play than a musical drama or epic, *Le paradis perdu*
employs a full chorus but reduces the solo parts to three: a soprano,
representing Eve or Mankind; a tenor, representing Satan; and a mezzo-
soprano, representing the life-force (la Vie) or perhaps the Holy Spirit.
The cantata is divided into two parts, the first of which recounts the
creation, Satan's attempt against Mankind, and the fall; the second,
Mankind's penitence, Satan's renewed assaults, and Mankind's salva-
tion. In essence, the oratorio presents Man's struggle toward life and
salvation, opposed on the one hand by Satan, who envies the beauty and
blessedness of the unfallen state, and aided on the other by la Vie, who
strives against Satan and Death and attempts to show Man the true way.
The chorus, as in so many of the oratorios we have already examined,
comments throughout, announcing Man's creation, fearing his immi-
nent destruction through Satan's hatred, and actually almost taking part
in the temptation scene, where it warns Mankind of its peril: "prenez
garde! mefiez-vous!" As Satan urges, "Mange" ("Eat"), the chorus cries,
"N'y touche pas!" ("Don't touch it!"), and when the fall is accomplished,
the chorus cries out in despair, while Satan exclaims, "Fuyons" (Let us
fly").

In the second part of the oratorio, the chorus once more plays a
leading role, comforting Mankind, who laments, "Mon Dieu, pourquoi
m'as tu abandonée?" ("My God, why have you abandoned me?"). Urging
mankind to turn to God's love and not to despair, the chorus prepares
the way for the saving work of la Vie, now countering Satan and gaining
precedence over him. In a splendid trio, la Vie, sung by the mezzo-
soprano, joins the soprano, Mankind, to urge Man to turn to God ("Ad-
mirable est Esprit. Il te montre la voie"); meanwhile Satan, as the lower
voice in the trio, opposes the two ("Parole odieuse"). The oratorio con-
cludes as the chorus and solo soprano celebrate the sovereign light ("O
souveraine lumière / O toi qui t'élèves") and, joined at last by the mezzo-
soprano, proclaim Mankind's salvation ("Car ceux qui vaincront verront
le fleuve de vie").

The two latest works based on *Paradise Lost*, Phillip Rhodes's opera-

oratorio, *Paradise Lost* (1972), and Krzysztof Penderecki's sacra rap-presentazione, *Paradise Lost* (1978), unlike many earlier works, use a great deal of Milton's text and make a serious effort to transform the epic into a faithful musical interpretation. Commissioned by the Louisville Philharmonic Society and performed by the Louisville Orchestra in 1972, Rhodes's opera-oratorio has a libretto after Milton by Richard and Louise Kain; commissioned by the Chicago Lyric Opera and performed in 1978–79 in Chicago, Milan, and Munich, Penderecki's opera has a libretto by the English poet and dramatist Christopher Fry and has received international attention because of the stature of its composer and librettist.[33] As the work of a leading Polish composer of choral and symphonic pieces, Penderecki's opera had full press coverage in the United States and Europe and was characterized as a grand opera-oratorio in the late Romantic nineteenth-century style with affinities to Wagner, Stravinsky, and Berg. It received attention also in scholarly publications, mostly in America, as the latest attempt to adapt *Paradise Lost* to music.[34]

Both Rhodes's and Penderecki's works closely follow the plot of *Paradise Lost*, retaining the basic ordering of the twelve books and a wide range of Milton's characters. Rhodes includes Satan and several of his associate angels (Beelzebub, Belial, Moloch, and Mammon), Adam and Eve, and Michael; Penderecki includes not only these, but also Sin and Death (sung by a mezzo-soprano and countertenor, respectively), Raphael, Ithuriel, Zephon, and Gabriel (countertenors, soprano, and tenor), as well as the Son and the spoken voice of God. Both operas also make use of an onstage narrator, who in Rhodes's work opens the opera by intoning the first line of the epic, "Of Man's first disobedience. . . , " and who in Penderecki's commences with "Hail, holy Light!" The actor in Penderecki's opera takes the part of the blind poet, who appears alone on the dark stage, and whose invocation to light signals both the dawning light on the stage and the introduction of the chorus with the words "Sing, Heavenly Muse: / What in us is dark / Illumine—/ And justify the ways of God to Men," whereupon the actor-narrator resumes with the opening lines of *Paradise Lost*.

Like all the opera-oratorios before them, Rhodes's and Penderecki's works make extensive use of the chorus, onstage throughout, commenting on the action or elaborating on words of the narrator or principal characters. Penderecki's work calls for a chorus composed of one hundred voices, which functions sometimes as an autonomous unit but sometimes takes on different character parts (as, for example, the fallen angels or the heavenly choir); it also requires a children's chorus, which takes part in onstage action. Rhodes's chorus has a more limited role.

Rhodes's opera-oratorio is divided into three acts: the first dramatizing the Stygian council; the second, Satan's temptation of Eve; the third, the fall of Adam and the aftermath. The work requires only three major voices: a soprano, who takes the part of Eve; a tenor, Adam; and a baritone, Satan. The narrator takes on the spoken roles of Beelzebub and, later, Michael. The longest dramatic sequence of the work is the first act in Hell, where Satan first revives his lost hopes ("What though the field be lost"), then rallies his forces ("Powers and Dominions, Deities of Heaven"), convenes the council of fallen angels, and lastly pronounces his intention of going to earth ("O Progeny of Heaven, long is the way / And hard"). The second act presents an opportunity for a duet between Adam and Eve ("Sole partner and sole part / of all these joys"), with Satan joining as a dissenting voice ("Sight hateful, sight tormenting"). Eve's "Sweet is the breath of morn," so popular in the eighteenth century, reappears, somewhat abbreviated, as a solo for soprano, supported by women's chorus. The night narrative from Book IV provides an introduction to the account of Satan's descent into the serpent from Book IX, which in turn leads to a brief scene in which Eve first meets the serpent. The narrator, however, actually recounts Eve's fall: "So glistered the dire Snake, and into fraud / Led Eve." Somewhat fuller treatment is given Adam's fall at the beginning of Act III; immediately after, a four-part ensemble follows in which Adam reviles Eve ("Out of my sight"), Eve pleads with him ("Forsake me not"), Satan exults, and the chorus comments on it all. The opera concludes with the appearance of Michael, who expels Adam and Eve from paradise. The couple join with Satan and the chorus in a four-part chorale, which is followed by a speech by Michael and the final narrative.

Penderecki's opera dramatizes many of the same episodes as Rhodes's, making, however, less use of the narrator and developing dramatic scenes more fully. The work is divided into two parts, the first encompassing events up to the fall, the second including the fall and its aftermath. To a large extent, the opera employs a number of brief episodes that move fluidly one into another; it changes scene easily from earth to Heaven to Hell, juxtaposing action and presenting simultaneous action and even flashback. The entire opera is a flashback in one sense, for the first scene after the prologue opens in Eden after the fall, where Adam in a scarlet robe laments his fallen condition, and Eve, similarly clad, pleads, "Forsake me not." As this first scene fades out, the narrator resumes, "Who first seduced them," and the chorus creates the scene in Hell with the fallen angels lamenting their defeat. Penderecki's Satan is sung by a dramatic baritone and resembles the villain-heroes of nineteenth-century opera and oratorio. The scenes in Hell duplicate in many

ways what we have seen in Du Bois's, Bossi's, and Rhodes's opera-
oratorios. Satan begins, "Is this the region"; Beelzebub at his direction
assembles the fallen angels; and the council begins with Moloch, Belial,
and Mammon, first singly, then in an ensemble with the chorus, arguing
the question of war. Beelzebub proposes an "easier enterprise," and
Satan, rising, begins to describe the newly created earth. At this moment
Penderecki effects a stunning transition, for as Satan speaks, the scene
changes, and the voice of God (here the same narrative voice that took
the part of Milton) announces, "Let us make Man in our image." Pen-
derecki dramatizes the Creation in song and dance: a dancer Adam,
crouched as though in the womb, uncurls and moves to the sound of
God's voice; then the singer Adam (the libretto indicates doubles for both
Adam and Eve) greets the sun and the earth and seeks his maker.[36] As
this scene fades out, the action returns to Hell, and Satan continues to
propose his plot for Adam's fall. During the scenes that follow, the action
once more shifts back and forth between Hell and earth as though to
imitate, if not the actual sequence of scenes in *Paradise Lost*, Milton's
design in his epic to juxtapose and contrast action in Hell, in Heaven,
and on earth. By dramatizing at the climax of the scene in Hell how the
fallen angels thunderously extol Satan, "Equal to the highest," and then
by shifting immediately to earth, where God, having newly presented
himself to Adam, is praised by a chorus of angels ("Great are thy works"),
Fry and Penderecki illustrate, like Milton, the difference between Satan
and God as rulers. Similarly, the scene following, where Satan first
encounters his children, Sin and Death, is juxtaposed to the scenes
where Adam names the animals and where Eve is created from the
sleeping Adam, a scene also dramatized by dance. Penderecki has the
opportunity in the naming scene to create some charming and humorous
musical effects, where Adam, echoed by the children's chorus, names
each animal ("*Adam*. Thou Lion. *Chorus*. Thou Lion, Thou Lion. Roar,
Roar. *Adam*. Thou Lamb. *Chorus*. Thou Lamb, Thou Lamb. Baaa,
Baaa"); the orchestra at the same time comically or sonorously imitates
each animal.

The strength of Penderecki's opera lies in the portrayal of Adam and
Eve, both in the joyous celebration of creation and love in the first part
and in the tragic realization of fall and human misery in the second.
Though, like the nineteenth-century composers before him, Penderecki
insists on a cosmic breadth and scope, he does not effect it through
diminishing the human stature of Adam and Eve. Restored to their
central place in the opera, Adam and Eve delight the audience, as they
once did eighteenth-century audiences, in the affecting presentation of
their first meeting, their courtship and marriage (depicted in song and

dance), and their sincere worship of God in the brief evening hymn. Yet, even while Penderecki focuses our attention on these delights, he keeps in mind, as nineteenth-century composers did, the drama at hand, for Satan is made witness to all these scenes in Eden and, like Milton's Satan in Book IV, expresses his anguish at the human pair, "Imparadised in one another's arms." Even while they sing praises to God, he plots to "excite their minds / With more desire to know." As in Du Bois's oratorio, he becomes the demonic third to their duet, and his are the final words as night descends on Eden: "Ah gentle pair, / Enjoy, till I return, / Short pleasures, / For long woes are to succeed." Indeed, in the final scenes of Part I, Penderecki inexorably prepares us for the fall: we see Satan inspire Eve's demonic dream; she, waking, recounts it to Adam; and at the end of the act, Eve separates from Adam, promising to return, "By noon, by noon, / By noon's repast / And after noon's repose." Using the chorus, as in oratorio, Penderecki makes it comment on the woe to come, "O much deceived, / Much failing, hapless Eve."

In focusing in Part II on the pathos of Eve's predicament and the fragility of human love and happiness, Penderecki chooses to stress the aspect of Milton's epic that so many composers of the late eighteenth and nineteenth centuries had found most compelling. He gives us an Eve who is lovely but vulnerable—ambushed, as it were, and overcome by a powerful and all-but-irresistible Satan. Eve enters surrounded by the children's chorus, which represents the animals of Eden, she carrying flowers and singing a pastoral song. Penderecki does not shrink from making the temptation the climax of the opera. Creating a scene between Eve and the serpent that is dramatically and musically taut, he commences with question and answer until the serpent's persuasion begins to overwhelm Eve. Then, the two join in a duet, with Eve echoing the serpent's words, while he repeats over and over again, "Taste." This scene, as some of the earlier ones from Part I, is written for doubles; as the singer Eve appears to reach for the tree, the dancer Eve mimes the fall. Building the tension even higher in the next scene, Penderecki has Adam, divining evil, seek Eve and, encountering her, express horror at her deed, while she exults in her new-found knowledge. Then, as she tempts him to taste, he rationalizes the act. This duet, where the human couple express discordant emotions, contrasts with the harmonious love duet of Part I, and the sensual dance that concludes the scene contrasts with the lovely ballet that marked the wedding in Part I.

Sin and Death, who figure in no operas before this one, are indispensable characters for Penderecki, especially in the denouement. As in Milton's epic, the demonic couple contrast with the human Adam and Eve; Penderecki introduces them immediately before the creation of Eve

and then reintroduces them following the fall, when musically they attain dominance. While Adam and Eve quarrel, Sin and Death exult in their victory, and the four form a discordant quartet. Sin and Death remain onstage during the later scenes to comment ironically on the devastation that Michael reveals to Adam. At this point in the action, Penderecki also introduces the Son of God, here called Messias, presenting a brief version of Milton's dialogue in Heaven to the borrowed strains of Bach's St. John's Passion, one of his more effective musical adaptations. The placement of the scene, immediately before the scene of judgment, is problematic, for Fry's libretto, although imitating Milton's Books X, XI, and XII closely, has given Penderecki far too much material to include after the climax of action with Adam and Eve's fall. Rather than confining the denouement to the judgment, the repentance of Adam and Eve, and their expulsion from Eden, Penderecki not only dramatizes Michael's narrative with stage tableaux, but also includes Michael's prophecy of the coming of the Messias and Adam's joyous outburst, "O goodness infinite." All this takes place in an extended scene before the angel and Adam can return to Eve, so that the opera can close at last with the chorus singing these non-Miltonic words as Eve and Adam depart:

> Through the world's wilderness
> Long wanders man,
> Until he shall hear and learn
> The secret power
> Of harmony, in whose image he was made.

As the latest of the opera-oratorios on the state of innocence and the fall of man, Penderecki's *Paradise Lost* is the most inclusive and in some ways the most balanced treatment of the epic, including material from all twelve books as well as events and characters never before treated for the stage. Like John Dryden before him, Penderecki's librettist, Christopher Fry, aims to create a work that is, like *Paradise Lost* itself, massive and heroic, and Penderecki himself attempts to rival nineteenth-century efforts, such as Berlioz's *Les Troyens*, in putting epic on the stage. Whether this most recent version of *Paradise Lost*, Miltonic both in its language and its ambitions, will succeed as musical theater, or whether, like the oratorios of the nineteenth century, it will fade to a musical footnote, time and the musical taste of future ages must decide.

NOTES

1. John Dryden, *The State of Innocence, and Fall of Man* (London, 1690). See, for example, pp. 1, 6, 9, 17, 18, 37.

2. Benjamin Stillingfleet regarded *Paradise Lost* as the proper subject for a devotional composition because of its "unrivalled sublimity"; music only was necessary to complete the religious devotion. See *Paradise Lost, An Oratorio. As it is Performed at the Theatre-Royal in Covent Garden. Altered and adapted to the Stage from Milton. Set to Music by Mr. Smith* (London, 1760), pp. 3–4.

The French writer A. Tanevot, who composed a five-act tragedy, *Adam et Eve ou La Chute de L'Homme* (Paris, 1752), based on *Paradise Lost*, observed that poetry took its origin from religion and that Milton's work, in particular, expressed the transports and beauties of religion (p. i).

3. Richard Jago, *Adam or, The Fatal Disobedience. An Oratorio. Compiled from the Paradise Lost of Milton. And adapted to Music by R. J.*, in *Poems, Moral and Descriptive* (London: J. Dodsley, 1784), p. 220.

4. For a general guide to adaptations to music of *Paradise Lost*, see John T. Shawcross, "Adaptations," in *A Milton Encyclopedia*, Vol. 1, ed. William B. Hunter, Jr., John T. Shawcross, and John M. Steadman (Lewisburg: Bucknell University Press, 1978). For commentary on eighteenth-century settings of Milton, see Brian Morris, "'Not Without Song': Milton and the Composers," in *Approaches to Paradise Lost*, ed. C. A. Patrides (Toronto: Toronto University Press, 1968), pp. 137–61; Also see Robert Manson Myers, *Handel, Dryden, and Milton* (London, 1956); Alwin Thaler, "Milton in the Theatre," *Studies in Philology* 17 (1920): 269–308.

5. *The Morning Hymn, From the Fifth Book of Milton's Paradise Lost. Set to Musick by Philip Hart* (London, 1728); *The Morning Hymn, taken from the Fifth Book of Milton's Paradise Lost. Set to Music by the late John Ernest Galliard. The Overture, Accompanyment & Chorusses added by Benjamin Cooke* (London, 1773). See Brian Morris's discussion of Galliard's hymn in *Approaches*, pp. 141–49.

6. *The Hymn of Adam and Eve, Taken from Milton's Paradise Lost* (1738) (printed with Handel's Anthem for Queen Caroline's Funeral).

7. *The Death of Abel, An Oratorio, From the Italian of Metastasio*; and *The Morning Hymn, From Milton's Paradise Lost, As it is performed at the Theatre Royal in the Haymarket, The Music by Signor Niccolo Piccini with Additional Choruses from other eminent Masters* (1768).

8. Galliard, *The Morning Hymn, The Overture, Accompanyments & Chorusses added by Benjamin Cooke* (London, 1773).

9. L'Abbé Nadal, *La Paradis Terrestre. Imité de Milton, Poëte Anglois. Divertissement Spirituel*, in *Oeuvres Mêlées*, Vol. 2 (Paris, 1738), pp. 29–40.

10. "Hail, Wedded Love," in *Alexander Balus. An Oratorio. Set to musick by Mr. Handel* (London, 1748).

11. *The Autobiography and Correspondence of Mary Granville, Mrs. Delany*, ed. Lady Llanover (London, 1861–62), 2:280. Also see Myers, pp. 45–46.

12. Jago, p. 220.

13. For the Smith-Stillingfleet oratorio, I have used both the libretto printed by Stillingfleet in 1760 (Benjamin Stillingfleet, *Paradise Lost* [London, 1760]) and the vocal score of the principal songs (*Paradise Lost, Set to Musick, by Mr. Smith* [London, 1760]). Text and page number, unless otherwise indicated, are

cited from the printed libretto. Smith's full score for the oratorio is extant (at the Staats-und Universitäts Bibliothek, Hamburg, MA/672). Kay Stevenson, to whom I am indebted for this information, is preparing a text of the complete score with selected music. She informs me that the complete score includes four additional choruses in Act I, a song for Eve in Act II, and one alternative song for Michael in Act III. Information about the Smith score is included in an article by Andrew D. McCredie, "John Christopher Smith as Dramatic Composer," *ML* 45 (1964): 22–38.

14. Morris, p. 152.

15. See the biography of Matthew King in *The New Grove Dictionary of Music and Musicians*, ed. Stanley Sadie (London: Macmillan, 1980).

16. See Brian Morris's discussion of the different versions of the Morning Hymn in *Approaches to Paradise Lost*, pp. 141–59.

17. Brian Morris comments, "The contact between Haydn and Milton is slight, because Haydn is concerned to explore and present the process of Creation itself" (p. 160). H. C. Robbins Landon, in *Haydn, The Years of 'The Creation': 1796–1800* (London: Thames and Hudson, 1977), reviews the criticism of the libretto to *The Creation*. Edward Olleson, "The Origin of Haydn's *Creation*," *Haydn Yearbook* 4 (1968): 148–66, looks at some of the influences of Milton's text on Van Swietan's libretto.

18. See Landon (p. 343) and Olleson (pp. 149–53) for an account of the generation of the libretto to *The Creation*. Also see Thaler for an account of the performance of *The Creation* in the retranslated English libretto. Haydn's oratorio was performed in English one time in 1800 at Covent Garden, six times in 1803 at Drury Lane, and repeated in 1814 with special recitations of Adam and Eve's Morning Hymn and other Milton selections (p. 283).

19. Haydn, *The Creation, an oratorio for soprano, tenor, and bass soli, SATB, and orchestra* (Sevenoaks, Kent: Novello, n.d.).

20. Biographies of composers, unless otherwise indicated, are from *The New Grove Dictionary of Music and Musicians*.

21. Pio Cianchettini, *A Cantata for two voices, with choruses, and a full band, Words taken from Milton's Paradise Lost. Performed with unbounded applause at the New Argyll Rooms on the 17 April 1820* (London, n.d.).

22. Matthew P. King, *The Intercession, An Oratorio, As performed at the Theatre Royal Covent Garden. The Words selected from Milton's "Paradise Lost"* (London, 1817).

23. Henry R. Bishop, *The Seventh Day, Cantata, Milton's Paradise Lost, Book VII, Composed Expressly for and performed at the Concerts of the Philharmonic Society* (London, n.d.). See *Grove* for further information on Bishop's oratorios: an oratorio, *The Fallen Angel*, was performed on 10 June 1839 in Oxford. Other oratorios on Miltonic themes from this period are Charles Edward Horn's *The Remission of Sin* (1835) and Henry Wylde's *Paradise Lost* (1853).

24. Henry R. Bishop, *The Battle of the Angels. The Celebrated Scene sung with greatest applause by Mr. Braham at the Covent Garden Theatre . . . The words selected from Milton's Paradise Lost* (London, n.d.).

25. John L. Ellerton, *Paradise Lost. An Oratorio in Four Parts, the Words Selected from the Works of Milton and the Music composed by J. L. Ellerton* (London: Kirby and Son, 1862) (libretto only).

26. Biographies of Rubinstein, Du Bois, and Ritter are from *Grove*; for Bossi, see *Enciclopedia della Musica* (Milan: Ricordi, 1963).

27. *Paradise Lost [Das Verlorene Paradies], Oratorio in Three Parts (from a*

poem by Milton), English Version by Josiah Pittman, Music by Ant. Rubinstein (London: Enoch and Sons, 1875).

28. Theodore Du Bois, *Le Paradis Perdu, Drame oratorio en quatre parties, Soli, Choeurs et Orchestre, paroles de Édouard Blau, musique de Theodore Du Bois* (Paris, 1903).

29. M. Enrico Bossi, *Das Verlorene Paradies, Il Paradiso Perduto, Poema Sinfonico Vocale in un Prologo e tre parti per Soli, Cori, Orchestra, ed Organo, Azione poetica tratta dal poema di John Milton di Luigi Alberto Villanis, Musica di M. Enrico Bossi, Deutsch von John Bernhoff und Wilh. Weber* (Leipzig: C. F. Peters, 1902).

30. See Shawcross, "Adaptations," in *A Milton Encyclopedia*. Twentieth-century operas or oratorios on *Paradise Lost* include Alexander McKenzie's *The Temptation* (1914), Igor Markevich's *Paradise Lost* (1935), Maximilian Walten's *Paradise Lost* (unpublished, 1952), Phillip Rhodes's *Paradise Lost* (1972), and Krzysztof Penderecki's *Paradise Lost* (1978).

31. Franz Reizenstein, *Genesis, An Oratorio for Soprano and Baritone Soli, Chorus and Orchestra, Text arranged by Christopher Hassall* (London: Alfred Lengnick and Co., 1958). J. Bertram Fox (1919) and Charles Ives (1921) set the same text (see Shawcross, "Adaptations").

32. Igor Markevitch, *Le paradis perdu. Cantate en deux parties par trois soli (soprano, mezzo, tenor), Choeur mixte et Orchestre.* (Mainz and Leipzig, 1936). Alexander Kastalsky (c. 1918) also has set "Hail Holy Light" (see Shawcross, "Adaptations").

33. "Program," The Louisville Orchestra, World Premiere Performances, The Opera-Oratorio in three acts from "Paradise Lost," by Phillip Rhodes, Based on the Epic Poem by John Milton, Libretto, Prepared by Phillip and Jane Rhodes with the assistance of Richard and Louise Kain, 12 May 1972, 13 May 1972. I wish to thank Professor Joseph Duncan, University of Minnesota, Duluth, for furnishing me with a copy of this program with the libretto included; Krzysztof Penderecki, *Paradise Lost*, Rappresentazione, Libretto after John Milton by Christopher Fry (Mainz: B. Schott's Söhne, 1978).

34. *Milton Quarterly* published several pieces on the performances in November and December of 1978 by the Chicago Lyric Opera: Michael Lieb, "The Penderecki-Fry *Paradise Lost*: A Review," *MQ* 12 (December 1978): 151–52; Stella Revard, "Another View of the Opera *Paradise Lost*," *MQ* 13 (March 1979): 23–25; Roy Flannagan, "Still More on the Opera," *MQ* 13 (March 1979): 25–26. Reviews of performances in Chicago, in Milan (La Scala), and in Munich (Stuttgart Opera) appeared in *Opera* (1979) in the February, April, and August issues, respectively. The La Scala performances were by the Lyric Opera of Chicago with the same cast of singers, but the Munich performances were by producer Everding and included a different cast of singers.

35. See *Opera* 30 (1979).

36. According to *Opera* magazine (August 1979), the Munich production of *Paradise Lost* used no doubles for the dancing parts of Adam and Eve. The idea of using both singers and dancers in *Paradise Lost* goes back at least as far as John Dryden and the stage directions for his unstaged opera.

JEAN GAGEN

Anomalies in Eden: Adam and Eve in Dryden's *The State of Innocence*

Designed as an opera, Dryden's *The State of Innocence* (licensed 1674, published 1677) was never performed.[1] When it is read today, it is read as a play, and, as Bruce King has aptly pointed out,[2] it strikes most readers as a "curious affair." In Dryden's prefatory "Apology for Heroique Poetry," he admits that his poem received its "*entire Foundation*" and "*part of the Design*" as well as "*many of the Ornaments*" from Milton (p. 417). Although Milton had originally planned to compose *Paradise Lost* as a drama but had ultimately deemed the topic unsuitable for that medium, Dryden attempted in *The State of Innocence* something of what Milton himself had eschewed. Dryden modestly confesses, however, that he would be sorry to have his own poem compared with *Paradise Lost*, which he refers to as the greatest and most sublime poem that his age or nation has produced.

Nevertheless, such comparisons have been made from Dryden's day to our own, and *The State of Innocence* has had much adverse criticism directed to it. On more than one occasion, Dryden has been accused of "bad taste" and "effrontery" in debasing a "noble poem."[3] More often, the play has been ignored because of the assumption that it is not worthy of sustained comparison with *Paradise Lost*. Nevertheless, from time to time reputable critics *have* directed some serious critical attention to the play, and as a result much that is helpful in understanding the intellectual background of the play and Dryden's aims in composing it has appeared in print.[4] The verse of the play has also won some genuine plaudits, even from those who have had little respect for much else in the play.[5]

In the light of the willingness of some Dryden critics to spend considerably more than the "hour" that A. W. Verrall considered worth devoting to the play, it is perhaps surprising that the changes which Dryden has introduced into his portrayal of Adam and Eve have been almost totally ignored. Verrall remarked without elaboration that Eve is decidedly less suppressed in Dryden's play than in Milton's epic (p. 228). She is indeed. Although Dryden at times borrowed closely from Milton in his portrayal of Eve as inferior and subordinate to Adam, at other times he departed widely from this conception of Eve.

Not long ago it would have been unnecessary to support the assertion that Milton considered Eve inferior to Adam. But recent studies of Eve have sometimes seen in her a woman with an impressive intelligence, a strong sense of moral responsibility, and, in fact, all the abilities necessary for her to share in the entire range of human activities and achievements.[6] This emphasis on Eve's capabilities rather than on her limitations has encouraged some readers to challenge the idea that Milton did indeed regard Eve as inferior to Adam. Though the idea that Eve (i.e., woman) is inferior to Adam (i.e., man) may seem old-fashioned today, this is precisely what Milton believed was *generally* true and *specifically* true of Eve as he presented her in *Paradise Lost*.[7]

In many passages which the reader has every right to consider authoritative—particularly those spoken by the epic voice, by Raphael, and by the Son of God himself—Eve's inferiority to Adam is repeatedly underscored. In our first introduction to Adam and Eve in Book IV, the epic voice remarks that in both Adam and Eve "The Image of thir glorious Maker shone" (292). But he quickly adds that they are

> Not equal, as thir sex not equal seem'd;
> For contemplation hee and valor form'd,
> For softness shee and sweet attractive Grace,
> Hee for God only, shee for God in him.
>
> (296–99)

In subsequent portions of the epic, we see that Eve shares to a degree in Adam's ability to contemplate, while Adam is not without a "softness" and "sweet attractive Grace" peculiarly his own. Yet there is no question that Milton presents an Eve who is inferior to Adam in mind and body and a step lower than him in the hierarchy of being. Unlike Adam, who has been created to serve and obey God directly, Eve is intended to serve and obey God through serving and obeying Adam.[8] Adam is thus a kind of mediator between God and Eve. Indeed, Adam is given at times an almost godlike authority. Eve actually calls Adam her "Author and Dis-

poser" (IV, 635), and Adam never chooses to correct her, if indeed he realizes that Eve has attributed "overmuch" to him and not enough to God.

The prelapsarian Eve obviously accepts her inferiority to Adam without demur, even claiming that her lot is the happier one since she has a consort "Preeminent to her by so much odds" (IV, 447), while Adam "like consort" to himself can nowhere find. She remarks to Adam, apparently with perfect content, "God is thy Law, thou mine: to know no more / Is woman's happiest knowledge and her praise" (IV, 637–38). Adam also is fully apprised of Eve's inferiority to him. He assures Raphael that he well understands that

> . . . in the prime end
> Of Nature her th' inferior, in the mind
> And inward Faculties, which most excel,
> In outward also her resembling less
> His Image who made both, and less expressing
> The character of that Dominion giv'n
> O'er other Creatures.
>
> (VIII, 540–46)

Nevertheless, Adam's lavish encomium of Eve's beauty alerts Raphael to danger, and he somewhat sternly reminds Adam of the error of "attributing overmuch to things / Less excellent" and advises him to "weigh with her thyself, / Then value," adding that "oft-times nothing profits more / Than self-esteem, grounded on just and right" (VIII, 565–66, 570–72). Even the Son of God, when he is judging Adam after the Fall, reminds Adam that his "perfections far excell'd / Hers in all real dignity" and that for this reason God set him "above her made of thee / And for thee" (X, 149–51).

In the light of evidence such as this, it is certainly correct to say that Milton's Eve is portrayed as inferior to Adam, and that because of her inferiority she is expected to submit to Adam's authority.[9] Moreover, Dryden at times patterns his Eve closely on Milton's in these respects. At other times, however, Dryden's Eve is assigned a sovereignty over Adam which is considered just and right, not only by her and by Adam but by their angelic mentor as well. In fact, throughout the drama Eve assumes a much more active role than Milton's Eve and clearly surpasses her in intelligence. The juxtaposition of these two contradictory concepts of Adam and Eve and their proper relationship to each other creates many strange anomalies.

The reason why Dryden chose at times to depart from the Miltonic

pattern in his portrayal of both Adam and Eve may seem to be a puzzle until one recalls the many forceful, self-assertive women whom Dryden had presented in plays he wrote both before and after the composition of *The State of Innocence*. In his comedies and the comic plots of his tragicomedies, he presents a number of witty, independent young ladies, such as Florimel in *Secret Love* (1667) and Jacinta in *An Evening's Love* (1668), both of whom demand complete parity in their relationships with their gallants. [10] In fact, it has been claimed that, while such women have a variety of literary antecedents, such as Beatrice in *Much Ado about Nothing*, Dryden's emancipated women asserted their independence in innovative ways and helped to provide models for Etherege and later Restoration comic dramatists. [11]

Furthermore, in the heroic dramas which he had been writing for nearly a decade before he composed *The State of Innocence* (and in *Aureng-Zebe*, published in 1676), Dryden presented a number of extraordinarily powerful women. Zempoalla in *The Indian Queen* (1664), Lyndaraxa in *The Conquest of Granada* I and II (1670, 1671), and Nourmahal in *Aureng-Zebe* are all unforgettably heroic female villains, consumed by evil passions and ambitions and eventually destroyed by them. But in these heroic plays there are equally powerful women who are as dedicated to virtue as their counterparts are to evil. In his treatment of these virtuous women's relationships with their lovers, Dryden repeatedly made use of a concept of romantic love and of the proper relation of lover and beloved which is often clearly reflected in the portrayal of Adam and Eve in *The State of Innocence*. It is to these romantic lovers that Adam and Eve are most directly indebted for those elements in their make-up and behavior which are at variance with Milton's Adam and Eve.

This concept of love has a long and complex heritage and history. First popularized by the troubadours, it was a prominent feature in popular French romances and in D'Urfé's *Astrée*, to which they were indebted. It manifested itself in the courtly love tradition as well as in the "new religion" of Platonic love which Henrietta Maria helped to spread through the court of Charles I. And of course it influenced profoundly the amatory patterns of the poetry and romances of the Renaissance. What was distinctive about this attitude toward love was the belief that man's love of a beautiful woman could ennoble the lover and inspire him to perform good and great works. The development of the idea that the lover's lady is his chief "spur" to glorious achievements is associated closely with the idea that the lady exercises sovereignty over her lover and that he must serve her humbly and selflessly, even without assurance of any reward. [12]

Milton incorporates some elements of this tradition of love into *Paradise Lost*, as in the scene in which Raphael has heard Adam speak movingly but dangerously of the intensity and wonder of his love for Eve. Raphael appropriately warns Adam of the danger of overvaluing Eve's beauty and the joys of sexual love. Nevertheless, Raphael admits that love, as distinct from passion, has its seat in reason; it refines the thought, enlarges the heart, and "is the scale / By which to heav'nly Love, thou may'st ascend" (VIII, 591–92). Later, on the morning of the Fall, when Adam is striving to persuade Eve *not* to part from him for the sake of more efficient gardening, he lovingly assures her that from the influence of her looks he receives "Access in every Virtue" and that in her sight he is "More wise, more watchful, stronger if need were / Of outward strength" (IX, 309–12). But on one point Milton remained adamantly opposed to the romantic view of love, and that was on the matter of sovereignty. His conviction that women are in general inferior to men and intended to be subject to them was, he believed, rooted firmly in the teachings of the Bible. In this respect, the weight of very nearly universal opinion[13] and the practice of centuries were on Milton's side, even though the existence of exceptional women who were "above their sex" was also frequently acknowledged—and by Milton too.

Whether or not Dryden personally held a higher view of women than Milton is a matter of conjecture, since Dryden did not choose to express his opinions on this subject directly and unmistakably. What is undeniable, however, is that he was willing (as Milton certainly would not have been) to present sympathetically quite another view of women in his comedies as well as in his heroic dramas. In these heroic plays, a number of beautiful, virtuous women play prominent roles and exert a decisive influence over the men who love them. It is not, however, their beauty alone nor the mere example of their virtue which influences their lovers to choose good rather than evil, truth rather than falsehood. In addition to their personal attractiveness, they have the ability to engage in intellectual arguments and are highly skilled in ethical and even political disputations.

We are told that Catherine, the Christian princess of Alexandria in *Tyrannick Love* (1669), has vanquished in argument fifty of the learned philosophers at the court of Maximin, the tyrant of Rome. And she succeeds in converting one of them, Appollonius, to Christianity by convincing him of its ethical superiority to pagan systems of thought. In the same play, Maximin's wife, Berenice, not only exhorts her lover Porphyrius to control his sensual desire for her but argues persuasively against the belief that the killing of a tyrant is morally justifiable because of the heinousness of his crimes.

In *The Conquest of Granada*, Almahide, who is married to the king of Granada, subjects her headstrong and unruly lover, Almanzor, to lectures on the sacredness of oaths, especially wedding vows. She will allow Almanzor to love her only Platonically and persuades him to fight valiantly, without any hope of reward, for the unjust, inept, and ungrateful king of Granada because her personal loyalty to her husband demands a similar loyalty from her lover and also because her ethical and political code requires absolute loyalty to one's monarch no matter how great the provocation to revolt may be.

In *Aureng-Zebe*, Indamora inspires the villainous Morat, who loves her, to abandon his Hobbesian code of ethics and to embrace hers. When Morat has determined to overthrow the Emperor, who is his father, and to gain the crown for himself, even though it would not be his by right of inheritance since he is a younger son, Morat justifies his intended actions in obviously Hobbesian terms:

> who by force a Sceptre does obtain,
> Shows he can govern that which he could gain.
> Right comes of course, what e'r he was before;
> Murder and Usurpation are no more.
>
> (V.i.145)

Indamora, however, is well able to refute these arguments. She declares that the greatness which Morat seeks in mounting the throne is a false greatness. True renown,she insists, does not lie in power, as Hobbes maintained, or in unjust dominion. Instead greatness and true renown are joined with virtue; only through virtue can genuine fame, "which will to endless Ages last," be won (V.i.146).

Because in the years immediately preceding and following the writing of *The State of Innocence* Dryden had been portraying forceful and highly articulate women—women who were capable in comic contexts of more than holding their own in witty combats with their lovers and capable in heroic contexts of participating effectively in intellectual disputes and wielding power over men's minds—it is not difficult to see why Dryden may have felt very ambivalent over the submissive role Milton had assigned to Eve. At any rate, Dryden did not choose to present either his Eve or Adam entirely in accordance with the Miltonic pattern. Instead, Dryden moved back and forth between the Miltonic view, which emphasizes the necessary subordination of woman to man, and the romantic view, which emphasizes the subservience of the lover to the lady whom he serves and obeys.

Dryden's borrowings from Milton in portraying Eve as inferior to

Adam in reason and obligated to accept his headship over her are sprinkled liberally throughout *The State of Innocence*. In the first moments of his existence, Dryden's Adam is informed by Raphael that he shall be given an appropriate mate—one who, in comparison with the brute creation, will be his equal, yet who will be subject to him. Adam is also told that his "stronger soul shall her weak reason sway" (I.i.432). The night before the Fall, when Lucifer whispers in the sleeping Eve's ear the suggestions which cause her to dream of partaking of the forbidden fruit, he confesses that he has chosen to work on Eve rather than on Adam because Eve is the "weaker" and "the easier prey" (III.i.440). Milton's Satan likewise rejoices in finding Eve alone, for he preferred not to have to contend with her husband's "higher intellectual" (IX, 483). When Raphael and Gabriel descend to warn Dryden's Adam and Eve of the designs of Lucifer, Dryden's Adam, like Milton's, goes forth alone to meet his heavenly visitants. Eve, on the other hand, chooses to retire into the shades because the flood of light from the angelic presences is too much for her to bear. Moreover, in the conversation between Adam and the two angels, Raphael specifically warns him to guide Eve's "frailty" by his "timely care," just as Raphael in *Paradise Lost* had instructed Adam to "warn / Thy weaker" (VI, 908–9) of the threat to them posed by Satan. Likewise, just as Milton's Eve took no part whatsoever in the conversation between Adam and Raphael concerning the war in heaven and the creation of a new world, Dryden's Eve does not participate in the long and abstruse conversation among Adam, Gabriel, and Raphael over free will.

On the morning of the Fall, Dryden's Adam, like Milton's, warns Eve not to leave his side, because the enemy she may encounter is full of art. In fact, Dryden's Adam is less tactful than Milton's, for he bluntly reminds Eve that she is weak, while Milton's Adam avoids any specific reference to Eve's rational inferiority. Without revealing any resentment, Dryden's Eve proceeds to exploit this reference to her weakness as an argument in support of her desire to do some gardening independently of Adam. "Our foe's too proud the weaker to assail," she assures Adam (IV.i.448). After Eve has been seduced by Lucifer, one of the reasons why she momentarily hesitates to share the fruit with Adam is that she believes it is now in her power to be "a Sovraign" and by "knowing more" to make Adam's manhood bow to her (V.i.452).

In the quarrel which follows the Fall, Adam blames Eve for her willfulness, only to have Eve blame him for not having exerted his authority and "Soveraign-like" restrained her from leaving him (V.i.456). As the quarrel continues, Adam scornfully claims that Eve lacks "That reason which her will should sway / And knowes but *just enough* to disobey"

(V.i.457). Like Milton's Adam under similar circumstances, Dryden's Adam refers to Eve as that "fair defect" of nature. Moreover, just as Milton's Adam in his anger with Eve wondered why the wise Creator could not have found some way to generate mankind without using woman, Dryden's Adam refers to his fallen mate as "this helpless ayd call'd wife." In all these respects in which Dryden is borrowing closely from *Paradise Lost*, he is underscoring Eve's inferiority to Adam and her need to accept his sovereignty over her.

At other times, however, Dryden departs radically from Milton in his portrayal of Adam and Eve. In spite of the many references in *The State of Innocence* to Adam's sovereignty over Eve, there is no passage in Dryden's play corresponding to the one in *Paradise Lost* where we are told that Adam's "fair large Front and Eye sublime declar'd / Absolute rule" (IV, 300–301). As a matter of fact, there are numerous references to Eve's sovereignty over Adam. For example, after Raphael has told Adam that his "stronger soul" shall sway Eve's "weak reason," Raphael adds in the very next line that Adam "through love" shall *obey* Eve's *beauty*. In *Paradise Lost*, this is precisely what Raphael insists that Adam should *not* do. After Milton's Adam has eulogized Eve's beauty and its power (VIII, 540–59), Raphael, with a frown creasing his angelic countenance, warns Adam that, while he should love, cherish, and honor Eve, she is unfit to rule over him because she is "less excellent" than he. Dryden's Raphael, however, gives no sign that there is anything amiss in Adam's obeying Eve because of his love for her and her beauty. Instead he seems to assume that such obedience is the proper response of a lover to his beloved.

In fact, on Adam's first sight of Eve, he immediately declares that he yields to her his "boasted Soveraignty" (II.i.435). Though he admits that he was "Made to command," he announces that he chooses freely to obey Eve and to lay at her feet "the whole Creation" (II.i.436). Moreover, he not only refers to her as the fairest of the great Creator's works but tells her that "angels, with pleasure, view . . . her matchless Grace" and "love their Maker's Image" in her face (II.i.436). He even calls her a "Goddess" ordained "on Earth to Reign" (II.i.435). In *Paradise Lost*, it was Satan who told Eve that she should be a goddess adored by angels numberless.

Not only does Dryden at times reverse the roles of Adam and Eve in matters involving sovereignty and submission, but he endows his Eve with far more intellectual curiosity than Milton's Eve and with a far greater capacity for "contemplation." Though we are told in *Paradise Lost* that Eve's ear is not incapable of what is "high," the extent of her intellectual curiosity is apparently limited to wondering why the stars

shine all night when she and Adam are asleep, and even this question reflects the narrowness of her range of vision. Dryden's Eve, on the other hand, plays an active part in a number of intellectual discussions and reveals a greater awareness of the world outside herself, her nuptial bower, and the flowers which, like her Miltonic original, she lovingly tends.

The differences between Dryden's Eve and Milton's become apparent during the early moments of their conscious existence. When Milton's Eve relates to Adam her experiences during the first moments of her life, she refers briefly to her "much wond'ring where / And what I was, whence thither brought, and how" (IV, 451–52). After this brief statement, however, she concentrates her recital on her fascination with what is in reality her own image in a pool of water, and she has to be told by a divine voice that what she is gazing at fondly is an image of her own fair self.

Like Milton's Eve, Dryden's also wonders on awakening into life what and where she is. But like Milton's Adam rather than his consort, Dryden's Eve looks about her at the hills and dales and the sun and asks *them* to tell her who she is and whence she began. Again like Milton's Adam she notices the birds and beasts that are gazing at her. She even senses that they are looking at her as if they are supposed to obey her and as if they wished that they could be what she is. Furthermore, when Adam first speaks to her, he tells her that wherever her "happy footsteps tread, / Nature in triumph" is led after her. Obviously Eve's sovereignty over the lower orders of creation is emphasized by Dryden much more than by Milton, whose Eve not only resembles the Image of God less than Adam does but expresses less well the dominion given over other creatures (VIII, 543–46).

Dryden borrows from Milton the episode in which Eve falls in love with what she fails to recognize as a reflection of herself in a pool of water. But in his treatment of this episode Dryden again makes significant changes. Milton's Eve has to be told by a voice, which is never explicitly identified, that what she sees in the water is her fair self. Dryden's Eve, however, displays a sharper intellect than Milton's, for without any prompting she quickly realizes that there is no other being in the water and that, whatever it is which she is seeing, it is false and deceitful, for she cannot touch or grasp it.

On the morning of the Fall, Dryden's Adam does indeed warn Eve of the danger she may face apart from him. But in almost the same breath he remarks, "Constraint does ill with love and beauty sute / Better be much remiss than too severe." He also asks in purely rhetorical terms, "In love, what use of prudence can there be? / More perfect I, and yet

more pow'rful she" (IV.i.448). Though Adam realizes that he is betraying his obligation to sway Eve's reason, he is only doing what Raphael had originally told him he would do and without any suggestion of disapproval—namely, obey Eve's beauty through love.

After Eve has been seduced by Lucifer's clever tale of the wondrous power of the fruit of the "Heaven'ly tree," she uses the power of her beauty and love to persuade Adam to share her "crime," but she is not suddenly transformed into a villainess seeking the destruction of her mate. She remains a romantic heroine. Though she has fallen, her motives in persuading Adam to share her experience are purer than those of Milton's Eve.[14] Her first thought after tasting the fruit is to hasten to her "dear lord" with the "lovely fruit" so that he may "partake" her "bliss" (IV.i.452), and she seems genuinely convinced that her "crime" is justified and that Lucifer was right in the claims he made for the forbidden tree. In fact, even when she fancies that she is already prepared to ascend to Heaven and leave the base earth behind, she thinks unselfishly of Adam—that it would be unkind to leave him behind because she loves "the wretch." Only as an afterthought does it occur to her that the "Empire" which she thinks she has acquired is sweet. But the possibility that she herself might die and another Eve take her place persuades her that Adam must eat the fruit also and either die with her or live with her in heaven. Her first reaction, however, is a magnanimous desire to share with Adam the godhead which she supposes she has acquired. Only later does fear of possible death and jealousy temporarily corrupt her motives. Milton's Eve, on the other hand, vetoes the idea of sharing her happiness with Adam as soon as the possibility occurs to her. She is intent on keeping for herself whatever advantages she has gained until her fear of death and the prospect of "*Adam* wedded to another *Eve*" confirm her in her decision that Adam shall share with her in either bliss or woe (IX, 828, 831).

In fact, the behavior of Dryden's Eve throughout this entire episode is in every way more dignified and less reprehensible than that of Milton's Eve. Dryden's Eve does not greedily engorge the fruit "without restraint," and she is also guiltless of the idolatry of Milton's Eve, who worshipfully addresses the fatal tree as this most "precious of all Trees" and vows to tend it with care each morning, accompanied by song and "due praise" (IX, 800). Moreover, Dryden's Eve does not lie to Adam as Milton's Eve does. True, she does not tell him the whole truth about her motives. But at least she does not claim that she tasted the fruit chiefly for Adam's sake, so that he might grow up to godhead (IX, 877–78). That Eve is the first to repent and seek forgiveness from her mate puts her in a favorable light too, but in this respect, of course, she is like, rather than unlike, Milton's Eve.

In spite of the fact that Dryden's Eve, in comparison with Milton's, is strikingly purified in her motives and behavior, Adam condemns her for her willfulness in parting from him on the morning of the Fall with a harshness that is not essentially different from the condemnation which Milton's Adam levels against Eve. But Dryden's Eve, in defending herself, bitterly protests the action that Adam now claims she should have taken—that she should have accepted his advice without argument. (Adam apparently forgets how readily he permitted her to go and how absolutely he condemned the very thought of using constraint.) Eve's contempt for the role that Adam now assumes she should have played reveals much the same ability to question the divine scheme of things which Adam himself revealed in his long argument with Raphael and Gabriel over free will and determinism. Her words have an uneasy ring of truth about them:

> Better with Brutes my humble lot had gone;
> Of reason void, accountable for none:
> Th' unhappiest of creation is a wife,
> Made lowest in the highest rank of life:
> Her fellow's slave; to know and not to chuse:
> Curst with that reason she must never use.
>
> (V.i.457)

Although Eve eventually admits to Adam that she was wrong in demanding that she have her own way, she never retracts what she has said about the unhappy role of women.

When the reconciliation between Adam and Eve finally takes place, both of them admit that they have sinned against Heaven and deserve punishment. But there is no scene in Dryden's play in which Adam and Eve express their penitence before God and seek his forgiveness. Instead they ask each other for forgiveness and receive it as well as a mutual restoration of their love for each other. As Dryden presents Adam and Eve's reconciliation, it is much more like that of two romantic lovers who have had a serious lovers' quarrel than that of two penitent sinners who need to be forgiven by their Maker.

When Raphael arrives to pronounce judgment on Adam and Eve, his words to Eve are far harsher and more degrading than the corresponding words in *Paradise Lost*. He refers to the command that women must obey their husbands as a "thraldome" and "a curse, of future wives abhorr'd" (V.i.459). Perhaps not too much is being read into these lines if one suggests the possibility that Dryden is expressing indirectly some sympathy for Eve's protest against her plight and that of her future daughters. At any rate, the "thraldome" with which she, along with her

daughters, is supposedly to be cursed does not prevent her from taking an active part in the conversation with Raphael, and, as in earlier scenes, much of what Eve says was spoken by Adam in *Paradise Lost*.

For example, when Milton's Adam is not yet reconciled either with God or with Eve, he protests that he had never asked to be created and that the terms by which he was to hold the good that was given him were too hard (X, 741–52). But in *The State of Innocence*, it is Eve who protests to Raphael that God's laws are too hard. She then asks the question which, with slight variations, has echoed down the ages:

> Did we solicite Heav'n to mould our clay,
> From darkness, to produce us to the day?
> Did we concur to life, or chuse to be,
> Was it our will which form'd, or was it he?
> (v. i. 458)

Though Adam quiets Eve's protests by insisting that they must not accuse their Maker of injustice, Eve continues to participate actively in the conversation with Raphael.

Instead of being put to sleep, Dryden's Eve witnesses with Adam the vision of the future, which concentrates on "death of several sorts." Moreover, it is Eve who asks Raphael what death is, and she joins Adam in lamenting the future miseries of mankind and the doubtful boon of life to man who is condemned henceforth to suffering and to death. After Adam and Eve are later given a vision which assures them that their race will "revive" and live in "deathless pleasures" blessed with immortality, Adam apostrophizes the "goodness infinite" which has produced such good from so much ill. But it is Eve rather than Adam who pronounces the paradox of the fortunate fall when she remarks that she is "*Ravish'd* with Joy" and can but "half repent / The sin which Heav'n makes happy in th' event" (V. i. 461).

In *Paradise Lost*, when Michael informs the Edenic couple that they must leave Eden, Adam is most afflicted by the thought that he will be deprived of the "blessed count'nance" (XI, 317) of God, that he will not be able to frequent with worship the places where God vouchsafed his divine presence and to relate to his sons just where God had stood visible before him and where he had heard God's voice (315–27). Dryden's Adam engages in a similar lament over leaving the places where he conversed with winged messengers from heaven. But Dryden's Eve also voices a lament, and unlike Milton's Eve her lament is not limited to leaving her flowers and her nuptial bower. Instead she first expresses her sorrow over leaving a place frequented by angels and nearer to heaven than the outer world which lies before them. Milton's Eve relates

to the supernal world chiefly through Adam. In fact, when Eve asks why the stars shine all night, Adam has to remind her that millions of spiritual creatures walk the earth unseen both day and night and that the two of them have often heard these celestial beings singing songs in praise of their great maker. But Dryden's Eve does not have to be reminded of the angelic presences. She is more aware of the heavenly world than Milton's Eve and values her contact with it more highly, for she is saddened at the prospect of leaving the "happy shades" where angels first practiced hymns and strung their "tuneful Harps when they to Heav'n wou'd sing" (V.i. 461).

By borrowing from Milton the notion that Eve is inferior to Adam and rightfully subject to him and then juxtaposing this idea with a view of Eve which accords her sovereignty over Adam, an active, inquiring mind, and the ability to concern herself with issues not limited to her flowers, her nuptial bower, and her relationship to Adam, Dryden has inevitably created an interesting and anomalous portrait of Eve and of Adam as well. Although Milton's Eve is a rational being whose ear is capable, we are told, of what is "high," who can question, reflect, and often argue very well indeed, we are repeatedly shown that in comparison with Adam she is limited both intellectually and spiritually. In fact, in her unfallen state, Milton's Eve seems to worship Adam rather than God, for she refers to Adam as her "Author" and "Disposer" and is content to know nothing of God except what Adam chooses to tell her (IV, 635–37). In spite of the poetry Milton lavishes on Adam's description of his love for Eve and her beauty, Milton's Eve seems at times a little less than fully human.[15] Although there are contradictions in Dryden's portrait of Eve because of her dual ancestry, Dryden has nevertheless presented an Eve who is a genuine intellectual and spiritual partner to Adam and who is much more capable of "careful questioning" and "sober reflection"[16] than Milton's Eve.

The State of Innocence is not an unrecognized masterpiece. Nevertheless, Dryden's portraits of Adam and Eve certainly deserve attention, for they are among the most interesting and paradoxical features of a paradoxical play, one which is indeed worthy of a sustained comparison with *Paradise Lost*.

NOTES

1. The edition used for *The State of Innocence* and for all other references to Dryden's plays is *Dryden: The Dramatic Works*, ed. Montague Summers, 6

vols. (London: Nonesuch Press, 1931–32). In the Theatrical History attached to the Summers edition of the play, which is in vol. 3, Summers refers to an adaptation of *The State of Innocence* which was performed by Robert Powell's marionettes in the early eighteenth century and which drew large crowds to the puppets' playhouse, Punch's Theatre in the Little Piazza, Covent Garden (p. 410). In my references to *The State of Innocence* or to any of Dryden's other plays, I shall use Roman numerals to refer to act and scene, Arabic numerals to refer to pages.

2. "The Significance of Dryden's *State of Innocence*," *SEL* 4 (1964): 371.

3. See Charles E. Ward, *The Life of John Dryden* (Chapel Hill: Univ. of North Carolina Press, 1961), p. 104. Ann Davidson Ferry, in *Milton and the Miltonic Dryden* (Cambridge: Harvard Univ. Press, 1968), expresses similar sentiments.

4. A. W. Verrall, in *Lectures on Dryden*, ed. Margaret De G. Verrall (Cambridge: Univ. Press, 1914), may seem unduly patronizing in asserting that *The State of Innocence* is worth an hour of a reader's time (p. 217). Yet Verrall admits that the play is "full of interest," and his study (Ch. 8, pp. 217–37) is still the best *general* survey of the differences between Milton's poem and Dryden's play yet to appear.

P. S. Havens, in "Dryden's 'Tagged' Version of *Paradise Lost*," in *Essays in Dramatic Literature: The Parrott Presentation Volume*, ed. Hardin Craig (Princeton: Princeton Univ. Press, 1935), pp. 383–97 argues that *The State of Innocence* was designed principally as an experiment: first, to apply in a concrete example criticisms Dryden had made of *Paradise Lost*; second, to test his theory that a heroic play ought to be an imitation on a small scale of a heroic poem; and finally, to instruct himself so that the epic he intended to write might benefit from this experiment.

Bernard Harris, in "'That Soft Seducer, Love': Dryden's *The State of Innocence* and Fall of Man," in *Approaches to Paradise Lost*, ed. C. A. Patrides (London: Edward Arnold, 1968), pp. 119–36, explores the various difficulties in judging what Dryden's artistic intentions were in *The State of Innocence*. Among other points, Harris draws attention to the fact that the dignity of Adam and Eve at the close of the play has been established by Dryden's emphasis on the "transforming power of love" (p. 133).

Bruce King, in "The Significance of Dryden's *State of Innocence*," examines Adam's argument with Raphael and Gabriel over free will in the light of seventeenth-century debates on free will and determinism, especially the controversy between Hobbes and Bishop Bramhall. King provides a valuable intellectual background to the play here and in *Dryden's Major Plays* (New York: Barnes and Noble, 1966), pp. 95–115.

5. T. S. Eliot, in "John Dryden," in *Selected Essays*, new ed. (New York: Harcourt, Brace, and World, 1966), considers *The State of Innocence* a "feeble play" but admits that Dryden has shown himself capable of producing splendid verse (p. 271). Bonamy Dobrée, in "Milton and Dryden: A Comparison and Contrast in Poetic Ideas and Poetic Method," *ELH* 3 (1936), pays Dryden the compliment of having conferred inestimable benefits on English poetry (p. 99). The favorable opinion of Dryden's verse is disputed by Morris Freedman, who, in "The 'Tagging' of *Paradise Lost*: Rhyme in Dryden's *The State of Innocence*," *Milton Quarterly* 5 (1971): 18–22, asserts that Dryden's work illustrates few of the advantages of rhyme and that the merits of the play lie chiefly in its brevity.

6. See Barbara Lewalski in "Milton on Women—Yet Once More," in *Milton Studies*, ed. James D. Simmonds, vol. 6 (Pittsburgh: Univ. of Pittsburgh Press, 1974), p. 9. Lewalski admits that Eve's intellectual powers are weaker than Adam's and that he is her superior and her appointed guide. But Lewalski emphasizes Eve's capabilities more than her weaknesses, pointing out, for example, that the prelapsarian educational curriculum is precisely the same for her as for Adam, that she is not limited to her maternal role, and that Adam's leadership is meant to function in such a way that Eve's freedom of choice, adult responsibility, and personal growth are enhanced (pp. 7–9, 13). More recently, Diane McColley, in *Milton's Eve* (Urbana: Univ. of Illinois Press, 1983), has devoted an entire book to a study of Eve—a book which is valuable for its many insights into Milton's portrayal of Eve as well as for information McColley provides about the presentation of Eve in iconographic and literary traditions and about Milton's departures from these traditions. McColley acknowledges briefly Eve's subordination to Adam in creation (pp. 51–52), in her perceptions (p. 88), and in her ability to reason "straight to first causes" (p. 89). But McColley's emphasis is on the positive factors in Eve's mind and personality, and she more than once suggests that there is a kind of equivalence, if not absolute equality, between Adam and Eve, or that perhaps Adam and Eve are unequal only in the sense of being different, and that Eve's subordination to Adam has no suggestion in it of inferiority (see, for example, esp. pp. 22, 35, 41, 129). However provocative and illuminating McColley's book is, she, like Lewalski, does not take into account sufficiently the repeated emphases on Eve's very real inferiority to Adam on the part of "voices" in the epic that are indisputably authoritative.

7. Edition used: *John Milton: Complete Poems and Major Prose*, ed. Merritt Y. Hughes, 1st ed. (New York: Odyssey Press, 1957). In my citations, Roman numerals refer to the number of the book in the epic and Arabic numerals to the lines.

8. It is true, of course, that Adam also serves Eve, though not in the same way that Eve serves Adam. He serves her by loving, guiding, and teaching her, she by loving and obeying him and learning from him.

9. McColley says that Milton purges subordination of all idea of inferiority (p. 35). Yet the entire rationale for the subordination of the unfallen Eve to Adam is that she is inferior to Adam "in the mind / And inward Faculties" (VIII, 541–42). The Son of God himself reminds Adam that, because his perfections excel Eve's, God has set him "above her" (X, 149).

10. See the discussion of these and other independent ladies in Restoration comedy and the provisos they often make with their lovers in Jean Gagen, *The New Woman: Her Emergence in English Drama, 1600–1730* (New York: Twayne, 1954), pp. 141–59.

11. See Susan Flora Glassman, "The Emancipated Woman in John Dryden's Comedies," DAI, Humanities and Social Sciences, 39A Nos. 5–6 (1978), 2953A (Univ. of Rhode Island).

12. See Maurice Valency, *In Praise of Love* (New York: Macmillan, 1958), esp. pp. 15, 77–78. See also Jefferson Butler Fletcher, *The Religion of Beauty in Woman* (New York: Macmillan, 1911), pp. 32–38; and Kathleen Lynch, *The Social Mode of Restoration Comedy* (New York: Macmillan, 1926), p. 46.

13. Of course voices had been raised already in behalf of the equality of women, but these voices were still a small minority.

14. Harris briefly alludes to the fact that Eve's loving concern for Adam immediately after she tastes the fruit preserves her as a romantic heroine and that she is not Milton's greedy Eve, who engorges without restraint (p. 135). Otherwise there are few, if any, points of contact between Harris's approach and mine.

15. This statement may seem outrageous to some readers. But it is justified by the spiritual inferiority which Milton assigns to Eve—an inferiority greater than that attributed to her by a significant number of Church Fathers and Reformation theologians and contradicted notably by many devout Puritan women of Milton's own day.

16. The quoted phrases are from McColley, p. 29.

LEO MILLER

"Why Was Spontini's Opera *Milton* Sponsored by Empress Josephine?"

PARIS, 1804

MILTON, *an opera, music by Gaspard Spontini, libretto by Joseph Etienne de Jouy and Joseph-Armand-Michel Dieula-foy, dedicated to the Empress Josephine, performed by the Comédiens Ordinaires de L'Empereur at the Théâtre National de l'Opéra Comique, Paris. World Première, November 27, 1804.*

Paris, 1804. Fifteen years have passed since the storming of the Bastille. It is eleven years since a reign of terror has in six frenzied months retaliated on the seigneurs of the Ancien Régime for their six centuries of cold-blooded terror over peasants and villagers. The great French Revolution is finished; and its fruits are *liberty* to compete in a free trade economy, *equality* before the courts of law, *fraternity* in a soldier's uniform under the eagles of new imperial France. On a rising tide of popular patrioteering, profitable nationalism, and chauvinist militarism, Napoleon Bonaparte has moved from General to Consul, 1797; from Consul to Emperor, by proclamation May 18, 1804, by coronation December 2, 1804.

Life goes on. Paris craves entertainment. Citizens seek escape from their own paltry lives at the theatre, and petty talents, heirs to Corneille and Molière, eke out a living conceiving ephemeral fantasies for their divertissement.

THE LIBRETTISTS

Victor Joseph Etienne de Jouy, child of the eighteenth-century Enlightenment, reciting pages from both Voltaire and Horace by heart, is graduated from military school as an officer of artillery and sees service in the French enclaves in India. Enamored of a Ceylonese girl, he abducts her from a pagoda, is attacked by enraged lascars, the girl is killed in the fracas, he is jailed. Rescued by his fellow officers, he falls overboard into the sea, is picked up by a British ship and carried to Madras. He reaches Bengal, where he rushes in to save the life of a Hindu widow about to be burned alive in a suttee sacrifice on her husband's bier, has to be rescued again from the hands of furious fanatics by a detachment of Sepoys. Back in France at age twenty-four, he fights for the Revolution in its army. At a banquet, the name of Marat is offered as a toast; he does not respond, he is accused of covert royalism, he is sentenced to death, he escapes to Switzerland; returns after the fall of Robespierre, again serves in the army, is jailed again on political charges, finally withdraws from the military to a fifty-year career in literature, leaving twenty-seven volumes of collected works in octavo.

His collaborating librettist is Joseph-Marie-Armand-Michel Dieulafoy, born at Toulouse, bred to a career in the law, sent overseas to manage his family's speculative plantations in Santo Domingo, arrives there just in time to lose everything in slave uprisings, barely escaping with his life from a massacre in 1793, fleeing to Philadelphia, returning later to France. His personal experience puts him in tune with the changing times, writing epigrams against the Jacobins. Turning to the popular kind of theatre then known as *vaudeville*, he earns the plaudits of the monarchists by putting on the stage the figure of a noble king in time of anarchy.[1]

In 1804 Jouy and Dieulafoy make the acquaintance of a young aspiring composer, Gaspard Spontini.

SPONTINI

Gaspare Luigi Pacifico Spontini (1774–1851) is a name which does not these days evoke a ready response even among opera afficionados, although he is amply treated in biographies and encyclopedias, and at least four of his major works may be heard on phonograph records. His best known opera, *La Vestale*, has in our time been sung at La Scala in

Milan, by Maria Callas, at the Metropolitan in New York by Rosa Ponselle and Ezio Pinza.

As a child Spontini was destined by his parents for the church, but he fled from family control to the study of music. He early found favor as composer at the royal court of Naples, which he followed, at first, to Palermo, after the French invasion; but by 1803 he had made his way to the bustling Paris of Napoleon Bonaparte. Here one of his first efforts at opera, *La Finta Filosofa*, fell victim to the vociferous hostility of local cliques and claques. It was his good fortune, however, to meet up with Jouy, which led to the composition of *Milton*, of *La Vestale*, and (with the blessing of imperial patronage) to a successful career in Paris for fifteen years.

In 1819, somewhat sidetracked in France by the rising popularity of Rossini, he accepted appointment as court composer to King Friedrich Wilhelm of Prussia. In Berlin he had a second distinguished career, despite recurrent political intrigues and personal rivalries, despite constant clashes, at least partly caused by his own eccentricities and his exalted sense of self-esteem; so he continues there for twenty-one years, until 1841, when he was occulted by the ascendant star of Meyerbeer.[2]

It is a common fate of fashionable composers applauded in one generation to be cast off as old-fashioned in the next. Some revive in popularity. Others, like Spontini, somehow fade into obscurity. But in his own day, Beethoven praised him highly, and to Berlioz and Wagner, Spontini ranked with the greatest.[3]

Berlioz in fact worshipped Spontini; wrote in his memoirs that he learned his art "by studying the methods of the three modern masters, Beethoven, Weber and Spontini"; and linking the names of Gluck and Spontini, he "could conceive of nothing more grand, sublime or true than the works of those great composers."[4]

Wagner frankly acknowledged how much his *Rienzi* owed to Spontini (*Eine Mitteilung an Meine Freunde*, 1851). In the same year he wrote an obituary essay, *Erinnerungen an Spontini*, concluding:

> Spontini aber—starb, und mit ihm ist eine grosse, hochachtungsvolle und edle Kunstperiode nun vollständig ersichtlich zu Grabe gegangen; sie und er gehören nun nicht mehr dem Leben, sondern—der Kunstgeschichte einzig an. Verneigen wir uns tief und ehrfurchtsvoll vor dem Grabe des Schopfers der *Vestalin*, des *Cortez*, und der *Olympia*.

> [But Spontini—is dead, and with him a great, an inestimable and noble period in art has now manifestly descended to the grave. It

and he belong no more to Life but only—to the History of Art. Let us bow in deep and reverent homage before the tomb of the creator of the *Vestale*, the *Cortez*, and of the *Olympia*.]

For Wagner this was no mere memorial hyperbole. Thirty years later, in 1880, drawing up proposals for the Naples Conservatory, Wagner specifically recommended the study of Spontini:

> Was das tragische Genre betrifft, so würde ich zunächst die beiden *Iphigenien* von Gluck und dann die *Vestalin* von Spontini zum Studium empfehlen.
>
> [With regard to the genre of tragedy, I would first of all recommend the study of both the *Iphigenias* of Gluck and then the *Vestale* of Spontini.][5]

In 1804 Spontini was still a struggling newcomer to the Parisian scene when Jouy and Dieulafoy recognized his talent and invited him to compose music for a one-act opera about the English poets Milton and Davenant, based on a story recently brought to France from England by homecoming royalist refugees.

MILTON AND DAVENANT: THE TRADITION AND THE LIBRETTO

Whose idea it first was, we do not know, Jouy's or Dieulafoy's, or who may have suggested it to them, this anecdote which links John Milton and Sir William Davenant in a rigid satisfaction, a life for a life. The facts are few but the tradition is strong: in the early years of the English Commonwealth, when Davenant's life was forfeit because of his exploits for the Stuarts, Milton interceded on his behalf (*so it is said*); and when, at the Stuart Restoration, Milton was marked among those to die, Davenant interceded for him; and thereby both lived (*so it is said*).

As for verifiable facts, what really may have happened, in 1804 Jouy and Dieulafoy knew no more than anyone else has known since 1660. As contrivers of libretti and lyrics for opera, they had total license. The genre permitted *anything*. About Restoration England, the Parisian theatre-goers knew nothing and would swallow everything. Some journalists, indeed, scoffed at the historicity of the tale; the librettists responded by citing Samuel Johnson's *Lives of the Poets* (1781), the *Life of Milton* by William Hailey (their misspelling) in its 1799 printing, and their

clincher, "Pacquerson" (their error for *Betterton?*), who heard it from Davenant himself and told Alexander Pope.[6]

With only this scrap of undocumented hearsay passed down, and a bland ignorance of seventeenth-century Britain, they proceeded to concoct their one-act playlet, pen-free and fancy-loose.

They set the scene in the village of "Huston" (*intending "Horton," perhaps, and so, an anachronism*), in a cottage belonging to Godwin (*his name taken, perhaps, from Milton's fellow-proscriptee John Goodwin*), who is described as a Quaker and justice of the peace (*in 1660 an impossible combination, fantastic even for an opera libretto*). Here blind and hunted Milton (*described as age 60, actually 51*) is in hiding, while Godwin is away seeking help. With Milton is his "daughter Emma," a young woman of marriageable age (*his real daughters, Anne, 14, Mary, 12, Deborah, 8, do not appear*). Contrary to Godwin's strict instructions, his niece Charlotte (described as unwed at 38) has admitted a stranger into their household, a young man named Arthur, ostensibly to be reader and amanuensis for blind Milton. The stage setting shows two rooms, Godwin's and Milton's.

After the overture, Scene 1 begins with Emma reproaching Charlotte for imprudently introducing this stranger Arthur, and for pretending, to blind Milton, that Arthur is an old man. Charlotte long ago had resigned herself to being a role model of unwed innocence, but is now infatuated with Arthur, deluding herself that he loves her. Emma is dependent on Charlotte's uncle Godwin for her father's safety; she accepts Charlotte's illusory belief, and consents to Arthur's continued stay, particularly since she herself is being tutored by Arthur in music and drawing.

Godwin returns home, reporting failure in his efforts at Court in Milton's behalf. His distrust of Arthur's presence is not at all dispelled by Charlotte's assurances that she is loved by this young man of twenty-five. Arthur enters, and Godwin, despite embarrassed interruptions from Charlotte, refers (delicately, he thinks) to this matter of love. A comic trio follows, all three singing about secret love: Godwin about Arthur's alleged secret love for Charlotte, Charlotte about her secret love for Arthur, and Arthur about his fear that they have guessed his secret love for Milton's "daughter Emma." Godwin is anxious, Charlotte is ecstatic, Arthur is horrified (Scenes 2, 3, 4).

Emma, alone, sings a solo: she also loves Arthur, and is certain it is in vain. She is a flower doomed to bloom unseen in the desert. Arthur enters, and there follows a sadly comic scene of mutual misunderstanding: Emma implies congratulations are due to Charlotte (Scenes 5, 6). Alone, Arthur soliloquizes: a secret duty imposed upon him has brought him into this house, and that responsibility forbids him to make any

advances to Milton's daughter. His "jockey" comes in (*all English gentlemen had personal jockeys, as every Frenchman knew*), addresses him as "milord," and delivers a message: Arthur's letters have reached King Charles II, Milton's name is on the fatal list (Scenes 7, 8, 9).

Scene 10: Milton enters into his room, with Emma, and notices the aroma of a new plant. It is a prothea, an import from abroad, a gift from Arthur. Milton sings a solo "Hymn to Light" (*echoing phrases from "Paradise Lost"*). Arthur joins them. Milton compares himself to unfortunate Oedipus, his "daughter Emma" to faithful Antigone; Arthur suggests Homer instead (*rather prematurely; Milton's epic is unfinished, and Milton fears it never will be finished*). To divert the blind poet, Emma and Arthur sing a Scottish air about an old man happy with his daughter in a secluded mountain refuge till love intrudes in the form of a stray hunter (Scene 11). Godwin comes in. He had gone to Court, hoping to remind Charles II's favorite, Davenant, of that day April 24, 1650, when at City Hall, London, he was under sentence of death, but was saved when his one-time schoolfellow Milton appealed to the Protector (*They were never schoolfellows, there was no City Hall in London, and Cromwell was not Protector till 1653*). But instead, he heard that Davenant is hotly pursuing Commonwealth fugitives, such as Milton. Arthur's manner is cold, and Godwin is convinced the young man is a covert Royalist agent (Scenes 12, 13).

Privately Milton consults Arthur about attempting to flee to the Scottish highlands for safety (*Jouy and Dieulafoy were oblivious to the role of Scotland during the Interregnum, and of the Stuart risings of 1715 and 1745 in the Highlands*). Arthur proposes to accompany Milton, who says, that for an old man, Arthur sounds like a twenty-year-old carrying off a mistress. Emma comes in, to continue copying, with Arthur's guidance, a portrait of Heloise; they sing a touching duet full of double meanings, since Arthur's status is pathetically similar to Abelard's at the first meeting of that historic couple. While they are engaged in their drawing, they overhear Godwin talking to Charlotte. Godwin has cross-examined Arthur's valet, who has revealed that perfidious Arthur really loves Emma. This revelation is all that Emma and Arthur need, and they unite in a love duet (Scenes 14 to 18).

Milton re-enters, blindly feeling his way. Inspired, he sings of the love of Adam and Eve. Arthur and Emma, in analogy with Milton's poetry, move into each other's arms. Blind Milton, unaware of this parallel drama, is in poetic rapture, says he feels he is in Eden, whereupon Godwin announces that the Serpent has also appeared, meaning Arthur, ready to betray Milton to his death. Already the house is surrounded by men in royal livery asking for Arthur, who goes out to meet them. There

is a tense moment of despair and horror. Arthur re-enters, bringing a letter; it announces a royal pardon for Milton. Arthur identifies himself as Lord William Davenant, Jr., entrusted by his father on his deathbed with the responsibility of saving Milton (*Davenant lived to 1668; this son was three years old in 1660*). Arthur asks Emma's hand in marriage, Milton consents, and the entire troupe, including the once-again disappointed Charlotte, join in a concluding "Hymn to Hymen" (Scenes 19 to 23).

THE PERCEPTION OF MILTON IN FRANCE, 1650–1804

To appreciate the significance of this opera libretto in its time, we need to review the reputation of Milton in France over the years. Its factual boners are one indication of how he was misunderstood.

Milton's first celebrity there, as elsewhere, was political, and officially it was negative. His *Pro Populo Anglicano Defensio* was burned by the public hangmen in Paris and Toulouse in 1651: any who may have admired its principles were discreetly silent. Milton's first work translated into French was *Eikonoklastes*, done by John Dury, who was no great prose stylist; there is no conspicuous record that it received any favorable reception. A century and a half later, at the outbreak of the French Revolution, his *Defensio* and his *Areopagitica* had some brief circulation through paraphrases by Mirabeau and his circle. [7]

Milton's poetry was not unknown in eighteenth-century France, but mainly by translations, none of which conveyed any true feeling of its genius. Translation between languages is always a problem, but consider what happens to Milton's allegory of female Sin bringing forth male Death, when, in French, Sin is male *Le Péché*, and Death is female *La Mort*. The favorable judgments in Voltaire's serious writings reached very few, but his flip mockery of *Paradise Lost* registered on everyone who read *Candide*. [8] Napoleon was no great critic of literature, but the opinion credited to him in his Consulat days was then characteristic of most Frenchmen: Shakespeare was in no way comparable to Corneille and Racine, while Milton was memorable only for his invocation to the sun, and two or three other fragments. [9]

With the irony of which only true history is capable, what won for Milton real recognition in France as a great writer was the arrival in England of the royalist emigration of the 1790s. These émigrés learned to read English well, and began to appreciate Milton's poetry in the originals. These Frenchmen returning to France later in that decade and

during the next fifteen years brought this new appreciation with them. The first forty years of the nineteenth century saw a great increase in attention to Milton's works in France, where he became a hero of the Romantic era as he was in England. In 1804, our year of particular interest, *Paradise Lost* was published in a French verse translation by Jacques Delille, and the same issues of the daily *Journal des Débats* which reported the first performances of *Milton* featured five install- ments of a long review of Delille's work. In that same 1804, *Paradise Lost* was printed in Paris, in English, and between March and June the literary weekly *Mercure de France* ran four articles of commentary by the royalist Charles Delalot. [10]

Always with the irony of history. It was not as the revolutionary re- publican that these royalists re-introduced Milton into France. They described him as a great poet who had *reprehensibly* served the usurper Cromwell, who shared in the *criminal* guilt of Charles I's death, who would have suffered a penalty he deserved except for the gratitude of Davenant and the generous and magnanimous pardon granted by Charles II.

Chateaubriand, the most influential of the returning émigrés in the world of belles-lettres, was also the one who did the most, initially, for Milton's reputation among them. It was he also who gave this royalist image of Milton its classic expression, in his poem *Milton et Davenant*, written in London, 1797:

> Charles avoit péri: des bourreaux-commissaires,
> Des lois qu'on appeloit révolutionnaires,
> L'exil et l'échafaud, la confiscation . . .
> C'étoit la France enfin sous la Convention.
>
> Dans des nombreux suivants de l'étendard du crime
> L'Angleterre voyoit un homme magnanime:
> Milton, le grand Milton (pleurons sur les humains)
> Prodiguoit son génie à de sots puritains;
> Il détestoit surtout, dans son indépendance,
> Ce parti malheureux qu'une noble constance
> Attachoit à son roi. Par ce zèle cruel,
> Milton s'étoit flétri des honneurs de Cromwell.
>
> Un matin que du sang il avoit appétence,
> Des prédicants-soldats traînent en sa présence
> Un homme jeune encor, mais dont le front pâli,
> Est prématurément par le chagrin vieilli,
> Un royaliste enfin. Dans le feu qui l'anime,

Milton d'un œil brûlant mesure sa victime,
Qui, loin d'être sensible à ses propres malheurs,
Semble admirer son juge et plaindre ses erreurs.
"Dis-nous quel est ton nom, sycophante d'un maître,
Vassal au double cœur d'un esclave et d'un traître,
Réponds-moi."—"Mon nom est Davenant." A ce nom
Vous eussiez vu soudain le terrible Milton
Tresaillir, se lever, et, renversant son siége,
Courir au prisonnier que la cohorte assiége.

"Ton nom est Davenant, dis-tu? ce nom chéri!
Serois-tu ce mortel, par les Muses nourri,
Qui, dans les bois sacrés égarant sa jeunesse,
Enchanta de ses vers les rives de Permesse?"

Davenant repartit: "Il est vrai qu'autrefois
La lyre d'Aonie a frémi sous mes doigts."

A ces mots, répandant une larme pieuse,
Oubliant des témoins la présence envieuse,
Milton serre la main du poète admiré.
Et puis de cette voix, de ce ton inspiré,
Qui d'Ève raconta les amours ineffables:
"Tu vivras, peintre heureux des élégantes fables;
J'en jure par les arts qui nous avoient unis
Avant que d'Albion le sort les eût bannis.
A des cœurs embrasés d'une flamme si belle,
Eh! qu'importe d'un Pym la vulgaire querelle?
La mort frappe au hasard les princes, les sujets;
Mais les beaux vers, voilà ce qui ne meurt jamais,
Soit qu'on chante le peuple ou le tyran injuste:
Virgile est immortel en célébrant Auguste!
Quoi! la loi frapperoit de son glaive irrité
Un enfant d'Apollon? . . . Non, non, postérité!
Soldats, retirez-vous; merci de votre zèle!
Cet homme est sûrement un citoyen fidèle,
Un grand républicain: je sais de bonne part
Qu'il s'est fort réjoui de la mort de Stuart."

"Non," crioit Davenant, que ce reproche touche.
Mais, Milton, de sa main en lui couvrant la bouche,
Au fond du cabinet le pousse tout d'abord,
L'enferme à double tour, puis avec un peu d'or
Éconduit poliment la horde jacobine.

Vers son hôte captif ensuite il s'achemine,
Fait apporter du vin, qu'il lui verse à grands flots.
Sème le déjeûner d'agréables propos:
De politique point, mais beaucoup de critiques
Sur l'esprit des Latins et les grâces attiques.
Davenant recita l'idylle du *Ruisseau*;
Milton lui repartit par le vif *Allegro*,
Du doux *Penseroso* redit le chant si triste
Et déclama les choeurs du *Samson agoniste*.
Les poètes, charmés de leurs talents divers,
Se quittèrent enfin en murmurant leurs vers.

Cependant, fatigué de ses longues misères,
Le peuple soupiroit pour les lois de ses pères:
Il rappela son Roi; les crimes refrénés
Furent par un édit sagement pardonnés.
On excepta pourtant quelques hommes perfides,
Complices et fauteurs des sanglants régicides:
Milton, au premier rang, s'étoit placé parmi.

Dénoncé par sa gloire, au toit d'un vieil ami
Il avoit espéré trouver ombre et silence.
De son sort, une nuit, il pesoit l'inconstance:
D'une lampe empruntée a la tombe des morts
La lueur pâlissante éclairoit ses remords.
Il entend tout à coup, vers la douzième heure,
Heurter de son logis la porte extérieure;
Les verrous sont brisés par de nombreux soldats.
La fille de Milton accourt; on suit ses pas.
Dans l'asile secret un chef se précipite:
Un chapeau de ses yeux venant toucher l'orbite
Voile à demi ses traits; il a les yeux remplis
De larmes qu'un manteau reçoit dans ses replis.
Milton ne le voit point: privé de la lumière,
La nuit règne à jamais sous sa triste paupière.

"Eh bien! que me veut-on?" dit le chantre d'Adam.
"Parlez: faut-il mourir?"—"C'est encor Davenant,"
Répond l'homme au manteau. Milton soudain s'écrie:
"O noire trahison! moi qui sauvai ta vie!"

"Oui," repart le poète interdit, rougissant,
"Mais vous êtes coupable et j'étois innocent.
Ferme stoïcien, montrez votre courage!

Mon vieil ami, la mort est le commun partage:
Ou plus tôt, ou plus tard, le trajet est égal
Pour tous les voyageurs. Voici l'ordre fatal."

La fille de Milton, objet rempli de charmes,
Ouvre l'affreux papier qu'elle baigne de larmes:
C'est elle qui souvent, dans un docte entretien,
Relit le vieil Homère a l'Homère chrétien
Et des textes sacrés interprète modeste,
A son père elle rend la lumière céleste
En échange du jour qu'elle reçut de lui.
Au chevet paternel empruntant un appui,
D'une voix altérée elle lit la sentence:
"Voulant à la justice égaler la clémence,
Il nous plaît d'octroyer, de pleine autorité,
A Davenant, pour prix de sa fidelité,
La grâce de Milton. CHARLES." Qu'on figure
Les transports que causa la touchante aventure,
Combien furent de pleurs dans Londres répandus
Pour les talents sauvés et les bienfaits rendus!

[Charles had perished: hangmen-judges,
Laws which they called revolutionary,
Exile, the scaffold, confiscation . . .
'Twas like France under the Convention.

Among so many following the ensign of crime
England still saw one high-souled man:
Milton, the great Milton (for humanity we weep)
Squandered his genius on Puritan dolts;
Above all he detested, in his Independency,
That unhappy party whom noble constancy
Held fast to their king. For this zeal cruel
Milton stained himself with the honors of a Cromwell.

One morning when athirst for blood,
Into his presence the preaching soldiers dragged
A man still young, but with pallid brow
Prematurely age-whitened by sorrow,
A royalist, in short. In passion fiery
With burning eye Milton scans his victim,
Who, far from showing his own terrors,
Seems to admire his judge and pity his errors.
"Tell us what's your name, sycophant of a master,

Henchman with two-sided soul of a slave and a traitor.
Answer me." "My name is Davenant." At this name
You might have seen of a sudden Milton the terrible
Tremble, rise, overturning his chair,
Run to the prisoner besieged by the band.

"Your name is Davenant, you say? That dear name?
Could you be that mortal, by the Muses bred,
Who, roaming his youth in the sacred groves,
Enchanted by his verse the banks of Permessus?"

Davenant replied: "Tis true that in other times
The Aonian lyre has throbbed to my finger tips."

At these words, shedding a pious tear,
Forgetting the presence of hostile witnesses,
Milton grasps the hand of the poet he admires.
And then from that voice, of that tone inspired
Which had told the ineffable loves of Eve:
"You shall live, happy painter of elegant tales;
I swear by the arts which used to unite us
Before they were banished by the bane of Albion.
To hearts aflame with so fair a flame,
Eh! what matters the carnal quarrel of a Pym?
Death strikes down at random subject or prince:
But verse sublime is what never dies,
Whether one sings the people or the tyrant unjust:
Vergil is immortal celebrating Augustus!
What! shall the sword of the law in its pique
Strike a son of Apollo! No, no, posterity!
Soldiers, withdraw. Thanks for your zeal!
This man is certainly a faithful citizen,
A great republican: on good warrant I know
He was quite happy at Stuart's death."

"No," cried Davenant, wounded by this charge.
But Milton, his hand sealing Davenant's lips,
Straightway pushes him to the room beyond,
Double-locks him in, then with a little gold
Politely turns the jacobin horde away.

Then to his captive guest he hurries back,
Has wine brought in, pours the goblets full,
Seeds a snack with agreeable chat:

Of politics naught, but many a comment
Of the Romans' wit and graces Attic.
Davenant recited his idyll of the *Brook*,
Milton responded by his lively *Allegro*,
Repeated the melancholy chant of gentle *Penseroso*,
And declaimed the choruses of *Samson Agonistes*.
Enjoying each other's talents, murmuring
Their lines, the poets part at last.

At length, wearied by their endless miseries,
The people sighed for the laws of its fathers:
Recalled their king. Those unbridled crimes
Were by edict sagely pardoned.
Yet they excepted certain perfidious men,
Complices and fomentors of the bloody regicides:
Milton, in their front rank had ranged himself.

Denounced by his own glory, under an old friend's roof
He had hoped to find shadow and silence.
One night he weighed the inconstancy of his fate:
The glimmer of a lamp on loan from the tomb
Cast its faint flicker upon his remorse.
All at once at midnight hour he hears
The outer door of his shelter shaken;
The bolts are broken by a soldier mob.
Milton's daughter runs in, they are at her heels.
Into the secret sanctuary a chief presses in:
His hat pulled down over his eyes
Half veils his face. His eyes are full
Of tears falling into his mantle's folds.
Milton sees him not: deprived of light,
Night reigns forever beneath those sad eyelids.

"So well, what is wanted of me?" says the chanter of Adam.
"Speak: I must die?"—"'Tis Davenant once again,"
Replies the man in the mantle. Milton cries out at once:
"O dark treachery! I who saved your life!"

"Yes," returns the censured poet, reddening,
"But you are guilty and I was innocent.
Firm stoic, show your courage!
My old friend, death is our common lot:

Or sooner or later, the voyage is the same
For every voyager. Here is the fatal order."

Milton's daughter, a figure full of charms,
Opens the frightful paper, bathes it in tears:
'Tis she who oft in learned discourse
Rereads the ancient Homer to the Christian Homer
And modest interpreter of the holy texts
Returns the celestial light to her father
In exchange for the life received from him.
Borrowing support from her father's bedstead,
In altered voice she reads the sentence:
"Desiring to balance justice with clemency,
We are pleased to grant in full authority,
To Davenant, as reward of his fidelity,
The pardon of Milton, CHARLES." Let one imagine
The transports following this touching outcome,
How many tears were in London shed
For talents rescued and good deeds repaid.]

In this opinion of royalist Chateaubriand, Milton's favor to Davenant
was only an act of justice, because Davenant's actions were proper in
support of his king, while Charles II's royal pardon was an act of magna-
nimity because Milton was truly guilty of defending the execution of
Charles I. Chateaubriand's errors of fictionalizing are also characteristic
of his outlook.[11] This distorted version of the conditions of Milton's
"pardon" was the story which prevailed in France when Jouy and Dieu-
lafoy wrote their libretto. If they portrayed Milton in a light more favor-
able than did Chateaubriand, without condemning him for having justi-
fied the regicide of Charles I, it was perhaps due to Jouy, who, despite
his own varied experiences, retained an allegiance to some of the princi-
ples of the French Revolution into the era of the Bourbon restoration.

Their libretto came in 1804: a particular moment in French history.

JOSEPHINE

Marie-Joseph-Rose Tascher de la Pagerie was how she was baptized in
Martinique in 1765. They called her Josephine, and in 1779 at age
fourteen she became Madame la Vicomtesse de Beauharnais by mar-
riage to the Viscount Alexandre de Beauharnais. They had two children,
Eugène and Hortense, but the marriage was not too happy. Alexandre

tried to effect a divorce; there was a period of separation (when Josephine was so poor that she could not buy a pair of shoes) and, later, a patched-up reconciliation. Still, Josephine was a woman of verve and character, and at the court of Marie Antoinette she soon became a popular favorite.

Alexandre de Beauharnais was a military man. He served under Rochambeau in the American Revolutionary War; in the French Revolution aligned himself with the Third Estate; in the night of August 4, 1789, was among those nobles who rose to renounce their hereditary privileges. He served in the armies of the Revolution, but when the political winds shifted, his former status brought his neck under the knife of the guillotine, July 25, 1794.

Josephine, in prison, heard that her husband was killed, and waited her scheduled turn to die a day or two later, with no hope, when the downfall of Robespierre on July 27 (the Ninth Thermidor) came just in time to spare her life.

A year and a half later, there was a general order to surrender weapons. The romantic story is told that their son Eugène de Beauharnais appealed to Napoleon that he be permitted to retain his father's sword. Bonaparte, deeply impressed, met Josephine at that time, and presently afterward they were wed (March 9, 1796); and step by step she rose with him to the highest pinnacle in France.[12]

But Josephine was no Lady Macbeth driving a hesitant spouse. Quite the contrary, after what she had endured. Emotionally she was linked to the old nobility, and tried to be a bridge between them and her upstart husband. In 1800, when Napoleon was "Consul" of a nominal republic, an attempt was made by the future King Louis XVIII to convince him to play the role of Monck and restore the monarchy. Josephine was tempted. Napoleon knew better: not only would he not be the king-maker, but his would be the first head to roll in such a Restoration. It was well known that more than once Josephine interceded with Napoleon seeking to save one condemned opponent or another: for General Moreau, accused of conspiracy; for Toussaint L'Ouverture, the Haitian liberator betrayed into a French dungeon; and for the life of the Duc D'Enghien, when in March 1804 he was doomed by Napoleon in a final gesture to crush the Bourbons, under circumstances that did much harm to his prestige then and afterward.

The greater the power wielded by Bonaparte, the more glamorous the title he assumed, the more Josephine, first lady of France, found herself confided to a gilded cage. Herself an accomplished musician, and an avid booklover, she turned to the world of artists and writers. Poets, painters, composers began to feel the warmth of her patronage. Among

the first of these was Spontini, young, unknown, newly arrived in France.

His first effort in Paris was a production of his *La Finta Filosofa*, revised from its previous Naples première, at the Théâtre-Italien, February 11, 1804.[13] Josephine came to the performance, and the next day Spontini sent her these verses, set to music, in appreciation:

Un oiseau tout fier des leçons qu'il reçut d'un illustre Maître,
Modulait déjà quelques sons dans le bosquet qui le vît naître,
Mais hélas! il n'a plus d'appui qui le soutienne et l'encourage;
Il était par malheur pour lui trop de rossignols au bocage.

Il apprend qu'un bosquet lointain, du bon goût antique Patrie,
Offre le plus heureux destin aux fils du Dieu de l'harmonie.
Aussitôt il prend son essort; il court disputer la victoire.
Il est timide et jeune encor, mais que fait l'âge pour la gloire?

Il prélude; un succès flatteur accueille son premier ramage.
Hé! comment l'heureux voyageur n'eût-il pas séduit le bocage?
La Reine de ces lieux charmans, des talens amie empressée,
Pour faire applaudir à ses chants sur sa tête s'était placée.[14]

[A songbird proud of lessons received from an illustrious master
Already modulated his tones in the woods where he was born,
But alas, he had no support to sustain him or encourage;
By his ill luck there were too many nightingales in that copse.

He learns that a distant grove, an ancient fatherland of good taste,
Offered the happiest destiny to sons of the god of harmony.
Forthwith he takes his flight; he hastens to challenge victory.
He is shy and yet young, but what does that age for glory?

He tries; a flattering success welcomes his first warbling.
Oh, has not the happy voyager captivated the arbors?
The Queen of these charming locales, ardent friend of talent,
To lead applause to his chants set herself at his head.]

That performance of *La Finta Filosofa* was decisive for Spontini. Looking back, in 1830, he wrote *pour lequel succès, Napoleon me chargea de la direction de sa musique particulière, et principalement de celle de Josephine*, "for that success, Napoleon entrusted me with the management of his personal music, and especially Josephine's." Thenceforth and for many years, Spontini was to enjoy a somewhat favored, not quite official status, which, however, in 1804 was not immediately evident to the opera-going public.

Spontini's next work, his first "French" opera, *La Petite Maison*, was given an excessive advance ballyhoo by the theatre managers, which enabled a hostile local faction to break up the première performance in a riot which did not lack its comic side, May 12, 1804. The debacle was blamed on the libretto's story line and on the way the performers mishandled the first hissing, not on the music composed by Spontini: he was approached immediately afterward by Jouy, with an invitation to compose *La Vestale*.[15]

As often at crucial points of history, the documentary record is incomplete. *La Vestale* was not produced until three years later, and then with the emphatic patronage of Josephine. No written account has come to light which tells of the discussions of Jouy, Dieulafoy, and Spontini in the composition of *Milton*. We have found no record of any performance of *Milton* attended by Josephine and Napoleon; both were very occupied during the months of November and December by the ceremonial pomp and the political decisions accompanying their coronation. We do know that Josephine publicly signified her approval of the *Milton* opera when she gave her permission to Spontini to dedicate it to herself. This dedication was prominently featured on the title page of the first edition of the score, *Dédié à Sa Majesté L'IMPERATRICE*, and then displayed on a full page in large and elegant script:

A SA MAJESTÉ L'IMPERATRICE DES FRANÇAIS

Madame,
Les paroles encourageantes que votre Majesté voulut bien m'adresser, à mon debut en France, ont été le plus puissant aiguillon pour mon faible talent.

J'ose aujourd'hui lui presenter *Milton* qu'Elle m'a permis de lui dédier.

Milton est devenu français, sous la plume du celebre traducteur des Georgiques, et ce succès n'est pas inutile à sa gloire; mais il est encore plus heureux, Madame, par la protection dont Vous l'honorés, en daignant accueillir mon ouvrage.

Je suis avec le plus profond respect, Madame, de Votre Majesté
Le très humble et très obéissant Serviteur,
Gaspard Spontini.[16]

For the widow of the guillotined Vicomte de Beauharnais, who herself had escaped the Reign of Terror at the last minute to become wife to the all-powerful master of France, this one-act opera, presented, just before their coronation, to the politically sensitive public of Paris, was no mere

diversion of a passing hour: it was a message, proffering a role model of a generous and magnanimous king, forgiving the sins of the opposition in an atmosphere of reconciliation.

ANTICLIMAX

L'Opéra de Milton vient de réussir, "The *Milton* opera has been a success," wrote the reviewer for *Journal de Paris,* November 28, 1804, page 461. He summarized the libretto with its surprise coming at the end "to the great astonishment of everyone except the audience," praised the music for taste, for rather more beauties in the orchestral than the vocal parts, well played by the cast. "The authors were called for. M. Spontini appeared as composer of the music." *Gazette Nationale* praised the production; despite the weak plot, the writing was tasteful, and the composer was talented; even his youthful excesses have their charm (November 30, 1804, page 254). *Mercure de France* faulted the story, questioned the validity of the subtitle *Fait historique,* praised the performers, "des morceaux très brillans et trop d'abondance la musique" (December 1, 1804, CLXXVIII, pages 473–76).[17]

There were ten more performances before the year's end, and more thereafter. Luigi Balochi translated the libretto and lyrics into Italian for the first printed edition of the score, which also included the French text. There was also a German version, and performances in Vienna, Dresden, Weimar, Berlin, and Aachen.[18]

Spontini went on to greater successes, as opera composer, as director, presently as head of the Théâtre Italien; but often involved in controversy. His loyalty to Josephine, when she was discarded by Napoleon, became a negative factor during the latter years of the Bonapartist regime. Under the Bourbon restoration, his musical reputation continued high, but he had problems both with the returned monarchists and with his former "liberal" associates. He was, therefore, happy to move to Berlin as *Generalmusikdirektor* to King Friedrich Wilhelm III. Here for two decades he again had many successes and many squabbles.

All through these years, Spontini cherished the aim of expanding that first success *Milton* into a full-length grand opera. With the popular vogue of Sir Walter Scott's historical themes on the Continent, and the sensational *Cromwell* of Victor Hugo in France, the theme was most tempting. But always some other project or factor got in the way.

It was one of Spontini's first efforts in Berlin, with E. T. A. Hoffmann to do the libretto, during 1821 and 1822. In 1823 Spontini is talking with librettists P. A. Wolff and Karl Alexander Herklots about two acts

and a ballet, and these discussions go on for several years, until we hear there is a new libretto by Ernst Raupach, which retains only the "Hymn to the Sun" from the 1804 text. At this moment (1830 or 1831) there is a question whether to proceed with this revised *Milton*, or to do a different work on Theseus and the Minotaur, based on a libretto by Jouy. Spontini wanted the *Milton*, but he was always subject to counter pressures from the officials in charge of the royal theatre, Graf Karl von Brühl in the 1820s, Graf Wilhelm von Redern in the 1830s. On June 17, 1831, Spontini sent a letter to King Friedrich Wilhelm III, urging his case for the *Milton*, from which we learn that the ludicrous historical boners of 1804 have been transmogrified into monstrously horrendous distortions:

> Je ne saurais rendre assez de graces à Votre Altesse Royale pour le bienveillant intérêt qu'elle daigne en toute occasion me témoigner, et tout récemment, pour le désir qu'elle a bien voulu me faire exprimer par Mr. le Comte de Redern, que je m'occupasse maintenant et antérieurement de la composition des *Athéniennes*, plutôt que de *Milton*.
>
> Telle avait été an effet ma première intention à mon retour de Paris: mais des observations judicieuses, des raisons assez justes que M. Raupach, qui a travaillé à ce poème, m'opposa à plusieurs reprises, et la crainte de l'indisposer, me firent en partie, changer d'opinion; en outre, comme l'opéra de *Milton*, qui est un grand ouvrage de l'étendue de *Nurmahal*, est presque entièrement nouveau, que la musique de la moitié est déjà très avancée, et que je suis certain de pouvoir faire représenter cet opéra au carnaval prochain, et avec une médiocre dépense de décorations et costumes, je me suis décidé de m'en occuper sans relâche et de m'affranchir de ce souci pour me livrer ensuite entièrement à la composition des Athéniennes, qui est un sujet de la plus haute région du grand et noble genre lirico-dramatique, qui exige les plus profondes méditations, les inspirations les plus élevées et hardies, et pour lequel je ne pourrais pas limiter les dépenses ni borner le tems de ma composition.
>
> Si néanmoins Votre Altesse Royale tenait positivement à ce que je laissasse dormir encore dans sa tombe le puissant counseiller et secrétaire de Cromwel, aveugle, proscrit, et errant avec sa tendre et intéressante Antigone dans les montagnes d'Ecosse pour échapper à la hache des bourreaux, poursuivi, découvert et prêt à être livré à la Justice de la réaction, protégé par des chefs de Clan, inspiré au milieu de toute cette agitation par l'ombre d'Os-

sian et des Bardes célèbres qui lui apparoissent sur des nuages et lui retracent le Paradis terrestre, représenté dans un songe aux yeux de son imagination, et obtenant enfin sa grâce du Roi par l'intercession et la gratitude infinie de lord Davenant, général-issime et favori de Charles deux, qui sous un faux nom et dé-guisement s'est attaché aux pas de Milton, parce que celui-ci sauva jadis son père de l'échaffaud par sa toute puissante faveur auprez du Protecteur: Si cette action, ces Personnages et ce su-ject historique ne sembloient pas dignes ni convenables à Votre Altesse Royale d'être représentés ici sur la scène dans les tems actuels de démence et de délire, je suis tout prêt de laisser encore dormir en paix Milton (aprez en avoir requis le consentement de l'autorité supérieure) et de me consacrer entièrement et sans re-lâche au triste sort des victimes Athéniennes, de Thésée, d'Ari-ane, et du Minotaure. Que Votre Altesse Royale daigne me faire connoitre, par un mot, ce qu'elle préfère, et à l'instant même ma decision sera prise; et soit l'un ou l'autre sujet que je traite au premier lieu, il me deviendra beaucoup plus intéressant encore par l'intérêt puissant pour mon imagination, que Votre Altesse Royale veut bien y prendre.

[I could not return enough thanks to Your Royal Highness for the benevolent interest which he deigns to witness me on every occasion, and quite recently, for the desire which he has asked Count von Redern to express to me, that I should now and pri-marily spend my time on the composition of *The Athenians* rather than on *Milton*.

That had in fact been my first intent on my return from Paris: but some judicious observations, some rather good reasons which M. Raupach, who worked on the libretto, argued with me at several points, and my fear of offending him, made me change my opinion somewhat. Further, as *Milton*, which is a large work on the scale of *Nurmahal*, is almost entirely new, since the music of half is already far advanced, and since I am certain of being able to mount this opera at the next Carnival, and with moderate ex-penditure for sets and costumes, I decided to undertake it without relaxation, and to free myself from that care in order thereafter to apply myself entirely to the composition of *The Athenians*, which is a subject in the most exalted region of the great and noble lirico-dramatic genre, which demands the most profound meditations, the loftiest and most daring inspirations, and for which I could not stint the expenditure nor limit the time for my composition.

If nonetheless Your Royal Highness positively holds that I should still leave sleeping in his tomb the puissant councillor and secretary of Cromwell, blind, proscribed, and wandering with his tender and moving Antigone, in the mountains of Scotland to escape the executioners' axe, pursued, found out, and about to be turned over to the justice of the reaction, protected by clan chiefs, inspired in the midst of all this turbulence by the shade of Ossian and the renowned bards who appear to him in the clouds and retrace for him the terrestrial Paradise, represented in a vision to the eyes of his imagination, and obtaining at last his pardon from the King by the intercession and infinite gratitude of Lord Davenant, generalissimo and favorite of Charles II, who under an assumed name and disguise had tagged on to Milton's footsteps, because the latter by all powerful favor with the Protector had in time past saved his father from the scaffold. If this plot, these characters and this historic subject would not seem worthy nor suitable to Your Royal Highness for presentation on the stage in the present time of madness and delirium, I am fully ready to let Milton still sleep in peace (after having requested the consent of the aforementioned authority) and to consecrate myself entirely and without respite to the melancholy fate of the Athenian victims, of Theseus, of Ariadne, and the Minotaur. Would Your Royal Highness deign to let me know by a word which is his preference, and at that same instant my decision will be settled; and be it one or the other subject which I treat in the first instance, that will become for me so much more interesting, by the interest, so potent for my imagination, which Your Royal Highness is pleased to take in it.]

The "present time of madness and delirium" was the year of revolutionary upsurges against the despotisms of the Metternich era, and it would seem that the King of Prussia much preferred the legends of Theseus to any story of a pardoned regicide. When we next see Spontini, always a staunch monarchist, pressing this theme, in 1837, the title and the conception have been changed to *Miltons Tod und Busse für Königsmord*, "Milton's Death and Penitence for Regicide." At this time Spontini asks Redern to prevent the showing of any competing production whose content might refer to the era of Cromwell and Charles II. In 1838 he travels to Britain to study local color and historical detail, and, in one more effort to render the work acceptable, he has his librettist, Dr. Josef Friedrich Sobernheim, recast the mishmash into a three-act *Das Verlorene Paradies*, "The Lost Paradise."

This final libretto, and whatever music with it, as well as all the intervening versions done for the enlarged grand opera, are lost, because Spontini's fall from favor in Berlin came just as it was finished. [19]

Many are the works of art which have perished by neglect through the ages, which we forever regret; but in this instance, spared the vision of Ossian's ghost dictating a description of Eden from his perch on a damp cloud over the Scottish Highlands, and the nightmare falsification of dying Milton humbly doing penance before the Stuart throne, we must be forever grateful to the fates who decreed that this intended masterpiece should be lost.

NOTES

English translations following extracts quoted in other languages in the above text and in these notes are all by the author of the present narrative.

1. Brief biographies of Jouy (1764?–1846) and Dieulafoy (also spelled Dieula-foi, 1762–1823) are given in Michaud's *Biographie Universelle* (Paris, 1855) and Dr. Hoeffer's *Nouvelle Biographie Générale* (Paris, 1858). The *de* in Jouy's name may have been his own affectation, and he is also the prime source for the picaresque adventures of his colorful career, of which we here have given only *some*. His works are not quite in oblivion: his libretti for Spontini's *La Vestale* and *Cortez* and for G. Rossini's *William Tell* are still in circulation. His *Oeuvres Complètes* came out from 1823 to 1828, but he was active long after. He was elected to the Académie Française. The vaudeville by Dieulafoy was *Moulin de Sans Souci. Milton* is printed in Jouy's *Oeuvres*; what exactly was Dieulafoy's share is not on record.

2. There is a large bibliography on Spontini. In addition to sources cited herein, useful works include: Charles Bouvet, *Spontini* (Paris, 1930); Alfred Ghislanzoni, *Gaspare Spontini, Studio Storico-Critico* (Rome, 1951); Paolo Fragapane, *Spontini*, (Bologna, 1954). Two unpublished doctoral dissertations at Princeton University, *Gaspare Spontini: His French and German Operas*, by Dennis A. Libby (1969), and *Spontini's Later Operas*, by M. Steinberg (1961), do not discuss the 1804 *Milton*. Spontini's first name is given variously as *Gaspare, Gasparo, and Gaspard* and is herein varied according to the context. His work is treated at length in all large standard encyclopedias and dictionaries of music, and was very frequently discussed in the writings of Hector Berlioz, Richard Wagner, Heinrich Heine, and others of that era. His activities were regularly reported in newspapers and journals devoted to music and literature in Paris, Berlin, and elsewhere.

La Vestale was sung long ago, in 1828, in New Orleans and in Philadelphia (Wallace Brockway and Herbert Weinstock, *The World of Opera*, 1941, 1962).

In a production then regarded as "magnificent," it premiered at the Metropolitan Opera in New York under Giulio Gatti-Casazza, Tullio Serafin conducting, with Rosa Ponselle, Edward Johnson, Giuseppe di Luca, and Ezio Pinza (debut), November 12, 1925; played four more times that season, and opened the following season on November 1, 1926. *Cortez* premiered there January 6, 1888, Anton Seidel conducting, with four performances. There is no record of *Milton* ever performed in the United States. (Source: Robert Tuggle, archivist at the Metropolitan Opera, September 25, 1982.)

Spontini's name is conspicuously engraved on the facade of the Paris Opera House on the same line with Beethoven, Mozart, and Meyerbeer.

3. Karl Gottlieb Freudenberg, *Erinnerungen aus dem Leben eines alten Organisten*, bearbeitet von W. Viol (Breslau, 1870), page 42, recorded (in indirect discourse) that, about 1825, Beethoven said *Spontini habe viel Gutes, den Theatereffekt und musikalischen Kriegslärm verstände er prächtig.*

4. Hector Berlioz, *Mémoires*, various editions, Chapters XIII and XIV. His almost extravagant devotion to Spontini is seen in his letter of 1841, printed in his *Voyage Musical en Allemagne et en Italie* (Paris, 1844), I, 403–4; and in his "Spontini. Esquisse Biographique," which is the "Treizième Soirée" in his *Les Soirées de L'Orchestre* (Paris, 1853), pages 165–94.

5. The two essays of Wagner, and his letter of April 22, 1880, "An den Herzog von Bagnara, Präsidenten des Konservatorium der Musik in Neapel," are printed in several different editions of Wagner's collected works, as are some amusing discussions of Spontini's eccentricities.

Another highly laudatory evaluation of Spontini, beginning *Wilkommen unter uns, du hoher herrlicher Meister!*, was the "Gruss an Spontini," by E. T. A. Hoffmann (best known through Offenbach's *Tales of Hoffmann* and Tchaikovsky's *Nutcracker Suite*), reprinted in his *Schrifften zur Musik. Nachlese* (Munich, 1963), page 338; originally written May 30, 1820.

Heinrich Heine was a sharp critic of Spontini's later career in Berlin, and often found Spontini's peculiarities an easy mark, for his witticisms, but he nonetheless wrote that *La Vestale* and *Cortez* were *zweier Prachtwerke, die noch lange fortblühen werden im Gedächtnisse der Menschen, die man noch lange bewundern wird*, "two splendid works which will long remain bright in the memory of men, which will long be admired," page 84 in Heinz Becker, *Der Fall Heine-Meyerbeer. Neue Dokumente Revidieren Ein Geschichtsurteil* (Berlin, 1958).

6. Any pleas by Milton for Davenant in 1650, or by Davenant for Milton in 1660, necessarily had to be secretly offered, and therefore unrecorded. It is needless to reproduce here the extensive bibliography of this tradition. In both instances the recorded traditions are unclear, complicated, and in some respects possibly contradictory. The kernel of the story, as I have summarized it, is probably true. For our discussion here, what is needed only is the fact that the story was believed by many in 1804, and subject to embellishment by literary folk.

The wrong name for Pope's informant was spelled *Pacquerson* in the (first? 1805?) separate printing of the libretto, *Milton, Fait Historique, Opéra en un Acte, Par MM. Jouy et Dieulafoy, Musique de M. Spontini . . . à Paris. Chez H. Nicolle et C^e . . . A Lille, Chez Vanackere*, and in its reprint by H. Lepeintre, editor, *Suite du Répertoire du Théâtre Français*, Tome X (Paris, 1822; also reprinted so in 1823 and 1829, but I have not seen these). It was spelled *Facquerson* in the reprint in Jouy's *Oeuvres Complètes*, volume 21. The name

was taken from some unspecified edition of Pope's letters, perhaps confused with the name *Macpherson* of Ossian fame. Jouy also found the tradition in the *Dictionnaire Historique Portatif* of L'Abbé Ladvocat (1760, article *Davenant*). Ladvocat's 1755 and 1760 editions included relatively well-informed articles on Milton, but this anecdote is given only under *Davenant*.

To us it might seem that the Davenant-Milton theme was rather off the beaten operatic track, but in fact it fit very well into a genre popular during the French Revolution and long after, the "rescue" opera, of which Beethoven's *Fidelio* is the best known example, featuring suspense, a loyal savior in disguise, virtue triumphing. A good treatment of this subject is: Franz Schmitt von Mühlenfels, "Die Rettung Miltons durch Davenant: Eine Anekdote als Opernstoff Spontinis," *Archiv für das Studium der Neuern Sprachen und Literaturen* 211 (1974), 382–91.

7. Milton's personal letter to Henry Oldenburg, August 1, 1657, suggests that interest in his political writings at the Huguenot center of Saumur was mild at best. Among the advertisements in *Mercure de France*, July 14, 1804, CLIX, 186, was a notice by bookseller Ph. Lenoir, offering copies of *Sur la liberté de la Presse, imité de l'anglais de Milton, par Mirabeau l'aîné; seconde edition* for five francs, but these appear to have been unsold copies of the 1792 printing.

8. Milton's poetry was known in France, apart from translations, by a few critical discussions besides Voltaire's, notably in R. P. Nicéron's encyclopedic *Mémoires*, and in translations of Addison's commentary on *Paradise Lost*. Milton was first really popularized by François René de Chateaubriand in his *Génie du Christianisme* and other writings, from a standpoint which Milton would have found quite alien.

Recent accounts include: John Martin Telleen, *Milton dans la Littérature Française* (1904; 1972 reprint); Jacques Blondel, editor, *Le Paradis Perdu, 1667–1967* (1967: eleven contributors); Jean Gillet, *Le Paradis Perdu dans la Littérature Française de Voltaire à Chateaubriand* (1975).

Sin and Death: Louis Racine in his 1775 prose translation substituted the Greek figures Ate and Ades (=Hades). Jacques Delille in his 1804 alexandrines substituted *La Révolte* for Sin and *Le Trépas* (="Demise") for Death.

Voltaire's *Candide* has a character mocking Milton as "ce barbare," and *Paradise Lost* as "ce poème obscure, bizarre et dégoutant."

9. Napoleon's opinion: *Dictionnaire ou Recueil Alphabétique des Opinions de Napoleon Ier* (1964 reprint Au Club de l'Honnête Homme, Paris, from the 1838 and 1854 editions), page 227.

10. *Journal des Débats* repeatedly printed advance notices and dates of scheduled performances for *La Finta Philosopha* (*sic*), *La Petite Maison*, and *Milton*; May 9, a critic's discussion of those first two works; May 14, an account of the disrupted performance of the second, and May 17, a report of a repeat performance of *La Petite Maison*; a long review of *Milton*, November 30, 1804, with notices of its performances, advance and scheduled, from November into January 1805. Delalot's essay appeared on pages 57–66, 105–15, 293–300, and 581–89 of the 1804 *Mercure*.

11. This text of *Milton et Davenant* is taken from Chateaubriand's *Oeuvres Complètes* (Paris, 1858), volume 3, 549–52. The preface says that it was first printed in the 1828 *Oeuvres Complètes*, but Chateaubriand and his friends brought his verses to France not long after their composition.

Chateaubriand deliberately draws parallels between the English and the

French Revolutions. However, both scenes in his poem are entirely fictional, with no conceivable basis in fact. Although Milton wrote several books justifying the people's right to change a tyrannical government by revolution, and to execute justice on a tyrant king by the laws of the land, he was never in such a position as Chateaubriand depicts, bloodthirstily condemning royalist partisans to death. Milton may well have been moved to intercede for Davenant, who had been poet laureate and had composed famous verse dramas and poems, but until 1667 Milton himself was only slightly known as a poet for his *Mask* of Comus and his little volume of 1645 *Poems*. Anachronisms are pervasive in *Milton et Davenant*. Parliament spokesman Pym was an appropriate symbol, but dead since 1643. Only some few chorus passages from *Samson Agonistes* may date from before 1650.

Davenant's *Ruisseau*, "Brook," is unidentified; possibly his three stanzas in honor of Shakespeare.

12. Josephine has been the subject of many memoirs by her contemporaries and by later biographers. Michaud's *Biographie Universelle* (1855) has a detailed sketch. There is a highly laudatory account in Etienne de Jouy et al., *Biographie Nouvelle des Contemporains* (1823), volume 9, page 455 stressing Josephine's role as intercessor: "Une foule d'émigrés durent à Josephine leur radiation, leur rentrée dans leur biens, ou de grands secours . . . Ce fut à ses larmes que MM. de Polignac et de Rivière durent la vie."

13. *La Finta Filosofa* was variously spelled at that time. The daily *Gazette Nationale ou le Moniteur Universel*, February 15, 1804, page 585, reviewed the performance, in great detail, beginning: "Au théâtre de l'opéra Buffa, le plus brillant succès a couronné le début en France d'un jeune compositeur italien, M. Spontini, élève de Cimarosa, digne de ce maître dont on reconnaît en lui le style brillant, et déjà connu en Italie par un assez grand nombre d'ouvrages. Nous n'avons pas contracté l'habitude de rendre compte du sujet des poëmes italiens; celui-ci intitulé: *La Finta Philosopha*, nous paraîtrait peut-être mériter une exception, car il offre quelques situations, et des scènes assez comiques; mais il ne peut être ici question que de M. Spontini, et de l'éclat de son succès parmi nous: il a été demandé à grands cris après la représentation et couvert d'applaudissemens."

14. These verses and the music, technically a "romance," are preserved in a transcript in Spontini's own hand, dated May 10, 1830, now filed as Manuscript ML 96.S 77 in the Library of Congress, Washington. The 1830 quotation that follows is from Spontini's handwritten note following the transcript, addressed to Mme de Witzleben, for whom he prepared it.

15. Amusing and detailed descriptions of the disrupted première, with the ad-lib exchanges between audience and performers, appeared in *Mercure de France*, May 19, 1804, pages 420–21; *Journal des Débats*, May 14, 1804, pages 1–4; and *Gazette Nationale ou le Moniteur Universel*, May 17, 1804, page 1078. The libretto was by Dieulafoy and N. Gersin. *Mercure de France* and *Gazette Nationale* stressed that the hostility was not directed against Spontini's music but against a politically outdated libretto and the inept response by the cast to the first hissing in the audience. *Journal des Débats* took a rather different tone. Jouy, *Oeuvres Complètes*, volume 19, page 54, wrote that he was present that night and that in his opinion "une cabale, aussi injuste que violente, décida du sort de l'ouvrage, dont la chute fut accompagnée de circonstances qui ne laissèrent dans mon esprit aucun doute sur les moyens qu'une rivalité ja-

louse avait employés pour éloigner de la carrière un talent qui s'annonçait d'une manière aussi brillante."

According to Adolphe Jullien, "Les Commencements de Spontini," in *La Chronique Musicale* (1875, Tome 10e, 31–43, 61–70), the opposition came from local French composers who resented any competitors coming from Italy, and also from Italian composers in Paris who recognized in Spontini a formidable rival. Geoffroy, critic of the *Journal des Débats* (his articles were not signed), was notoriously hostile to the Italian musicians in France.

16. "Milton est devenu français": Spontini is referring to the verse translation by Delille, who had also translated Vergil's *Georgics* and *Aeneid*.

The French and Italian texts in the first (1805) printings are not exactly identical. Milton's solo is a hymn to light (*Lumière*) in the French, and to the sun (*Sole*) in the Italian, but it is the sun which is addressed in both. We wonder if Napoleon's so-reported reference to a Milton invocation to the sun derived from this number in Spontini's opera.

17. The hostile review, with its few grudging compliments, in *Journal des Débats*, November 30, 1804, is rather long, but it is worth reprinting for its intrinsic interest:

C'est souvent un avantage au théâtre d'avoir peu d'instruction; on ne se chicane point soi-même sur son plaisir, on se livre à l'illusion; on jouit de tout: si les caractères sont dénaturés, les anciens personnages défigurés sur la scène, on n'en est point choqué, parce qu'on ne s'en aperçoit pas. Par exemple: voilà *Milton* à l'Opéra Comique: ceux qui ne connoissent pas *Milton*, lesquels composent au moins les 9 10e de l'Assemblée ne sentent pas l'inconvenance et le ridicule de cette mascarade. Le fanatique et féroce Milton, ce théologien barbare, métamorphosé en vieillard doux, humain et sensible, ne peut déplaire qu'à ceux qui savent quelles étoient les moeurs et les opinions de l'homme qu'on a si singulièrement travesti. Pourquoi donner à ce personnage de l'Opéra Comique le nom de Milton? Qu'a-t-il de commun avec le Milton secrétaire de Cromwel, de son fils et du parlement appelé *le Croupion*? Voilà ce que demanderont les gens de goût. Les spectateurs vulgaires s'imagineront que Milton étoit un homme aimable; ils auront plus d'égard pour ce vieil aveugle que pour un père ou un tuteur de comédie, par la raison qu'il appelle comme l'auteur d'un poëme épique dont ils ont entendu parler.

Lorsque Milton, dans la plus agréable scène de la pièce, chante les amours d'Adam et d'Eve, au moment où sa fille fait aussi l'amour avec un jeune lord, le commun des auditeurs se laisse aisément attendrir par la sensibilité du bon vieillard: mais les gens de lettres qui connoissent la doctrine et les sentimens de Milton, ont le coeur beaucoup plus dur, et s'en rapportent bien plus à ce que l'histoire raconte du personnage, qu'à ce qu'on lui fait chanter à l'Opéra Comique. Il n'y a point d'illusion pour eux, lorsqu'ils se rappellent que ce chantre des innocens plaisirs de nos premiers parens a fait l'éloge de la cruauté de Cromwel, surtout quand ils songent de quel style cet éloge est écrit. On ne sera peut-être pas fâché d'en trouver ici un échantillon.

Le fameux critique Saumaise avoit composé en faveur des Stuart, un livre qui commence ainsi: *La nouvelle du triste événement dont l'Angleterre vient d'être le théâtre, a blessé depuis peu nos oreilles, et encore plus nos coeurs.* Milton, scandalisé de la délicatesse du coeur et des oreilles de Saumaise, fit cette étrange réponse: *Il faut que cette nouvelle ait eu une épée plus longue que celle de Saint-Pierre, qui coupa une oreille à Malchus; ou les oreilles*

*hollandaises doivent être bien longues, pour que le coup ait porté de Londres
à la Haye, car une telle nouvelle ne pouvait blesser que les oreilles d'âne.*
Abusant ensuite de la conformité du nom de Saumaise en latin *Salmasius*,
avec celui de la nymphe *Salmacis*, il prétend que les larmes que ce triste
événement a fait couler sont des larmes *lâches et pusillanimes*; *ce sont*, dit-il,
*des larmes telles qu'il en coula des yeux de la nymphe Salmacis, qui produi-
sent la fontaine dont les eaux énervoient les hommes, leur ôtoient le courage,
et en faisoient des hermaphrodites.* Milton ne laisse pas échapper une si belle
occasion d'appeler Saumaise *eunuque hermaphrodite* né de la nymphe *Salm-
acis* à-peu-près comme Voltaire appeloit Fréron sodomiste,
 Vermisseau né du c. de Desfontaines.
Il faut convenir que lorsqu'on est instruit de toutes ces pauvretés-là, on est
bien moins touché de l'aménitie du soi-disant Milton de l'Opéra-Comique.

 Avec quelque teinture de l'histoire de ces temps-là, on ne peut croire que
Milton ait demandé et obtenu la grace de milord Davenant, prêt à périr sur
l'échafaud par l'ordre de Cromwel; on est également incrédule sur l'aventure
de Milton, réfugié chez un Quaker, parce qu'on sait que ce farouche républi-
cain fut compris dans l'amnistie, lors du rétablissement de Charles II; enfin il
est impossible de concevoir que le fils d'un lord distingué par son zèle pour les
Stuart, s'avise de rechercher la fille du plus ardent ennemi de cette famille, la
fille du secrétaire de Cromwel, d'un vieillard aveugle, pauvre, odieux et
méprisé à la cour. On regarde comme absolument invraisemblable le strat-
agème du jeune lord, qui se fait recevoir dans la maison de Milton sur le pied
de lecteur du père, pour exercer plus commodément les fonctions d'amant de
la fille; enfin la grace de Milton obtenu par le credit du lord, est une fable non
moins extravagante que tout le reste; car il étoit impossible que le roi accordât
la grace de Milton au lord Arthur, pour faciliter son mariage avec la fille du
secrétaire de Cromwel: ce mariage étoit plus propre à le faire disgracier lui-
même qu'à lui faire obtenir des graces pour les autres.

 Il faut donc en allant voir *Milton*, laisser toute sa science historique à la
porte, oublier l'esprit quit regnoit alors en Angleterre, oublier ce qu'étoit
Milton, ce qu'étoit lord Davenant, et ne regarder tous les personnages que
comme des êtres chimériques inventés par l'auteur: avec cette précaution on
peut s'intéresser en faveur d'un vieillard malheureux et persecuté; on peut être
touché de la candeur, de la sensibilité de sa fille Emma; on peut admirer les
sentimens nobles et généreux du lord. Enfin, on peut, sur la foi de l'auteur,
prendre bonnement pour un *fait historique* un roman tout pur. Quoique ce ne
soit pas un grand crime d'avoir fait Milton meilleur qu'il n'étoit, je crois qu'on
devroit avoir quelque scrupule d'induire ainsi le public en erreur, et d'emprun-
ter les noms des anciens personnages pour altérer totalement leur caractère at
leur histoire.

 La pièce est assez bien conduite, a l'exception des premières scènes, qui
languissent, et de l'épisode trivial d'une vieille nièce du Quaker qui se croit
aimée du jeune lord. Le dialogue a de l'agrément; il y a quelques situations
piquantes; Madame Gavaudan a mis beaucoup d'intérêt, de sensibilité et de
graces dans le role d'Emma. Cette actrice paroit faite pour consoler l'Opéra
Comique des pertes dont il est menacé. Gavaudan est comme on sait, un fort
bon amoureux: il a joué en amant vif et passionné et chanté en homme de
goût. L'auteur, M. Dieulafoi, est connu par la petite pièce de *Défiance et
Malice*, qu'on joue souvent au Théâtre Français.

La musique est de Spontini, élève de Cimarosa: beaucoup de richesses, peu de choix, d'ordre et d'économie. Ce compositeur fécond et prodigue a de la peine à s'arrêter, et ne sait pas encore finir: son ouverture est brillante et très longue; plaisirs de ses morceaux sont charmans et très-longs: c'est un beau défaut que l'excessive abondance, mais c'est un grand défaut. M. Spontini charge un peu son orchestre; il n'a pas toujours l'intention dramatique assez nette et assez précise; il a besoin d'étudier encore notre goût, notre scéne, et notre Grétry. Mais il a tout ce qu'il faut pour profiter de ces connoissances: son talent ne demande qu'une meilleure direction; il a fait assez dans cet ouvrage pour prouver qu'il est capable de faire très-bien.

This anonymous critic makes some telling points about the fallacies in the story of the opera, but he was not above interpolating words and otherwise distorting his quotations from Milton.

18. Jouy, *Oeuvres Complètes*, volume 21, page 4, writing in 1824, said that the role of Milton had been designed especially for the baritone [Jean Pierre] Solié. After Solié's death in 1812, the lack of another baritone with comparable voice and acting ability discouraged further productions. In the first cast, Emma, soprano, was sung by Mme Gavaudan; Arthur, tenor, by M. Gavaudan; Godwin, basso, by M. Chenard; Charlotte, soprano, by Mme Cretu.

I have seen two printings of the original complete text and musical score, vocal, and instrumental for full orchestra (as of that time). The first printing (1805?) has one title page in French, *MILTON OPERA EN UN ACTE* (etc.), another title page in Italian, *MILTON, OPERA In un Atto e in Prosa* (etc.), and a dedication page to Josephine; the composer is listed as Gaspard Spontini, Maître de Chapelle du Conservatoire de Naples. The second printing has one title page, in French, no dedication, and a long string of Spontini's titles and honors, which suggests that it dates after the Bourbon restoration, near the Prussian appointment. The text, 290 pages, is identical in both. The overture is long, in complex symphonic form. The words printed with the vocal music of the dialogue are in Italian paraphrase, but the *morceaux* (solos, duets, trios, ensembles) are in both French and Italian. The French text is printed in full apart from the score, on separate pages. Both printings were "chez Mlles Erard" in Paris. (Spontini's wife was née Céleste Erard.)

I have seen three printings of the libretto in French, with minor variants in title page and text (see note 6 above). There was a German version, *Milton. Singspiel in einem Aufzug* (Vienna, 1808), which I have not seen, done by Georg Friedrich Treitschke, who is better known for his share in Beethoven's *Fidelio*. Alfred Loewenberg, *Annals of Opera 1597–1940* (1943), page 290, mentions a Spanish translation for a Madrid performance, done by F. Conciso Castrillon, November 4, 1805, and performances in Brussels and elsewhere in 1839.

I have seen a piano-vocal score, *Milton, Opera*, edited by Filippo Caffarelli for Gli Amici della Musica da Camera, printed by G. and P. Mignani (Firenze, 1950). At the Eda Kuhn Loeb Music Library of Harvard University, there is a tape recording of this opera, somewhat abridged, in Italian, by six singers and the Orchestra Sinfonica di Milano della Radiotelevisione Italiane, Alberto Pauletti conducting. Having heard this recording, I found both the instrumental and the vocal music as pleasing and satisfying as any from that era, and far more so than a great deal of what passes for opera done in our century. With due warning to listeners about the fatuity of the libretto, this opera deserves to be performed and heard.

19. The vicissitudes of Spontini's proposed grand opera on the Milton theme may be traced in great detail in: Wilhelm Altmann, "Spontini an der Berliner Oper. Eine Archivalische Studie," in *Internationalen Musik-Gesellschaft*, Leipzig, Jahrgang IV, Heft 2, Januar-März 1903, pages 244–92, reprinting letters from and to Spontini from 1821 to 1840, from the Archives of the Intendants-General of the Royal Theatres. Other pertinent correspondence has been printed in: Alessandro Belardinelli, *Documenti Spontiniani Inediti*, two volumes (Florence, 1955). The letter to King Friedrich Wilhelm is printed in: Hedwig M. von Asow, "Gasparo Spontinis Briefwechsel mit Wolfgang von Goethe," in the *Chronik des Wiener Goethe-Vereins*, LXI Band, 1957, pages 42–58. Not having Spontini's original manuscript, I have regularized the chaotic accent marks and some other inconsistencies in the printed text.

Another fantastic version of the Milton-saved-by-Davenant anecdote was excogitated by Abel Hugo (brother of Victor Hugo), and published as *Milton, Fragment*, in *Tablettes Romantiques* (Paris, 1823), 58–72. In his fiction, as of May 1660 Milton is already married to Elizabeth (married, in fact, in 1663), and she is represented (entirely mistakenly) as mother of his three daughters, who are here given the (imaginary) names Eve, Rachel, and Judith; Davenant is (erroneously) taken prisoner at Dunbar in 1650, "Nicolas Elvood" the Quaker prepares an escape via Dover, William Davenant asks to marry Eve. All unhistorical. Milton and Milton-Davenant were literary subjects for other Continental authors, among them Victor Hugo, Alfred de Vigny, and Alexander Pushkin.

WILLIAM A. SESSIONS

Milton and the Dance

When in 1942 the renowned English dancer and choreographer Robert Helpmann chose *A Masque Presented at Ludlow Castle* as the subject of his first ballet to be choreographed for Sadler's Wells, and then chose Margot Fonteyn, his young co-star, as the Lady, he was adding to a legacy, more than three hundred years old, of Milton and the dance. Helpmann called his new ballet *Comus*, the name popularly given for Milton's *Masque* since the theatrical adaptations of the eighteenth century, and once more, in the twentieth century, Milton's theater-work proved intriguing to audiences, offering its special sensuality as fertile ground for dance invention and theater ingenuity. Such a combination belies the dichotomy we make so easily between Puritan poet and theatrical display, especially the display of dance, which cannot succeed unless it stirs appetites. Although no great art has come of this combination of Milton and the dance in these three hundred years, the fact that Milton's influence has existed at all in the realm of dance tells us that we may not have read carefully enough the Christian poet of seventeenth-century England, especially in his uses of dance in his own time, on the one hand, and on the other, in the actual place of dance in his texts. Indeed, if we look at these texts themselves, we shall discover a typical Milton strategy: metamorphosis. In them formal principles of dance and actual seventeenth-century genres are transformed, with the help of Lawes and the extraordinary musical atmosphere of the seventeenth century,[1] for Milton's own purposes.

IN A DANCE WORLD

Exactly how well Milton knew the dances, both country and courtly, of his time can only be a matter of conjecture. The evidence in his texts indicates that he knew much more about them than a modern reader accustomed to easy historical generalizations might suppose. If Milton had indeed, as revealed by the portraits and by various personal descriptions, a moderate but sturdy and robust physical frame, he may have had, with his superb ear and natural sense of rhythm, an equally natural desire to dance himself. It is clear from his *Masque* that he believed dancing and chastity could easily go hand in hand. The opportunities to see and participate in dancing were considerable for a young man of London, Cambridge, and Horton in the 1620s and 1630s. Dancing was still one of the most popular entertainments in a day when neither books, mass communication, nor technological recreations dominated—nor, for that matter, anything approaching our modern conception of sports. Above all, the sense of communal entertainment still prevailed. There were public theaters where, for example, the plays of Shakespeare, even *Julius Caesar*, regularly ended in dances; there were the occasions where, through his father's musical connections, he might have seen the masques and theatrical evenings of the aristocracy (even have heard his father's musical celebration of the King of Poland on such an occasion). Especially there were still country fairs and lingering holy days during which near Horton or Cambridge Milton would have observed or even danced in the morris-dances, sword-dances, and jigs in a natural setting and with communal significance that would virtually disappear toward the end of his life. Texts like Marvell's *Upon Appleton House* still specifically recall peasant rural dances (stanza 34), and there were ceremonies of dance, as when Cromwell himself danced at the wedding of his daughter, merely to take images from a world familiar to Milton himself.

On his trip to the Continent, Milton would have had the opportunity to view in the urban centers of Paris, Venice, Florence, Rome, and Naples those formal dances that accompanied operas like those of Monteverdi, that marked festivities like those of Cardinal Barberini (which he attended in Rome), or that were part of the simpler entertainments of his hosts, like Manso. In fact, in his letter of March 30, 1639, to the naturalized Roman of German birth Lucas Holste, the librarian at the Vatican, Milton describes one such spectacle at the palace of Holste's patron, Cardinal Francesco Barberini. As cardinal-patron to all visiting Englishmen and Scotsmen, Barberini was especially gracious to Milton, as he had been to other of his countrymen, most of whom were Protes-

tant: "Barberini himself [possibly the Cardinal's brother Antonio]," writes Milton, "waiting at the doors, and seeking me out in so great a crowd, almost seizing me by the hand indeed, admitted me within in a truly honourable manner."[2] What Milton was admitted to was "that public musical entertainment with truly Roman magnificence," in describing which Milton adds the Greek "akpoama," meaning anything read, recited, or sung that was heard with pleasure. It is unlikely that such an entertainment lacked dancing, staged or social. Either staged or social dance would have found a formal space within the grand design of the recently completed Renaissance palace of the Barberinis. If indeed, as has been suggested,[3] Milton saw Giulio Rospiglioni's comic opera *Chi soffre speri* at the theater of the Barberini Palace at the Quattro Fontane, with its settings by Bernini, he would certainly have seen the dancing, often modeled on classical scenes, marking such "comic" spectacles of the day.

Rome in the late 1630s merely reflected like a microcosm a dance world that had flourished in the theater of Renaissance Europe for almost a hundred years. Italian Renaissance spectacles like *La liberazione di Tirreno*, produced in Florence in 1616, were, as an engraving of this event shows,[4] splendid mixtures of wedding celebrations and state occasions in which interpolated dance scenes had political overtones and the final grand ballet entered the auditorium proper to unite performers and audience. Such spectacles in Rome, Venice, and Paris, the legacy of which Milton could easily have seen, had their genesis in the famous *Le ballet comique de la Reine*, a five-hour entertainment presented in Paris in 1581 to Catherine de Medici on the occasion of a state wedding. This first great Renaissance spectacle, designed to show the unity and power of the French court in a time of civil unrest, was to revise the notion of the masque, especially in England, where such entertainments were generally simpler and depended more often on poetry or language. The myth that formed the basis of this first grand entertainment in Paris was the legend of Circe, integrally connected to Milton's own later myth of Comus. In this 1581 entertainment the metamorphosis of the myth, its living transfer into a new reality as the definition of that very reality, proved itself through an enactment in the music, poetry, and the allegorical dances in which the queen herself, her ladies, and the nobles of the court participated. Ben Jonson owned a copy of the choreographer Beaujoyeulx's libretto of *Le ballet comique de la Reine* (sent out to all the courts and capitals of Europe), which interestingly shows Jonson's personal annotations.[5] Inigo Jones used the ballet, several decades later, as a model for his own designs, and Aurelian Townshend wrote the dialogue for the English version of the

French spectacular. Its dances were made even more accessible to English audiences through *Orchesographie*, a popular text by a French priest, who described, through the pseudonym of Thoinot Arbeau, the main court dances of his day with such clarity that they can be reconstructed today.

Of these, the *danse basse*, with its prime example of the pavane, had long been a favorite at the English court. By 1530, however, Anne Boleyn, educated at the courts of Burgundy and France, had brought from France the galliard (her means to counteract the Spanish influence of Catherine of Aragon), and so the *danse haute* entered English culture and gave rise to the term "the dancing English." As examples of the *danse haute*, both the lively galliard, with its quick running steps, jumps, and capers, and also the volta, where couples rotated in high speed before the lady was lifted off her feet, were particular favorites of Elizabeth I, Anne Boleyn's daughter. Elizabeth's court encouraged dancing, and in the famous masques of her court, as in those Jacobean and Caroline masques, the element of dance frequently predominated or formed, particularly in the seventeenth-century court entertainments that combined poetry and scenic design and motion with subtle complexity, climactic moments of theme and dramaturgy. Francis Bacon's essay of 1625, "Of Maskes and Triumphs," appearing at the ascendancy of the Caroline era, immediately defines a masque by seeing it as dance: "Dancing to song, is a thing of great state and pleasure."[6]

Thus the world of John Milton was one in which dance was still part of a whole culture, from farmer to king. The cleavage that the later Puritan dominance of the lower and middle classes was to effect in reducing the place of dance in popular and civic occasions had not yet occurred in English society at large. Milton's Puritan world still rather effortlessly released the very human desire to express praise and love through rhythmic motions of the body, at levels in the human community suitable for all stations of that society, especially for occasions that marked the unity and amity of that society. Milton's response to this human instinct to dance, an instinct for him likely both personal *and* communal, particularly reveals itself in the texts of his poems. Here images of dance demonstrate not only the effects of the natural world on the human community of his text but also the changes within that community being made by his own time and his own person, a shift from an earlier harmony of culture to a new reality marked by a new music. Essentially there are three divisions for images of dance in Milton's poems: those representing the motions of the cosmos; those indicating the innocent actions of nature; and those portraying evil. There are two single images which are distinctly different from these categories, one in

a Psalm translation and one ending Milton's *Masque Presented at Ludlow Castle*. This latter dance image distinctly moves beyond the three divisions. It embodies a conception of dance that Milton may have envisioned as the basis for the harmonic mimesis of his final works in epic and drama but that he does not express as dance. The *Masque* dance image reveals, as we shall see, nothing less than the concord inherent in temperance itself.

TEXTS FOR DANCE

The first two categories of Milton's dance allusions fit easily into the world he inherited. The notion of stars and spheres as a dance was implied in the Pythagorean and Platonic paradigm the Western world had inherited. Milton's handling of this traditional trope, a recurrent science-fiction *topos* from Plato to Dante to Milton, can be found most incisively in Book Three, ll. 579–87, of *Paradise Lost* (a passage essentially repeated but reshaped for the purposes of Raphael's dialogue on astronomy in VIII, 122ff.). In these lines Milton actually choreographs what Satan sees. The ensuing dance action reflects the ballet Milton might have seen earlier in a Renaissance spectacle.

> They, as they move
> Their starry dance in numbers that compute
> Days, months, and years, towards his all-cheering lamp
> Turn swift their various motions, or are turned
> By his magnetic beam, that gently warms
> The Universe, and to each inward part
> With gentle penetration, though unseen,
> Shoots invisible virtue even to the Deep;
> So wondrously was set his station bright.

This kinesthetic description of the sun and its effects in space (as Copernican as any passage written) shows the effect of motion like the *danse basse*. If we imagine a Uriel-sun in center stage, a personification dressed in the costumes of the Italian spectacles or in the Caroline designs of Inigo Jones, and a corps de ballet circling around him in solemn but precise "numbers" and steps, we can see the emergence of one of those dance genres Milton knew and here builds from. If we watch the Uriel-sun stage-center, with the powerful, theatrical gestures of his arms, efforts implying strength ("Shoots") and "gentle penetration," send out other dancers from him as a rising "virtue," we are

witnessing three dances (or variations on them) Milton himself might have seen before 1640.

First, the older pavane, with its lightly lifting steps, soft but decisive turns, and slow balances in 4/4 time, was not the kind of Balanchine geometry we expect in modern ballet; rather, as here, somber, always ceremonial, and slow patterns worked at all times toward a tableau or moment of stasis. Second, the newer sarabande, which Milton might have seen at dances on the Continent, had recently been reworked by the French court from its earlier Spanish bawdy origins and also emphasized a solemnity in its sense of procession, a slow and serious walk and turn of men and women, but in a triple rhythm that did not allow for tableau. Third, this movement of the stars at the motion of the sun could be an allemand, which often replaced the pavane in the four-part classic suite. In 4/4 time it was slow and grave, and it demanded that the partners maintain hand contact. Any one of the three could also be the "mystical dance" in heaven which Raphael describes in Book Five as that which the stars "resemble nearest" (1. 622). This is the same dance described earlier by Adam and Eve in their morning hymn, the dance of the stars:

> fixed in their orb that flies,
> And ye five other wandering fires that move
> In mystic dance not without song, resound
> His praise, who out of darkness called up light.

Further, all three types of dance reflect the solemn movements and dances of the masque figures in the Nativity Ode that John Demaray has so effectively analyzed.[7] The solemn basis of the "mystical dance" also underlies the centripetal dance that gives earth its special place in creation, as Satan poignantly recalls in Book Nine (ll. 103–13). For Comus this mystical starry dance on earth not only determines time, "in swift round the months and years," and "the sounds and seas" but also moves into nature with a moon morris-dance and awakens the natural forces of "pert fairies" and "dapper elves" (ll. 113–18).

The second division of Milton's images for the dance, those of nature, develops what Comus had implied: the relationship of Platonic "mystical dance" and the actual forces of nature. Thus, at the height of his litany awakening Sabrina, the Attendant Spirit invokes this combination of nature and stars: "By all the Nymphs that nightly dance / Upon thy streams with wily glance" (ll. 883–84). In *Paradise Lost* we also find "the Hours in dance" uniting with the Graces and "universal Pan" in a solemn pavane leading "eternal Spring" in a mystic climax to the first

description of the Garden of Eden (IV, 266–68). Equally in Book Five (ll. 394–95), spring and autumn dance "hand-in-hand" in this Garden of gardens. Such harmony of edenic nature still predominates, although with rougher notes, in the satyrs and fauns of *Lycidas*, in the fairy references in "At a Vacation Exercise" (l. 60), and in the various references to peasant "Dancing in the chequered shade" in *L'Allegro* (ll. 95–96). Such country dances are specifically choreographed by Milton in his text of his *Masque*, as we shall see; the general reference in *Arcades* implies, in the looser scenario of that entertainment, the same sort of natural dance at the same climactic moment as in the Ludlow entertainment: "Nymphs and shepherds dance no more / By sandy Ladon's lilied banks, / On old Lycaeus or Cyllene hoar, / Trip no more in twilight ranks" (ll. 96–99). Although the natural dance of Mirth and her crew in *L'Allegro* may resemble an anti-masque, its "light fantastic toe" is not that of a raucous anti-masque but of innocent liberty.

In his third division, Milton inverts his dance imagery into dance as evil or leading to evil effects. Milton's response here exceeds previous literary images of licentiousness often associated with dance and drink. Like Milton's Satan in *Paradise Lost*, who can use good arguments for bad purposes, here Milton turns the good uses of dance into evil effect. Although the view of dance as diabolical is implicit, for example, in the various European versions of the Dance of Death, this dance was generally viewed as an organic phenomenon, a terrible but inevitable aspect of nature and human society. In Milton dance becomes more than a simple negative response. It is not merely the Lapland witches in *Paradise Lost* (II, 664–65) but the "dismal dance about the furnace blue" of the *Nativity Ode*, a saraband of "shadows dread" calling on their "grisly king" (ll. 206–10). This sense of positive evil becomes human, if grotesquely transformed, in Comus's exhortation to his rout, dance imagery that will be specifically transmuted into an ambivalent description of the shrunken devils in Pandemonium (I, 780–88). Even the Lady describes Comus's "wanton dance" as that of "loose unlettered hinds" who "thank the gods amiss"—natural indeed, if confused, but still dramatically different in its effect from the Brueghelesque peasant dancing already viewed in *L'Allegro* and to be observed in the climactic dances of Milton's *Masque*. This is a new note in English literature describing dance, and such positive evil is further heightened in Comus's description of his fatal drink, "this cordial julep here, / That flames and dances in his crystal bounds" (ll. 672–73). Here the theme of temptation is combined, as it will be in *Samson Agonistes* in its description of dancing wine (l. 544). This theme is further underscored when dancing is associated in *Paradise Lost* with:

> the bought smile
> Of harlots, loveless, joyless, unendeared,
> Casual fruition, nor in court amours
> Mixed dance, or wanton mask, or midnight ball,
> Or serenade, which the starved lover sings
> To his proud fair, best quitted with disdain.

Dance also figures in Milton's epic in Satan's sneer and pun at the "ministering" / "minstrelsy of heaven" (VI, 167–68) and the various wickedness of the "bevy of fair women" in the early stages of mankind (XI, 584, 619, and 715) and in *Samson* in the jugglers and dancers performing evil rites to honor the false god Dagon (l. 1325). Is it significant that there is not a single image of dancing in *Paradise Regained*? If this is Milton's last work, the dance images of his inherited world, heavenly and natural, may have ceased to hold any mimetic value; equally his earlier invention of dance as an image for evil may no longer have been necessary. In this last text, the various guises for this greatest temptation of all do not include dance, nor is this highest form of temperance to be equated, at least analogically, with any human dance or even the dance of the stars. Its Christological realm is unique.

THE DANCE OF TEMPERANCE

There is one image of dance in Milton that is supremely equated with human temperance, however, and unique both as mimetic and representational statement and as literal dance. This is the image in Milton's *Masque* that literally completes the drama, both as language and as theatrical action, the "triumph" of "victorious dance / O'er sensual folly and intemperance" (ll. 973–74). The epilogue that follows these lines, with their images of fertility specially noted by Angus Fletcher,[8] logically extends this image of temperance as dance. Dance as one of the primitive analogies for sexuality, here ordered and refined, naturally becomes a source of, and preparation for, a fuller life. These final dance sequences also effectively answer those critics who have questioned Milton's ability to integrate the formal elements of the masque, notably the dance, into his intellectual content. So, in the second song just before his final speech, the Attendant Spirit leads the three children down the stage to their mother and father and, in this gesture, completes the formal compliment that was the purpose of the masque given at Ludlow Castle in September 1634. Milton has carefully choreographed this gesture and its setting in sequences of concord both before and after

the gesture. Indeed, according to Eugene Haun, "on the basis of the Bridgewater Manuscript . . . there is every reason to assume that *Comus* was continuous music from the invocation of Sabrina to the end of the masque, with only one interval of speech of nineteen lines."[9]

First, in a three-part movement, Milton begins with the "duck and nod" of a country dance. Lady Alix Egerton, in her 1910 edition of *Comus*, speculates that the "Countrie daunces and sports" that conclude the masque (except for Lawes's twelve lines of verse in his epilogue) "may have been performed by the 'Morrice dancers' of the neighbourhood."[10] Such speculation may be valid, but in fact, except for the songs written by Henry Lawes, the entrepreneur who staged the entire production (with four songs for himself and one for the Lady), and for two terms in the text, we have neither musical nor choreographic directions for the play. Any instrumental music was "of a casual nature, and if written down at all, would have been regarded as not worth preserving in autograph or print," as Hubert J. Foss remarks.[11] Yet, whatever our exact knowledge of the music and dance in the original production, the lines themselves show us that this anti-masque rhythm is set to contrast with the sublime climax of Sabrina's epiphany shortly before, in her tableau with sliding chariot of agate, turquoise, and emerald that "stays" (l. 891). The rising of this *dea ex machina* was the typically balletic denouement of many Caroline masques and of productions of the *dramma per musica* and later Baroque opera (the kind of effect to be found in Milton's transformation of this image in *Paradise Lost* in the Son as literal *deus ex machina* in the Chariot of Paternal Deity). Even the actions of Sabrina's sprinkling are carefully choreographed by Milton (with the dramaturgical advice of Lawes, no doubt). Thus, after the Attendant Spirit's more subdued but still vigorously kinesthetic litany of blessings for Sabrina, the Spirit gives his directions, literal stage directions, to the children. As he moves them downstage, they pause as the setting of Comus's chamber changes to Ludlow Town. Then the dancing of an anti-masque, the "jigs and rural dance" that the Attendant Spirit has announced to the children, welcomes the four actors, doubling "all their myth and cheer."

If we may judge by the language here, the music surrounding it and supporting it probably would have been considerably more harmonious and "round" than the dissonant sounds of the other anti-masque, the dance of Comus's troop, although, as John S. Diekhoff suggests, the dancers here "may have doubled as the rout of Comus," the final interlude of dance balancing the earlier one.[12] That earlier anti-masque dance at the beginning of the *Masque*, designed for amateur aristocratic performers, would probably have been either a galliard or courante, with

hands knitted and feet beating the ground, its constant "light fantastic round" amid the tipsy antic behavior Milton describes for these demonic figures. Such dances had ended John Marston's masque, written in 1607 for Lady Alice Egerton at the request of her daughter, the Countess of Huntington: "the Masquers presented theire sheelds, and tooke forth their Ladyes to daunce. / After they hadd daunced many measures, galliards, corantos, and lavaltos, the night being much spent; whilst the Masquers prepared themselves for theire departing measure." In 6/8 time the courante became even more popular after 1620, more so than the galliard from the previous century. Eighteenth-century instrumental music set for this particular dance in the *Masque*, with running eight notes and mixed meter, suggests such a combination of lightness and demonic figures swirling about. In fact, like Marston's text, line 145 here actually calls for a "measure." Although a measure is defined by the *Oxford English Dictionary* as "a grave and stately dance," Milton himself qualifies the term to one like that in Marston's text. The Trinity manuscript (closer to the original performance than the printed texts) is fuller: "the measure (in a wide rude & wanton antick)."[13] Indeed the Lady in the lines following Comus's transformation actually describes the dancing sounds as "noise" and:

> Of riot, and ill manag'd merriment,
> Such as the jocund flute, or gamesome pipe
> Stirs up among the loose unlettered Hinds,
> When for their teeming flocks, and granges full
> In wanton dance they praise the bounteous Pan,
> And thank the gods amiss.
>
> (ll. 171–76)

The second anti-masque dance at the end of the drama recalls Milton's second division of dance images in nature; this anti-masque is benevolent and harmonious, like all the forces of the New Arcades in Ludlow Town. Thus the "duck and nod" may imply a dance like the jig "Heart's Ease" suggested by Demaray or the variations of the "Longwayes" dances described by John Playford in his famous 1651 *The English Dancing Master*.[14] Whatever the social level of these dancers, the text echoes the rhythms of a gigue (the eighteenth-century instrumental music has the 6/8 meter and skipping feeling typical of this dance). The pattern of steps would likely not be the intricate footwork of the morris-dance but rather would follow an earthy beat, unlike the lighter, earlier dance of Comus's wicked troop. Like Brueghel's dancers in his "Kermesse," whose pungent rhythms William Carlos Williams so

accurately caught in his poem on the painting, Milton's own language at this moment in the drama reflects this earthiness. There is, however, just enough sweep, lightness, and formal edge to suggest an aristocratic imitation of "jigs and rural dance," and this fact hints at a possible variation on a dance more formal than the gigue, such as the courante or the galliard with its leaps and jumps.

The second part of Milton's choreography of this climactic scene is also announced by the Attendant Spirit. "Back, shepherds, back!" he calls (l. 957). The dancers who have occupied center stage now pull back stage right and stage left, forming lines that focus on the center-piece of the scene, the Attendant Spirit and the children. There are now, as the Attendant Spirit once again directs, "Other trippings to be trod," and it will be a more formally aristocratic dance "of lighter toes" (ll. 960–61). Milton is quite specific about this second dance: The children and the Spirit will be "mincing," a technical term in which the dancing doubles the time of the music. As Willa McClung Evans speculates, after the country people left the stage and the Egerton children appeared, "the simple tune changed into the sophisticated measures of court music, syncopated melody and base, delayed first beats, divided counts, accidentals, etc." and "the very steps of a dainty court dance."[15] The eighteenth-century music that we have for the masque actually spells out these quick but relatively easy steps with hints of special pirouettes for the Lady or some such variant. The main purpose of this "mincing" is the practical one of getting downstage with speed and covering space. If Evans is correct,[16] it was even more involved. The Attendant Spirit had to lead the children down the stage, off the proscenium, and across the floor of the banqueting hall to the dais at the other end where the Earl and the Countess of Bridgewater sat.

Even here Milton works his own invention. Varying the traditional role of Mercury in the Caroline masque, Milton has this "court guise" which Mercury "did first devise" for the "Dryades / On the Lawns and on the leas" transformed into a choreographic instrument. This "guise" will not merely present the main actors in the masque, who have now actually danced down the stage and through the hall and to the dais, but will also enhance, with mythological allusions and idealized tableaux, the final scene. Indeed this scene is the compliment that is the purpose of the masque. In its gesture of representation, the compliment defines the subject of the masque, temperance. This representation will be made through a dance that lifts human gesture to "deathless praise," a "triumph in victorious dance." For Milton this is exalted dance. In fact, by no accident, Milton has only one other image besides that of temperance that does not fit the categories of dance already noted in his texts. It is

the image of the dance of the holy man in Milton's translation of Psalm 87. That psalm describes the holy man of Zion in contrast to the man of other nations. The Lord, writing in a "Scroll / That ne'er shall be outworn," marks the man who is chosen; and the marks of his election, like the Lady's ability to sing and dance, are clear. Even his haunts are like those of Milton's muse Urania, who also "didst play" and sing.

> Both they who sing, and they who dance
> *With sacred songs are there,*
> In thee *fresh brooks, and soft streams glance,*
> *And* all my fountains *clear.*
>
> (ll. 25–28)

In the third part of Milton's choreography, therefore, the Attendant Spirit brings the three children to their parents. At the same time, he sings his second song and all four probably turn their "mincing" steps into slow, ceremonial motions as the Spirit leads the children forward up the dais. Such an action would have been a processional and, in terms of dance, likely the appropriately slower *basse danse*, possibly a pavane, the popular dance at the early Tudor court through the influence of Catherine of Aragon. The "new delight" that the Attendant Spirit has brought the "Noble Lord and Lady bright" is not merely the epiphany of the children from the dark wood but the knowledge of their "triumph" in the trial through which they have gone. The proof of this triumphant trial is, in fact, the very dance that the parents are seeing enacted in front of them, a dance which has truly given their children to them. This dance is but an outward and visible sign of that deeper dance of "their faith, their patience, and their truth." Indeed, at this moment in the masque, the dancing children before them, the new Lord President of Wales and his "Lady bright" cannot tell these dancers from the "victorious dance / O'er sensual folly and intemperance" (ll. 973–74). No father or mother could have a greater compliment than the dance that ensures in their children maturity and an outlook toward reality opened by temperance to courage and compassion. For Milton this is the very human "mystical dance" that earth imitates, as the stars, so Raphael told Adam, are an analogue to the dance of heaven itself.

Thus, far from being extraneous to Milton's masque at Ludlow Castle, the dance is at the very heart of its theatrical, literary, aesthetic, and spiritual experience. Within the strategies of this theater-piece the dance represented a system of complex analogies which Samuel Johnson, among other critics of the work, could not figure out. Simply unable to comprehend and fathom the genres and formal principles at work in

Milton's masque and especially missing the larger cosmic and sexual metaphor of dance, Samuel Johnson began, with bold innocence, the critical tradition that was to denigrate the masque elements in Milton's *Masque*, especially dance. The eighteenth century further revealed, with its truncated and artificial productions of *Comus*, the general suspicion of dance as a serious means of understanding reality. It even gave Milton's drama a new name, that of its villain, shifting away from Milton's clearly enunciated theme of temperance. The work could not be understood any longer in holistic terms except as revelation of pure good and pure wickedness, the latter made considerably more interesting. What the Johnson tradition (actually cultural forces Johnson merely articulated) demonstrated, above all, was the loss of perception that the dance in Milton's *Masque* represented a cultural and natural harmony of the levels of human existence. Although both Johnson and Thomas Warton recognized the special force of the work, Warton seeing it as inferior only to *Paradise Lost*, such a conception of Milton's *Masque* as integrative in its structure could only reappear after the basis of Johnson's criticism, Newtonian science and its positivistic interpretations, had disappeared. In the intervening centuries and until the 1950s, criticism turned to the intellectual and religious content of the masque, with remarkable discoveries in our century but always with a firm cleavage of content and form. Indeed D. C. Allen called the form of the *Masque* "an error in artistic judgment." Even Enid Welsford could write in her comprehensive study of the masque: "It is possible to read *Comus* and hardly realize that there are dances; it is possible to act *Comus* without introducing any dances at all. . . . " William Riley Parker, accepting these arguments, tries to blame the circumstances of production for the artistic failures of *Comus* as a masque.[17]

Fortunately the studies of John Demaray, C. L. Barber, and Stephen Orgel, among others,[18] have rescued *A Masque Presented at Ludlow Castle*. Orgel has stated, in fact, a general principle that implies the mimetic and representational basis for Milton's final image of the dance of temperance: "the function of the court masque is the making of viable myths, whereby courtiers take on the character of heroes, kings of gods, events of symbols." The "Puritan" Milton's ideologically ironic transformation of this aristocratic mode emerged precisely because he understood that the vitality of *his* myth lay in his own re-invention of strategies within the theater-piece, such as the dance. Thus, dance images dramatized in language and spectacle that persistent mythic theme in all of Milton's work and here most centrally and decorously set, the triumph of temperance. Furthermore, the proof of the vitality of Milton's strategies in *Comus* has been its popularity in the next three centuries. Not

only did the work make its way into English schoolrooms, but also for two centuries (in distorted form) it had its place in the theater. There, of all Milton's texts, it continued in attraction like the "Cynosure" which L'Allegro describes, until it reached a kind of apogee in the mid-twentieth century. At that time, in a purer form than the theatrical productions of the eighteenth and nineteenth centuries, Milton's text had a direct influence on modern ballet, most surprisingly for a crucial short period in England. What Milton understood about the structure of his *Masque* (and so many later critics did not), its natural dialectic that released theatrical energies, was revealed at a moment in the developments of one of the greatest ballet companies of the century, of a renowned choreographer and director, and of a very great ballerina.

THE METAMORPHOSIS OF COMUS

It was exactly one hundred years after Henry Lawes published *A Maske* in 1637 that the first known adaptation of Milton's theater-piece was staged. Although the anniversary date of 1737 may have been an incentive, more likely, as David Harrison Stevens suggests,[19] it was the Licensing Act and the need for English materials, a vogue in theater since Addison's attempt to make his *Rosamund* the forerunner of a line of native musical plays and then the success of Gay's very English *Beggar's Opera*. Paolo Antonio Rolli renamed this first version of Milton's masque *Sabrina*, setting it in a Herefordshire forest with Italian characters. The dance sequences were probably little more than country dances and the posturing and balancing that in this period often substituted for any genre of theatrical dancing. When Campaspe, or Comus, disappears at the end of Rolli's version, Sabrina rises, posing, in what must have been a tableau to bless the lovers in a prophecy that is the compliment of the work and an indication of its level of production: "propitious smiles" for the "British isles."[20]

This work was merely a prelude to the production in the next year of the musical *Comus*, whose original cast had four dancers in the bill. This production, which would change the name of Milton's *Masque*, had successive runs for the next thirty-five years. Its producer, John Dalton, clearly discovered, in his adaptations of the original with music by Thomas Arne, the formula for entertaining an eighteenth-century audience. No small part of his success was his handling of the basic dialectic of Milton's myth of temperance. In this version Comus emerges, of course, as a character role that an actor could develop with enormous success. To balance his evil, Dalton invents a character, Euphrosyne,

who speaks didactic lines directly to the audience. After one of her sermons and advices on love, the stage directions call for Naiads to "dance a slow Dance agreeable to the subject of the preceding lines and expressive of the Passion of Love."[21] If this dance is typical, it is more of the same posturing typical of the eighteenth-century conception of dance but perhaps in the nature of a sarabande (the pavane had died out by this time). In the Dalton *Comus* the myth of temperance still dominates, and in the end the First Spirit tells the Younger Brother that, after these "hard Essays," he will triumph "in victorious Dance." The final couplet completes the myth: "But to be grave, I hope we've prov'd at least / All vice is folly, and makes man a beast."[22] By 1772 George Colman had continued the tradition of adaptation by revising Dalton's *Comus* to emphasize the sensual and reduce the moralizing. Thus the brothers' speeches, full-length in Dalton, are reduced to comments; a pastoral girl becomes a female bacchanal (and the dances, one assumes, would change character); and because for Colman the "divine arguments on temperance and chastity" are too embarrassing to recite, they are "expunged and contracted."[23] Needless to say, Comus comes again to dominate the action. This same version of Milton's masque as *Comus* appeared in 1790 and then in 1815; it was reduced still further in a complete operatic version in 1842, with little of the original structure. In that same year Madame Vestris, a London entrepreneur who had married into the most famous dancing family in Europe, made a French version of the adapted *Comus* at the Theatre Royal, Covent Garden, and the famous man of theater William Macready had some sort of production in the next year. After this production, except for the various tableaux and posturings in the operas based on *Paradise Lost*, there seems to have been no influence of Milton on the dance until in a remarkable period in English ballet in the twentieth century.

Again, it is the vital myth of Milton's *Masque*, with its basis in the dialectic of Comus and the Lady, that accounts as much as anything else for the sudden recrudescence of a work as seemingly antiquated as Milton's 1634 theater-piece. Indeed all three twentieth-century ballet productions of *Comus*, as the work was by now called, emphasized this pristine myth of temperance, if we judge by the photographs and what we know of the productions. It is likely, furthermore, that at the root of these productions, particularly the Bloomsbury ones, lay the memory of Rupert Brooke and his appearance in a well-known Cambridge production of *Comus*. The photographs of this production, with Brooke's own crystalline *fin de siècle* poses, reflect the directions and ideas from Lady Alix Egerton's then recent edition of Milton's text. The Brooke legacy suited the new ballet productions, as we shall see.

The last of these three productions of *Comus* is the least known. In 1946 *Comus* was performed as part of the repertory of the International Ballet, a company built around its founder, Mona Inglesby. This group played the English provinces and some overseas theaters from about 1941 to the early 1950s, and its ballets were largely classical favorites. In this kind of context a version of Milton's original masque was revived, with long dance sequences staged by Leslie French and choreographed by Mona Inglesby to original music of Lawes with arrangements from Handel. Although the production appears to have been in response to the Sadler's Wells production four years before, the very fact of its production as late as the postwar years shows the continued attraction of Milton's original work.

The first twentieth-century production of *Comus*, in late 1930, however, was hardly a dance production in the full sense of a ballet. The choreographer was none other than Frederick Ashton, at the beginning of his illustrious career as England's most famous choreographer in the twentieth century. After his first ballet for the incipient Camargo Society in the late 1920s, the young Ashton's second assignment was to stage incidental dances and two short ballets for an evening of entertainment called "A Masque of Poetry and Music," subtitled "Beauty, Truth and Rarity," all to be presented by Arnold Haskell (later a prominent dance critic) at the Arts Theatre Club in London.[24] The centerpiece of the evening was the renowned Lydia Lopokova, the Diaghilev ballerina who had married John Maynard Keynes and who was, with her famous husband, at the heart of the Bloomsbury circle. George Rylands (later to become an eminent stage director) played Comus and directed the production, which included excerpts from Milton and an adaptation of Shakespeare's *A Lover's Complaint*, whose cast included Michael Redgrave, of equally prominent later fame. What is significant about this program, given December 10–16, 1930, is that, amid a selection from the Renaissance musician John Dowland's *Lachrymae* (with a title from Campion, "Follow Your Saint," and the subtitle "The Passionate Pavane") and then the light relief of "Dances on a Scotch Theme," Ashton chose to choreograph (to music by Henry Purcell directed by the young Constant Lambert) the dance that concluded *Comus*, the heart of Milton's myth of temperance. If Lydia Lopokova's "unique charm," as one reviewer commented, showed itself throughout, it was doubtless her own dancer's response to this myth of Milton's that also gave the audience the feeling that in seeing Ashton's *Comus* "they were witnessing something rare and exquisite, graceful and gossamer."[25]

In fact, this was Lopokova's third performance of *Comus*. Encouraged to act and dance by her husband, England's most illustrious economist,

who would shape postwar Europe and America, Lopokova performed versions of Milton's masque in the rooms of George Rylands at Cambridge and then later at "an exceptionally grand party" at the Keynes home in Gordon Square, Bloomsbury. [26] Virginia Woolf saw the Keynes very often (two weeks after the second Lopokova *Comus* she had Maynard and Lydia for tea at Lewes) but obviously did not share her friends' enthusiasm for the piece. She had not seen the interlude of December 1930, but in a letter of January 5, 1931, she alludes to this production, confusing and satirizing it and finding "Lydia slightly depressed by her comparative failure to tempt the British public with slabs of *Paradise Lost* recited by half naked young men in American cloth."[27] Two weeks later she writes sneeringly: "But the most illusory part of Lydia's visit was that she proposes to set a scene in *Orlando* to music and dance to it behind a microphone" in a radio studio, and Woolf is to "rearrange" the words to suit music to be written by Constant Lambert.[28] For Lopokova, obviously *Orlando* and *Comus* were both myths of a kind that could be theatrically effective, although the question of just why Lopokova chose Milton's drama—and started the whole cycle of *Comus* productions—remains intriguing. Even Virginia Woolf's attitude needs to be qualified, for in this very period Milton was a special solace to her: "a thousand sucking vampires attach themselves to my ribs, and if I snatch up Milton once in a blue moon, its [sic] about all the reading for pleasure, I ever do."[29] Readers of Woolf will also recall her own ironical uses of an English pageant like *Comus* in her very last novel, *Between the Acts*, and her manipulating of lines from *Comus*, especially about the virginal metamorphosized Sabrina, in her first novel, *The Voyage Out*. The nexus of these Bloomsbury figures with *Comus* is further complicated when we remember that earlier in 1930 Lydia Lopokova, always supported and directed by her economist husband, had founded, with a handful of other famous figures, the Camargo Society, the genesis of the organization that would become Sadler's Wells and later the English Royal Ballet. It was in a production of this new company during the Second World War that *Comus* would appear once more, in Orgel's term, as "viable" myth.

The Sadler's Wells production of *Comus* in 1942 was the most ambitious staging of Milton's work since 1634, at least intellectually, although no attempt was made to reproduce the masque, merely to choreograph a ballet based on the original *Masque Presented at Ludlow Castle*. In a kind of historical irony, the motives of patriotism that inspired the jingoistic 1737 productions of Milton's masque equally engendered this production during the first terrible years of the war. Productions of *Hamlet* and a ballet based on Spenser's *Faerie Queene*, *The*

Quest, followed the success of the 1942 ballet of *Comus*; all were native English creations and, in their ways, quintessentially English. The memory of Frederick Ashton's production of *Comus* twelve years before was no doubt in the company, for by now Ashton had become the resident choreographer of the native English ballet company and had established himself as the center of its artistic development. Although he would return to choreograph *The Quest*, Ashton had been drafted in 1941 into the Royal Air Force, leaving Robert Helpmann behind him as the only member of the company capable of staging and producing new ballets.

An Australian, Helpmann had become the leading male dancer in England at this time. Technically never very proficient as a dancer, Helpmann had also acted in London theater, and encouraged by Ninette de Valois, the artistic director of the company, Helpmann turned to his love of theater as well as English literature in his very first creations as a choreographer, *Comus* and *Hamlet*. In both he could combine theater, myth, and dance. Thus, in these first ballets, begun in the summer of 1942, designed to fill in the gap left by Ashton's drafting, Helpmann brought into traditional English ballet more elements of drama and decorative theater and less of the abstract design already familiar to audiences in Continental *Ballet Russe* productions and to American audiences in the creations of George Balanchine. Working under adverse wartime conditions, Helpmann developed his *Comus* into a ballet of two scenes, really a mimed play with dance sequences and even spoken lines from Milton's original text.

Helpmann had seasoned collaborators and well-trained, intelligent dancers for his own interpretation of Milton's drama. For the Lady he chose the young ballerina of the company, Margot Fonteyn, who was then in her early twenties. In her *Autobiography*, Fonteyn recalls this period, Helpmann's support for the entire company, and the ballets he created at this time, his *Hamlet* "definitely a masterpiece" and the others, including *Comus*, "original and exciting theatrical experiences."[30] Fonteyn's perception of the role of the Lady in Milton's myth revealed itself in a performance that immediately garnered the highest praise. Indeed, the whole cast understood the nature of this first work by Robert Helpmann, not least Moyra Fraser, who revealed her "elegant long line" as Sabrina.[31] Constant Lambert arranged and directed music from various works by Henry Purcell, and although Lawes's songs were omitted, it was proclaimed a masterly arrangement. The elaborate set by Oliver Messel, influenced by Inigo Jones, suggested the period fully but was not entirely suitable for a ballet.[32] Furthermore, both *Comus* and *Hamlet* (the latter to influence Olivier's film *Hamlet* a few years later)

reflected Helpmann's personal emphasis, and on the dust jacket for
Caryl Brahms's study of Helpmann published in London the next year,
Leslie Hurry drew the dancer with two faces, the demonic Comus and
the youthful Hamlet. Such literary and psychological emphasis may
have caused the production to be viewed by some as "a decorative occa-
sion rather than a dramatic one,"[33] but at the same time, Helpmann
clearly understood the dialectic at the heart of Milton's myth. That, as
Helpmann knew, was quite dramatic enough. The proof was an enor-
mous box-office success for the production.

What Helpmann succeeded in integrating, if we can judge by the ex-
tant photographs and reviews of the 1942 *Comus*, were both sides of
Milton's dialectic, the dance of Comus versus the dance of the Lady.
These became literal representations of calculated chaos and of ordered
temperance whirling on a stage before a wartime audience. Helpmann
added to the vigor of his role as Comus by including two delivered
speeches from the original *Masque*, Comus's exhortation to his troop
and a composite address to the Lady from the temptation scene in
Comus's chamber. Helpmann's staging of the anti-masque scenes was
particularly dynamic. When the action of the ballet actually stopped for
his speeches, which, according to reviews, he delivered clearly if with an
over-deliberate enunciation, the tableaux of the scenes were spectacu-
lar, as a London *Times* photograph of January 17, 1942, shows. In this
photograph the troop of Comus, with their monster-heads of chickens,
cats, pigs, and birds, are in a diagonal line with hands outstretched
toward Helpmann, as though in a Nazi salute. Helpmann, with one leg
on a box, lifts his arms toward them. Behind him on the elevated box
waits Fonteyn as the Lady, staring stiffly but with complete balance and
poise. In another photograph Helpmann, dressed as a late Renaissance
gentleman, stands in the center of his enchanted circle of followers, also
dressed in seventeenth-century costume, but with monster heads as
hideous as any that Milton envisioned.[34]

The success of Helpmann's *Comus* was both critical and financial. It
was performed fifty-nine times in wartime London alone over the next
six months. As one of a series of Helpmann's creations, *Comus* offered,
as critics noted, a "civilised and fluent action" that "countered wartime
austerity," forming a "unity of the arts."[35] Writing years later, the ballet
critic Arnold Haskell, who had been a part of the original Lydia Lopoko-
va performances of *Comus*, recalled how Helpmann carried the "quality
of the true theater professional into his choreography" in such "magnifi-
cent dance dramas" as *Hamlet* and *Miracle in the Gorbals* and how in
Comus he created "a wonderful vehicle for Fonteyn and himself."[36] This
success was possible not only because Helpmann had understood the

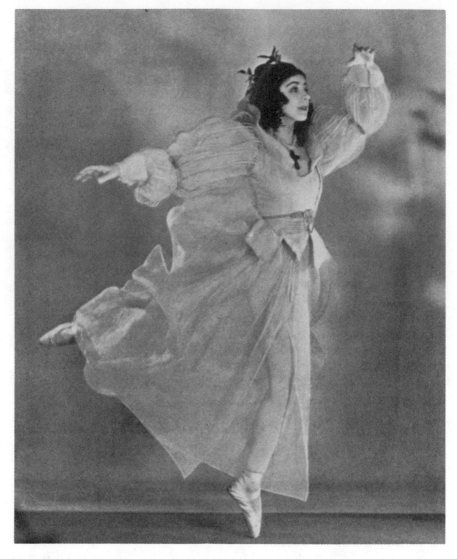

FIG. 35. Gordon Anthony's photograph of Margot Fonteyn as the Lady in Help-
mann's *Comus*.

perennial entertainment implicit in any performance of the wicked Comus, potentialities fully exploited in the eighteenth and early nineteenth centuries, but also because he understood the other side of the dialectic, which Milton's text and Lawes's original production in 1634 delineated and which had been lost in the intervening centuries.

This was the representation of the dance of temperance, and this was the achievement in 1942 of Margot Fonteyn in one of her earliest creations. The London *Times* reviewer in January 15, 1942, remarked how, "a beautiful figure as the Lady," Fonteyn "dances with grace but without ever losing the sense of frozen restraint which is essential to the character." This sense of silence, which may have been Helpmann's special emphasis in contrast to his own Comus, was shaped by Fonteyn through the voiceless motions of her dance into a serenity that translated the Lady's arguments into the dance of her own being. The famous photographer Gordon Anthony, the brother of Dame Ninette de Valois, the renowned director of the Royal Ballet, called Fonteyn's performance "a lesson in sustained drama in a low key." He also noted the very dimensions of Milton's dance of temperance, which our one photograph (Fig. 35) of Fonteyn as the Lady (by Anthony himself) confirms: "Fonteyn as the Lady whose virtue was unassailable, even by the wiles of witchcraft, gave a superb, trance-like rendering, surrounding herself with a sort of spiritual, virginal serenity."[37]

Fonteyn's is the last living image of Milton's dance of temperance and, like all other dances, is now lost. The implicit life of that dance still remains, however, in Milton's text. The strange reappearances of Milton's mythic structures, in the three centuries since *A Masque Presented at Ludlow Castle* first appeared, attest to the vitality of this old story and its possible resurrection in the next century. Indeed, the reality of Milton's text as embodying a fundamental human perception about the nature of life itself was summed up by the London *Times* critic of 1942, who began his review of that mythic reenactment by Fonteyn and Helpmann with: "*Comus* is as good a subject for modern ballet as Milton found it to be for the seventeenth-century masque."

NOTES

1. Peter Le Huray, "The Fair Musick That All Creatures Made," in *The Age of Milton*, ed. C. A. Patrides and Raymond B. Waddington (Manchester and Totowa, New Jersey: Manchester University Press, and Barnes and Noble,

1980), p. 241. Also see references to the popularity and accessibility of dance forms, pp. 248, 250, 252, 254 (Milton's school plays involved music and, one presumes, dance); 259 (the masque as primarily dance); and 261. I obviously do not believe that Le Huray is correct in assuming (269) that Milton's verse does not refer to dance forms because he has no explicit references.

2. David Masson, *The Life of John Milton* (1881; New York: Peter Smith, 1946), I, 802–3.

3. William Riley Parker, *Milton: A Biography* (Oxford: Oxford University Press, 1968), I, 177; II, 828. Also see John Arthos, *Milton and the Italian Cities* (New York: Barnes and Noble, 1968), pp. 81–86.

4. Mary Clarke and Clement Crisp, *Ballet: An Illustrated History* (New York: Universe Books, 1973), p. 34.

5. Ibid., p. 28.

6. "Of Masques and Triumphs," in *Works*, ed. James Spedding, Robert Leslie Ellis, and Douglas Denon Heath (London: Longman and Co., 1858–74), VI, 467.

7. *Milton and the Masque Tradition* (Cambridge: Harvard University Press, 1968), pp. 31–40.

8. *The Transcendental Masque* (Ithaca: Cornell University Press, 1971), pp. 174–75.

9. Eugene Haun, "An Inquiry into the Genre of *Comus*," in *Essays in Honor of Walter Clyde Curry*, Vanderbilt Studies in the Humanities, vols. 1–3 (Nashville: Vanderbilt University Press, 1954), p. 236.

10. Lady Alix Egerton, *Milton's Comus, being the Bridgewater Manuscript, with Notes and a Short Family Memoir* (London: J. M. Dent, 1910), p. 30.

11. Cf. Willa McClung Evans, *Henry Lawes: Musician and Friend of Poets* (New York: Modern Language Association, 1941), p. 97, and John T. Shawcross, "Henry Lawes' Settings of Songs for Milton's *Comus*," *Journal of the Rutgers University Library* 28 (1964): 22–28. See also Le Huray, p. 261, for a reminder of the basic nature of this masque dance music: "Most of the dance music, though, is of the simplest kind: melodies are stepwise, the harmonic progressions smooth, and the phrases four-square. This in fact is the idiom of the popular ballad tune, and it is here (as in the splendid virginal music of the period) that courtly and popular music most effectively meet."

12. "A Maske at Ludlow," in *A Maske at Ludlow: Essays on Milton's Comus*, ed. John S. Diekhoff (Cleveland: Case Western Reserve University Press, 1968), p. 9.

13. William B. Hunter, Jr., *Milton's "Comus": Family Piece* (Troy, New York: Whitston Publishing Co., 1983), pp. 58 and 49.

14. There are a number of these basic dances not unlike our Virginia reel, a pattern reflected in many other dances. The problem with Demaray's suggestion (p. 118) is that Playford says that "Hearts Ease" was only for four and the *Masque* cast would have called for more dancers.

15. Evans, p. 105.

16. Ibid.

17. See the summary of criticism in Demaray, pp. 1–4. D. C. Allen's remarks are from *The Harmonious Vision* (Baltimore: Johns Hopkins Press, 1954), pp. 31–33. Enid Welsford, *The Court Masque* (Cambridge: Cambridge University Press, 1927), treats Milton's *Masque* in passing, pp. 317–18. Parker's analysis is from I, 130–31.

18. C. L. Barber, "*A Mask Presented at Ludlow Castle*: The Masque as a Masque," in *The Lyric and Dramatic Milton*, ed. Joseph Summers (New York: Columbia University Press, 1965), pp. 35–63; Stephen Orgel, *The Jonsonian Masque* (Cambridge: Harvard University Press, 1965), pp. 102–3.

19. David Harrison Stevens, "The Stage Versions of *Comus*," in *Milton Papers* (1927; New York: AMS Press, 1975), p. 21.

20. Ibid., p. 25.

21. Ibid., p. 28.

22. Ibid., p. 30.

23. Ibid.

24. David Vaughan, *Frederick Ashton and His Ballets* (New York: Alfred A. Knopf, 1977), p. 47.

25. Ibid., p. 48.

26. R. F. Harrod, *The Life of John Maynard Keynes* (New York: Harcourt, Brace, 1951), pp. 400–401.

27. *The Letters of Virginia Woolf*, ed. Nigel Nicholson and Joanne Trautmann (New York: Harcourt Brace Jovanovich, 1978), IV, 276.

28. Ibid., 279.

29. Ibid., 119.

30. *Autobiography* (New York: Alfred A. Knopf, 1976), pp. 79–80.

31. Katherine Sorley Walker and Sarah C. Woodcock, *The Royal Ballet: A Picture History* (London: Threshold/Corgi Press, 1981), p. 43.

32. The reference to Lambert is from the London *Times* review of the ballet on January 15, 1942; the Messel comment is from Mary Clarke, *The Sadler's Wells Ballet* (New York: Da Capo Press, 1977), p. 168.

33. Alexander Bland, *The Royal Ballet: The First Fifty Years* (Garden City, New York: Doubleday & Co., 1981), p. 68. The drawing by Leslie Hurry of Helpmann as Hamlet and Comus can be found in Mary Clarke and Clement Crisp, *Ballet Art from the Renaissance to the Present* (New York: Clarkson N. Potter, 1978), p. 122.

34. Ibid., p. 72.

35. Walker and Woodcock, p. 43.

36. *Balletomane at Large* (London: Heinemann, 1972), pp. 75 and 97.

37. Gordon Anthony, *Margot Fonteyn* (New York: British Book Centre, 1951), p. 92.

ALBERT C. LABRIOLA

"Insuperable Highth
of Loftiest Shade":
Milton and Samuel Beckett

S amuel Beckett's awareness of Milton is rarely mentioned, let alone
discussed. Three centuries apart and advocates of vastly different
worldviews, Milton and Beckett seem quite naturally to be dis-
sociated rather than connected. Interestingly, however, Beckett's
awareness and admiration of Milton began at an early age. How early we
cannot say for sure. But in *From an Abandoned Work*, presumably
autobiographical, the narrator remarks: "Fortunately my father died
when I was a boy, otherwise I might have been a professor, he had set
his heart on it. A very fair scholar I was too, no thought, but a great
memory. One day I told him about Milton's cosmology, away up in the
mountains we were, resting against a huge rock looking out to sea, that
impressed him greatly."[1] Other explicit references to Milton occur in
Beckett's correspondence, particularly in letters to Thomas McGreevy,
with whom he maintained a lifelong friendship: from 1928, when they
first met in Paris, until 1967, when McGreevy died. In a letter dated
November 16, 1955, Becket confides to McGreevy that he "can't get a
verse of Milton out of my mind: 'Insuperable highth of loftiest shade'."[2]
Almost one year later, on October 18, 1956, Beckett writes to Mc-
Greevy that he has been "re-reading *Paradise* indeed *Lost*. . . ."[3] Twen-
ty years earlier, references to Milton are in the letters to McGreevy,
indicating that Beckett's interest was long-standing, even habitual. The
effect of such rereading should not be underestimated, for as Deirdre
Bair remarks about Beckett's citation of "Insuperable highth of loftiest

shade," his contact with Milton "was leading him to all sorts of reflections."[4]

The verse "Insuperable highth of loftiest shade" (IV, 138) describes how Satan perceives the ascending slopes of the mountaintop whereon the Garden of Eden is situated.[5] Circling the slopes are rows of different trees: " . . . the ranks ascend / Shade above shade . . . " (IV, 140–41). After "th'ascent of that steep savage Hill" (IV, 172), Satan alights in the Garden, and from " . . . the Tree of Life / The middle Tree and highest there that grew" (IV, 194–95), he surveys the landscape below him: " . . . and next to life / Our Death the Tree of Knowledge grew fast by" (IV, 220–21).

In the few lines I have quoted—the immediate context of the verse that haunted Beckett—words like "highth," "loftiest," "ascend," "ascent," "above," "steep," "highest," and "grew," not to mention the elevation suggested by "hill" and "tree," predominate. But the emphasis on height or ascent is more pervasive than a few short passages indicate. Even in descriptions of descent—for instance, Satan's entrance into the serpent—the opposite condition of loftiness is the remembered and repeated frame of reference by which degradation is measured:

> O foul descent! that I who erst contended
> With Gods to sit the highest, am now constrain'd
> Into a Beast, and mixt with bestial slime,
> This essence to incarnate and imbrute,
> That to the highth of Deity aspir'd;
> But what will not Ambition and Revenge
> Descend to? who aspires must down as low
> As high he soar'd, obnoxious first or last
> To basest things.
>
> <div align="right">(IX, 163–71)</div>

The verse from Milton that Beckett continued to recall and the passage in *From an Abandoned Work* discussing Milton's cosmology are more similar than we might expect. Together they call attention to height or ascent as a central and recurrent image in *Paradise Lost*. In identifying what is virtually omnipresent in Milton's work, Beckett thereby stressed what is absent from his own. This contrast between them has numerous implications for a study of their art. To make discussion of this topic manageable, for the time being I will limit myself to a comparison of *Paradise Lost* and *Waiting for Godot*, the work that first catapulted its author to international prominence. Apart from the fame that it garnered for its author, *Godot*, written in 1948–49, is in

many ways a dramatic adaptation of some of Beckett's earlier fiction, including *Mercier and Camier*, written in 1946–47, and *Murphy*, published in English in 1938. In fact, Beckett remarked to Colin Duckworth, "If you want to find the origins of *En attendant Godot*, look at *Murphy*."[6] *Godot*, in other words, manifests the essence of Beckett's creative art at its formative stages, during which, as the letters to McGreevy indicate, Milton was being reread periodically.

The central scene of *Godot* is a tree with a mound or hillock and roadway nearby, the location at which all the dialogue and encounters take place. Because of countless biblical allusions in the play, this tableau has multiple significance. It recalls events of biblical history, like the creation of Adam and Eve, their marital union, the Fall of mankind, and the Redemption. In traditional iconography, including illuminated manuscripts, illustrated Bibles, stained glass, books of hours, missals, and the like, these events of the Old and New Testaments are depicted in a garden setting, often with a lofty tree, hillock, and way of travel as prominent features. By adapting these features in a single work, an artist highlighted the typological relationship of several events of biblical history. In effect, such artwork visualizes traditional interpretations of Scripture, whereby exegetes, especially the Church Fathers, view the temporal ministry of Christ as the fulfillment of many Old Testament types and prefigurations.

As Beckett recognized, *Paradise Lost* is the most significant literary expression of this theological outlook, standing as a virtual encyclopedia of biblical commentary. And in its variations and adaptations of the tableau of the garden, including a lofty tree, hillock, and way of travel, *Paradise Lost* is a compendium of traditional iconographic imagery. Throughout his adaptations of events of biblical history, Milton stresses height or ascent. In recalling his creation, Adam likens himself to a seedling warmed by the sun and uplifted suddenly: " . . . till rais'd / By quick instinctive motion up I sprung" (VIII, 258–59). Eve's first moment of consciousness occurs "Under a shade on flow'rs" (IV, 451). Variously likened to fruits, flowers, foliage, and trees, Adam and Eve in *Paradise Lost* exemplify the God-given potential to be fruitful, to multiply, and to fill the earth with their progeny. With that guidance and in a garden setting, they are conjoined in marriage by God in *Paradise Lost*. One of God's admonitions is that Eve should remain alongside Adam, a relationship also described as that of a vine clinging to a tree. Significantly, in her first view of Adam, who is under a tree, Eve appraises him as "fair indeed and tall" (IV, 477).

A related biblical event that took place in a similar setting is the Fall of mankind. In Milton's epic the serpent-tempter, having led Eve to the

interdicted tree, is compared to an orator: "So standing, moving, or to highth upgrown" (IX, 677). Throughout the temptation scene, such images of height have double application: first, to the serpent-tempter, who claims that "by vent'ring higher than my Lot" (IX, 690) he acquired the intelligence of man; second, to Eve, who becomes height-conscious—or aware of the scale of being and her place on it—after having been infused with the ambition to become godlike. Satan, for instance, argues that God interdicted the fruit of the Tree of Knowledge in order to keep mankind "low" (IX, 704). As she partakes of the fruit, Eve, "through expectation high" (IX, 789) and "hight'n'd as with Wine" (IX, 793), fancies herself being elevated, a reaction that Adam shares when he joins her in the consumption of the forbidden fruit.

Another biblical event typologically related to the creation and Fall of mankind is the Redemption. When in *Paradise Lost* God the Father prophesies eventual salvation for mankind, he employs a tree image— notably "second root" (III, 288)—to describe how Adam and Eve and their progeny will be "transplanted" (III, 293) in the Son in order finally to be taken heavenward. Explained by the Church Fathers and depicted in iconography, the Redemption becomes a re-creation, with mankind upraised at what George Herbert calls in *The Sacrifice* "the tree of life to all." Milton's concept of "A paradise within" man's heart (XII, 587) recapitulates traditional explication and visualizations of the crucifixion in an enclosed garden (*hortus conclusus*), at the center of which is a treelike cross luxuriant with foliage and laden with delectable fruit. The saving Lord implanted in man's heart is an image of newly acquired life.

Paradise Lost and the traditions of biblical commentary and iconographic depiction reflected in it supply the context in which the tableau of Beckett's play, the dialogue at the tree, and encounters there may be interpreted. Within view of a tree, a dominant sign of the immanence or presence of God in the human condition, Vladimir and Estragon, descendants of Adam and Eve and representatives of modern-day man, seek reassurance of fundamental elements of the Christian theology historically transmitted to them: their origin as God's creatures; their worth and dignity, which are derived from resemblances to their maker; God's awareness and compassion, evident in his willingness to sacrifice his Son for their salvation; and their life on earth as the preparatory phase for ascent heavenward and ultimate union with God. Reexamined by modern-day man in a setting similar to that in which they were originated, these elements of theology, both affirmed and dramatized in *Paradise Lost*, are challenged in Beckett's play.

By their imploring presence at the tree, which they describe as "prayer" and "supplication," Vladimir and Estragon seek to elicit some manifestation of the godhead that would upraise them psychologically

and spiritually by renewing man's faith in the past, revitalizing hope in the present, and reintroducing promise to the future.[7] For modern man is portrayed as uncomfortable and heartsick with a theology that is thousands of years old, transmitted by faith in events that occurred in a faraway location and unfamiliar culture. In this theology, the chief sign of its origin and continuity, notably the tree, is inapplicable or obsolete unless periodically validated or authenticated. In such a time-conscious condition, with mankind awaiting verification of the theology explaining existence, Vladimir and Estragon experience nervous agitation and deep anxiety. As they wait by the side of the tree, there is no more concise an explanation of their outlook than this passage from Proverbs 13:12: "Hope deferred makes the heart sick, but a wish fulfilled is a tree of life."

In line with this argument, one of the most striking contrasts between Milton and Beckett is their adaptation of the biblical account of God manifesting himself to Moses from the tree or bush on Horeb. Interestingly, Milton alludes to this Old Testament theophany during Adam's account of his creation. In his first moments of consciousness, Adam apostrophizes the sun, but overcome with drowsiness he is about to lapse into his previous insensibility. He has a dream, however, in which "one . . . of shape Divine" (VIII, 295) summons him to "rise" (VIII, 296). Adam is taken "by the hand" (l. 300), "rais'd" (l. 300), and "led . . . up" (l. 302) over the same mountainside earlier described as "Insuperable highth of loftiest shade." At the summit of the Garden of Eden, his "Guide / . . . from among the Trees appear'd, / Presence Divine" (VIII, 313–15). Beset with joy and awe at the presence of the godhead, Adam "in adoration at his feet . . . fell" (l. 315) until he was "rear'd" (l. 316) upward, after which he heard the deity speak: "Whom thou sought'st I am" (l. 316). Conveyed by images such as "rise," "rais'd," "led . . . up," "Guide," and "rear'd," all associated with height or ascent, man's dependence on the godhead is fully detailed in this encounter and the ensuing dialogue at the tree.

But in *Godot* the deity does not respond to the seeking and waiting presence of Vladimir and Estragon. In this situation man becomes increasingly uncertain of his self-image, which is attributable, as even Satan recognizes in *Paradise Lost*, to "Divine resemblance" (IV, 364). Whereas the declaration on Horeb and to Adam in *Paradise Lost*— "Whom thou sought'st I am"—is a resounding affirmation of God's presence in the human condition, *Godot* changes declaration into doubt. If the existence of the deity is uncertain, then man's self-image is doubtful. In response to Vladimir's acknowledgment of him at the outset of the drama—"So there *you are* again" (italics mine) (p. 7)—Estragon replies, "Am I?" That becomes the play's existential question.

From this perspective the play is a series of nearly desperate but futile

endeavors by Vladimir and Estragon to affirm or deny not only their "Divine resemblance" but also their very existence and consciousness. Uncertain of their being and consciousness, they cannot know, for example, whether the tree at which they seem to be standing is the same tree that marked their location of the previous day, if indeed there was a yesterday or past. They are unsure whether they are to rendezvous with Godot on a Saturday evening, whether the present moment—the reality of which cannot be demonstrated—is a particular day of the week, whether the boy with whom they converse at the end of the first and second acts has really encountered them, and on and on.

Recognition is a crucial word and concept. Briefly defined, it is, as Vladimir says, the "impression" that he and Estragon "exist" (p. 44). But recognition is not possible without experience. Unsure of their sensible experience (seeing, hearing, touching, tasting, smelling), Vladimir and Estragon likewise cannot be certain that they do or can think. After Vladimir has conjectured that he and Estragon "*have* thought" (p. 41), Estragon by his questioning reply—"But did that ever happen to us?"—challenges the axiomatic truth of Descartes's "*Cogito ergo sum.*" At another point Estragon states, "let's contradict each other" (p. 41). The implication is that, by affirming and denying a proposition in the manner of a medieval or Hegelian disputation, resolution will be achieved. But neither Vladimir nor Estragon can begin the process of dialectical interaction, let alone continue it toward a conclusion. To "turn resolutely towards Nature" (p. 41) is also Estragon's proposal, but after having observed leaves on what may be the tree that was bare and black the previous day, an observation that leads them to conclude that it is spring, Vladimir and Estragon agree that it is impossible for seasonal transition to have taken place in one day. One day may not have passed, for there has been no change in the diurnal cycle. Evening and darkness have not yielded to dawn and sunlight.

Significantly, the cross-talk of Vladimir and Estragon parodies a method of teaching and means of learning dating back to the Middle Ages. In, for example, St. Augustine's *Eighty-Three Questions* and St. Thomas Aquinas's *Summa Theologica*, replies were framed to questions in Christian apologetics, scriptural exegesis, theology, and philosophy. Within a catechetical framework the questions and replies were to be closely studied and, at times, paraphrased or memorized. But in *Godot* scores of questions, most of which are variations of the basic existential question, "Am I?", remain conspicuously unanswered. In this way the play implies that traditional beliefs are perpetuated not by rational understanding but by the authority of esteemed exegetes and catechists, by ecclesiastical dicta, and by the credulity of the so-called

faithful. Added resonance is obtained when the context for understanding the questions of *Godot* includes works of literature in which existential questions go unanswered. Vladimir's utterance, "What are we doing here, *that* is the question?", echoes not only medieval exegesis and catechesis but also Hamlet's most renowned soliloquy. Like Hamlet, Vladimir and Estragon contemplate suicide; but indecisive and irresolute after reflection, they, like him, remain inactive. Whereas inaction erodes Hamlet's sense of self-worth, it causes a more extreme reaction in Vladimir and Estragon: They doubt their very existence.

The play thus becomes a comprehensive parody of traditional ways of knowing and of the knowledge elicited thereby. From a related viewpoint Vladimir and Estragon are shown to be incapable of experience: sensible, cognitive, reflective. In addition, endeavors to affirm or deny their being, the resulting failures, and the psychological effects are not arranged by sequence or according to dramatic structure; nor is there progression toward a climax in the emotional and psychic life of the characters. Without an awareness of the past or, to put it another way, unless they have had previous experience, the use of the same means to answer the question "Am I?" is not repetitious. For Vladimir and Estragon that fundamental question remains unanswered, though the audience comes to know that it is unanswerable. The measure of the difference, a source of dramatic irony, explains the futility of Vladimir and Estragon, leading them to the same activities and through uniform responses. If the play were run or read backwards, it would remain unchanged.

In *Paradise Lost* Adam and Eve undergo no such existential disorder or uncertainty. After the Fall, admittedly, they are confused, but that state of mind is part of the process of regeneration. The Son, described as "the mild Judge and Intercessor both" (X, 96), as well as the "gracious Judge" (X, 118), descends from above to encounter Adam and Eve in the garden. While "pitying" (X, 211) them, he leads Adam and Eve toward contrition and remorse, a state of mind and heart reflected in their "Petition" (XI, 10), "prayers" (XI, 14), and "supplication" (XI, 31) after his ascent heavenward. Images like "wing'd" (XI, 7), "speedier flight" (XI, 7), and "Flew up" (XI, 15) suggest the upraised minds and spiritual state of Adam and Eve. God the Father, anthropomorphically rendered, is described as seeing and hearing them (XI, 22, 30). Approved by the deity, regeneration is described by the Son as new growth: ". . . first fruits on Earth are sprung" (XI, 22).

With the fallen angels of *Paradise Lost*, there is, as well, no doubt of the all-seeing presence of the deity. In rebutting Moloch's advocacy of continued warfare against the godhead, Belial asserts:

> War therefore, open or conceal'd, alike
> My voice dissuades; for what can force or guile
> With him, or who deceive his mind, whose eye
> Views all things at one view? he from Heav'n's highth
> All these our motions vain, sees and derides.
>
> (II, 187–91)

Such an assertion anticipates God the Father's vantage point at the outset of Book III: "High thron'd above all highth, bent down his eye, / His own work and their works at once to view" (ll. 58–59). From this vantage point he surveys Adam and Eve, then Satan, who is journeying from Hell and Chaos to the Earth. In what follows the epic narrator continues to describe God the Father's vantage point and to recount his prescience, emphasizing, as he does throughout the epic, the height of the deity enthroned above, the Father's all-seeing eye, his awareness of the deliberations of his creatures, and his intervention in the activities of angels and mankind alike.

In *Godot*, on the other hand, the pleas of Vladimir and Estragon for some manifestation of the deity go unanswered, if not unheeded: "God have pity on me!" (p. 49) and "Christ have mercy on us!" (p. 59). And the question "Do you think God sees me?" (p. 49) is simply a variation of "Am I?" When Vladimir, alongside the tree, says, "Well I suppose in the end I'll get up by myself" (p. 52), he is stating that the ascent of man, traditionally associated with the deity's intervention (at the creation, in the Redemption, and during the process of regeneration), must come from oneself. In *Paradise Lost* such a notion—that one may be self-raised—is punishable by an opposite downward movement and forced dwelling in a place where "hope never comes / That comes to all" (I, 66–67). Somewhat adapted, this description of Milton's hell may be used to describe the human condition in which Vladimir and Estragon find themselves.

At first glance there seems to be nothing in *Godot* comparable to Milton's anthropomorphic characterization of the godhead. Indeed, most critics have argued there is no supernatural presence in Beckett's play. Closer scrutiny, however, indicates that Pozzo and Lucky may be respective characterizations of the Father and the Son. Described as a slave and servant in language recalling St. Paul's epistle to the Philippians 2:4–11, carrying a burden, tied, whipped, bleeding from a wound, and traveling a roadway, Lucky humiliates himself in accordance with the will of Pozzo. Anthropomorphically rendered according to modern man's conception of an unyielding master, Pozzo is insensitive to the plight of Lucky and imperious toward mankind, represented by Vladimir and Estragon.

In the transition from the Old to the New Dispensation, whereby inflexible justice gives way to bountiful mercy, the deity undergoes transformation, or, to put it another way, the God of the Old Dispensation, in effect, dies. There is no better dramatization of the "killing" of the God of the Old Dispensation than iconography of the crucifixion in which the Father, while standing above and behind the Son, reaches downward to grip the extremities of the transverse beam so that his hands are likewise pierced by the nails. In place of a regal crown he sometimes wears thorns, like the Son. Between the mouth of the Father and that of the Son are the outstretched wings of the Holy Spirit.[8] A well-known adaptation of iconography of the suffering Father (or *Pater Dolorosus*) is El Greco's *Trinity*. At the center of the painting is the enthroned Father. At his sides are angels, and above him is the Holy Spirit with wings outspread. On his right knee and with his right hand, the Father supports the dead Christ, who is in a sitting, rather than a reclining, position, a reason no doubt why the composition is also known as the *Throne of Grace*. When in *Paradise Lost* the Father forecasts that "Mercy first and last shall brightest shine" (III, 134), he signals the beginning of a new Dispensation, of a different image of himself, of a changed relationship with the Son, and of a new rapport with mankind. Act II of *Godot* may be viewed as an ironic adaptation of such changeover; for if in Act I Pozzo is implacable and arrogant, in Act II he is infirm and dependent. Whereas Pozzo indulges in luxuries in Act I, in Act II he is anxious about basic necessities. Throughout the play Lucky is the suffering servant: obedient to the will of Pozzo, the master, in Act I; but compassionate to Pozzo, the old man, in Act II. If in *Paradise Lost* the Father and Son are anthropomorphically depicted by their dialogue and interaction, in *Godot* they are humanized to the extent of being ravaged by time, beset by needs, and invested with emotions. In short, they participate in psychodynamic relationship, the effect of which is kaleidoscopic: a deity with many faces and multiple personalities.

The foregoing remarks suggest that *Godot* adapts and accelerates the process of self-disclosure in Scripture whereby the deity unfolds his variegated nature and changes his relationship with mankind. Furthermore, biblical episodes, when examined and reexamined by successive generations of commentators, acquire different meanings and yield disparate views of the deity. From the accretion of commentary and the proliferation of views, one conception of the deity after another emerges, each altering or displacing the preceding one. In the midst of all its ironies, Beckett's play suggests that God exists as, when, and if man creates him. This is nowhere better exemplified than in Lucky's long speech in Act I (pp. 28–29), in which names resembling those of

learned commentators (Puncher and Wattmann, Testew and Cunard, and others) are cited and contradictory but humanized conceptions of the deity are recounted: a deity "with white beard" who "loves us" and "suffers" while some of mankind are "plunged in fire" by him, a deity for whom light was the first act of creation but from whom the light of fire will signal Doomsday and ensuing destruction, a deity whose attitude toward man ranges between indifference ("divine apathia") and forgetfulness ("divine aphasia"). More than that, the trappings and accoutrements of the players add to their characterization. The folding stool carried by Lucky and used by Pozzo suggests, among other things, the throne of God, the seat on which Christ was buffeted and mockingly called "king," and the chair of the all-judging Christ at the Second Coming.

Like Scripture, scriptural commentary, and Christian iconography, *Godot* acquires focus in relation to the Paschal triduum, the three-day period during which Christ died, descended into Hell, and was raised from the dead. Two central mysteries of the Christian faith are thereby enacted, the Redemption of mankind and the Resurrection. The former rescues us from damnation, the latter from death. As the Paschal triduum unfolded, it fulfilled the ministries of deliverance of numerous Old Testament prophets and patriarchs, most notably Noah and Moses. From a typological perspective Christ's Paschal triumph imparted both meaning and structure to thousands of years of biblical history. Since Christ's Ascension, moreover, the faithful are enjoined to maintain a state of spiritual readiness, waiting and watching for his promised return at the Second Coming.

Such a view, which highlights the continuity and interrelation of past, present, and future, is nowhere more emphatically affirmed than in *Paradise Lost*: in the dialogue in Heaven (III, 227–343), when the Son's temporal ministry, the Paschal triduum, and Second Coming are foretold; and in Adam's dream-vision of the future (XI–XII), when Old Testament prefigurations of the Son's roles as redeemer of mankind and judge at the Second Coming are recounted. This view of redemptive history also characterizes earlier literature, especially the medieval cycle-dramas, which began as offshoots of liturgical celebration. As evidence of their origin, these plays express communal faith. Like the liturgy from which they were derived, cycle-dramas, as the term suggests, reflect the changing seasons of the church year. In its rotational sequence the church year is a liturgical paradigm of Christ's earthly ministry. His Nativity, brief life, death, and Resurrection constitute the framework around which the liturgical seasons cluster. The Paschal triduum, furthermore, is a microcosm of the larger church year. Within

its three-day span (Good Friday to Easter Sunday) are reflected changes from death to life, darkness to light, descent to ascent, winter to summer, and suffering to triumph. What seem to be opposites are really transitions, already experienced by the Son in his earthly ministry but offered to mankind as a pattern of conduct, frame of mind, and state of heart to be imitated. *Imitatio Christi* is the keynote of Paschal liturgies and medieval dramas adapted from them.

The mimesis and symbolism of sacramental celebration likewise afford man an opportunity to commemorate and participate in Christ's Paschal triumph. Surely the best example is the sacrament of Baptism, about which the archangel Michael instructs Adam in *Paradise Lost*. About the early church Michael foretells that the disciples will be

> Baptizing in the profluent stream, the signe
> Of washing . . . from guilt of sin to Life
> Pure, and in mind prepar'd, if so befall,
> For death, like that which the redeemer dy'd.
> (XI, 442–45)

The sign of Baptism—immersion in water and emersion—recalls salvation from the Deluge and the Red Sea Deliverance. At the same time, the baptismal rite, as St. Paul emphasizes, enables man to participate in Christ's death, burial, and Resurrection (1 Cor. 12:13, Gal. 3:27, Rom. 6:3, Col. 2:12). In the early church, in fact, the baptismal rite was part of the Easter vigil. Following behind the celebrant, the neophytes entered a river or stream, waded across it, and emerged onto the opposite bank. As they came forth, the celebrant, with arms outstretched and cross uplifted, faced them. Behind him was the Easter sunrise. For the neophytes the transitions from darkness to light, descent to ascent, and sinfulness to sanctification were dramatized in a rite that conjoined biblical history of the Old and New Testaments and that reflected the symbolism of the diurnal and seasonal cycles. Indeed, daybreak and the coming of spring demonstrated the spiritual changes undergone by the neophytes.[9]

The context outlined by the foregoing remarks is a basis for understanding *Godot*, which may be viewed as an ironic commentary on the events of the Paschal triduum, its Old Testament prefigurations, and liturgical and sacramental celebrations of man's faith, hope, and participation in Christ's redemptive ministry. As such, Beckett's play is a virtual counterstatement to the affirmative tenor and tone of literature like the cycle-plays and especially *Paradise Lost*. Indeed, Beckett himself may have supplied the very clue that reinforces this kind of inter-

pretation, for more than once he has claimed to have been born on Good Friday. Generally reticent about his life and work, any such comment of his is pursued with intense interest; but in this instance scholars have been thwarted because no authoritative record of Beckett's date of birth has been found. More pertinent, however, is the larger, symbolical implication and application of Beckett's claim, which recapitulates his vision as an author and, perhaps, his outlook as a person. His claim—to have been born on the day when Christ died—paradoxically juxtaposes birth and death in a manner that recalls one of the most memorable lines of *Godot*: ". . . birth astride of a grave . . . " (p. 57). Unlike the cycle-plays and *Paradise Lost*, in which transition from Good Friday to Easter Sunday is viewed as essential to the Christian theology, time in *Godot* remains fixed at Good Friday, so that faith is tested or eroded by doubt. As one continues to await the Easter sunrise, anticipation gives way to scepticism. In short, Beckett challenges traditional belief in the risen Christ, who, with his cross of triumph upheld, stands astride of the tomb in nearly all iconography of the Resurrection, and who in his ascendant glory over Satan midway in *Paradise Lost* presages his final victory at the end of time. In *Godot* there are no transitions from darkness to light, death to life, winter to spring—the very transitions in which man participates through the mimesis and symbolism of liturgical and sacramental celebration, enabling him to reenact redemptive history in the present. If the faithful are enjoined through the liturgy and sacraments to share in the joy of living, in *Godot* Vladimir and Estragon participate in the suffering of being when they are not doubting their very existence.

To be sure, Beckett's explicit references to *Paradise Lost* (in *From an Abandoned Work* and in the letters to McGreevy), as well as Deirdre Bair's assertion that Beckett's abiding interest in Milton was a source of continuing reflection, encourage comparative analysis of the two authors. In pursuing such leads, the present study of ironic similarities between *Paradise Lost* and *Godot* emphasizes dialogue, characterization, tableau, and imagery—in short, literary and dramatic elements—along with the intricacies of their interaction. The complexity of such elements is less adequately explained by simple reference to Scripture but more fully understood in relation to another literary work, well known to Beckett, that advocates the Christian theology being challenged by the contemporary playwright. From this perspective Beckett may be participating in a dialectical encounter with Milton.

If the present comparative study of *Paradise Lost* and *Godot* is suggestive, then further inquiry into the relationship of Milton and Beckett should take place. Nor should comparative study be limited to *Paradise*

Lost, for in Milton's other works Beckett may have had similar interest. *Godot*, like *Samson Agonistes and Paradise Regained*, may be construed as a near-static drama of inner trial, though Samson's "rousing motions" or intimations of Providence contrast with the inertia and uncertainty of Vladimir and Estragon. Another example of probable relationship between Milton and Beckett is the line: "They also serve who only stand and wait." The quiet self-confidence of the foregoing assertion, which concludes Milton's Sonnet XIX, differs from the intense agitation of Beckett's characters in *Godot*. Whereas Sonnet XIX is an exercise of reason and an affirmation of faith, both of which result in the speaker's utterance of the last line of the poem, *Godot* ends with its principal characters in a condition of scepticism and silence.

NOTES

1. Samuel Beckett, *Breath and Other Shorts* (London: Faber and Faber, 1971), p. 42.

2. Letter of Dr. Deirdre Bair to Albert C. Labriola, January 21, 1981. Dr. Bair mentions this letter by Beckett in *Samuel Beckett: A Biography* (New York: Harcourt Brace Jovanovich, 1978), p. 475 and n. 83. In her letter to me, Dr. Bair indicates that the correct date of Beckett's letter is November 16, 1955, not 1956 as the biography states. I am grateful to Dr. Bair for her friendship, cooperation, and willingness to reexamine the McGreevy letters for Beckett's references to Milton.

3. Letter of Dr. Bair to Albert C. Labriola, January 21, 1981. Dr. Bair mentions this letter by Beckett in *Samuel Beckett: A Biography*, p. 475 and n. 82.

4. *Samuel Beckett: A Biography*, p. 475.

5. Milton's poetry is cited from *John Milton: Complete Poems and Major Prose*, ed. Merritt Y. Hughes (New York: Odyssey Press, 1957).

6. *Samuel Beckett: En Attendant Godot*, ed. Colin Duckworth (London: George C. Harrap & Co., 1966), p. xlvi.

7. Samuel Beckett, *Waiting for Godot* (New York: Grove Press, 1980), p. 13. *Godot* is cited from this edition.

8. For numerous such examples of iconography of the Trinity, see Adolphe Napoleon Didron, *Christian Iconography*, trans. E. J. Millington (1886; rpt. New York: Frederick Ungar Publishing Co., 1965), II, 63–82; and Gertrud Schiller, *Iconography of Christian Art*, trans. Janet Seligman (Greenwich, Connecticut: New York Graphic Society, 1971), I, 9–12.

9. *Baptism: Ancient Liturgies and Patristic Texts*, ed. André Hamman (New York: Alba House, 1967), pp. 7–26.

NANCY MOORE GOSLEE

"Promethean Art": Personification and Sculptural Imagery After Milton

For a critic evaluating the relationship between sculpture and personification in the eighteenth century, Milton's figure of Death is a dangerous starting point—but one whose contentious energy has its uses. Although clearly a personification, this "shape . . . that shape had none"[1] takes up its threatening stance against the *ut pictura poesis* argument that personification should be vivid and detailed. As Burke argues, Death achieves power as a personification through a "judicious obscurity" possible only in words.[2] Yet as critics debate over the element of *ut pictura poesis* in Milton's personifications and those he inspires, they have for the most part neglected a third art—that of sculpture. Ironically evoked in Milton's repeated denial of "shape" to his Death, the analogue of sculpture for poetic creativity becomes central both to the theory and to the practice of personification in the eighteenth century. Shaftesbury's comparison of the poet to Prometheus celebrates this mythic figure as a demiurge whose shaping of "plastic Nature" is both agent and mode for human creativity; Joseph Warton and Edward Young continue the analogy.[3] Mark Akenside's poetic version makes this Promethean sculpting more specifically analogous to personification: The "plastic powers" of the poet's mind use a "Promethean Art," then "breathe" life into "the fair conception."[4] As Earl Wasserman shows, eighteenth-century theorists of personification repeatedly make the ability to endow abstract conceptions with living human form the criterion for poetry.[5] Reinforcing this Promethean analogy, moreover, is

a tendency during the eighteenth century to define sculpture itself as tactile, more than visual, in its modes of creation and perception.

Opposing this analogy, however, is the view that personifications are not primarily plastic, but rhetorical, figures. This insistence upon the priority of the word includes not only Burke's praise of the verbal sublime but also other writers' perception of these figures as rational concepts. Milton's Death might epitomize the latter as well as the former, since according to at least one late-eighteenth-century theorist, verbal abstractions mark the awareness of a deathlike fallen state.[6] In this view personification is a fallen rhetorical mode, not a newly creative plastic form. By looking at the interplay between these two views of personification—the Deathlike rhetorical concept and the Promethean plastic form—we can see more clearly how the eighteenth-century allegorical odes grow out of Milton's own sculptural images and personifications.

In *Paradise Lost*, voiced words, more than sculptural shaping, seem the primary power of life-giving creativity. Although he says in *De Doctrina Christiana* that God did not "merely breathe that spirit into man, but moulded it in each individual" ("Nec inflavit duntaxat illum spiritum, sed in ipso quoque homine formavit"),[7] his descriptions of more materially plastic shaping in *Paradise Lost* appear as subversive, almost Satanic. Even without knowing *De Doctrina Christiana*, however, eighteenth-century writers and critics fused biographical and stylistic analyses of Milton to praise his poetic art as sculptural. After looking briefly at sculptural images of creativity in *Paradise Lost*, and then at elements in Milton's poetry and his life which led readers to think of his art as sculptural, we can then turn to the development of Shaftesbury's Promethean analogy, through the ideas of sculpture and language, in England and on the Continent.

Like Longinus, Milton finds in the first chapter of Genesis a sublime power expressed through God's "powerful Word / And Spirit coming to create new Worlds" (VII, 208–9); and it is a power echoed in the "voice divine" of his muse Urania. Following Genesis 2, Adam's creation is more plastic: "He form'd thee . . . Dust of the ground, and in thy nostrils breath'd / The breath of life; in his own image he / Created thee" (VII, 524ff.). Not until Eve's creation, however, does sculptural molding become explicit: "The rib he form'd and fashion'd with his hands; / Under his forming hands a creature grew, / Manlike, but different sex . . . " (VII, 469–71). Almost instantly that sculpture prompts a Promethean rebellion against divine order: Adam tells Raphael that his "earthly bliss" with Eve surpasses all delights of "taste, sight, smell" and "melody," for "Love, / . . . transported I beheld, / Transported touch; here passion first I felt . . . " (520–30). Through this account the cre-

ator's touch, his "forming hands," becomes a lower mode of creation, conveying too sensuous and irrational a power not to threaten the Word and its "image express."[8]

Yet this insurrectionary image of sculptural shaping generates not only the human race but also generations of commentators who see Milton's poetic art as sculptural. At least three elements contribute to this impression. First, the descriptions of his heroic, mythic figures, "godlike erect," recall for critics from Jonathan Richardson through Herder to Keats and Hazlitt the statues of classical gods.[9] Second, as Rachael Trickett argues, the personifications of Milton's minor poems, more than those in Spenser's poetry, become the progenitors of statuelike personifications in the eighteenth-century allegorical ode.[10] Although these two aspects seem to belong to two different genres, a single passage from *Paradise Lost*, just before Adam's recalling of Eve's sculptural shaping, shows their closeness in Milton's own mind: "With goddesslike demeanor forth she went, / Not unattended for on her as queen / A pomp of winning Graces waited still . . . " (ll. 59–64). The next lines in the passage recall, though in ironic contrast, the third element contributing to critics' perception of Milton as a poet of sculptural, tactile qualities: "And from about her shot darts of desire / Into all eyes, to wish her still in sight." Milton's own desire as blind poet "to wish her still in sight" prompts speculation about the creativity of blindness.[11] Thus, if a shaping touch is subordinate, even censured, in Milton's hierarchy of creative acts, later readers nevertheless found in his poetry the models for a new interest in sculpture as a separate art. Later writers, moreover, found in it an analogy to strengthen the rhetorical figures of personification that they borrow for a self-consciously allegorical, more than mythic, art.

It is the mythic figure of the sculptor Prometheus, nevertheless, which makes sculpture the model or archetype not only for all other arts but for all other schemes of symbolic representation. In his *Advice to an Author*, included in *Characteristics* (1711), Shaftesbury writes:

> . . . the man who truly deserves the name of poet . . . is indeed a second *Maker*; a just Prometheus under Jove. Like that sovereign artist or universal plastic nature, he forms a whole, coherent and proportioned in itself . . . The moral artist . . . can thus imitate the creator, and is thus knowing in the inward form and structure of his fellow-creatures. (I, 135)

Because Shaftesbury follows the medieval tradition in which Prometheus, though a creator, remains a demiurge "under Jove," or God, we

should not simply equate him with Shelley's, Byron's, or Goethe's more Satanic rebels against heaven. [12] Yet the very fact that the poet can create another "whole" makes him strikingly self-sufficient.

Unlike Aeschylus's pinioned figure, Shaftesbury's mythical Prometheus receives no specific definition as figure; though archetypal sculptor working on "plastic nature," he is also that plastic force itself. Instead of developing his mythic figure, Shaftesbury goes on in an unfinished essay-fragment called *Plastics* to develop a theory of representation as "Characters" which attempts to preserve, first, the continuity between material and spiritual designs and, second, a continuity between speech and the visual and plastic arts. Although he does suggest such continuity, however, he also characterizes their differences in ways that define the ambiguity of personification as plastic and as rhetorical figure. At the opening of the *Plastics*, he distinguishes three types of characters: first, "marks of sounds, syllables, words, speech, and of sentiments, sense, meanings, by that medium"; second, "signs, . . . imitations of real forms and natural beings, plastically (convex or concave) or lineally and graphically (by lines and colours) from the superficies and extremities of the body"; and "a third and middle sort, emblematic. As when the latter signs are used as mediums (speech being passed over) to convey sentiments, senses, meanings, etc. . . . Of this latter sort, the true . . . is emblematic and graceful without mixture; the false enigmatic merely, mixt and barbarous: as the Egyptian hieroglyphics."[13] This "third sort" is the basis for a theory of signs from which we might draw a theory of personification as a subcategory: All "natural beings" can be read as expressive of "inward," mental "form" (a phrase he uses in *First Characteristics*, I, 136). This "true . . . emblematic" mode would apparently interpret "real forms and natural beings" as sculptural wholes whose stance and gesture express their own or the artist's "mental forms," in contrast to the more linguistically codified "false" mode either of the hieroglyphic or of the traditional, overloaded and unnatural figures of emblem books, each attribute of which reveals a specific verbal meaning. [14]

As his elaborate instructions for the designs of his own book show, Shaftesbury continues to draw upon the resources of this older, "enigmatic" tradition—not surprisingly, given its links to Florentine neo-Platonism. [15] Yet in his third, "true" category, his attempt to unify plastic or visual medium and significant meaning through "imitation" suggests that Shaftesbury seeks to overcome a pre-Saussurean perception of the arbitrary relations between sign and signified through a more natural, less mystical route than those Gombrich has traced in Ficino and others. By constantly using the same vocabulary of "sign," "form," "mean-

ing" to refer to verbal representation of ideas or sentiments and their "plastic" representation, he implies that there can be no break in the continuity between the "plastic" forms of "natural things" and the "mental forms" of human and ultimately divine "characters." This plastic continuity becomes the mark of a Promethean continuity between natural, human, and divine creative forces and energies—a Titanic link between earth and heaven.

Although Shaftesbury's *Plastics* was left incomplete and unpublished at his death in 1713, he had already touched upon many of these ideas in his earlier work and in letters.[16] Not only his nephew James Harris but also a succession of Continental theorists continued to explore the plastic, tactile aspects of sculpture as a mode of perception and of creativity. In fact, Shaftesbury's influence extends in two different directions, splitting apart his distinct and yet synthetic relationship between plastic and verbal characters. The first of these lines of influence completes its development earlier: Shaftesbury's neo-Platonic "mental forms" reinforce Milton's semi-abstract, yet sculptural personifications in the English allegorical odes of mid-century. The second, Shaftesbury's similarly neo-Platonic metaphor of a Promethean world-creating demiurge as source and archetype for the human arts of sculpture and poetry alike, finds reinforcement in a far more empirical analysis of the dependence of perception upon the individual senses. In his *Three Treatises* (1744), James Harris argues that music and poetry are based in hearing, and painting in sight.[17] Following this line of argument, and also fascinated by English reports of the blind mathematician Saunderson, Denis Diderot and Johann Gottfried Herder develop analyses of the importance of touch for all perception, but particularly for the perception of sculpture. Harris's and Diderot's discussions come almost at the same time as the first burst of allegorical odes from the Wartons, Thomson, and Collins, but Herder's more extended discussions, influenced by these earlier ones and also by much English poetry, do not begin to appear until the 1760s; and he publishes his *Plastik*, surely echoing the title of Shaftesbury's draft, in 1778. Yet because their arguments make explicit tendencies already present in the English writers, this second, later-developing phase of a Promethean attitude toward creativity can interpret the "mental forms" of the English allegorical personifications.

In his *Lettre sur les Aveugles* (1749), Denis Diderot argues that a blind person's touch alone, unassisted by sight, can perceive objects and lead him to understand their significance. As a tactile art, he suggests, sculpture is especially suited to the blind. Because he is primarily concerned with the perception of ordinary reality by the "aveugle né," or

"born blind," Diderot does not speculate here about Milton's sources of creativity; but he points the way to later speculation both about Milton as a sculptural poet and about the tactile perception of sculpture.[18]

Following Diderot, Johann Gottfried Herder argues that in its three-dimensionality touch permits fewer illusions than sight: "Im Gesicht ist Traum, im Gefühl, Wahrheit"—in sight is dream, in touch, truth (*Plastik*, VIII, 9). One can perceive soul through touch, moreover, because the hand of the sculptor has given it that way (p. 60). According to Robert T. Clark, Herder "assigns to the touching person, blind or seeing, a special type of attention, special creative abilities," and a "special plastic experience of space and shape."[19] Instead of resting content with such a championing of touch as a separate sense, however, Herder answers Diderot's questions about the way the senses work together by developing at the same time a psychology in which sensation and cognition are two aspects of a whole person. As Herder says in his 1772 *Essay on the Origin of Language*, "For what else are all the senses but forms of perception of a single positive force [*Kraft*, or energy] of the soul?"; for " . . . all sense impressions commingle into one."[20] Described by Herder as a "spiritual bond"—"ein geistiges Band"—this power recalls the "plastick spirit" which for the Cambridge Platonists and for Shaftesbury creates the world. Because it "informs both the sensory organ and the thing sensed," according to Clark (p. 225), it anticipates Coleridge's "plastic . . . intellectual breeze" or, later, his "esemplastic imagination."[21]

For Herder as for Shaftesbury, poetry more than any other art manifests this shaping, Promethean energy. Because poetry is itself dependent on no single sense, though developing from an expressive language or sensation, it integrates all senses and all arts developed from those senses;[22] and that integration is world-shaping. Even at its most elementary levels, language builds or expresses consciousness of mythic forces. In his *Essay on Language*, Herder describes how "all of nature sounds," and thus "nothing is more natural . . . than to think that it lives, that it speaks, that it acts." If the "rustling crown of a tree" leads to worship, "Behold, that is the story of sensuous man, the dark link by which nouns are fashioned from verbs—and a faint move toward abstraction. . . . Everything is personified in human terms" (p. 133). If primitive, the "dark link" still exists and binds power in man to power in nature. Yet Herder grants that poets may emphasize one part of this continuum more than another. In dividing poets into more sensuously lyrical or more intellective, rationally abstract classes, he includes Milton among the latter—and thus, one might argue, among poets who show more than a "faint move toward abstraction."

Denying Herder's claim of a Promethean continuity between the "lower senses" and conceptual thought, two of his German contemporaries propose relationships between these processes which further define the plastic and rhetorical qualities of Miltonic personification. Although a number of German critics praised Milton for his Promethean ability to give life to the "unsichtbar," or invisible spirits,[23] the theories of Johann Georg Hamann and G. E. Lessing might more appropriately be associated with just one of Milton's "living" beings, his paradoxically energetic personification of Death. For Hamann, an original, mystical unity between divine and human is broken with the advent of speculative reason. In this version of the Fall, Milton's Death might well epitomize the result of abstraction. Because it extends Burke's distinction between the plastic or visual and the poetic arts, Lessing's *Laocoon* draws, although implicitly, upon Burke's analysis of Milton's Death as an example of verbal energy. Explicitly Lessing develops a distinction between sculptural "allegory" and the poetic creation of "living beings" which supports Burke's analysis of Milton's Death as verbal creativity and power. He also asserts, in contrast to Burke and to Herder, a priority of the abstract concept—Death, for example—over the "living being" of the personification.

Although he had begun to develop it earlier, Hamann's version of an Adamic theory of language receives its most vivid statement in response to Herder's *Essay on Language*:

> Adam was . . . God's, and God himself introduced the firstborn and the oldest of our race as the vassal and heir of the world which was created by the word of his mouth. . . . Every phenomenon of nature was a word—the sign, symbol, and pledge of an inexpressible, but all the more intimate union, communication, and community of divine energy and ideas. Everything that man heard in the beginning, saw with his eyes, and his hands touched was a living word, for God was the word.[24]

With the assertion of an abstract, almost Satanic, reason, this "intimate union" of divine and natural, signified and sign, breaks apart. Only a realization of the Logos as incarnate Christ can fully restore such unity; but "poetic genius," Hamann suggests, can bring about a partial restoration: "O for a muse like a refiner's fire, and like fuller's soap! She will dare to purify the natural use of the senses from the unnatural use of abstractions, which mutilate our ideas of things as badly as they suppress and blaspheme the name of the creator."[25] Because "all our knowledge comes from the senses and through figures,"[26] personifica-

tions seem to Hamann poised between life-denying abstraction and life-giving figurative language. Analyzing his attitude toward personification is particularly difficult because he uses a mixture of sculptural metaphor and personification to distinguish between abstract language based on a fallen reason and a poetic language based on the senses and the passions. "Passion alone," he writes, "gives to abstractions . . . hands, feet, wings, to images, and signs, spirit, life, and tongue."[27] In a later passage (1786), his own power to give corporeal form to abstraction nearly undermines his criticism of "philosophical genius" for splitting apart living wholes into logical elements:

> Philosophical genius expresses its power by striving, by means of abstraction, to make the present absent, unclothing real objects and making them naked concepts and merely thinkable attributes. . . . Poetic genius expresses its power by transfiguring, by means of fiction, the visions of the absent past and future into present representations.[28]

Although one might think of these "naked concepts" as logical bases for distinguishing attributes, Hamann's language transfigures them into sculptural figures of gods or animate personifications representing those concepts. Yet that Deathlike gap between representation and concept remains, even in the "present representations" or fictions of "poetic genius." Only in Hamann's prelapsarian world or in the redeeming eschatological vision of the Logos does the "living word" achieve its "intimate union . . . of divine energy and ideas." That union seems, if in somewhat mystical terms, the equivalent both of a Promethean demiurge mediating between divine archetype and object, and also the created sculptural object itself. Yet for Hamann such creativity comes not in the individual human's active integration of sense experience, as it does for Herder, but in a divine gift, repeating "the word of his [God's] mouth."[29]

For Gotthold Ephraim Lessing, in contrast to both Hamann and Herder, rational concepts are both original and normative, since they precede the myths and personifications through which artists—sculptors or poets—illustrate them. Because of this underlying rationalism, his development of Burke's distinction between poetic and pictorial capacities cannot follow the English writer's argument that poetry draws its strengths from the obscurity and affective power of language.[30] As a result, Lessing's attempt to defend Milton from charges that his poetry is inadequately pictorial does not follow Burke's route of making that apparent defect a virtue and of praising Milton's Death for a "judicious

obscurity." Instead, Lessing defends Milton through a broader discussion of *enargeia*, or vividness. Milton shows an aspect of this almost Promethean-like ability to give subjects a living presence; a poet's use of personification to create "real beings, acting and working," shows another.[31] Although Burkean in its praise of energy or vitality, Lessing's concept of enargeia emphasizes the original visual and logical clarity of the abstraction as one source of the poet's power.

Far from failing to overcome the handicap of his blindness, Milton finds that "inward vision" frees him from the "limitations" of the "bodily eye" (p. 87). In a metaphor probably drawn from the painter's brush, but strikingly suggestive of the sculptor's hand, Lessing praises "every touch, or every combination of touches, by means of which the poet brings his subject so vividly before us that we are more conscious of the subject than of his words" (p. 88). In talking of a "vivid" subject, he is not speaking exactly of a "living being," as he does in his discussion of personification; but as he attempts, with an injudicious obscurity of language, to clarify the sort of illusion Milton and other apparently unpictorial poets create, he refers to "enargeia" or the quality of "illusion in . . . poetic pictures" more as if it means an energy of presence than a detailed visual description.[32] If this language begins to point toward a Herder-like Prometheanism, however, his insistence upon the priority of rational concepts limits that tendency.

Also limiting it is his almost total refusal to distinguish between plastic and visual arts. Although his *Laocoon* repeatedly attacks equations between sculptural and poetic interpretations of subjects, he regards those equations as part of the larger problem of *ut pictura poesis* comparisons. Unlike Herder a few years later, he does not follow Diderot in investigating the tactile qualities of sculpture—probably because Diderot's sense-based, empirical investigations would jeopardize the primacy of the rational concept. Instead, he carefully analyzes the contemporary tendency to equate sculptures of gods, emblematic engravings of sculpture-like figures representing concepts, and verbal personifications of such concepts—exactly the equation we have seen Hamann playing with so dangerously in his Actaeon-like condemnation of "naked concepts."

"When a poet personifies abstraction," Lessing writes, "he sufficiently indicates their character by their name and employment," and is thus free to develop them as "real beings, acting and working, and possessing, beside their general character, qualities and passions which may upon occasion take precedence. Venus is to the sculptor simply love. . . . To the poet, Venus is love also, but she is the goddess of love who has her own individuality" (p. 58). Because the sculptor lacks this abil-

ity to name his conception in speech or writing, "he must give to his personified abstractions," or to the "gods and other spiritual beings" he wishes to represent, consistent symbolic attributes. Thus these sculptures become "allegorical" figures, closer to emblems than to "living beings":

> A female figure, holding a bridle in her hand, another leaning against a column, are allegorical beings. But in poetry, Temperance and Constancy are not allegorical beings but personified abstractions. . . . By the use of symbols the [plastic or graphic] artist exalts a mere figure into a being of a higher order. Should the poet employ the same artistic machinery, he would convert a superior being into a mere doll. (p. 68)

That "superior being" is, evidently, the poet's endowing of his concept with an animate energy.

As I suggested earlier, because these Continental writers had read Shaftesbury and James Harris as well as Milton, their theories about sculpture and personification grew out of the same milieu as the allegorical odes of Collins, Thomson, and others. Thus we might well use these slightly later theories to explore a tension between Promethean and Deathlike, plastic and conceptual, appearances of personification in these writers' odes. Critical attitudes toward Collins's odes, in particular, have moved from Ainsworth's description of his personifications as plastic, to more recent critics' equating them with Milton's Death as shadowy instances of the indefinite verbal sublime.[33] Moreover, as shown in a fragmentary poem addressed to James Harris, Collins was well aware of Harris's interdisciplinary interests. He also apparently had plans to answer one of Shaftesbury's dialogues in the *Characteristics*, and thus had surely seen its second version, if not the manuscript of the *Plastics*.[34] Though this paper cannot examine Collins's odes with any real degree of thoroughness, even a brief survey shows how he develops Shaftesbury's ideas of a Prometheus *plasticator*: With his own personifications as living agents, he revises and challenges Milton's Deathlike denial of a plastic creativity.

In the "Ode to Fear," Collins's speaker describes Fear herself only briefly and then more through her whole pattern of abrupt motion, mirrored in his, than through her whole figure: "I know thy hurried Step. . . . Like Thee I start, like Thee disorder'd fly."[35] Fear's own figure, however, becomes less important than her role as Promethean shaper of other figures, for the speaker attributes their shared experience of the emotion to Fear's ability to manifest Fancy's "World unknown / With all its shadowy Shapes" (ll. 1–2). Of the "*Monsters*" in her

ironically pursuing "Train," one epitomizes Rachael Trickett's description of plastic, objective form limited to, and focused in, the most significant moment and gesture: "*Vengeance*, in the lurid Air, / Lifts her red Arm, expos'd and bare." That arm is the antithesis of a creative Promethean hand, yet through the circular process of witnessing in this ode, her gesture gives rise to Fear's more kinetic, less visually specific "steps" and "starts." The first Monster in Fear's train suggests even more strongly that Fear's realization is a plastic process: "*Danger*," with "Limbs of Giant Mold . . . stalks his Round, an hideous Form." Again, plastic form, monstrously enlarged to "Giant Mold," generates kinetic action: both his own stalking and Fear's starting.

In two odes, Collins uses explicitly sculptural images to develop his personifications as creative powers: the "Ode to Liberty" and the "Ode to Simplicity." In "Liberty," if I read its pronouns correctly, the "Giant-statue" which the barbarians topple from its base and break "to thousand Fragments" is Rome—or, more specifically, a Roman civilization based upon Liberty (ll. 18–25). This happens, the speaker tells a personified Freedom, "before thy weeping Face." Clearly Freedom is the sculptor of a liberty manifested in such civilizations, for "Th' admiring World thy Hand rever'd" (l. 26). Later, individual enlightened rulers share her task in a rebirth of this giant form: "wond'rous rose her perfect Form . . . in the great the labour'd Whole, / Each mighty Master pour'd his Soul!" (ll. 31–33). Their part in this rebirth is not an assembling of fragments, but a Promethean outpouring of energy. We might even use Herder's word, "Kraft," or power.

Collins's sculptural imagery in the "Ode to Simplicity" undergoes a similar change from an explicitly plastic image to one of fluid energy. That process does not appear in the completed ode, however, but in the contrast between that version and an earlier draft. In the earlier version, Fragment 9 in Wendorf and Ryskamp's edition (pp. 78–79), stanzas 4, 5, and 6 describe Simplicity's "gentle power" to guide rhetoric, painting, and sculpture—three "exalted Art[s]." In stanza 6, Collins represents sculpture with a striking image of a statue in a cave:

> O Chaste Unboastfull Guide
> O'er all my Heart preside
> And 'midst my Cave in breathing marble wrought
> In sober Musing near
> With Attic robe appear
> And charm my sight and prompt my temprate thought.

Out of this generative cave and out of this stanza grows the opening of his later version of "Simplicity." In this fragment, the figure of Simplicity

seems so well "wrought" in marble that she takes on "breathing" life and can appear as a Greek goddess. Because this coming to life takes place "midst my Cave," the poet seems as much creator as worshiper. In the completed version of the poem, the personality of this figure is indeed more developed and animate, and the sculptural image of a "breathing Marble" is transformed from one of three "exalted Arts" into an art that includes all the rest:

> Tho' Taste, tho' Genius bless,
> To some divine Excess,
> Faints the cold work till Thou inspire the whole;
> What each, what all supply
> May court, may charm our Eye,
> Thou, only Thou, can'st raise the meeting Soul!
> (ll. 43–48)

Here simplicity is the demiurge, the Promethean creator breathing life into the "cold work" to make it "breathing Marble." Because Simplicity and not the poet is now the sculpting demiurge, his own creation has become the creator.[36] Though this displacement may be read as an escape from the responsibility of rivaling divine power, it may also be seen as an affirmation of that responsibility. Perceived as a continuum from the poet's creative psyche to the plastic figure represented both as a sculptural object and as sculptor, this Promethean molding seems an apt model for Collins's art of personification.

In the ode where we might expect to find such a Promethean creativity most fully developed, however—in the "Ode on the Poetical Character"—we find only a faint, if fascinating, echo of Shaftesbury's theory of "characters" as plastic symbols of spiritual worth. The recurrent images of fabric interpose not only to curtain off a sacred scene of generation from sight but to frustrate any "presumptuous" Promethean "Hand." Collins's reading of Spenser early in the poem does indeed describe the actions of two opposing "Hands." The first, a "baffled Hand" that with "vain Endeavor . . . touch'd that fatal Zone," seems Promethean both in its rebellious over-reaching and in its touch. Reinforcing this reproof of touch, the second of these hands acts in a more acceptably Miltonic mode of creativity. Present only in simile and even then invisible, it acts through speech, not touch: "As if, in air unseen, some hov'ring hand . . . With whisper'd Spell had burst the starting Band, / It left unblest her loath'd dishonour'd Side . . . " (ll. 10, 12–13). Milton alone is purified, as if by his own repudiation of the "Rapture blind" of a creative touch, into becoming a godlike figure admitted into "th' inspiring

Bowers. . . . " Only Blake, apparently, challenges this anti-Promethean chastity, making the Milton of his illuminated book a sculptor who redeems himself and his work from a Deathlike abstraction through corporeal touch.[37]

Yet in the relation of this ode to others in the group, Collins can find an implicit answer to Milton's vocal and aural preeminence. Like Blake, he makes Milton sculptural—but, unlike Blake, he emphasizes his own regeneration, however gently and obliquely, at the expense of Milton. As Milton's figure lies in its sacred wilderness, it resembles those goddesslike personifications Collins calls upon to fill his waiting scenes. Milton's greater objectivity as present, sculptural object may mark his resistance both to Collins's shaping power and to such sculpting power itself.[38] Yet it also affirms, by contrast, the fluid energy of Collins's "shadow'y Tribes of Mind." This fluidity allows them to become both plastic figures attributable to the poet's own creativity and, like Freedom and Simplicity, generative goddesses who transcend him even as they continue to exercise his gift of power. Because these forms generated by the poet's mind are life-giving in their plastic energy, and not life-denying, their resemblance to Satan's projection of Sin from his own mind is evoked only to be corrected; the poet is Promethean, not Satanic.[39] Yet because these "shadow'y Tribes" must be named as concepts of mind to achieve their generative freedom as verbal figures creating living, plastic form, Milton's figure of Death must also be a partial mode for a "poetical character" that will survive or surpass Milton's own. Finally, however, Herder's "dark link" between touch, feeling, and conceptual thought, his Promethean "Kraft" of plastic power, insists that rational concepts are built, like mythic figures, out of sensuous and tactile experience: With awareness of this world's moral textures, the Promethean artist acknowledges death in order to shape life. Milton's fear of sculptural creativity as both sensuous and idolatrous—a fear that eighteenth-century sculptors seem to share as they avoid Miltonic subjects[40]—thus finds an answer.

NOTES

1. *Paradise Lost* II, 667–68, in John Milton, *Complete Poems and Major Prose*, ed. Merritt Y. Hughes (New York: Odyssey, 1957), p. 248. All further references to this work will appear in the text.

2. Edmund Burke, *A Philosophical Enquiry into the Origin of Our Ideas of the Sublime and Beautiful*, ed. J. T. Boulton (New York: Columbia Univ. Press, 1958), p. 59. A few pages later, however, he also uses this phrase to urge less clarity in painting. For a review of eighteenth-century and more recent arguments over the visual elements in Milton's poetry, see Roland M. Frye, *Milton's Imagery and the Visual Arts* (Princeton: Princeton Univ. Press, 1978), pp. 9–16.

3. Anthony [Ashley Cooper, third] Earl of Shaftesbury, "Advice to an Author," in *Characteristics of Men, Manners, Opinions, Times, etc.*, ed., intro., and notes by John M. Robertson (London: Grant Richards, 1900), I, 135; Warton, *An Essay on the Genius and Writings of Pope*, 2nd ed. (1782; facsim. rpt. New York: Garland, 1970), I, 113; Martin William Steinke, *Edward Young's "Conjectures on Original Composition" in England and Germany* (New York: Stechert, 1917), p. 59; Steinke reprints the text of the 1759 first edition. Young goes on in this passage to criticize Swift for "dipping . . . his pencil" in "ordure . . . What a monster hast thou made of the '—Human Face divine!' Milton!"

4. Mark Akenside, "The Pleasures of Imagination," ll. 380ff., as quoted by A. S. P. Woodhouse, "Collins and the Creative Imagination," in *Studies in English by Members of University College, Toronto*, ed. Malcolm W. Wallace (1931; rpt. Port Washington, N.Y.: Kennikat, 1969), p. 84. See also Warton, *Pope*, I, 36: Personification in a description of landscape "imparts . . . the same pleasure that we feel, when in wandering through a wilderness or grove, we suddenly behold in the turning of the walk, a statue of some VIRTUE or MUSE."

5. Wasserman, "The Inherent Values of Eighteenth-Century Personification," *PMLA* 65 (1950): 440ff. See also Joan Pittock's introduction to Joseph Warton's *Odes on Various Subjects* (1746; facsim. rpt. Delmar, N.Y.: Scholars' Facsimiles and Reprints, 1977), p. x, and my essay, " 'Phidian Lore': Sculpture and Personification in Keats's Odes," *Studies in Romanticism* 21 (1982): 73–85.

6. The critic is Johann Georg Hamann; see below, notes 24–28. William Blake, of course, suggests a similar view in his myths of Urizenic rebellion; see *The* [First] *Book of Urizen* or *Milton* in *The Poetry and Prose of William Blake*, ed. David V. Erdman, rev. ed. (Garden City, N.Y.: Doubleday, 1970). The importance of Hamann was drawn to my attention by Paul de Man's reference to his quarrel with J. G. Herder; see "The Rhetoric of Temporality," in *Interpretation: Theory and Practice*, ed. Charles S. Singleton (Baltimore: Johns Hopkins Univ. Press, 1969), pp. 174–75. Because it has stimulated my thinking about Shelley, Susan H. Brisman's essay, " 'Unsaying His High Language': The Problem of Voice in *Prometheus Unbound*," *Studies in Romanticism* 16 (1977): 51–86, may well have influenced my development of this opposition between Promethean and Deathlike polarities in personification. Her category of an oppressive "Hermetic" language, in which words possess specific conceptual or objective references, has some affinities with my idea of a rhetorical personification which is Deathlike. Yet her definition of Shelley's "Promethean" language as one imaginatively free from rigid reference to words and things in this world does not correspond, except in its emphasis on creativity, to my discussion of a concrete, sculptural Promethean personification. My discussion is more Blakean than Shelleyan in origin. For two other analyses of personification which explore the vacillation of such figures between poles of knowledge and fictionality, see Jan-

ice Haney-Peritz, "'In Quest of Mistaken Beauties': Allegorical Indeterminacy in the Poetry of Collins," *ELH* 48 (1981): 732–56, and Stephen Knapp, *Personification and the Sublime: Milton to Coleridge* (Cambridge: Harvard Univ. Press, 1985). Neither explores sculpture as an element in the figure.

7. *De Doctrina Christiana*, in *The Works of John Milton*, XV, tr. Charles R. Sumner, ed. James Holly Hanford (New York: Columbia Univ. Press, 1933), pp. 38–39. He later (p. 44) uses the even more concrete verb "fabricavit" to describe the creation of Eve, but here—as in *Paradise Lost*—he emphasizes the secondary nature of her creation.

8. Yet see Michael Lieb's "Milton and the Metaphysics of Form," *Studies in Philology* 71 (1974): 206–24, esp. 216, for an analysis of Milton's careful fusion of Aristotelian and Platonic ideas of external and internal form, drawing upon discussions in Augustine's *City of God*. See also Patricia A. Parker, *Inescapable Romance: Studies in the Poetics of a Mode* (Princeton: Princeton Univ. Press, 1979), pp. 136–37, 149, 154. She speaks of Milton's effort to avoid "the Satanic reduction of meaning, the premature collapse of words and things" by a "trial" or "process," a suspension of meaning in figural language which projects forward, in freedom, toward "the *parousia*." Parker's book was drawn to my attention by Herbert F. Tucker, Jr., in response to an earlier version of this essay.

9. Jonathan Richardson, *Explanatory Notes and Remarks on Milton's Paradise Lost* (1743; facsim. rpt. New York: Garland, 1970), p. clix, and also in James Thorpe, ed., *Milton Criticism: Selections from Four Centuries* (1950; rpt. New York: Octagon, 1966), p. 58. See also Johann Gottfried Herder's *Plastik: Einige Wahrnemungen über Form und Gestalt aus Pygmalions bildendem Traume*, 1778, rpt. in *Herders Sämmtliche Werke*, ed. Bernhard Suphan (Berlin: Weidmannsche Buchhandlung, 1892), VIII, 75; and for Hazlitt and Keats, my essay, "Plastic to Picturesque: Schlegel's Analogy and Keats's *Hyperion* Poems," *Keats-Shelley Journal* 30 (1981): 118–51.

10. Trickett, "The Augustan Pantheon: Mythology and Personification in Eighteenth-Century Poetry," *Essays and Studies*, n.s., 6 (1953): 76. See also Chester F. Chapin, *Personification in Eighteenth-Century Poetry* (New York: Columbia, 1955), pp. 3, 40ff., 68ff.; Edward A. Bloom, "The Allegorical Principle," *ELH* 18 (1951): 163–90; and Morton Bloomfield, "A Grammatical Approach to Personification Allegory," *Modern Philology* 60 (1962–63): 161–71. For discussions of the controversial eighteenth-century responses to Sin and Death, see Cherrell Guilfoyle, "'If Shape it might be called that Shape had none': Aspects of Death in Milton," *Milton Studies* 13 (1979): 35–57; *Milton: The Critical Heritage*, ed. John T. Shawcross (New York: Barnes and Noble, 1970), pp. 226–29, 254; Joseph H. Summers, *The Muse's Method: An Introduction to "Paradise Lost"* (Cambridge: Harvard Univ. Press, 1961), pp. 38–40; Thorpe, ed., *Milton Criticism*, pp. 30, 81–83; and Knapp, *Personification and the Sublime*, ch. 2.

11. For eighteenth-century English discussions of blindness and creativity, see Ralph Cohen, *The Art of Discrimination: Thomson's "The Seasons" and the Art of Discrimination* (Berkeley: Univ. of California Press, 1964), pp. 162ff. This reference was drawn to my attention by Jim Borck.

12. In his "Moralists" (*Characteristics*, II, 16), Shaftesbury discusses the problematic relationship of Prometheus, whether "a name for chance, destiny, a plastic nature, or an evil daemon," to "the Gods." Either the Gods are responsi-

ble for his creativity or they are not omnipotent; Shaftesbury argues that God is omnipotent and the material world good. Cited by R. L. Brett in *The Third Earl of Shaftesbury: A Study in Eighteenth-Century Critical Theory* (London: Hutchinson's Universal Library, 1951), p. 68.

13. From "Plastics: An Epistolary Excursion into the Original Progress and Power of Designatory Art," in *Second Characters or the Language of Forms*, by the Right Honorable Anthony, Earl of Shaftesbury, ed. Benjamin Rand (Cambridge: Cambridge Univ. Press, 1914), pp. 90–91. For Shaftesbury's reiterated suggestions that sculpture is the earliest human art to develop, see pp. 117 and 125 in "Plastics."

14. See "Plastics," p. 175. "The word [attitudes] . . . is by the deepest moralists borrowed from statuary, anatomy, designing, and applied as the most significant term of art in morals." See also Theresa M. Kelley, "Visual Suppressions, Emblems, and the 'Sister Arts,'" *Eighteenth-Century Studies* 17 (1983): 28–60, for a careful analysis of the turn toward a more visible and "natural" form of emblem in eighteenth-century editions of Ripa's *Iconologia*.

15. E. H. Gombrich, "Icones Symbolicae," in *Symbolic Images: Studies in the Art of the Renaissance* (London: Phaidon, 1972), pp. 139ff. This essay was drawn to my attention by John Sitter. For further evidence of the continuity of this "enigmatic" tradition, see my essay, "Shelley at Play: A Study of Sketch and Text in His *Prometheus* Notebooks," *Huntington Library Quarterly* 48 (1985): 210–55.

16. See *Second Characteristics*, Introduction, p. xiv, and also *The Life, Unpublished Letters, and Philosophical Regimen of Anthony, Earl of Shaftesbury*, ed. Benjamin Rand (New York: Macmillan, 1900).

17. Harris, *Three Treatises; The First Concerning Art. The Second Concerning Music, Painting, and Poetry. The Third Concerning Happiness*, 2nd ed., rev. and corr. (1765; facsim. rpt. New York: Garland, 1970), p. 55.

18. See Diderot, *Lettre sur les Aveugles*, ed. Robert Niklaus (Geneva: E. Droz, 1963), pp. 15, 37, 60ff. While imprisoned in Vincennes after the publication of *Les Aveugles*, Diderot apparently made notes on *Paradise Lost*, now themselves lost; see Otis Fellowes, *Diderot* (Boston: Twayne, 1977), p. 52.

19. Robert T. Clark, Jr., *Herder: His Life and Thought* (Berkeley: Univ. of California Press, 1955), p. 224.

20. Herder, "Essay on the Origin of Language," in *On the Origin of Language*, tr. and afterword by John H. Moron and Alexander Gode (New York: Ungar, 1966), p. 140.

21. In his "Aeolian Harp," l. 47, in *The Poems of Coleridge*, Oxford Standard Authors (1912; rpt. London: Oxford Univ. Press, 1961), p. 102; and in the *Biographia Literaria*, ed. James Engel and W. Jackson Bate, 2 vols. (Princeton: Princeton Univ. Press, 1983), 1:10 and 2:13. See William K. Wimsatt, Jr., and Cleanth Brooks, *Literary Criticism: A Short History* (New York: Knopf, 1962), p. 390, for a discussion of Coleridge's German reading on this term.

22. See René Wellek, *A History of Modern Criticism*, I: *The Later Eighteenth Century* (New Haven: Yale Univ. Press, 1955), p. 165.

23. See Oscar F. Walzel, *Das Prometheus Symbol von Shaftesbury zu Goethe* (Leipzig and Berlin: Teubner, 1910), pp. 15–17. Johann Jakob Bodmer and J. J. Breitinger, Swiss writers, were strongly influenced by Addison's essays on *Paradise Lost*, and Bodmer translated *Paradise Lost* into German prose in 1832.

24. From "The Last Will and Testament of the Knight of the Rose-Cross Concerning the Divine and Human Origin of Language," in Hamann, *Sammtliche Werke*, ed. Joseph Nadler (Vienna: Herder, 1949–57), II, 32, as quoted by James C. O'Flaherty, *Johann Georg Hamann* (Boston: Twayne, 1979), p. 127.

25. From *Aesthetics in a Nutshell* (*Aesthetica in Nuce*), 1763, tr. Ronald Gregor Smith, in *J. G. Hamann, A Study in Christian Existence, with Selections from His Writings* (London: Collins, 1960), p. 199.

26. Hamann, Nadler, I, 157–58, trans. Smith, p. 66.

27. From *Aesthetica in Nuce, Werke*, tr. Nadler, II, 208; cited and trans. O'Flaherty, p. 71.

28. From "A Flying Letter," first version, tr. Smith, in *Hamann . . . Christian Existence*, p. 234; he gives no reference to Nadler's edition.

29. Smith suggests that Hamann's view of the Logos is eschatological, not mythological (p. 64); for man's "creatureliness," see O'Flaherty, p. 34. See Haney-Peritz, esp. p. 742, for a deconstructive reading of Collins's claims to an Edenic language as Logos.

30. For Lessing's knowledge of Burke, see Wimsatt and Brooks, *Literary Criticism*, p. 269. Clark notes that when Herder met Lessing in Hamburg in 1770 they discussed Burke's essay (p. 107).

31. For a discussion of the distinction between Plutarch's *enargeia*, or vividness, and Aristotle's *energeia*, "the actualization of potency," toward which Lessing's discussion here seems to move, see Jean H. Hagstrum, *The Sister Arts: The Tradition of Literary Pictorialism and English Poetry from Dryden to Gray* (Chicago: Univ. of Chicago Press, 1958), pp. 11–12.

32. Lessing, *Laocoon: An Essay upon the Limits of Painting and Poetry* (1766), tr. Ellen Frothingham (New York: Noonday, 1961), p. 58.

33. See Edward Gay Ainsworth, Jr., *Poor Collins: His Life, His Art, and His Influence* (Ithaca: Cornell Univ. Press, 1937), pp. 33–41, but see also p. 107 for an acknowledgment of Collins's "shadowy" personifications. More recent critics who emphasize Collins's nonvisual sublime are Martin Price, "The Sublime Poem: Pictures and Powers," *Yale Review* 58 (1968–69): 194–213; Paul S. Sherwin, *Precious Bane: Collins and the Miltonic Legacy* (Austin: Univ. of Texas Press, 1977); Thomas Weiskel, *The Romantic Sublime: Studies in the Structure and Psychology of Transcendence* (Baltimore: Johns Hopkins Univ. Press, 1976), ch. 5. Other recent approaches which debate the psychological and transcendental elements in these personifications as mythic figures also deal, although less directly, with their status as outwardly perceptible forms; see Harold Bloom's opening chapter of *The Visionary Company* (1961; rpt. Garden City, N.Y.: Doubleday Anchor, 1963) and his more recent "From Topos to Trope, From Sensibility to Romanticism: Collins's 'Ode to Fear,'" in Ralph Cohen, ed., *Studies in Eighteenth-Century British Art and Aesthetics* (Berkeley: Univ. of California Press, 1985), pp. 182–203; Merle E. Brown, "On William Collins's 'Ode to Evening,'" *Essays in Criticism* 11 (1969): ii, 136–50; Geoffrey Hartman, "'False Themes and Gentle Minds,'" in *Beyond Formalism* (New Haven: Yale Univ. Press, 1970), pp. 283–97; and Paul Fry, *The Poet's Calling in the English Ode* (New Haven: Yale Univ. Press, 1980), ch. 5. Haney-Peritz divides critics' approaches into those who read the personifications as figures of knowledge, hence constative, and those who read them as figures of rhetoric, hence performative (pp. 734–36). Patricia Meyer Spacks, in

"The Eighteenth-Century Collins," *Modern Language Quarterly* 44 (1983): 3–22, divides critics into those who impose a falsely Romantic teleology upon Collins and those who, like Richard Wendorf in *William Collins and Eighteenth Century English Poetry* (Minneapolis: Univ. of Minnesota Press, 1981), place his work in a more immediate historical context.

34. See his Fragment 3, pp. 68–70, and editors' commentary, pp. 177–78, in *The Works of William Collins*, ed. Richard Wendorf and Charles Ryskamp (Oxford: Clarendon Press, 1979). Collins's letter to John Gilbert Cooper, Jr., in *Works*, pp. 87–88, proposes this Shaftesburyan dialogue. See also Ainsworth, p. 20.

35. All quotations of Collins's poetry are from Wendorf and Ryskamp's edition; further references will be included in the text.

36. Wendorf in *Collins* (1981) remarks that "each of these created figures acts in turn as a creative agent" (p. 55), and on pp. 100–102 he praises John R. Crider, "Structure and Effect in Collins's Progress Poems," *Studies in Philology* 60 (1963): 57–72, for the observations that, as the poet supplicates the personification, he becomes her object, and that the personification becomes reflexive. See also John Sitter, *Literary Loneliness in Mid-Eighteenth-Century England* (Ithaca: Cornell Univ. Press, 1982), p. 138, for a similar observation about Fancy in "Poetical Character" as a creator.

37. For discussions of the importance of chastity in Collins's revisions of Spenser and Milton, see Woodhouse, "Collins and the Creative Imagination," and his later essay, "The Poetry of Collins Reconsidered," in *From Sensibility to Romanticism: Essays Presented to Frederick A. Pottle*, ed. Frederick W. Hilles and Harold Bloom (New York: Oxford Univ. Press, 1965), pp. 93–137; Sherwin, pp. 16ff.; Fry, pp. 99ff. For discussions of sculptural touch as redemptive in Blake's *Milton*, see my chapter on Blake in *Uriel's Eye: Miltonic Stationing and Statuary in Blake, Keats and Shelley* (University: University of Alabama Press, 1985).

38. See Sherwin, pp. 27–30, for a discussion of Milton in this location as Adam in paradise or as "a god."

39. See Sherwin, pp. 34–36; Fry, p. 110; and Sitter, p. 139.

40. See Marcia R. Pointon, *Milton and English Art* (Toronto: Univ. of Toronto Press, 1970), Appendix B, "Sculpture on Miltonic Themes," pp. 247–50. She does point out (p. xli) that V. Gahagan exhibited a sculpture at the Royal Academy in 1817 called "Satan in Council, a design for the end of a Garden Walk." See also Gombrich, *Symbolic Images*, pp. 151–52, for the Renaissance fear of worshiping graven images.

Notes on Editors and Contributors

JEAN GAGEN, professor of English, University of Kansas, has written *The New Woman in English Renaissance Drama, 1600–1730* (1954) as well as essays on Milton, John Dryden, William Congreve, and the Duchess of Newcastle. She has been a Visiting Scholar at Cambridge University and has held fellowships at the University of Birmingham and the Stratford Summer School.

NANCY MOORE GOSLEE, professor of English, University of Tennessee, is the author of *Uriel's Eye: Miltonic Stationing and Statuary in Blake, Keats, and Shelley* (1985). She is writing a book on Sir Walter Scott's narrative poetry, as well as pursuing research on personification and metaphors of sculpture in literature.

ALBERT C. LABRIOLA, professor of English, Duquesne University, coedited and contributed to *"Eyes Fast Fixt": Current Perspectives in Milton Methodology* (1975). Secretary of the Milton Society of America since 1974, he was codirector of the First International Milton Symposium in England (1981), Distinguished Lecturer at the Milton Institute at the Arizona Center for Medieval and Renaissance Studies (1985), and recipient of the James Holly Hanford Award for the most distinguished article on Milton (1981).

MICHAEL LIEB, professor of English, University of Illinois at Chicago, is the author of *Poetics of the Holy: A Reading of Paradise Lost* (1981), for which he received the James Holly Hanford Award for the

most distinguished book on Milton. He also wrote *The Dialectics of Creation: Patterns of Birth and Regeneration in Paradise Lost* (1970) and coedited and contributed to *Achievements of the Left Hand: Essays on the Prose of John Milton* (1974) and *"Eyes Fast Fixt": Current Perspectives in Milton Methodology* (1975).

LEO MILLER, an independent scholar from New York City, has written *Milton among the Polygamophiles* (1974) and *Milton and the Oldenburg Safeguard* (1985). He was the recipient of the James Holly Hanford Award for the most distinguished article on Milton (1980). The author of numerous publications on Milton, currently he is doing research on Milton's state papers in European archives.

STELLA P. REVARD, professor of English, University of Southern Illinois at Edwardsville, is the author of *The War in Heaven: Paradise Lost and the Tradition of Satan's Rebellion* (1980), for which she received the James Holly Hanford Award for the most distinguished book on Milton. She has published numerous essays on Milton and, in 1976 and 1985, held NEH fellowships. An opera enthusiast since the age of eleven, she has taught classes in opera and literature, as well as in Milton, Renaissance literature, and classical literature.

ESTELLA SCHOENBERG, professor of English, State University College at Buffalo, New York, organized A Milton Festival (1983–84), which culminated in a 350th anniversary performance of *A Mask*. She has published a book on Faulkner's narrative technique, *Old Tales and Talking* (1977), as well as essays on Faulkner, James Joyce, and Milton.

WILLIAM A. SESSIONS, professor of English at Georgia State University, is the author of *Henry Howard, the Earl of Surrey* (1986), the first full-length study of that poet, and is currently writing a critical biography of Surrey. His monograph on Spenser and Virgil, *Spenser's Georgics*, has been widely acclaimed, and his annotated bibliography on Francis Bacon (1945–84) is the first in this century. He has also written two books, an anthology and commentary on forms of poetry and an introduction to *Romeo and Juliet*. As a poet, he has been published in the *Southern Review*, *California Quarterly*, *Georgia Review*, and other periodicals. He is director of the Georgia State University Poetry Series in Atlanta.

EDWARD SICHI, JR., associate professor of English, Pennsylvania State University (McKeesport Campus), has published essays on Milton, the *Roman de la rose*, Shakespeare, and Faulkner. A founding

member and secretary-treasurer of the John Donne Society of America, he is corresponding editor for *The Shakespeare Bibliography*. In 1985 he received an NEH fellowship to attend the Milton Institute at the Arizona Center for Medieval and Renaissance Studies.

ERNEST W. SULLIVAN, II, professor of English at Texas Tech University, edited *Biathanatos by John Donne* (1984) and has published essays on Shakespeare, John Donne, Milton, Lord Byron, and John Steinbeck. He is a textual editor of *The Variorum Edition of the Poetry of John Donne* (forthcoming) and has been a Fellow of the Henry E. Huntington Library, the William Andrews Clark Memorial Library, and the University of Edinburgh Institute for Advanced Studies in the Humanities.